Yorro Yorro

The cover image of the Namarali hunter Wandjina from the opening ceremony of the Olympic Games, Sydney 2000, is used by permission of custodian Donny Woolagoodiya and Worrorra Elders. Worrorra people are a distinctive cultural group with their own language, located to the north of the Ngarinyin, along the rugged Kimberley coast, from Collier bay to east of Augustus island, where their country adjoins that of the Wunambal people. All three groups share the Wandjina culture, although respecting different Wandjina identities, each with their own different stories.

Yorro Yorro

everything standing up alive

Spirit of the Kimberley

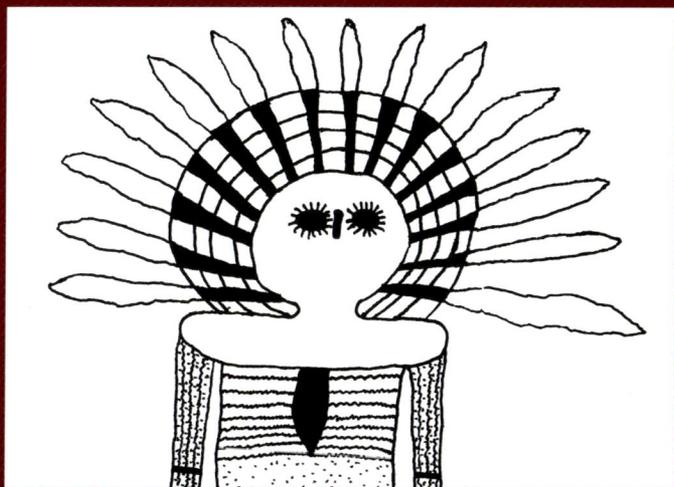

Mowaljarlai • Jutta Malnic

Magabala Books

First published by Magabala Books Aboriginal Corporation
Broome Western Australia 1993, U.S. Edition Inner Traditions 1993,
New Edition 2001

Magabala Books receives financial assistance from the Government of Western Australia
through the Department for the Arts; the Aboriginal and Torres Strait Islander Commission;
and the Aboriginal and Torres Strait Islander Arts Committee of the Australia Council,
the Federal Government's arts funding and advisory body.

Photographs on pp30-31 and 199, which first appeared in *Rock Paintings of Aboriginal
Australia,* 1981, reproduced with permission from Reed Books Australia

Cover image: the Wandjina Namarali, represented at Olympic Opening Ceremony,
Homebush Bay, photo by Kylie Smith, used by permission
Printed by Hyde Park Press, Adelaide
Typeset in Times 12/15

National Library of Australia
Cataloguing-in-Publication data

Mowaljarlai, David. c. 1928 –1996
Yorro Yorro: Aboriginal Creation and the renewal of nature: rock paintings and
stories from the Australian Kimberley.
Rev. and expanded ed.

ISBN 1 875641 72 6
1. Aborigines, Australian - Western Australia - Kimberley - Antiquities.
2. Aborigines, Australian - Western Australia - Kimberley - Religion.
3. Astronomy - Western Australia - Kimberley. 4. Rock paintings - Western Australia
- Kimberley. 5. Aborigines, Australian - Religion. 6. Kimberley (W.A.) - Antiquities.
I. Malnic, Jutta. II. Title.

994.14/0049915

Patsy Angburra, Mowaljarlai's great-aun
[mother's mother's older sister], 1938. Lomm

Cultural Sensitivity

In dealing with spiritual life, *Yorro Yorro* enters some areas of cultural sensitivity for Aboriginal persons. The procedure followed by the authors has been to consult with elders responsible as custodians in the communities of Mowanjum, Kalumburu, Iminji outstation, Kupungarri Station and community at Mount Barnett, Waa outstation, Mount Elizabeth and Gibb River stations. Finally, to ensure a correct approach and due permission, the publisher has carried out meetings in those communities to discuss and check the manuscript and photographs with interested parties, and with other Aboriginal persons who have cultural responsibility in various areas of the Kimberley. All those approached agreed to the publication of this material, as a permanent record, including the reproduction of photographs of places, persons, sites and cave paintings.

However, it is necessary to handle the material with discretion, always keeping in mind that much knowledge of this kind is normally both sacred and secret, and is confined to the men and/or women who have been educated in its rituals. Some of this material may therefore cause distress if it is discussed with Aboriginal people before establishing that the person concerned has the correct standing in his or her society, and is willing to speak of these matters.

These pages contain some images and names of significant persons who have died either before or since the project began in the early 1980s. They are included for their importance to history and to the future; as Mowaljarlai says, "This book is their story."

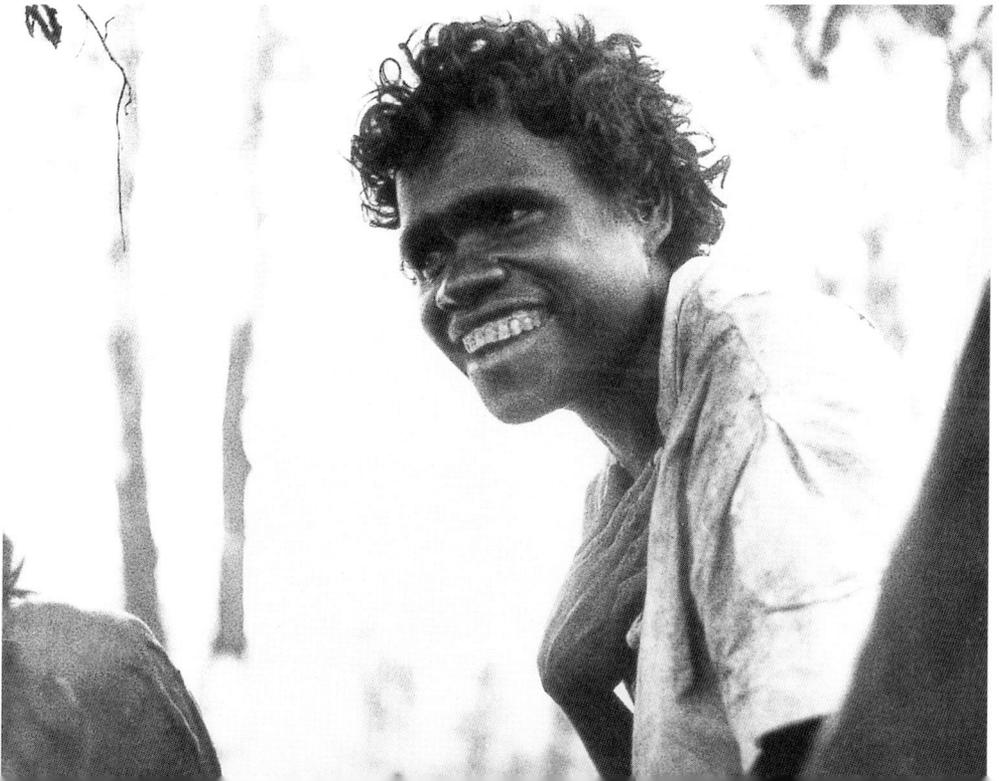

Acknowledgements

During the years of work on *Yorro Yorro* we received immeasurable help, rescue and support from a great number of people. They all gave unsparingly of their knowledge and hospitality, opened their understanding, and contributed professional skills beyond the call. Their gifts of time and patience cannot be quantified.

Thanks to Valerie Mowaljarlai, Sergei Malnic, Hector Dargnall, Jagamurro, Ondia Augustin (Gnangu), Manila Koordada, Geoffrey Mangalgnamarra, Elizabeth Kata, Irml Mensdorff-Pouilly, Andreas Lommel, Thea Waddell, John Ferguson, Les Lightowler, Ulli Beier, James Day-Hakker, Violet Jormary, George Jormary, Daisy Utemorrah, Laurie Utemorrah, Laurie Cowan, Paddy Neowera, Peter Yu, Johnny Umbagarumba, Harry Martin, Mirridji, Marilyn Keating, Barbara Mobbs, Alan Rumsey, Francesca Merlan, Graeme Ward, Joan Clarke, Maggie Gurruwela, Kitty Dereluk, George Aimbie, Joe Jorda, Judy Olding, Elaine Godden, Pamela Lofts, Andrew MacFarlane, Helen MacFarlane, Christine Bunjak, William Bunjak, Wilfred Goonak, Mayumi Minatani, Yvonne Gray, Suzie Dabingali, Dorothy Spider, Rastus Imitji, Daisy Carldon, Luciana Lussu, Kaori Zayasu, Joanna Wing, Pat Vinnicombe, Paul Jadman, Dutchy Bungud, John King, Ngalewan Nally (Fred Murphy), Peter Thompson, Gilgia Thompson, Patricia Knight, Matthew Richardson, Peter Randolph, Spider Burgu, Roger Burgu, Rita and Bluey Howie, Peter Burmeister, Anne Strange, John Koyers and the men and women at Drysdale Station, Nicholas Green, Visiongraphics, Michael Dillon, John Wolseley, Mimi Streber, Gary Taylor, Paddy Woma, Monica Knox, John Martin (Scotty) and Jodba.

Finally, a special thanks to Kerry Davies for indispensable proofing and copy editing assistance, and to Peter Bibby, our editor. His meticulous checking of lingual and cultural detail will doubtlessly contribute to a much wider acceptance of the work.

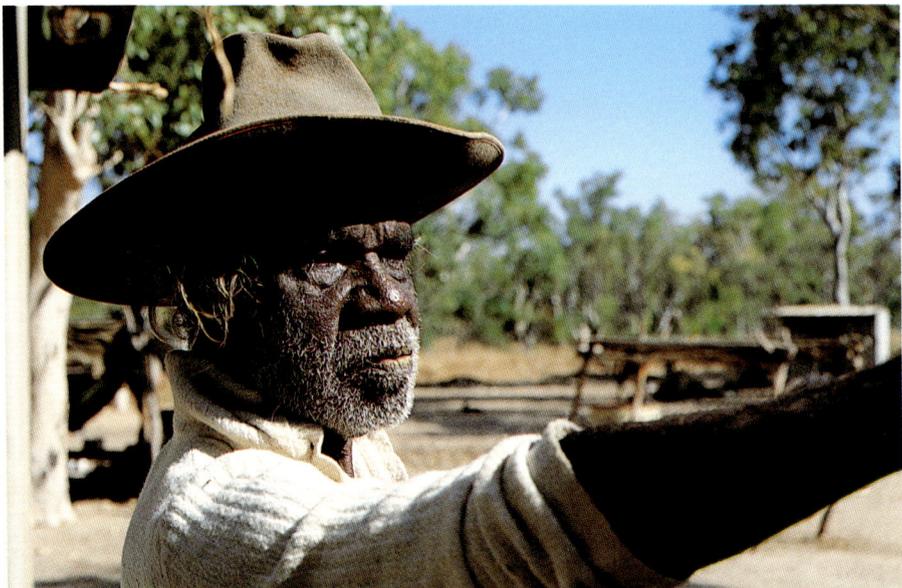

"You do the job." Johnny Umbagarumba at *Waa*

Contents

Part 3 LALAI

> *Note:* In most cases Aboriginal language words appear in italics the first time they are used. A full meaning can be found in the glossary, where a pronunciation guide is provided. In general, stress the first syllable. Ngarinyin is said: Nya-rin-yin [**ng** sounds like 'ni' in onion]; Mowaljarlai is said: Mull- (or Mowl-) jar-lee; Jagamurro is said: Yagga-murro [as J in Jutta is a 'y' sound]; some uses of **j** are as in joy: *Wo-jin;* **a** is said as 'ar' or 'ah', though sometimes like the 'u' in but; **u** is usually said as in put, not as in but; **r** is rolled slightly.

Foreword

Yorro Yorro is for young people to read and learn about. Also it brings memories back to the old people, so we can pass it on to the young. Reminding is good.

Daisy Utemorrah
Mowanjum

This book, written by Jutta Malnic in conjunction with Mowaljarlai, has given me great joy and aroused my admiration.

Joy, because it reminds me of my work in the Kimberley before the second World War and of my paper reporting on this work, *The Unambal: a tribe in Northwest Australia,* which saw publication only after the war, in 1952. That paper is, compared with this book, an incomplete work.

The outlining here of a Northern Kimberley Aboriginal "weltbild" [concept of the Universe] outranks my observations by far. Hence my joy and admiration.

I was in the Kimberley in 1938, member of an expedition under the auspices of the Frobenius Institute in Frankfurt on Main. My teacher, Leo Frobenius, had undertaken to establish a world archive of rock art. He was then sending colleagues to all the continents to record rock paintings. His grand scheme was not to be realised in his lifetime and has remained incomplete.

Our expedition was essentially engaged in the vicinity of the Glenelg River where, in 1838, Sir George Grey had been the first European to see rock paintings of *Wandjina.* This revelation was important. Grey was the first outside observer to draw attention to an artistic perception of Australian Aborigines. Until then, few Europeans appeared to have credited a profoundly gifted people with the ability to express themselves in art.

In the first part of this book, Malnic's journal of her travels with Mowaljarlai brings atmospheric life to the description of Kimberley scenes, interspersing this with frequent measures of a deeper story from Aboriginal voices.

It suddenly came to me as an astonishing realisation, that here flourished an epic mythology of the Wandjina that cited a Creator God of whom I knew nothing before. I had no knowledge of this aspect of the Wandjina.

In the thirties, the Wunambal elders I spoke to had naturally withheld this information. My stay had been too short to engage with their spiritual concepts to the depths revealed now, in this work. Nor had I become aware of a complex knowledge of the constellations in the Milky Way. My questions about stars had always been answered with a discreet avoidance.

But this now is magnificent. The statement here, that Aboriginal people always knew of galaxies beyond earth's solar system, it is resounding. And the wisdom, matched by the modest reservation, "But we only know about the Milky Way, that's as far as we can go." What magnificent and stable "weltbild", a universality of view which, as we now know, may have existed for 60,000 years. How far from all the Faustian dynamic that urges the white man on to ever new transgressions.

I remember Mowaljarlai as a ten-year-old boy. And I admire his dual achievement in gaining credibility and honours in the modern world while retaining access to the old, for becoming historian and proponent of a culture that has suffered so much attrition from the interloper.

He grew up at Kunmunya, under the practical Christian influence of the missionary John Love. He has combined this influence with his traditional culture, found a synthesis without schizophrenia.

I first met the young Mowaljarlai on a visit to the composer Alan, a heavily afflicted leper, who had gone back to live in the bush in order to evade forced incarceration in a leprosarium at Derby. Deeply contemplative and in constant meditation, Alan was composing a great djunbar, or corroborree. I was able to be present to admire a performance of this djunbar. I now read that a banman named Alan was cured by the Earth Snake licking him clean, while immersed in deep waters, a *wunggud* place, effecting a complete healing. A great story, attesting to the psychic healing powers of the Wunambal, Ngarinyin and Worrorra people.

My sincere congratulations to both authors on the completion of a magnificent and important work.

<div align="right">

Andreas Lommel
Munich

</div>

Kimberley Boab, Adansonia Gregorii, Napier Range
a Baobab species confined to North-Western Australia

Publisher's Note

The rock paintings and other cultural materials shown in this book are sites of religious power and significance. They are not curiosities. Neither are they a proper subject for casual tourist interest, which by its nature is passing and recreational. The purpose of this book is to further understanding and respect for the art and rituals of the people of the Wandjina. The Western Australian Aboriginal Heritage Act protects these sites. Readers who wish to visit them should contact community councils for permission. There is need for a strict observance of the protocol which has been the custom of the Ngarinyin, Worrorra and Wunambal for millenia. To the custodians themselves, entrusted with the care of a living heritage, it was always told, in the words of Hector Dargnall: "Don't think that because you own this you can do anything you like."

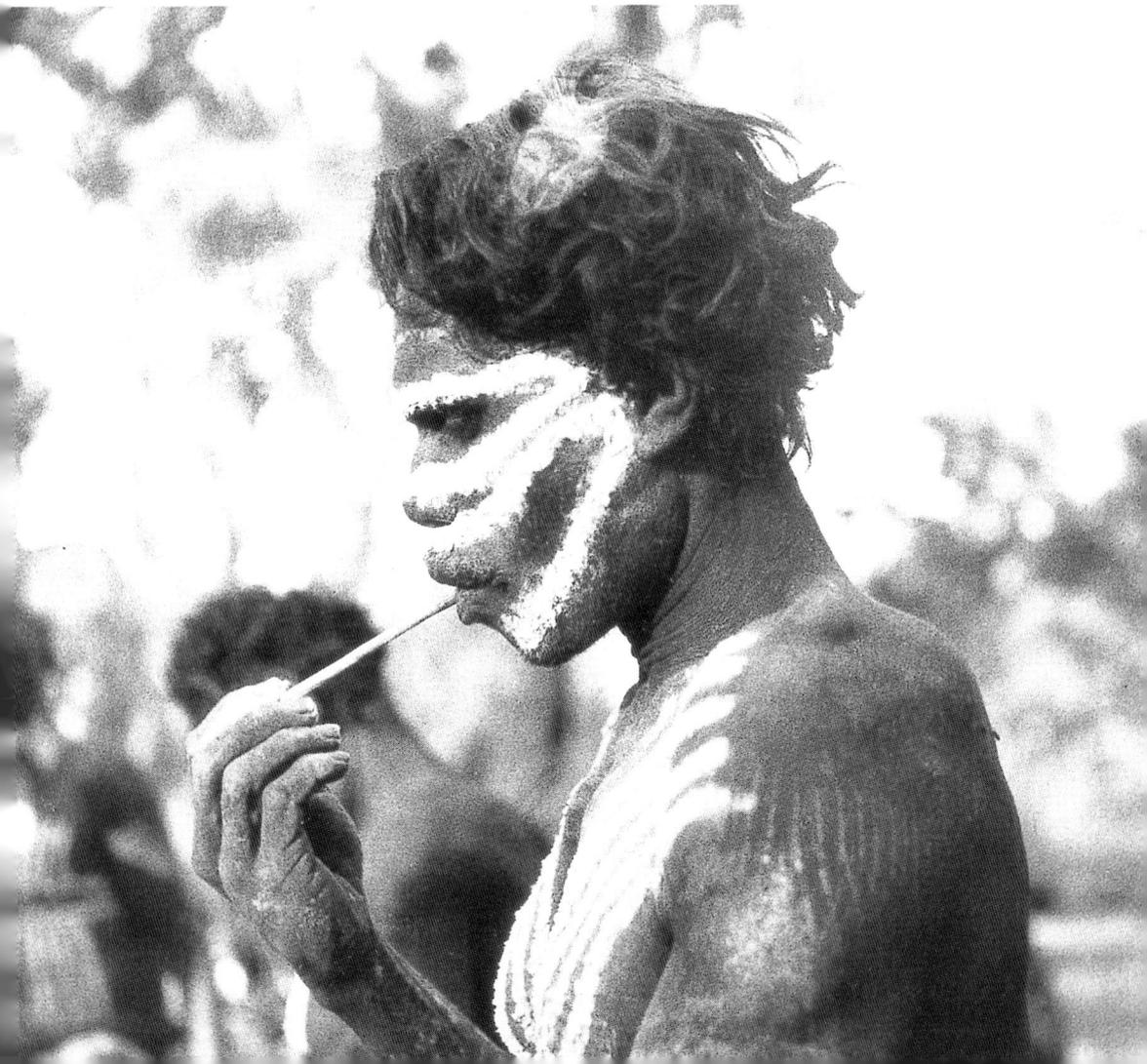

Preface

I'm very happy about this story. I've been carrying it from my old people for a long-long time, always thinking how I can do it. I worked with many anthropologists – Professor Elkin and Professor Freeman, Kingsley Palmer and Nancy Palmer, Nick Green, Pat Vinnicombe and many others. In the sixties I worked with Mister Coates. He was an anthropologist and a missionary.

We went out bush for a month's work. My old people showed me all the paintings and places and I was learning the story about Wandjina and Creation all over again, like in my young-fella days. Since then I've been carrying these old-time stories with me like a swag. I went to churches and places of the white man. In church-side it always used to remind me of my Aboriginal culture – worship and ritual, the things they used to preach about.

In 1980, Jutta came as a photographer, but she also got interested in the stories told by the old-man-who-ran-away and the other old men. She would say, "How can anybody understand all those stories, what they mean? All the time they are saying di-di-di-di-di. It's like sand between stones in a dry river – no water, no flow, no direction. You can't see it's a river." I had never seen it in fullness myself.

It has opened out more and more to me and given me understanding; what was behind all those stories the old people used to tell. I can see it clearly now, because we have been working on this.

What I am really saying: we walked together over many places and areas, travelled long distances around. Every day we were learning. We got closer and we were understanding it more – the country. It came out to us. Di-di-di-di-di-di – that's travelling across large spaces, talking, listening, all that. That's learning to understand.

When I worked with anthropologists, we never went back enough to find out proper beginnings, just bits and pieces, lots of little stories in the middle. I have never heard people ask such questions like Jutta. Those questions got us right into the nitty-gritty of Life Creation.

And my spirit guides have helped me with this work. At times they come and I can feel them standing next to me: my father, my grandfather or my mother or uncle. They are telling me the story, how it goes. They just pour it all out to me, telling me who they are. They have given me direction and identity. We all need that.

Mowaljarlai

Mowaljarlai's youngest grand-uncle Jimmy [Baba, mother's relation] painting up for djunbar, corroboree, 1938. Lommel

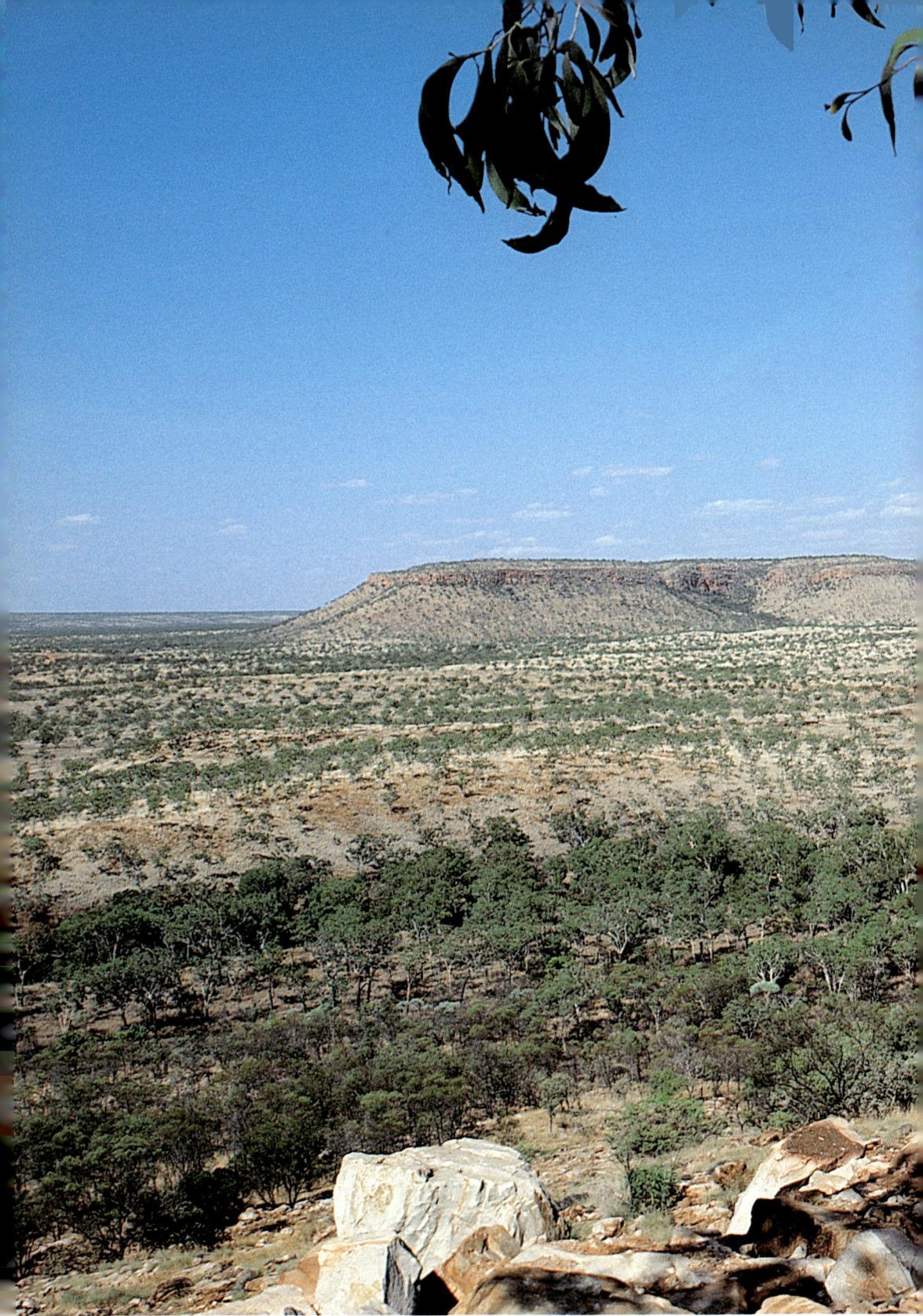

Marara Creek joins the Isdell River [Marara: the Snake that came with a spear in its tail]

View from Rifle Point to Bold Bluff, Balgajit Ranges

Introduction

On a cold and blustery day in 1980 Mowaljarlai walked into the high-rise building of the Australia Council in North Sydney. It was surely providence that made him head directly to the literature department, and to Elaine Godden. He was seeking financial assistance for the recording of sacred sites in the Kimberley region.

For several months prior to that day, in our own time, Elaine and I had been collaborating as writer and photographer on a book, *Rock Paintings of Aboriginal Australia*. The subject was the major painting sites around Australia. We had been to the Centre of Australia, to Cape York, Victoria, South Australia and the Far West of New South Wales, but were still looking for a guide to take us to the important Wandjina paintings in the Kimberley.

The timing of Mowaljarlai's arrival was perfect. There and then, in her tiny office, Elaine and he decided to record the Kimberley sites for Mowaljarlai's people and our book at the same time.

I could feel a buzz of excitement when Elaine phoned me. "Guess what, Mowaljarlai's just been here in my office. He wants some rock painting sites photographed. I said we'd do it."

"Who's Mowaljarlai?"

"An Aboriginal elder from the Kimberley. He's going to guide us."

"Terrific."

Later on an artist friend of both Elaine and Mowal , Pamela Lofts, decided to join us. That made a foursome of our party.

The Kimberley (singular) is a vast, sparsely inhabited country of rocky plateaux and plains at the very top-end of Western Australia, an area roughly one third larger than the United Kingdom (345,350 sq km against 244,000 sq km).

The coastline stretches to the northeast from Roebuck Bay to the Bonaparte Archipelago, across the Admiralty Gulf and Napier Broome Bay to the Cambridge Gulf and Wyndham. On a south-bound journey from Kununurra, the Great Northern Highway runs through Warmun, Turkey Creek, and only two small townships, Halls Creek and Fitzroy Crossing, before coming into Derby. It describes a rough outline to the inland borders of the Western Kimberley.

From its eastern reaches this ancient bushland undulates, either boulder-bare dry or monsoon flooded, to the western seaboard. There, out from the great river's final run, hordes of islands scamper into the Indian Ocean; and the great tides of the North-West rise and drain over violent whirlpools between the islands, drowning an immense coast to a depth of ten to twelve metres.

Opp.: Crystal Creek, remote Kimberley Coast. Photo Michael Dillo

Northern Kimberley

Wandjina paintings occur from the coast east of Derby,
north-eastward to Kalumburu and Forrest River,
and as far south as the Barker River

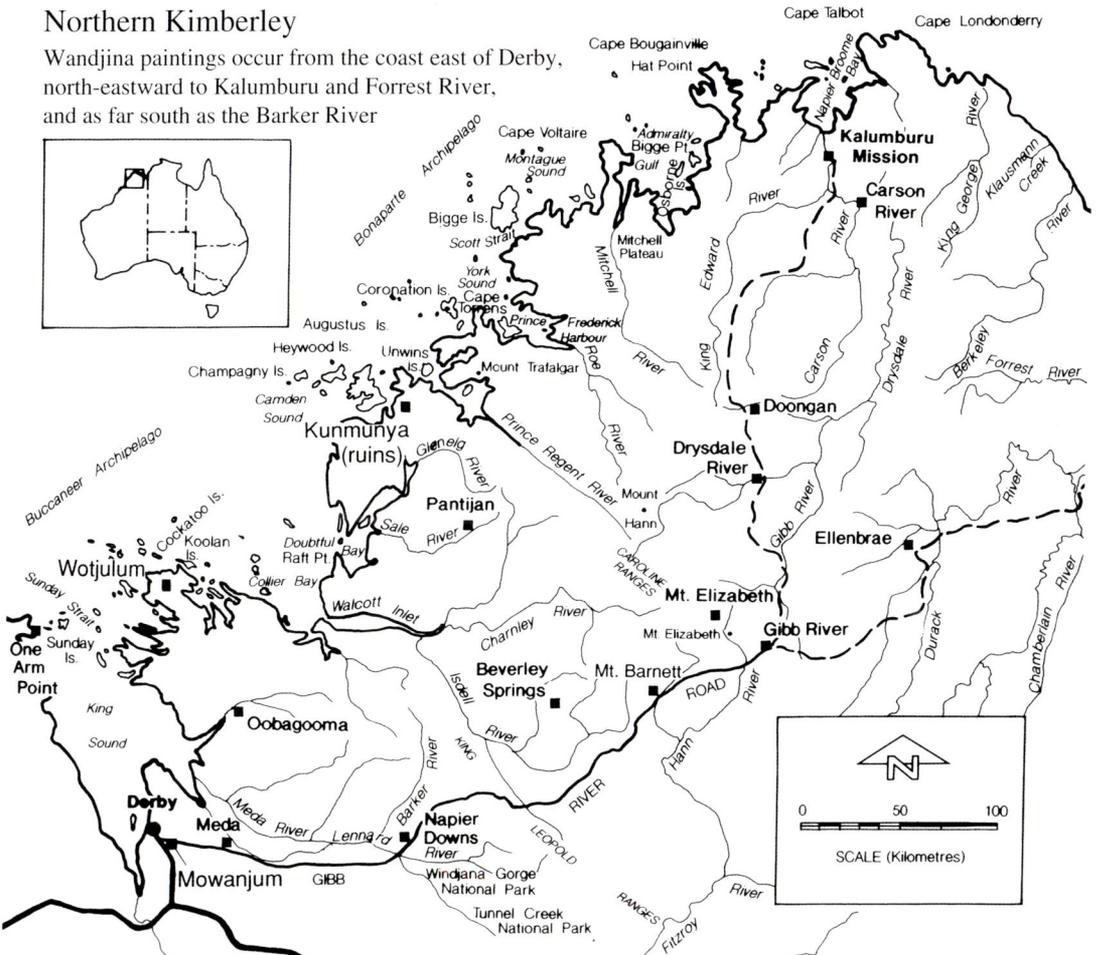

Cape Talbot
Cape Londonderry
Cape Bougainville
Hat Point

Bonaparte Archipelago
Cape Voltaire
Admiralty
Bigge Pt.
Gulf
Montague
Sound

Kalumburu
Mission

Carson
River

Bigge Is.
Scott Strait
York
Sound
Coronation Is.
Cape
Torrens
Augustus Is.
Prince
Frederick
Harbour
Unwins Is.

Mitchell
Plateau

Edward River

King George River

Klausmann Creek

River

Carson River

Drysdale River

Berkeley River

Forrest River

Heywood Is.
Champagny Is.
Mount Trafalgar
Roe
River
Mitchell River
King River

Camden
Sound
Kunmunya
(ruins)
Glenelg River
Prince Regent River

Doongan

Buccaneer Archipelago
Pantijan
Sale River
Mount
Hann

Drysdale
River

River

Gibb River

River

Cockatoo Is.
Koolan Is.
Doubtful
Bay
Raft Pt.
Collier Bay
Walcott Inlet

CAROLINE RANGES

Ellenbrae

Durack River

Chamberlain River

Wotjulum
Sunday Strait
Sunday Is.
One
Arm
Point
King
Sound

Charnley River
Mt. Elizabeth
Mt. Elizabeth
Gibb River
Isdell River
Beverley
Springs
Mt. Barnett
ROAD
Hann River

Oobagooma
Barker River
KING River

Derby
Meda
Meda River
Lennard
Napier
Downs
Mowanjum
GIBB
Windjana Gorge
National Park
Tunnel Creek
National Park
LEOPOLD
RIVER
River
RANGES
Fitzroy River

N

0 50 100

SCALE (Kilometres)

In such primeval wilderness, still much hidden, lie vital culture remnants of a Creation order that was known to four Aboriginal tribes – the coastal Worrorra, the (now extinct) Wunggarang of the islands, the north-eastern Wunambal, and the widely spread Ngarinyin of the more central Kimberley.

They lie manifest in the paintings of the mysterious Wandjina raingods which, to some Westerners, have suggested prehistoric spacemen. We will come to know the real aspects of these Wandjinas.

Now that the old tribal life in the bush has gone, some last old-time bushmen and bushwomen decided to hand down their knowledge, through Mowaljarlai, for future generations of Kimberley Aborigines. Some of this knowledge gleaned is woven into the tale of two excursions into the Kimberley. Part 3 is a summary and exploration of spiritual and historical elements, based on tape-recordings and diaries. Mowaljarlai and I have sorted, in parts rounded, the gathered material for clarity, and for a wider readership.

It is a knowledge given as the owners of Kimberley Aboriginal culture want it held on record: "the full picture, not just little pieces," as they repeatedly emphasised. Mowaljarlai and other Aboriginal elders are quoted verbatim to the greatest possible extent. His language pattern varies. At times he speaks haltingly, as do other bilingual Aborigines; yet when speaking to an avid audience, or in the bush, he can elaborate richly, often in poetic terms.

At the painting sites, Mowaljarlai had always introduced me to the Wandjinas as "This guy coming from same place as that Lommel guy," referring to the German anthropologist Andreas Lommel who first came to the Kimberley in 1938.

On visiting Lommel in Munich, I discovered he had taken photographs of Mowaljarlai as a young boy (Mowal thinks he was ten or twelve years old at the time). The former director of the Voelkerkunde Museum in Munich lives in retirement now. He kindly gave his permission to publish these pictures.

Mowaljarlai, a Ngarinyin tribal elder, is now in his mid-sixties. He has kept a strong hold on his old tribal culture and connections, as well as experiencing Western lifestyles. In 1991 he became Aborigine of the Year, an honour conferred for his services to the community. In 1993 he was made a Member of the Order of Australia.

Over thousands of years Kimberley people have held changes in their existing world, on earth and in the cosmos, on record. It is their cultural and evolutionary history. From the remaining fragments, we have tried to piece together an outline of this history – first and foremost for the future generations of Kimberley Aborigines whom it concerns.

Jutta Malnic 1993

Mowaljarlai at ten or twelve, with Patsy Angburra, 1938. Lomn

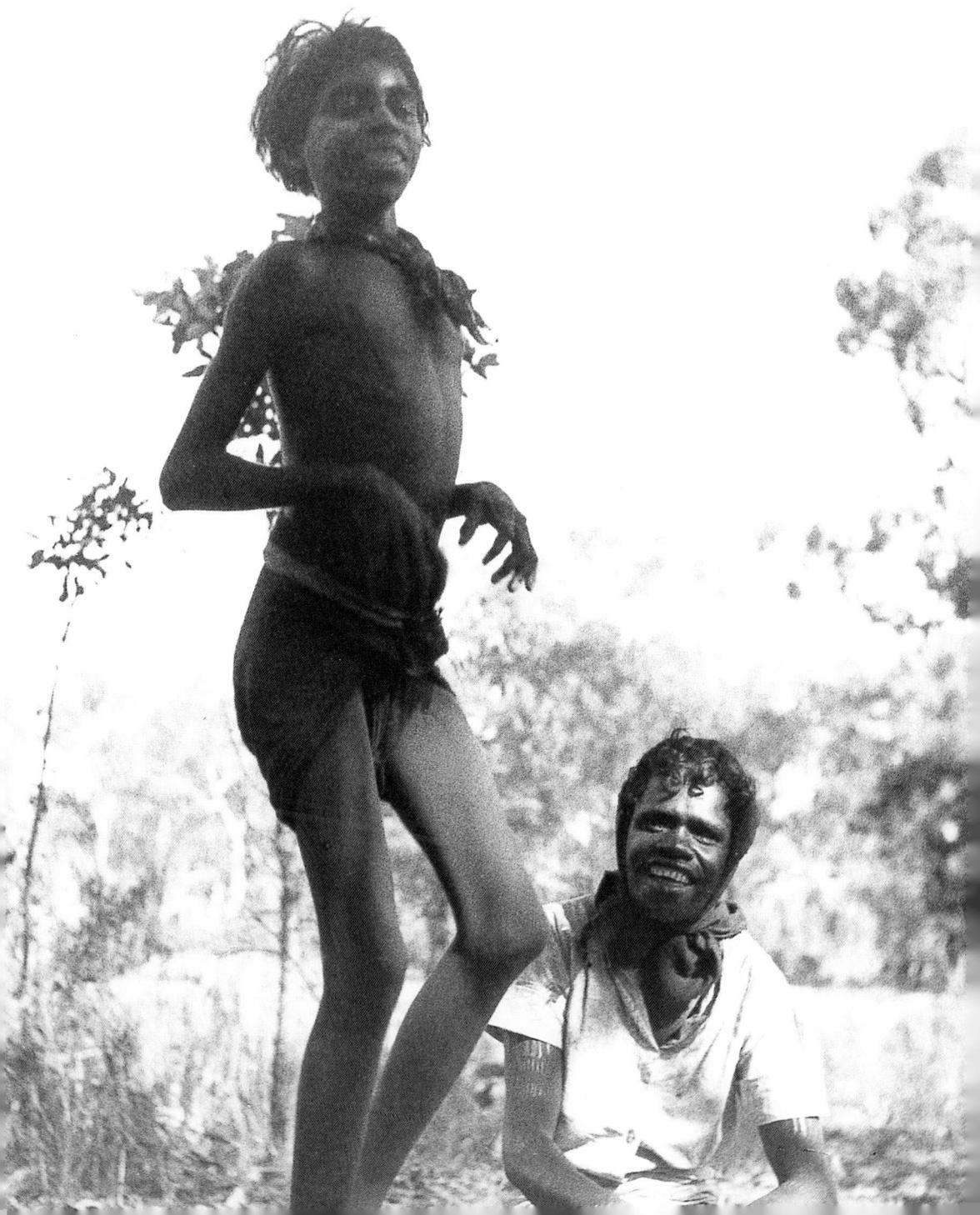

To our children
and to all the future generations

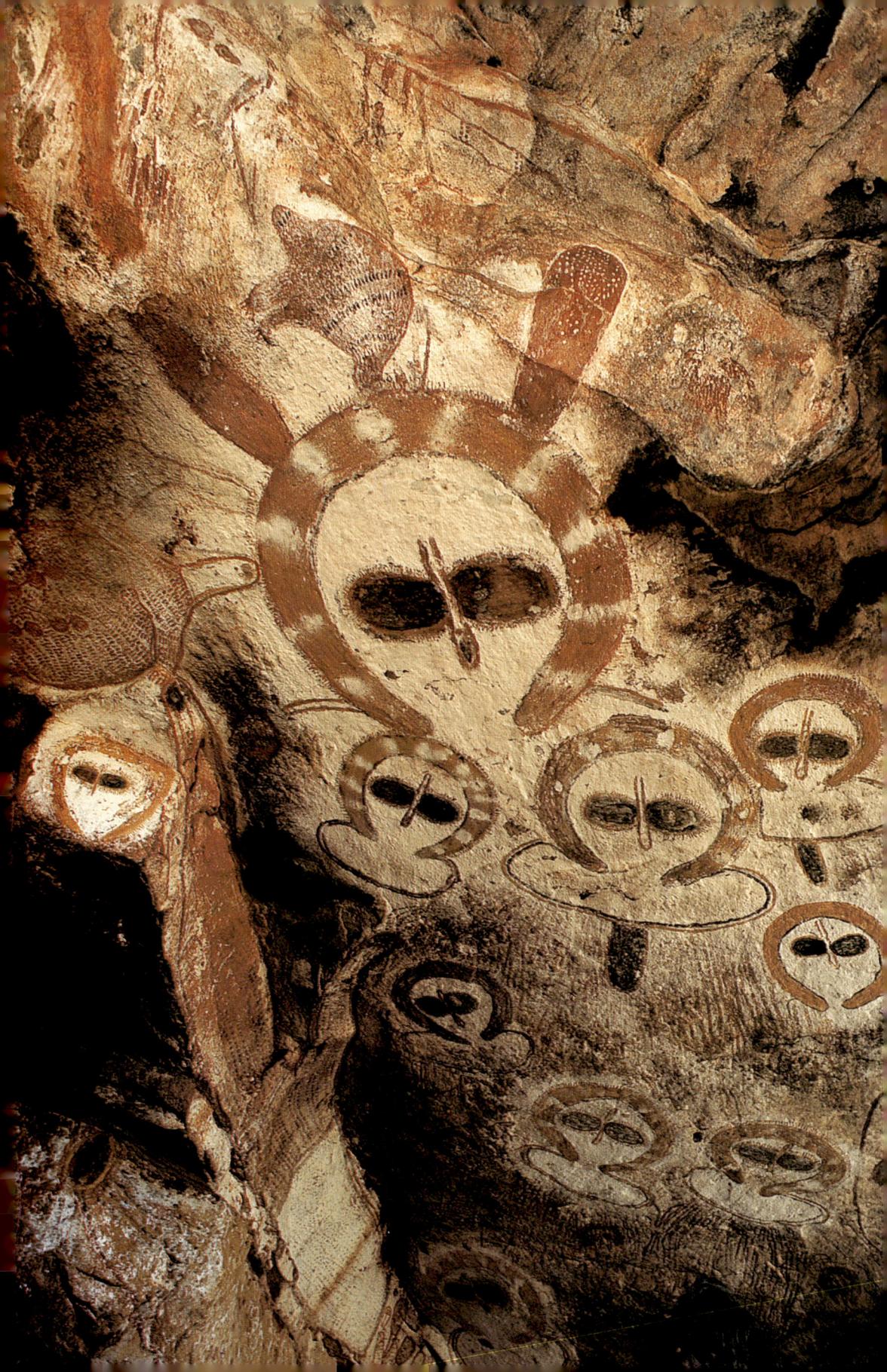

Part 1
A Journey to the Stars

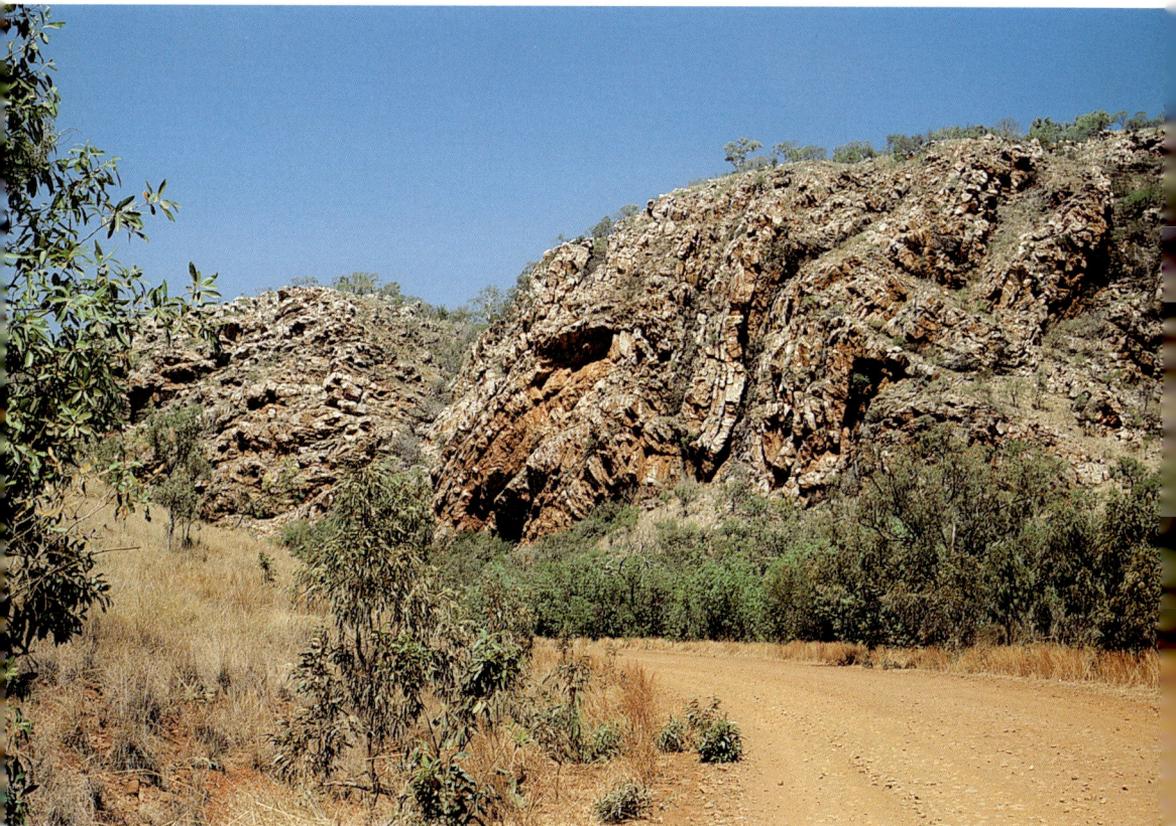

Leopold Ranges, Gibb River Road
Opposite: Waanangga, Bee Wandjina and followers, Sugarbag site

1 Start

We left Sydney by air. The usual turmoil before getting away was enriched by a bit of extra drama. Two days before departure, I broke my right elbow and sprained my wrist in a stumble and headlong crash onto hard city pavement. The arm was put in plaster, which was changed to a sling when I threw caution to the wind and decided to stick to plans, come hell, high water and gravel rash – but definitely no green ants into my plaster cast.

On the flight across the continent I had suddenly panicked. How would I manage in the bush? I couldn't even lift my camera to eye-level. I'd forgotten to think about that.

Now, after take-off from Darwin, relaxing into a travelling frame of mind and getting absorbed in the grandiose patterns of the landscape below, I contemplate the photographic settings of our adventure ahead.

The aircraft shadow flits towards a shining maze of rivers, then runs across arid plains to a row of petrified molars which focus as ranges. In the distance, coastal glare merges with the indigos of the ocean.

Then an emerald surprise – lush borders along liquid serpentines, the Ord River, Kununurra, and a first-time landing in Western Australia.

An hour's flight further west, the sun is going down, touching the horizon like a fiery gong, welding tidal wetlands and sea into one big sheet of glittering brass.

Crimsons and golds silhouette the boab trees beyond Derby's runway. They disperse under the landing plane like a tumble of pregnant bowling pins.

I had not met Mowaljarlai before. At the fence of the air terminal a dark figure in Stetson and jeans steps from the crowd, greeting us with hugs and strong handshakes. I feel instant friendship.

The next morning we set out to buy foodstuffs for the journey ahead; but Mowaljarlai draws the line at tea, sugar, flour, jam, biscuits and a few tins of meat-mixture. "Going to eat bushtucker," he says, "you'll feel good and strong." Then we head for the bush.

Being invalid, I can sit in the Landcruiser's cabin. Under canvas, on the back of the truck, Elaine and Pam settled into an odd assortment of things: ten-foot spears and a *womera* (spear-thrower); *didgeridoo;* a gun and a

tomahawk; three wooden sticks for digging grubs and roots (one for each female member in the party); a spade for making camp, firebreaks and toilet purposes; a water canister; two 44-gallon drums of petrol; mattress, tents, swags, camera cases, recorder and tapes, some personal belongings and a small cardboard box with a minimum of food items. Can't wait for the hunting and gathering!

Silence prevails over long distances. I slyly observe Mowaljarlai's fine profile, a silhouette against the glare outside, the straight, brushy lashes shading his eyes. They seem sore, even a bit frayed, at the lower rim, probably from inflammation. They attract flies. At times he points at a feature with his nose and pursed lips: "Meda Station," "Victoria Gap," "Napier Downs," he announces. On an open plain he observes, "I don't like that high grass. My spirits are strangled in high grass."

There is more specific information: a jump-up place is wherever a rise happens to cut through the plains. Then: this part of the Kimberley is Wandjina country. All Wandjina country is either *umangat*, the stone itself or a range; or *memangat,* sandstone country; or *garawut,* an area of pebbles; or *ngallarra,* grass country.

Ngallarra

Features in the landscape are reminders of mythical events in the past. At a distant escarpment, for instance, a little boy had run along crying. When he stopped to wipe his nose, the snot turned into yams. Then we pass a waterhole where some women were transformed into boab trees. Another place, *Njanggudunda,* is especially dedicated to kidneys.

But I am only half listening, wondering when we will get to see the rock paintings we came to photograph.

We pass through the gates of Mount Elizabeth Station, one of the big Kimberley cattle properties. Past the main homestead, from a setting of scattered dwellings and little tin sheds, Aboriginal people hurry to greet Mowaljarlai. Many are old and fragile, some crippled, others blind.

When the Overlanders brought their cattle from Queensland to settle, they hunted and rounded up the tribal men, then trained them to work as stockmen. The station manager Peter Lacey is no cattle king of earlier days, although he still issues supplies of tea, sugar, flour and tobacco once a week from the station store. He was brought up by Aboriginal people. An old lady on a polestick limps through the sand. Her free arm, an atrophied stump, balances a cardboard box with clothes and some food.

View from Inglis Gap, Gibb River Road

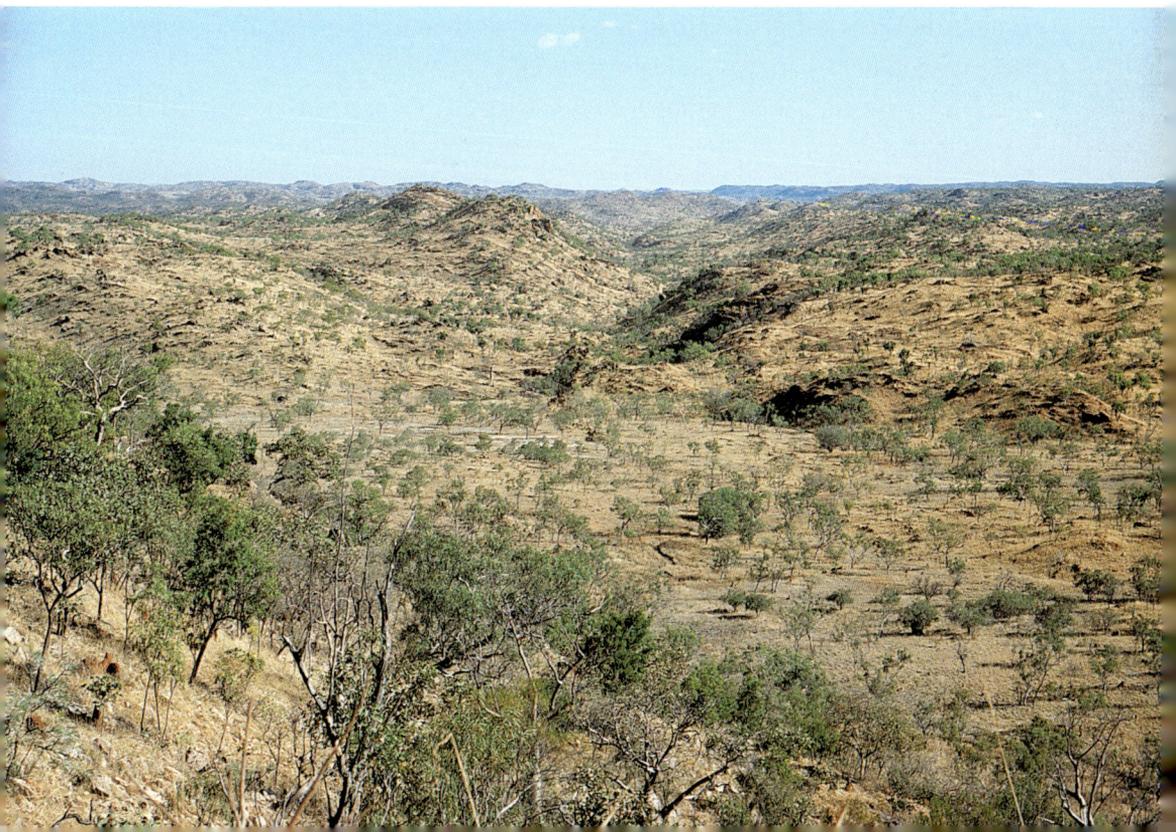

She hands it to a man with prominent tribal cuts, who then flings the box, and his swag, onto the back of our truck.

Jagamurro, elder and *banman* (a medicine man), will be coming with us; but thankfully not his shadowing pet, a huge and vicious emu; nor any of the mangy-looking dogs that sniff and scratch and yap, and that defecate almost anywhere.

"Bedja?"

"Bedja!" comes the answer from the back. That means "ready" – all aboard.

"Well, we're not here!" Mowaljarlai always says that before a departure. I like this nomadic prompter. It makes you feel at home on the road.

"What happened to Mrs Jagamurro's arm, Mowal?"

"Fighting. There's always this fighting."

And I wonder about the old man I saw, who had no feet.

"Maybe he sleep too close to the fire, maybe leprosy, or maybe cattlemen shoot off his feet. They did that, when they came with the cattle, so that Aborigines could not run and spear their bullocks."

At sundown we settle by the Gibb River. A truckload of Aborigines arrives and joins our camp. They are on their way to Kalumburu Community, another day's drive to the north.

In the fireside round, Daisy Utemorrah is the focal personality – a fascinating storyteller. We are invited to share their meal but, as it is pitch-dark, decide not to accept and to eat muesli.

"What happened to the moon tonight, Mowal? It was up last night when we cooked dinner."

Voice from the dark, "Moon rises one hour later each day, Jutta." Now, where was I when they taught that at school? Nor had I heard of the increasing moon being left-handed, and a right-handed sickle on the decrease.

Mowaljarlai plays with the children, throws firesticks high into the air. When they burst into sparks, the children run about shrieking with delight. The old men sing to clapsticks long into the night. When the left-handed moon climbs out of the trees, we can see their serene faces.

2 Towards the Little Lights

After three days without seeing a single Wandjina painting I ask Mowaljarlai, "Where are those paintings?" He says, "Ah, we'll find big mob of them!" And then, "Wait till we get to *Lejmorro,* you'll be so happy. Lejmorro is the boss of all the Wandjina in the Kimberley." Was there a stirring that the word Lejmorro would become engraved in my mind?

Lejmorro, Mowaljarlai explains, is the earthly manifestation of the Milky Way. The word comes from *lej* – little lights.

In connection with the Milky Way it means "lit", also "lit from outside". It is a carrier of light from regions beyond as well as translucent to and transporting enlightenment. Lejmorro also means "Light for all Aborigines." Mowaljarlai explains:

> We carry the light in us and shed it onto others by teaching. Everything under Creation is represented in the soil and in the stars. Everything has two witnesses, one on earth and one in the sky. This tells you where you came from and where you belong – to your mother's land, your father's or grandfather's land or whichever place.
>
> As you sleep beside the campfire at night you may think you are stiff on one side and turn over; in reality, you are following the Milky Way as it turns around the Earth.
>
> Everything is represented in the ground and in the sky. You can't get away from it, because all is one, and we're in it. As you see the Milky Way, it ties up the land like a belt, right across.

With a chattering noise, the truck crosses a cattle grid, then follows the edge of an airstrip to Drysdale River Station.

"How big is this property, Mowal?"

"About one thousand square kilometres, and some more."

We stop at the homestead to let the manager know we are going upriver across his station land. He flatly refuses to let us go in. He has scheduled a helicopter muster for the next few days and our truck will frighten the bush cattle.

It is easy to dislike this man. He will not speak to Mowaljarlai, just leans over his fence, looks us up and down, and says, "What about you girls come and clean up the homestead instead? The wife has left – for good. Can you cook?"

I can feel our combined tempers seething. In a minute he will get a boiling argument; that's cooking for him. Thoughts clatter through my head like water on prayer-wheels: If we can't drive across the property, we may have to fly in, with *his* helicopter pilot. In that case, we would need to buy aviation fuel here. We can't afford to get angry. Elaine and Pam will chop and peel, and I can be the left-handed cook. At a distance, unheard by the man, we reluctantly come to a compromise.

We make our camp not far from the road. The sand by the river is white and warm. We rise at dawn. Mists levitate over perfect silence. The first sunrays flicker golden tips onto the pandanus. Their aerobic poses mirror in the water.

By the fire, the old man's shirt looks surprisingly white. Erect and meditative, Jagamurro sings quietly to clapsticks. This skinny old man has a remarkable presence. When I hold my eyes to his, I feel them penetrating my thoughts, my mood and motives. He projects an intense independence

Drysdale River plateau

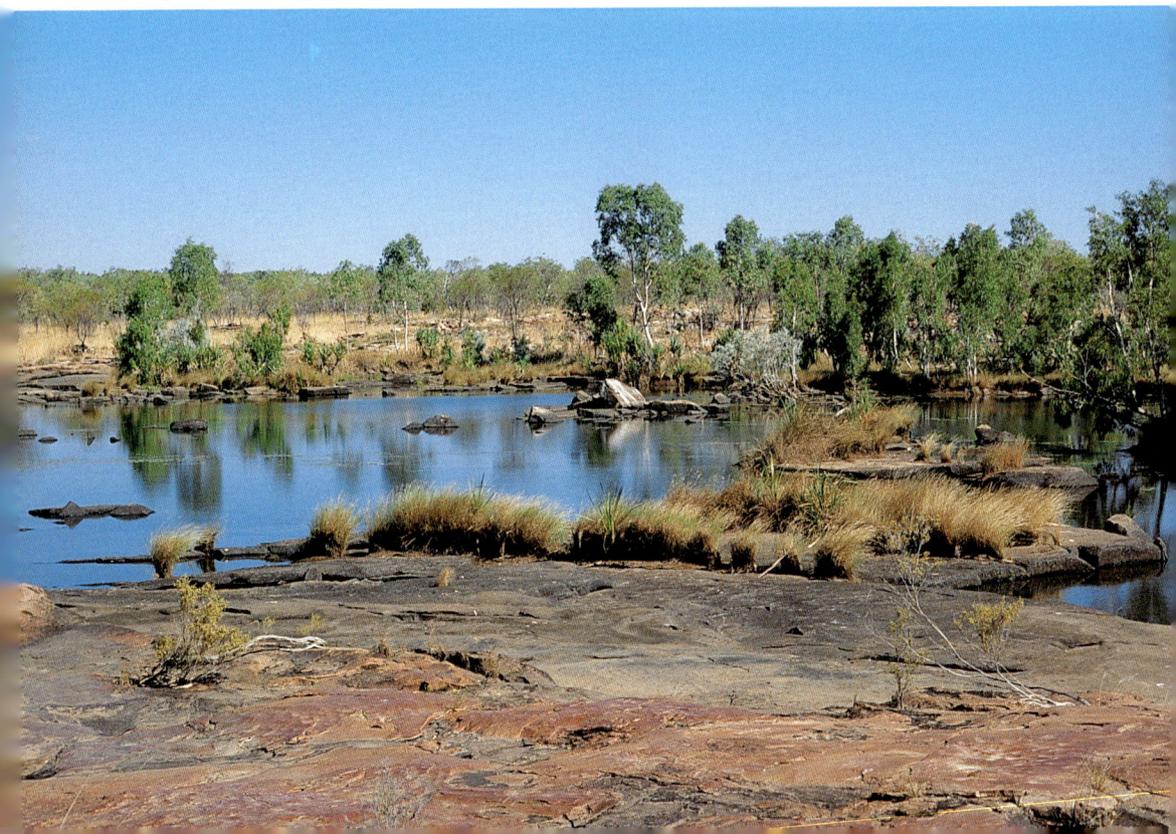

– but at times a quick twinkle alights on his face as if to say: "You've been waiting for that, haven't you?"

Last night we had unwelcome visitors, cattlehands from Drysdale. They roared out of the night in a battered bull-buggy, a cattle-rammer Jeep, jumped out and stood over us with scary, derisive questions: What were we doing here with those blacks by the river?

Elaine and Pamela bravely handled the banter. I kept in the background, blessed my only half-healed face, and thought that theirs looked like blunted meat-axes. There was so much hatred I did not want to follow the conversation. What relief when they finally left. We decided to shift camp in the morning.

Early, the sun still below eye-level, Jagamurro tracks ahead through fire-charred bushland. Hands clasped behind his back, he zigzags scanning the ground. When we catch up, he points to the remnants of a stone arrangement. They lie scattered by car tyres and driven into the sooty sand.

Jagamurro has found a *Bamale* in this endless bush, a King Brown Snake stone, a site he last saw fifty years ago. Later, we settle on a more distant plateau. Here, the water-smoothed sandstone slabs glide gently into the Drysdale's basins, emerge here and there between pads of waterlily.

Jagamurro sings to clapsticks

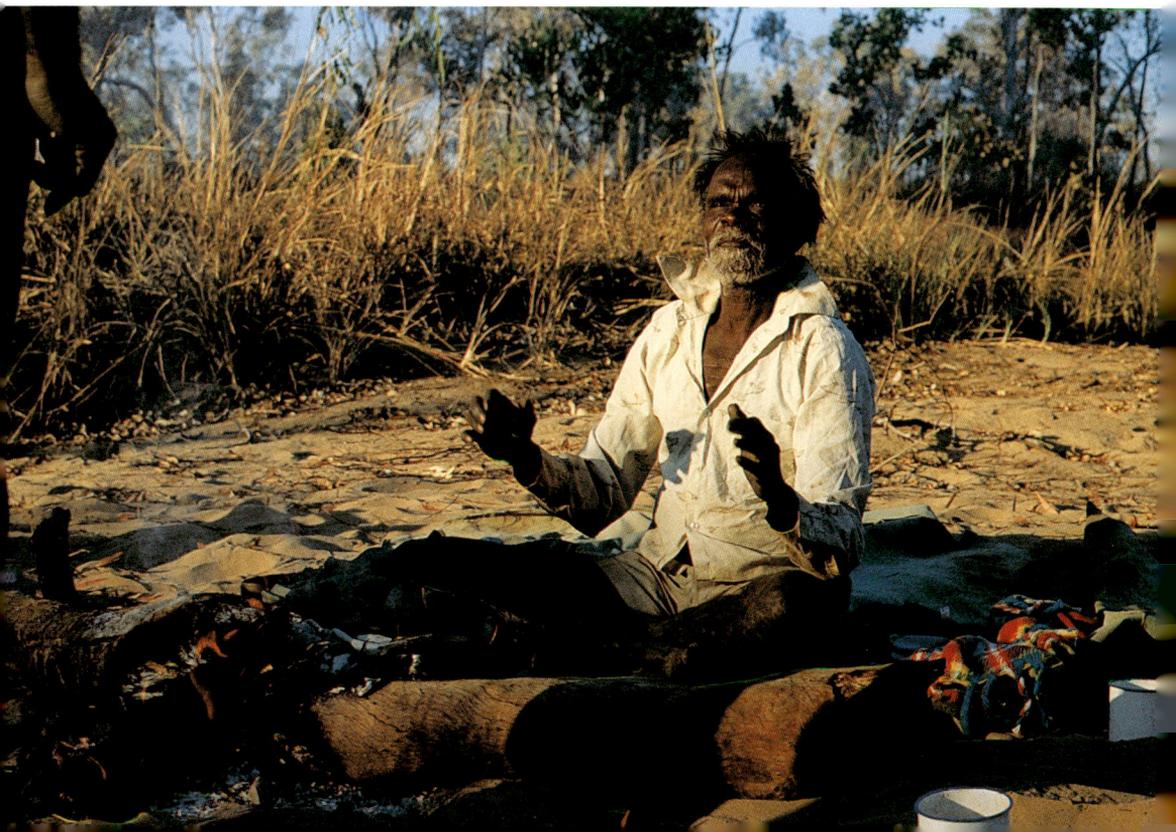

A few trees throw thin nets of shade, their leaves hiding with an edge-profile from the broiling sun.

On a higher plateau, *Dilagnari*, there is an area of rhythmically scattered stones, the *Wongai* Women. We hear their story:

> Long, long ago, the women made the law and kept the power of this sacred stone that joined the Milky Way with the Earth. When *Gorrid*, the Great Whirlwind, came and took their power, the women had huddled to the ground and turned themselves into stone.

Jagamurro now sits and sings by the sacred *Mahmah* stone. He has restored it to the upright position, a metre-high snake form. He takes a pebble and remakes the eyes and the sacred line. After fifty years, he has come back to attend to the great law stone.

Further on, we spot a pair of bush turkeys pecking through high grass. They remind me of an elderly couple I often see strolling in my street in Sydney. At times the old lady stops at a fence to look at some flowers; her husband has a habit of stirring his stick through the leaves beside the footpath; or he talks to a passing dog. They are rarely walking together, but are never far apart. Before crossing a street, he will turn to her, "Are you coming, Marjorie?"

When Mowaljarlai puts a bullet into one turkey, the other bends to the limp companion – aren't you coming? Still unaware of danger the bird stays close by and is easily caught and strangled.

Towards nightfall it's off to the station for the cooking. The pilot has arrived. At the kitchen table we chat over drinks. He agrees to fly us to Lejmorro. We will have to make several trips as the helicopter takes only two passengers at a time. The manager agrees to supply the aviation fuel.

When the casseroles simmer with a promising aroma, we are invited to stay for dinner; but no, we will eat with our friends in the bush.

There is the most pitiful cat underfoot. She is nearly hairless and therefore pink. Hardly a whisker is left of the once white fur, and she has no tail. She claws her way around the kitchen like a crawling pancake.

"She's had bad luck – the kids plucked her hair." Then she was run over by a truck and bitten by a snake, so they renamed her Short-Wheel-Base. We are glad to get back to the bush.

That's not easy though, finding our own track of flattened grass in the beam of the headlights. The night is pitch-dark. Over rocks, around fallen trees and ant heaps, we finally make it back to the plateau.

But instead of a happy welcome, we get ticked off for smelling of alcohol. The bush turkeys are (half) cooked and lying cut up on a rock. I am not hungry.

Jagamurro plays his clapsticks deep into the night, hums and murmurs to the flames of old old events. His eyes seek the night-space. He is not with us tonight. The old man can hear the sacred singing.

In the morning we go to a shining *wunggud* pond, where spirit children are waiting to be dreamt into their mother's womb.

"How does that come about, Mowal? When do you know that a spirit has entered into your baby?" We all want to know.

"I'll tell you," he replies. "You dream you are holding a baby, you see the baby, then suddenly it's gone – it's gone inside you."

Then he points to a log which protrudes from a thicket of reeds into the open water. "We service them," he says, "those sacred stones or logs. There are always two. One is in the water. We dive down, pull 'em out, dry 'em up a bit, put 'em back. The second one comes from the Milky Way, through the mirror in the water. There are two of everything, one in the Milky Way, one on the ground. They witness each other."

When the men distance themselves to attend to some sacred objects in a cave, they soon return dejected: "Hippy flower-people have taken the lot." From the appearance of the cave we guess that the people had to leave their shelter after a fire burnt the surrounding scrub and cindered the simple alternative household.

When we get back to our camping place, the plateau is frypan hot. We move with the shifting shadows, bathe and enjoy the leisure. Elaine and Pamela sit all afternoon at Jagamurro's side recording stories, while Mowaljarlai translates. I wonder how long this cattle muster will last. When will we finally get to see those rock paintings?

Another day of waiting begins. I day-dream with my toes in a lily tangle. Miniscule leaves and porcelain petals bob and jig with the shadows of fish. I feel guilty for bathing here last night, with toothpaste and soap; even washed my dirty socks in this elixir of delight.

Suddenly Mowaljarlai towers above, a grey kangaroo across his shoulders. Elaine and Pam rally quickly. We laugh and prance around the great hunter and his enormous prey.

Jagamurro follows to a shade of casuarinas with kangaroo liver seeping between his fingers. For the first time we see him with a really big grin on his face.

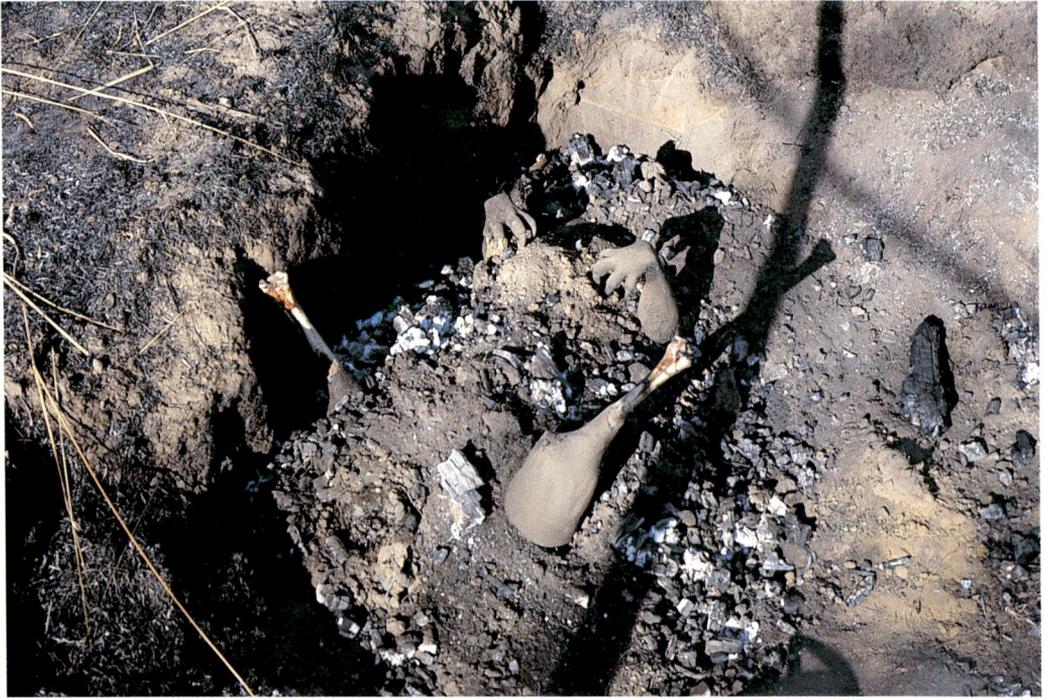

Bared leg bones, the timer: "When it's pure white and the hands bend, it's cooked."

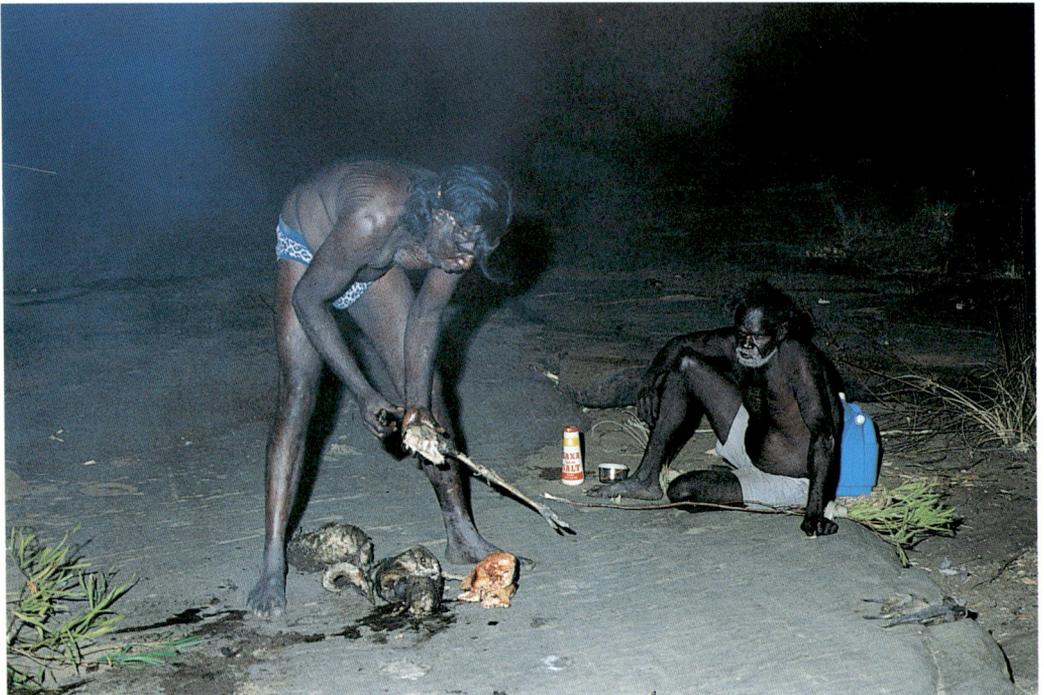

Jagamurro watches Mowal prepare bush turkey on a sheet of rock.

A hunted animal is always gutted quickly, we learn, to determine if the liver is clean and free of parasites. We collect firewood, help with the digging of a hole and the lighting of a big fire inside. Mowaljarlai removes the flesh and tendons from the kangaroo's feet, up to the hopping joints. A stench of singed fur belches from the flames, then the black-naked beast goes down into the solid heat in the pit.

The changing colour of the bared leg bones will tell us when the kangaroo is cooked. The waiting begins, a long wait. We are resting and listening to stories. In the midday heat, Mowaljarlai's voice carries lightly over the shrill, sleep-inducing insect concert of the bush.

He tells how a Snake Dreaming near Warmun Community (Turkey Creek) allows no wound to heal whatever medication one may use; and of the Rainbow Serpent's powers to make rain and wind to destroy people.

Then, that Jagamurro can also make rain, but runs into trouble every time there's storm and lightning; that he is the healer in his community, has inner eyes and powers for astral travel and, at times, joins in astral group travel with other banman men.

Meanwhile, Jagamurro has been hacking away at the kangaroo liver, threaded the pieces onto twigs, and proceeded to barbecue these roo-kebabs. Surprisingly, we all enjoy this entree. It conditions for the main course. A section of the tail, Wandjina food, is a must. After pulling off a scorched muff-like ring, previously tail fur, the meat is tasty but not tender. A slice of the thigh is also obligatory to strengthen our legs for walking. Operation Kangaroo goes off without a hitch.

Late in the afternoon the helicopter appears and lands nearby. The pilot has come to discuss the flight procedures for the following morning. He will come shortly after daybreak for an early take-off on the first flight.

He casts a glance at Jagamurro who sits pensively by the fire: "Anyone worried about flying?"

Mowaljarlai laughs, "No worries, him flying all the time."

Wunggud pond. "Deep part belonging to women's law. The snake stood up here, near the Wongai Women stones." An incised Wandjina shown on p183 marks this place.

One of the Wongai Women. "Snake got jealous because they had the law. They put their head down because of the whirlwind."

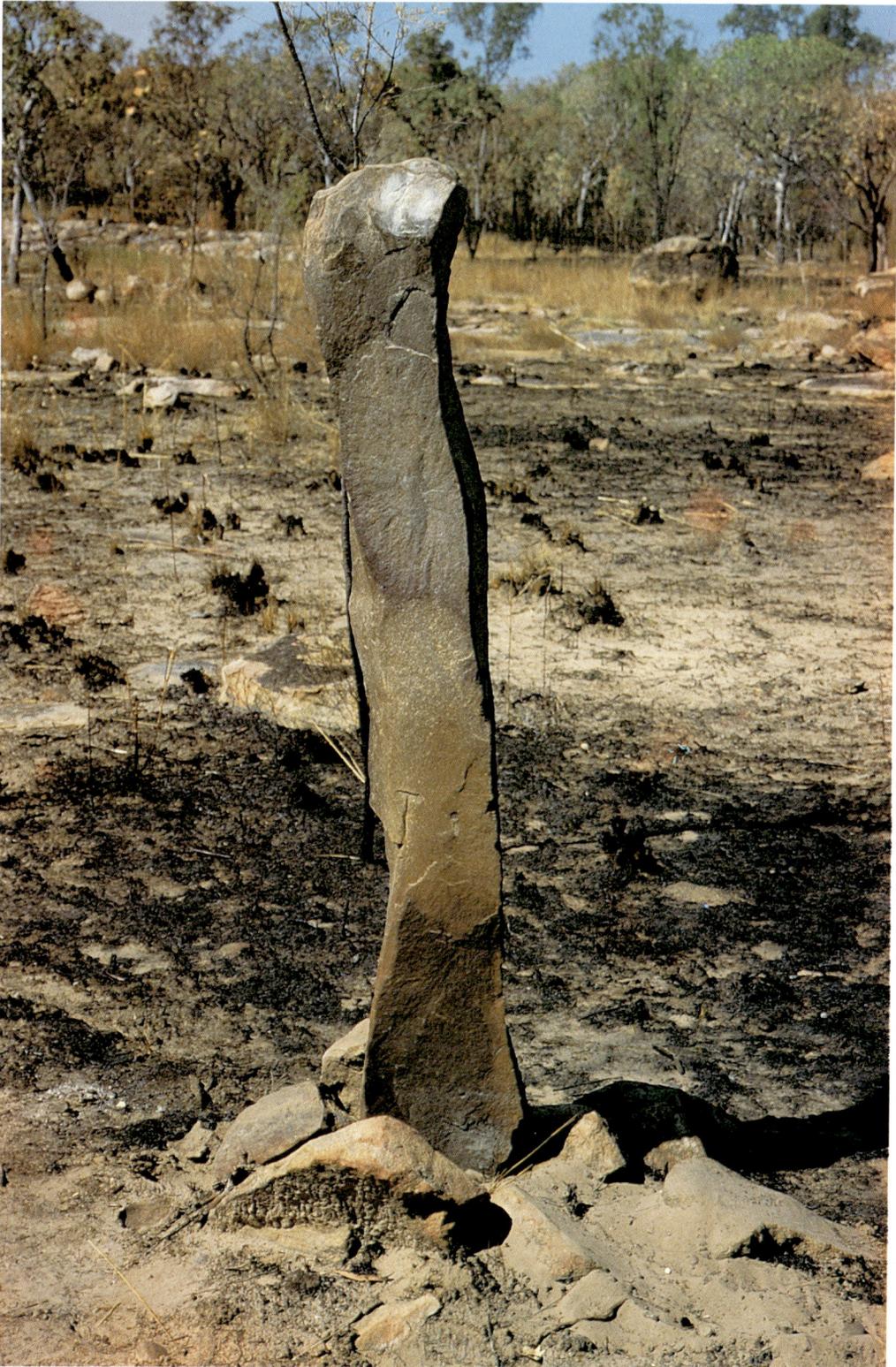

Mamah stone; in the background Wongai Women stones

3 Snakes

Dawn enters the tent at 5 a.m. Outside, Mowaljarlai and Pam huddle by the fire, with a big problem – Jagamurro has gone!

Had he, after all, become scared at the prospect of flying? That he might have woken to the difference between astral and helicopter travel crosses my mind.

The old man has taken his blanket, tobacco tin and his hat – but no weapon, fishing line nor food. Without him, we can't fly to Lejmorro now, only Jagamurro knows where to find it. We abandon all immediate plans for the Lejmorro site. Disappointed and very concerned for the old man's safety, we pack up and leave for Gibb River Station.

At Gibb River we meet up with Ngalewan Nally, (his English name is Fred Murphy), a short, frisky countryman of Mowal with an amusing range of facial expressions (who also pinches your bottom unless you watch out).

Ngalewan is the owner-custodian of the *Njallagunda* Snake Dreaming. He takes us to this site, a superb gallery nesting in the rounded ceiling of a rock shelter. Three small Wandjina faces peer from a fan-shaped formation of wriggling snakes (their upper parts only are shown). They are are all facing outside, looking at us with beady eyes.

The snakes are *Galaru* snakes. Ngalewan's eyes sparkle as he explains how exceptional it is for Wandjinas to "paint" (manifest) together with snakes.

And he blames a campfire of long ago for the burnt spot in the middle of the canvas; but it is "important symbol", he says, because the lower parts of the snakes were burnt in earth fires; as was that other snake, *Wunggadinda*, who went to Manning Gorge.

Wunggadinda is also depicted here in a separate cameo, still full-bodied, with the spirit child she totemised.

At a nearby rock outcrop, some upright stone slivers represent the snakes' saliva.

That night we camp on soggy ground by the river; and talk and worry throughout about Jagamurro's safety, the dive-bombing mosquitoes, and being trampled by bush cattle – not the best preparation for the following day's visit to *Wojin*, the Big Wandjina of *Wanalirri*.

14

Even at slow pace, the Old Wyndham Road leading there is a reliability test for any vehicle, and for the passengers' nervous systems. We gladly walk the last stretch to a point of descent into the gorge.

Privately, the men attend to some sacred objects, then warn the Wandjina of our coming: "Wojin, don't be worried, it is us," Mowaljarlai shouts across the gorge. "We are bringing you three guys: one from Australia [Pamela], one from other side big water [Elaine], and one guy from same place as that Lommel guy [myself]!"

With only one useful arm, the descent is difficult. Every sapling you cling to carries leaf-bundles that pour out hundreds of green ants at the slightest vibration.

Then, beyond the dry-bouldered river bed, we face the stare of Wojin, the dangerous, powerful Wandjina of a story shared by Ngarinyin, Worrorra and Wunambul people, the story of *Dumby the Owl:*

> He raged when he heard how two boys had teased and hurt Dumby, plucked his feathers, flicked the naked little bird with speargrass and had then thrown him into the air: "Now see how you can fly!"

> When Dumby told the Wandjina of his misfortune, Wojin brought on an enormous flood that killed all people in the area – except the two mischievous boys. They hid in the pouch of a kangaroo and started the whole tribe afresh.

I lie flat on my back to fit Wojin's length into the viewfinder. He is holding *gulay,* a native plumtree with a green fruit, and gazes back from the ceiling, listening with his dark eyes. And I keep on talking and talking to him.

Both men, Mowaljarlai and Ngalewan, carry themselves with alertness and elation as they silently move along the shelter inspecting individual paintings and telling their story.

> This is the living tree belong to this country. All the fruit we eat of this. It is the pattern of life and the track.

Then, as the light moves around, two Lightning Spirits are revealed that we could not see before. The painting must be more than ten thousand years old, says Mowaljarlai, "Before our time – we only know Wandjina story *after* the Flood."

With time, rock pigment on rock, the wall had reclaimed its own – yet revealed these memories to us for a few minutes.

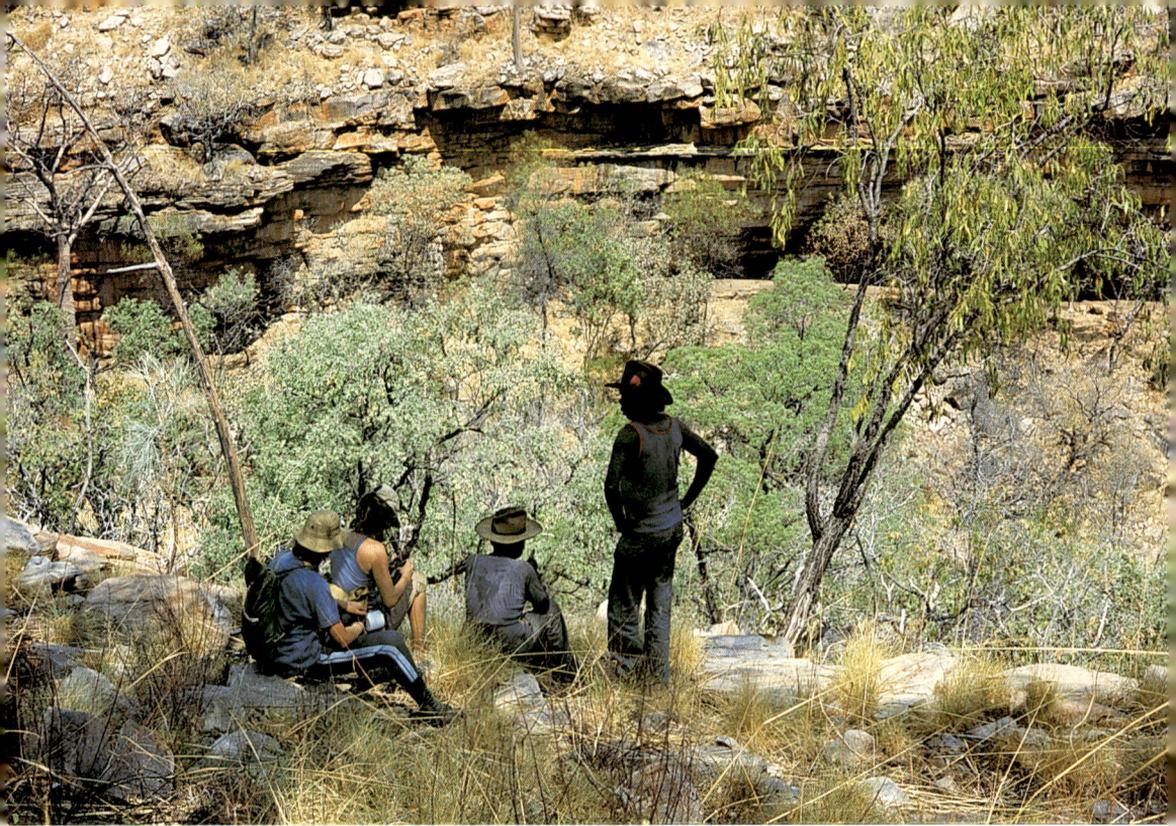

Gibb River Gorge; Elaine Godden, Pamela Lofts, Ngalewan Nally, Mowaljarlai

Opposite: Njallagunda Snake Dreaming, one of the few sites where Wandjinas and snakes are painted together. Top halves only; their lower parts were burnt in earth fires.

Wojin, the dangerous, powerful Wandjina at Wanalirri

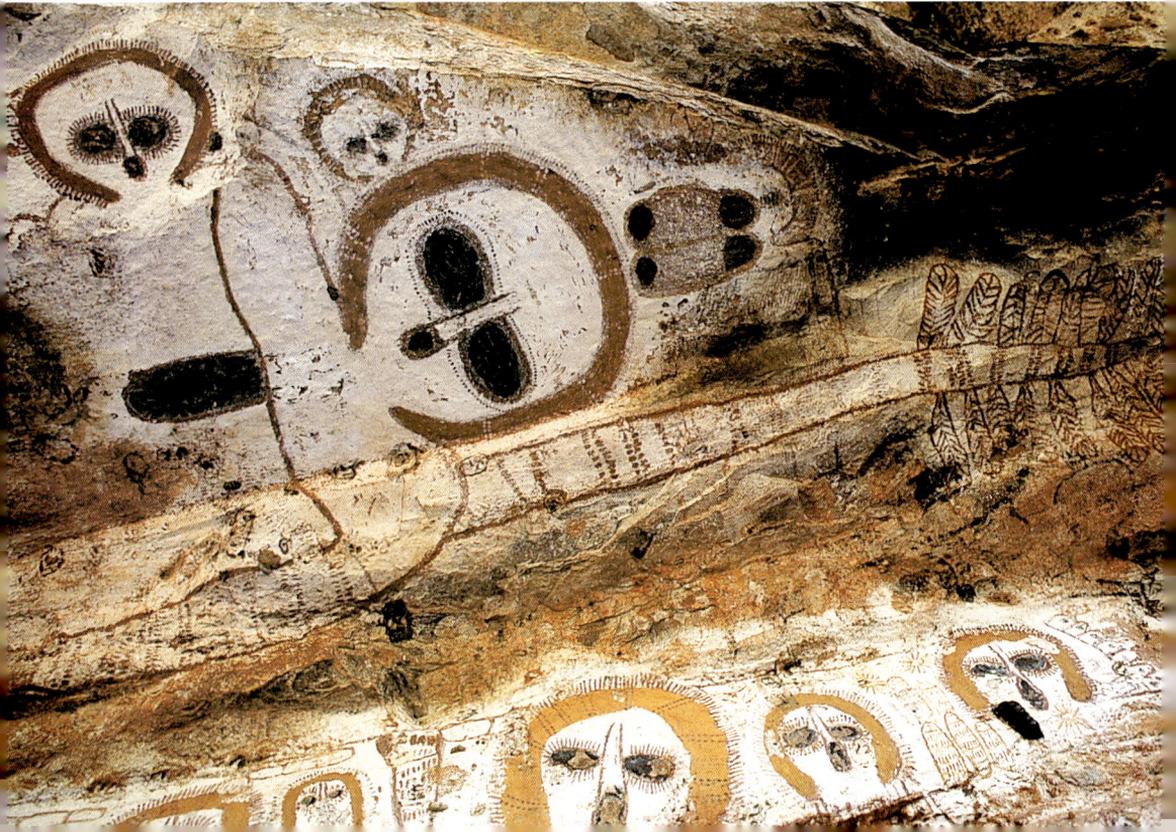

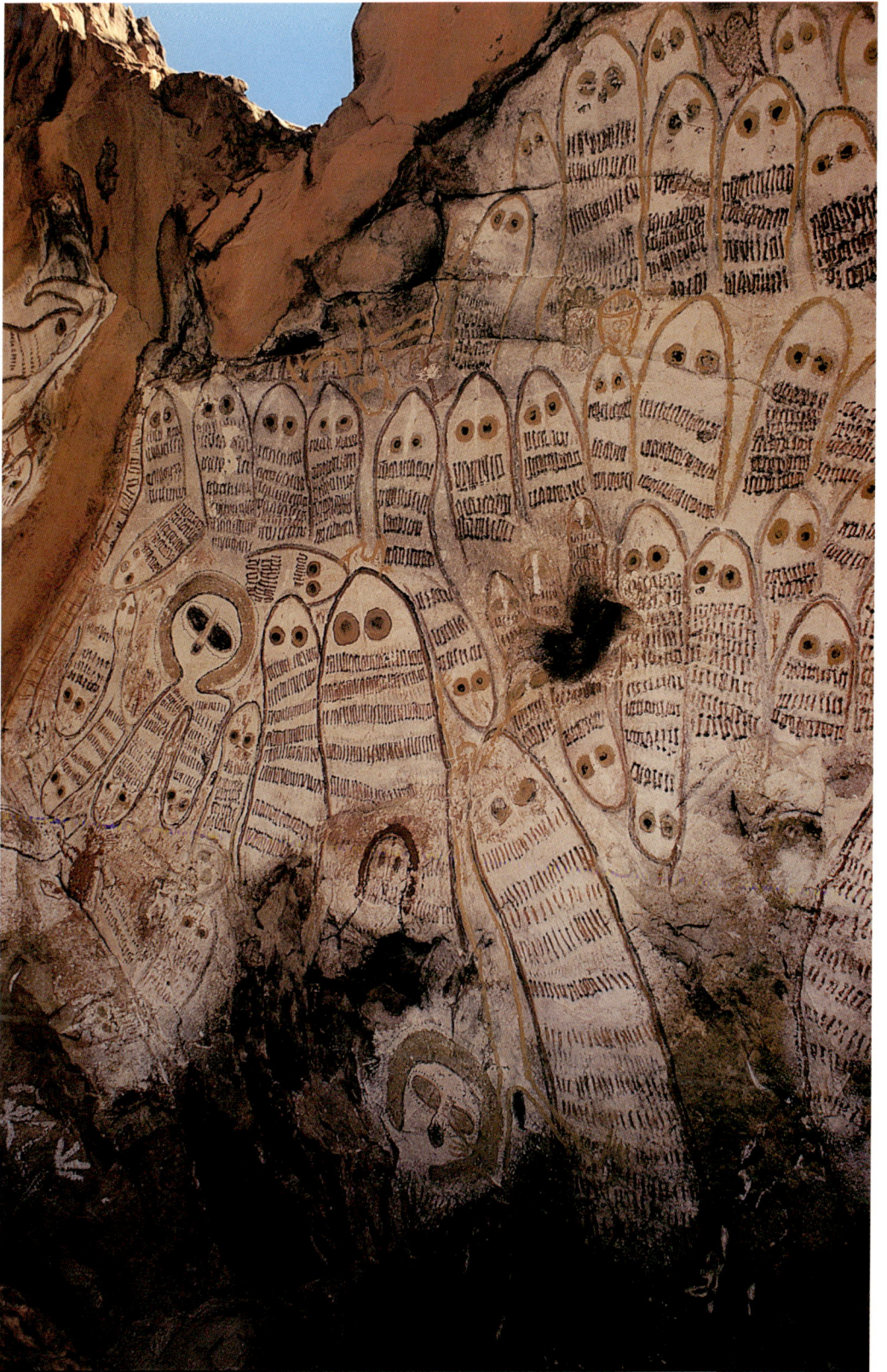

Another image is getting close to oblivion: *Ngolngol* the Cyclone Spirit. The figure has long fanned-out earlobes, rain curtaining from raised arms, ancient.

Ancient too is his neighbour, *Djua,* the Devil-Devil Bird with the big penis. His wife killed a little child and cooked it for him. At night, when the women heard his panting coming towards the camp, they would quickly put their infants to the breast so that Djua could not hear the babies' crying. Here, he is depicted as a hopping scrotum.

The climb from the gorge is steep and exhausting. Ngalewan worries about some dark clouds gathering over the river – now, in the middle of the Dry. "Better get the hell out of here!" Wojin has come with a flash-flood once, he might do it again.

The following day we depart for Waa, Jagamurro's home-camp at Mount Elizabeth. Surprisingly, nobody here is worried about the old fellow. They all seem to think that he will soon come back.

"The ol' bugger, make'im nuttin' but a heapa trouble. Him walkin' 'long this river all his life," says Sambo, a visiting relative from Forrest River, distinguished looking in horn-rimmed glasses.

Mowaljarlai questions Old Johnny Umbagarumba, who wears a dusty swath slung around his head and moves about very slowly. His eyes are clouded with cataracts. Besides Jagamurro, he is the only other man here who has been to Lejmorro, but is too weak now to take us. He will be sending his young wife, Mirridji, in his stead.

Mirridji, in a tribal connection, has the status of being Mowaljarlai's mother-in-law, his *rambud.* The word is also used for barrier, windbreak and screen. Tribal law prescribes that a man and his mother-in-law must never-ever look at each other, nor speak together; she must hide herself from him. Later on we find that Umbagarumba has given Mowaljarlai permission to alter this status – to renounce the rambudship and activate another relationship, that Mirridji can be our scout to Lejmorro.

So we take off on another phase of the quest, *per aspera ad astra,* towards the Little Lights. Ten long days ago none of us knew that we needed to find this ultimate site, that it would become so compelling. You know by now what Mowaljarlai never fails to say, "Well – we're not here!"

4 The Rambud

At this time of the year, the river rests in ponds. In the evening we disperse, each to her own sybaritic basin. As daylight glows down to smoky blues, we bathe away the day's dust. The stillness carries quiet conversations from pond to pond. Painters like Norman Lindsay would have revelled in such a scene.

We have two fires – Mowaljarlai's on the higher embankment, ours near the water. We carry food and utensils from one fire to the other. Mirridji's English is scant. She sits in silence and feeds our fire. After moonset I am levitated on my swag into the velvet night towards a trillion churning and beckoning lights.

Two fires in the morning, two billies brewing tea. Then Elaine, as go-between, mediates the status-altering between Mowaljarlai and his *rambud*. They must communicate if we want to find Lejmorro.

Mirridji means "sand". Mowaljarlai walks across to her fire. Privately, they cry together. Then the sand is no longer a rambud, a mother-in-law.

As we break up camp, Mowaljarlai wafts smouldering gum twigs around our feet and ankles, cleansing Wandjina smoke, a sign to the Lejmorro Wandjina that we are coming – today!

We drive past Mount Shadforth and on, then meet with Peter Lacey of Mount Elizabeth Station. His little vehicle is brim-full with people. Two are lounging on the roof rack. Peter thinks we should cross to the Lejmorro Dreaming on foot, but Mirridji confesses that she has water on her knees. She can't cope with a footwalk and wants to be taken back to Mount Elizabeth – a six-and-a-half-hour drive. Elaine and Pam stay behind. We leave them in a place with sufficient shade.

En route I spot an emu on my side of the track.

"Look, Mowal, an emu!" He slams on the brake. The emu emerges from the man-high grass, crosses the track and strides off into boxwood brush.

"Gimme gun!" Mowaljarlai slips from the driver's seat, aims.

For two seconds, a curious eye gleams above the grass, quite close.

Booom! The giant bird sways on folding legs and slowly, slowly the frightened eye sinks upon the neck and the neck slides beneath the surface of the grass. I feel sick and terribly guilty.

Mirridji

Where to find Lejmorro? Mowal with Johnny Umbagarumba, Mrs Jagamurro (bush name Gorrid, the whirlwind) and Sambo Halls Creek, at Waa.

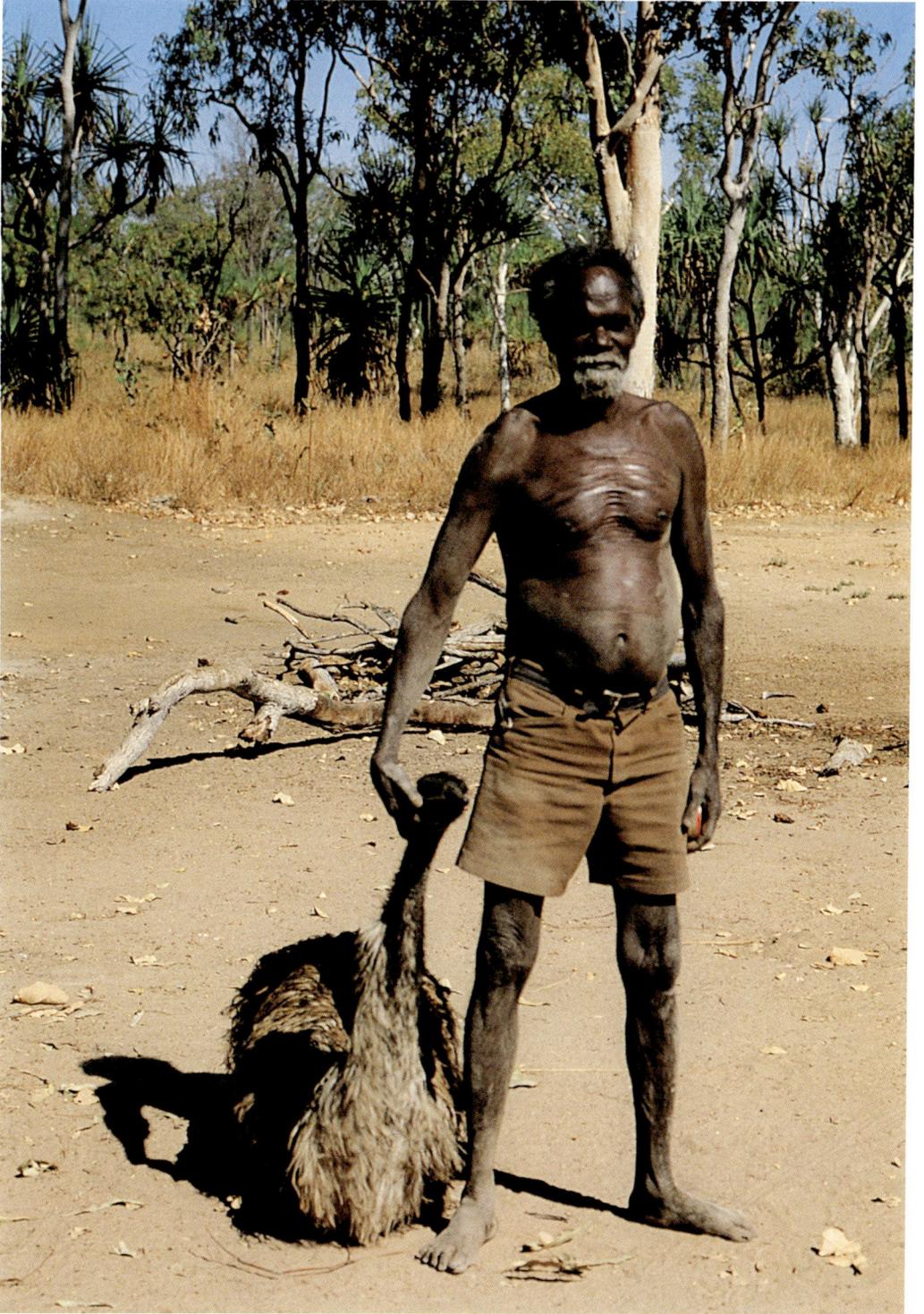

Jagamurro and pet emu

Mirridji pulls the floppy lump of plumage into the paraphernalia in the back. "Emu for old people," she says. "They'll be happy."

And happy they are, the old people at the station. Hunted food is a celebration of the good old ways of the past. In no time a fire roars out of a 44-gallon drum which is half buried in the ground. Before the bird is singed, Mirridji hurriedly plucks at the feathers. Farewelling us, she presents me with two feather dusters made of emu tail.

The following morning we drive to a point where we will leave the truck on top and descend from the range by foot. The distant horizons are blurred with the smoke of bushfires. If they come up from the plains, the Landcruiser will be damaged and useless.

"Clear firebreak, big one," Mowaljarlai orders. He stakes out a wide area around the truck and we are scraping off every bit of vegetation. The heat is stifling. From time to time, a blanket of even hotter air rolls up from the plains.

We hide our belongings under boulder-blocked rock ledges, then descend into moist passages with luxuriating reeds, ferns, pandanus and rotting timber debris – a dry season's recollection of many monsoons. Sunflecks slip through the canopy and dance in silence on this palette of greens.

Down on the open plain, the calico sling grinds into the sunburn on my neck. Gravel-rash scabs, sprained wrists, cracked elbow and sweaty itches are bothersome. I walk in a trance.

In a silent monologue I curse those green ants that pour from their leaf-pockets when you shake a sapling; the flies on lips, eyes, crawling into ears, scores of them hitch-hiking on the back of the others who walk in front of me – revolting! What if we were injured? They would surely swarm in, share a meal with the dingoes.

Then I come to think, what's wrong with that? In nature, under Creation, everything is equal – it's you or them. Life supports life.

Elaine, Pam and Mowaljarlai carry heavy loads of provisions and water. "We will hunt," Mowaljarlai had declared at the outset, "Plenty tucker in the bush."

Plenty of tucker okay, when you are an Aborigine with only a spear to carry; when you have the whole day to follow a prey, kill, gut and dig a cooking pit; when you have time to gather and winnow grass seeds, to grind them into flour with stones, dig roots, and collect lily bulbs in the creeks.

For us, living on bushtucker was not realistic. When we find some *barrawan,* bushnuts, they are smaller than macadamias, and even harder to crack. The kernels are delicious but tiny.

We walk and walk – across shadeless plains with tombstone anthills, through dry riverbeds and stringybark country, parched casuarina patches, past stands of ghost and salmon gum. At one place a stand of silky oak glitters against cloudless blue – ah wilderness!

Around noon we come to a little waterhole. It nests among lush reeds. Gliding into the root-tangled duckweed, three naked girls enjoy a cool Eden once again. Mowaljarlai is making a cuppa tea.

"Wash your hair, girls," he calls out to Pamela, Elaine and myself, "makes your head feel nice and light."

Already he taught us the hunter's way of drinking. The first splash of water goes over the head to cool the blood. Then kneeling, you swing the face from side to side, check over the shoulders for unwanted company, and drink as your mouth passes the cupped hands.

Broad daylight is the time for a wash and a swim, the better to see anyone or anything approaching. "Bush makes you feel alert and alive, gives you power."

We are walking again, on and on, through the heat and the hum of the whole hot afternoon, towards Lejmorro. Only the Wandjina knows where it is. Mowaljarlai allows only short rests, soon jumps to his feet again: "Well – we're not here!" And we walk again, with hazy heads, towards the distant fires.

Dusk. We call this the crocodile camp. Resting by a little pond, Mowaljarlai spots a shape arching from the water. "Crocodile!"

The gun is aimed. Elaine and Pam are instantly behind him, pulling down his arm. "Mowal, you are not going to kill this single little croc in the creek! Give it a chance to find a mate and breed." Mowaljarlai shrugs, disgruntled. "We'd better fish then."

They fish. Baited with damper crumbs, five or six blackbream soon wriggle on dry sand. Then another bushcraft lesson: "I'll show you fish cooked Aborigine way."

Hot embers are pushed from the fire. The fishes, neither gutted nor scaled, are packed and buried in the hot sand. Then you boil the billy, drink your first cuppa tea. After twenty minutes the sand-crust on the fish taps with a hollow sound, the guts break away clean with the skin, and the flesh inside is cooked, sweet and juicy – absolutely delicious.

We sleep in a square around the fire, close, but with room to stretch and shift. "Feel the ground till you find a good spot," Mowaljarlai instructs. "Some place no good for sleeping, some place really comfortable. Dogs always find good spots for sleeping."

Waking at night, I notice that his head rests on a large square stone, his pillow. The dying flames play their light over his fine facial lines and white beard stubble. He looks much older now in the bush.

I sit up, slip the camera from the rucksack, steady it on a piece of wood. The Leica shutter is quiet but audible in the stillness.

He has not stirred.

In the morning Mowaljarlai says, "Why did you take photograph of me last night?"

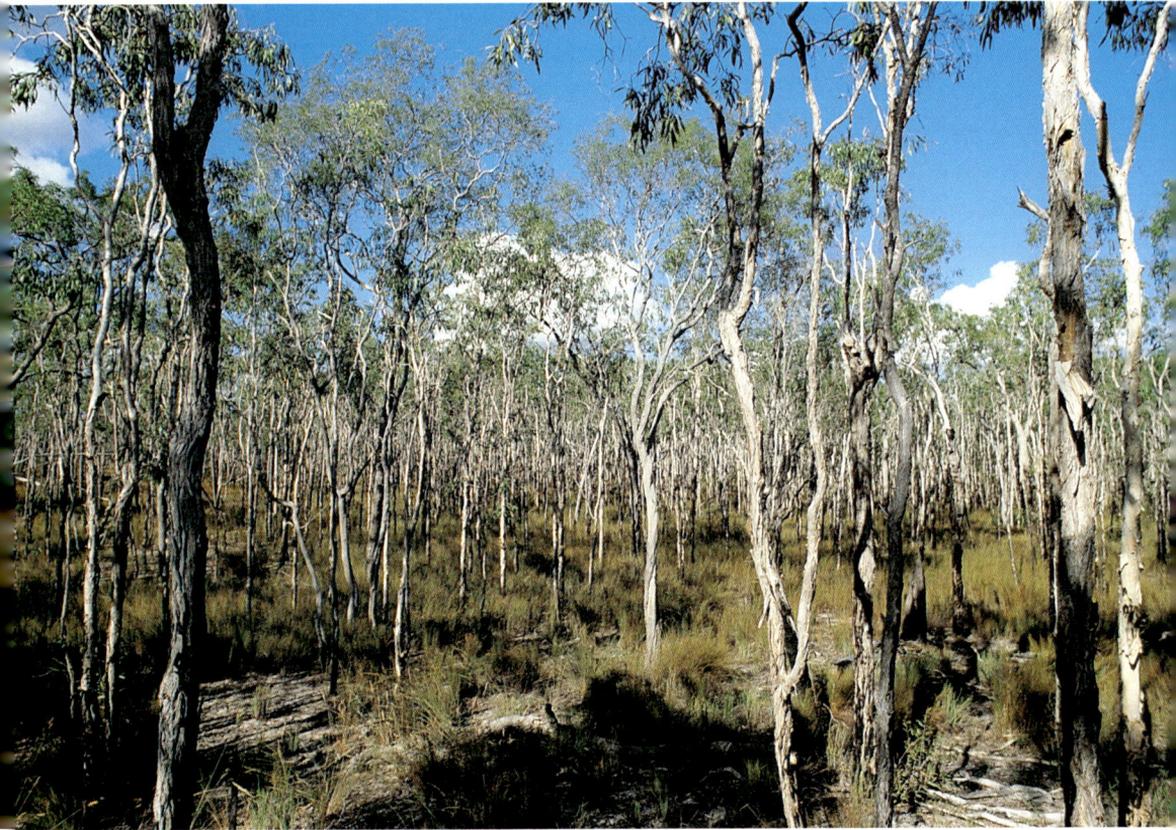

Stringybark country, Caroline Ranges

5 Turnback

Of the timeless travels on this day I clearly remember that yellow bull. "Look! Him coming for us, him copter-crazed, dangerous!" Instinctively we disperse, each choosing a tree for protection. The bull trots closer, stops, looks: are we the creatures that stole his wives? The horns go down, nostrils snort, hooves scrape the ground. Which one?

Ready to leap up the tree, I see the tender branches and also remember that I can't climb trees with one arm. Nor can the others; not one tree around here is thicker than a wrist. So we jump up and down and shout at the beast like cowboys, "Get away! Go on! Get away! Aaaaaah...!" To our great relief, the bull turns and trots off.

That was the first time I was really scared by an animal. Luckily, I had not seen any snakes, nor even thought of them when walking for hours through man-high grass. Some days later, at Mount Elizabeth, a man tells us: "In that high grass – you know how you walk a few yards and your ankles get twisted-up with grass; then you stop and kick it off with the other foot? Right, well that grass wouldn't come off my ankle. I kick and kick and it won't come off. So I bend down and have a look. Tangled up in that grass was a snake! I danced on one leg to the next clearing and managed to wrench off the bastard before it decided to bite."

With the afternoon sun in the back, we climb a long watershed jump-up. Sandshoes gripping well on stone – up and up. Mowaljarlai has a new lease on life. In his Akubra hat, jeans, long-sleeved check shirt, and with a firm grip on the gunsling, he once more fills the image of an energetic leader. Half-way on the incline, he points to some petroglyphs of kangaroo tracks and peckings. They are pointers to a Wandjina cave.

"Yahmaroo stop here, panting 'Eee-ya, eee-ya, eee-ya, eee-ya!' [Come on, come on, come on!]." The sun nears its sinking trail. "Eee-ya, eee-ya," we pant, like Yahmaroo, to the top.

And there across the clearing is the uncanny presence of the Wandjina *Warmaj Mulli Mulli,* carrying the Big Red Yahmaroo across his shoulders! Beautiful! Forgotten are the woes and troubles of getting here. Warmaj Mulli Mulli, we greet you with respect and admiration.

The sun perches on the rim of a nearby outcrop, and throws a direct spotlight onto the painting.

"Wait here till I've taken the pictures! The sun will be down in a couple of minutes!" I try to contain my excitement, talk to Warmaj Mulli Mulli, murmur flatteries, apologise for the suddenness of our visit. I kneel, crawl, squat, stretch, feel, think: another film, the tele, the wideangle. The spotlight dims. Phew!!! We'd arrived just in time. "Now you guys can go and have a close-up look."

From beyond an open space, six large Wandjina eyes gaze across through long lashes of grass.

"Who are they, Mowal?"

"Sons of Warmaj Mulli Mulli. They look to witness. Story also witnessed in Milky Way. This is Lejmorro country."

Yahmaroo had come from the East Kimberley of the Gurunji people, through Wunambul lands to Lejmorro, country of the Ngarinyin. As he hop-hop-hopped and stopped, he had named and mapped a vast territory. With recorder, notebook and torch, Mowaljarlai, Elaine and Pam remain near the painting until dark.

"Where will we camp?"

"There's a creek down the hill. You go ahead, slowly!"

The slope is steep and strewn with stones. One rolls from under my feet. With the good arm clutching the sleeping bag, I have nothing to break the headlong fall. Goodnight, Jutta, that's it! What a mess! Oooh, my head! Ouch, my arm!

An eggshaped lump swells above the wrist. Can't help sobbing with the misery of it all, moaning into the stone rubble. The Leica feels bashed-in too, ready for the panelbeater. This is hell.

It is dark when Mowaljarlai finds me. "What happened?" He wipes his eyes and his hands are moist on my face. Slowly, very carefully, we make it down to the camping place.

I feel better in the morning. At least the legs are still in working order.

We are trying to find the convergence of two creeks near a plain. From there the island rock Lejmorro should be clearly visible. "Do you know where we are, Mowal?" A hard look rebukes the question. We follow the creek bed down, clamber back up, look for other creeks leading down.

More and more frequent stops for rest. We're nowhere in the never-never, all day. Nightcamp at another oasis, a slim, dried-down riverpool breasted by terraced ledges. Into the distant banks of smoke the sun sinks, the colour of blood. We silently share a meal of two little fish, damper and a last tin of Irish stew.

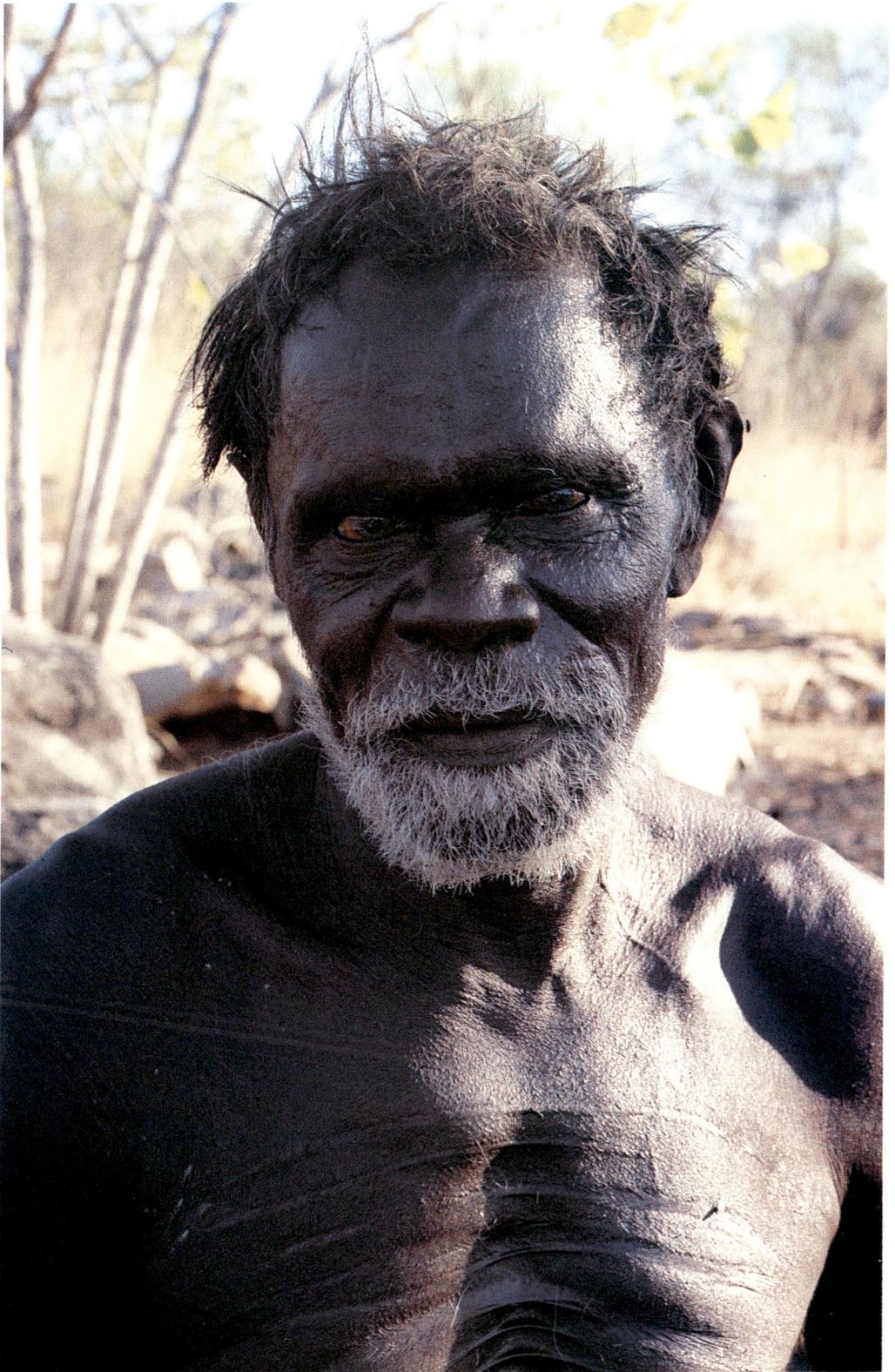

"You've been waiting for that, haven't you?" Jagamurro.

Another morning. "Are we lost, Mowaljarlai?" No answer. He scouts around the plateau, scans the plains, draws diagrams on the ground and darts around in circles – he is quite peculiar. He is also irritated. "They never taught me about this complicated compass in Canberra," he complains. "Now where is the sun?" More diagrams.

It is getting too hot in the open. Separately, we bide our time under rock-overhangs looking for paintings or pointers.

Then Elaine calls from a higher terrace, "Look at that smoke on the ridge! The fire is coming up!" We gather.

"What now?"

"Wait in a cave till it burns over."

The smoke between the crags is getting dense.

"We are running around in circles. This is crazy. Let's go back to the truck."

So, we are turning back. We give up the search for Lejmorro, the Dreaming of the Milky Way. Another night at the crocodile pool. Mowaljarlai sings little animal stories in Ngarinyin language, the songs they sing to the young boys during the night before initiation.

> Instead of anaesthetic, we make them really trusting, really relaxed
> with the families by the fire. At daybreak, we get them nice and early
> while they are still sleepy. We say to them, "Look at the Morning Star
> in its glowing colour, how strong and beautiful it climbs on its way."
> It's not so bad then.

The following noon we are back at the Landcruiser and by nightfall arrive at Mount Elizabeth. There is great excitement in the camp. Jagamurro has arrived back. He is emaciated and footsore after walking over eighty kilometres. "Him walkin' too bloody long way," says Sambo.

Why did he run away from us? Mowaljarlai is trying to find out. One version is that he got embarrassed because he told us something wrong about a painting, another that he thought he was coming only for a couple of days and it spun out too long. I sense that we were entering too far into the Banman's territory. Will we ever hear his deeper reason?

Once more he poses with his pet emu for the camera. On silent command, the bird crouches at his side like a small camel. One red angry eye glows fury, doubtlessly planning another chase.

Jagamurro had hunted this emu's mother. As he carried her to camp, the chick followed on his heals, so he reared it as a pet.

This pet, which the powerful old man seems to have under telepathic control, enjoys terrorising everyone else. With flashing speed it is close and kicks a mighty injurious blow. It will trail off to the great-yelling-cowboy-act and gurgle protest from the distance; but in fact, no grown-up nor child is safe from his menace. Like the Pharaoh's lion, this emu obeys but one master.

Now a group of people has gathered around the truck and the tale of our journey rolls forth in language. A parcel of black roasted beef sits on the bonnet of the vehicle. A woman adds a warm damper. Mowaljarlai picks at the meat with long, serrated fingernails. His face looks drawn. He leans heavily against the truck. At times he halts his tale to fend off the flies, dogs or cats that manage to get to the meat.

"We can camp here tonight," he whispers aside. "My people have accepted you."

We sit in a circle and are given food. A great warmth wells inside me as I am sitting among delicately boned, silk-skinned female bodies. How wonderfully comfortable it is to be fitted into this ring of women, how easy to love. I feel snugly plaited into a belt of womankind. Oh God, next time round, please let me be woman again!

We had failed to find the great Lejmorro, the manifestation and sacred home of the starry heavens on earth; yet here, amidst these women, I am completely content to be anchored in the earth.

Later that night we start on the drive back to Derby. Coming over a rise, a spectacular sight unfolds – a long sweep of ranges outlined by buntings of fires. When we get there, the flames flare up the bush for a few moments only, then graze and crackle quietly from shrub to shrub, grass tuft to grass tuft. All night long we don't see another vehicle.

At Napier Range a gap permits the road passage through the ramparts. Geologically, in the Devonian era, the Napier and adjoining Oscar Range were a continuous Great Barrier Reef in the ancient Gondwana Sea. With a steep and jagged spine, the narrow ridge climbs from the Barker River and crawls across the plain like a boab-sprouting reptile.

We stop for a rest at Victoria Gap. Mowaljarlai mentions rock painting sites along the flanks of the range. He will arrange for other guides to bring me back later on to take photographs. Shortly before dawn and Derby we turn onto a side track and camp down exhausted. When I wake cold and drenched with dew, my first glance lands on a line of wired telegraph poles. Alarmed at lying in the middle of a hard gravel road, I wake Mowaljarlai.

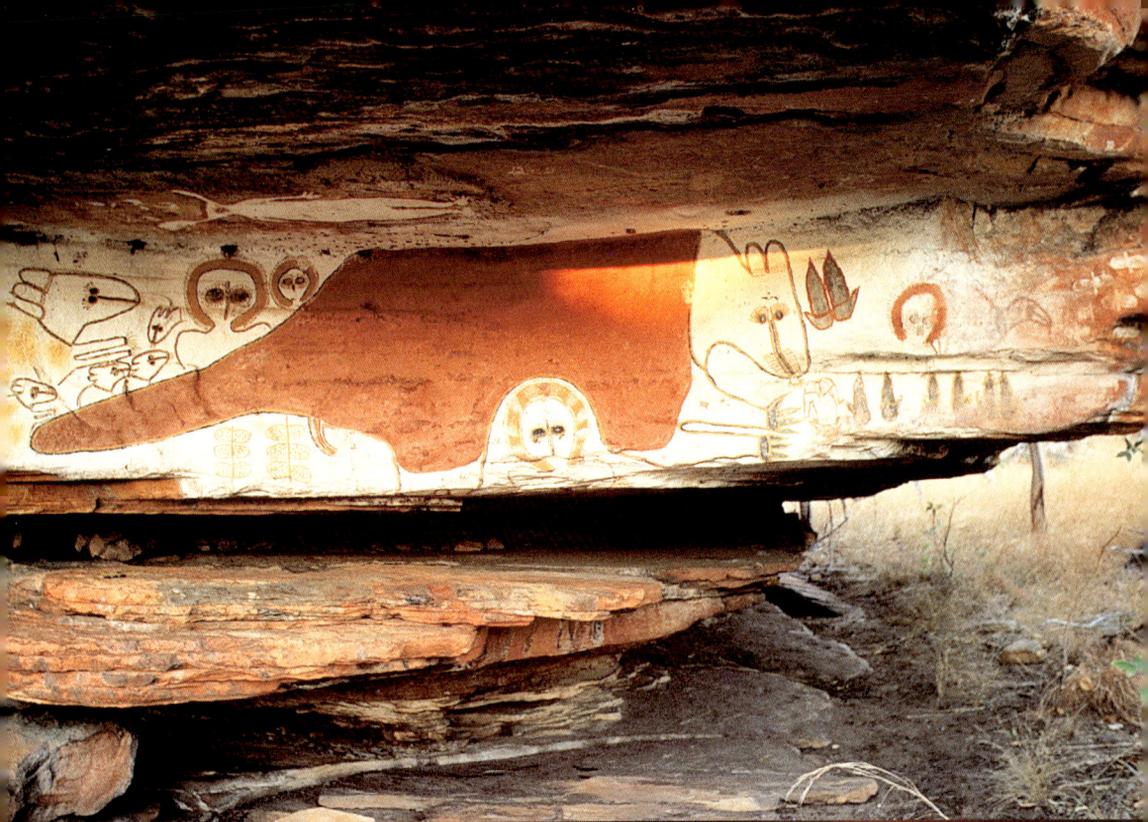
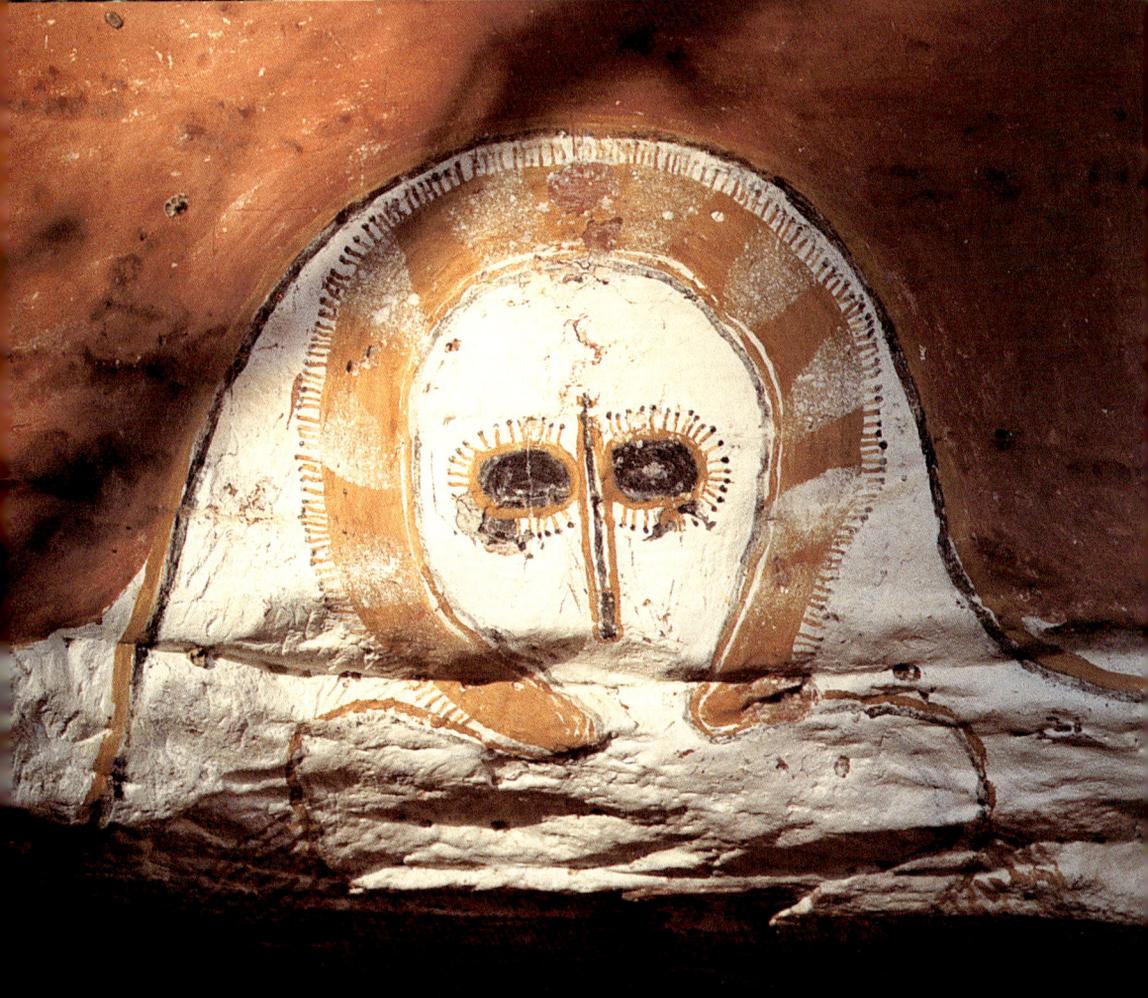

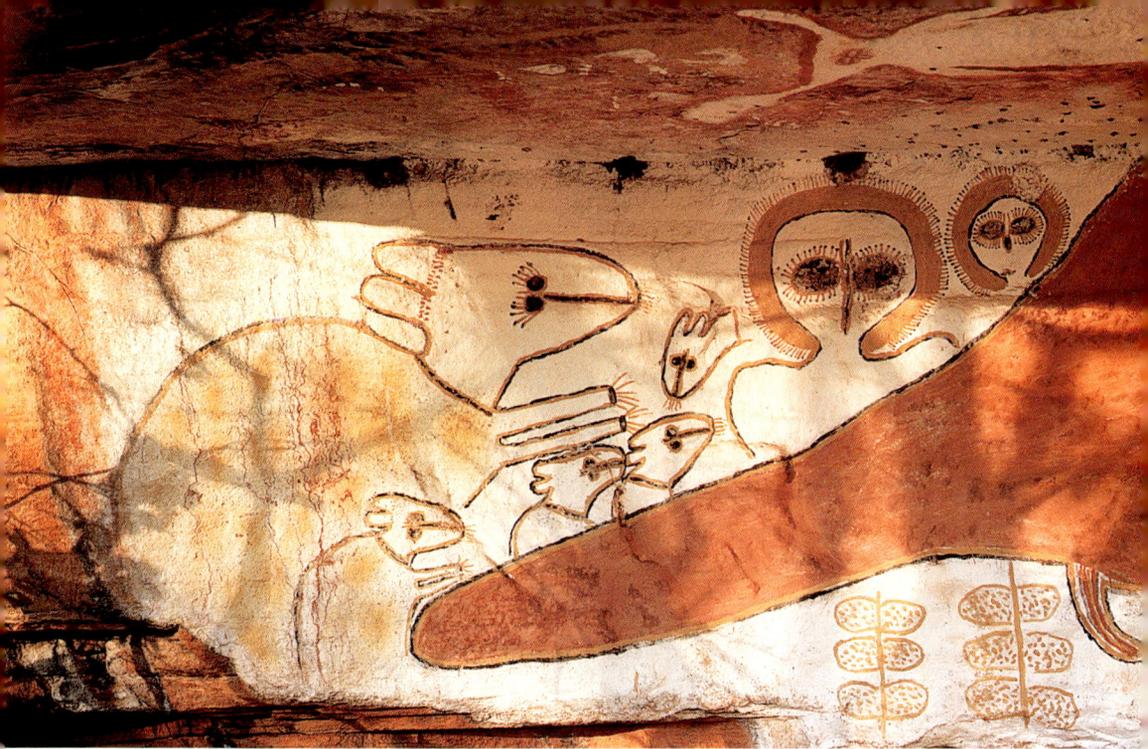

Nganowat, Yahmaroo's wife, boss mother of kangaroos, also called Goroni, meaning "she left him"; shown with offspring. Little bundles are droppings

bove left: Lejmorro country: Warmaj Mulli Mulli
elow left: Warmaj Mulli Mulli, carrying the Great Red Yahmaroo

The Guardians, sons of Warmaj Mulli Mulli, watch and witness across the clearing

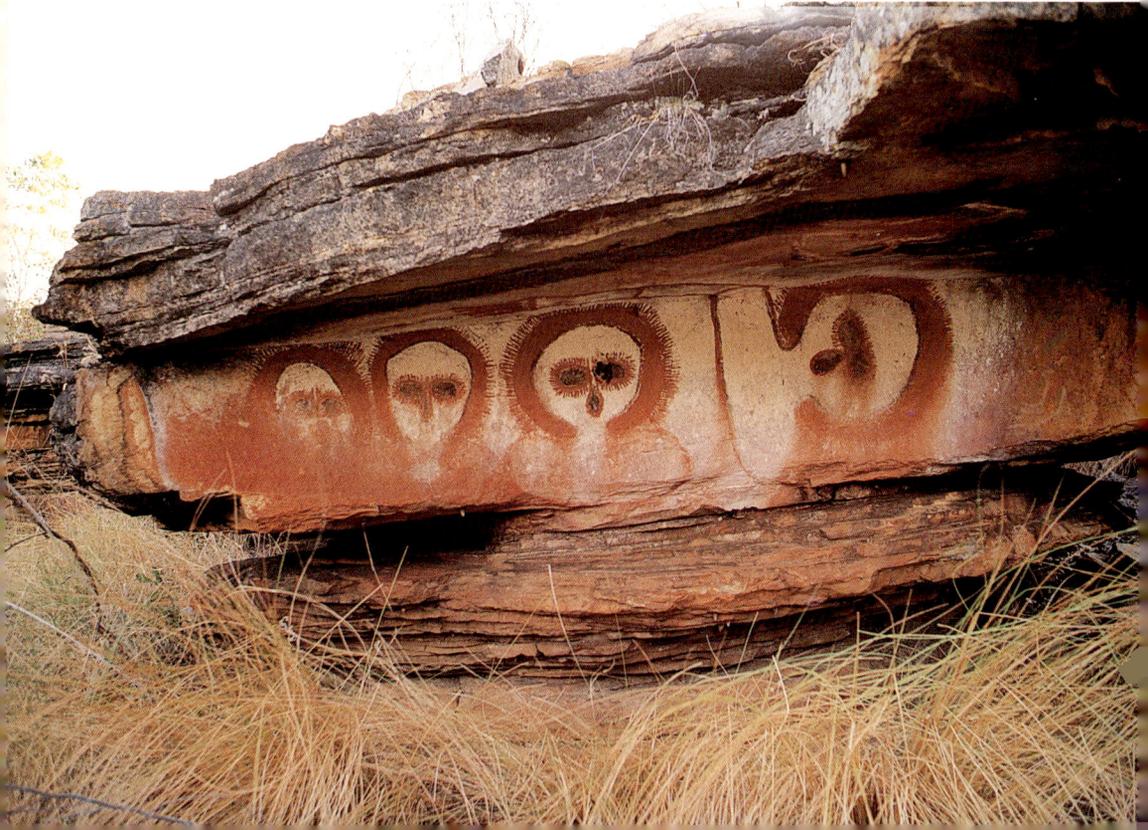

"Mowal, are you sure this isn't a freeway?"

"No worries, Old Gibb River road is abandoned now."

To me, these telegraph poles signal re-entry into the world of digital time. In Derby we part company. Mowaljarlai is instantly spun into the turmoil of political affairs; Elaine flies off to Sydney; and Pamela, for a time, remains independently in the township.

Returning to the bush without Mowaljarlai proves to be a different, very hard experience. Two attempts at finding the rock paintings at Napier fail. My Aboriginal guides, Roger and Jacob [Spider] Burgoo are uncertain about their location, and afraid of the manager at Napier Downs. Two rented vehicles prove unsuitable for the terrain.

At one stage, walking through open scrub, I am suddenly dizzy. Roger and Jacob are alarmed: "You dried out through skin, very dangerous, take us back quick." Somehow I drive the vehicle back to the station.

My brain begins to function again when I sit in Rita and Bluey Howie's kitchen at Napier Downs clutching a glass that Rita fills and refills with lemonade. I may owe my life to the Howies. Bluey, short, red-haired and freckled, is the hand-for-all-jobs at the station. Rita is part Aboriginal. My blood boils up when I see her taking food and drinks for my guides to the gate of their garden because the white station manager does not allow black visitors to enter the grounds of the little cottage.

At a third attempt, three days later, we finally manage to find the Napier Wandjina sites to complete a few more photographs. I feel richer for all these experiences, but leave the Kimberley in September 1980 without planning to return.

6 Sydney

In the following six years, when official affairs bring him to the eastern parts of Australia, Mowaljarlai comes to Sydney and stays with us at Wahroonga. Inevitably, that question comes up again – has the great Lejmorro site been found? And he has to say no, they have not yet managed to get there. Once I ask him how many painting sites he has seen in the Kimberley. "Big mob," he says. "Me and Watty Nyerdu, an elder, we walked all over the place."

After marking sites on an aeronautical map, the dots are clearly more concentrated in the coastal areas.

"Why are there so many sites near the coast, Mowal?"

"That's where the spirit came into Australia. Wandjina marked the old coastline from long-long time ago. We need a helicopter to go there."

Connecting the dots into a hypothetical helicopter route brings a surprise: "I've drawn a Wandjina!"

He is not impressed. "I've been telling you all along that Wandjina painted where spirit came into this country."

On another visit, Mowaljarlai brings up the subject of his visionary dreams. He dreamt dark prophesies, and they had materialised horribly. He knows that he was given a task with these dreams, could I help him to define that task?

I try to shirk from such responsibility. Had he asked me to mind a bonsai tree, I would have declined just the same. Babies, animals, ordinary plants – yes; decoding someone's visions can easily turn into a metaphysical bonsai and exceeds the scope of my hospitality.

Nonetheless, I recorded what he told us:

At Christmas time (1974), when we were back from Aurukun Mission (at a conference for Aboriginal church elders in Queensland), the Cyclone Tracy hit Darwin.

At the time when this cyclone was on at Darwin, I slept at Old Mowanjum (settlement in Derby). In my dream, the missionary Mister Love walked to my house and said in Worrorra language, *"Ngungguluma kalli kalli pamaneri."* Stay on the straight and

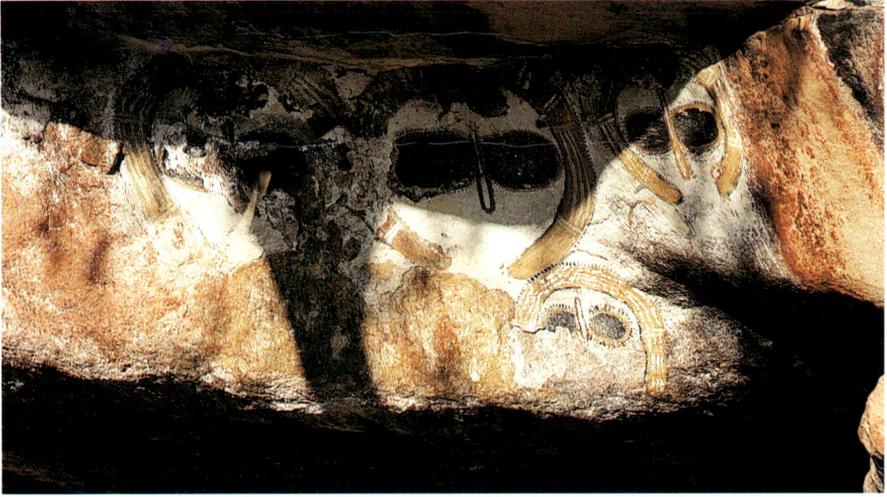

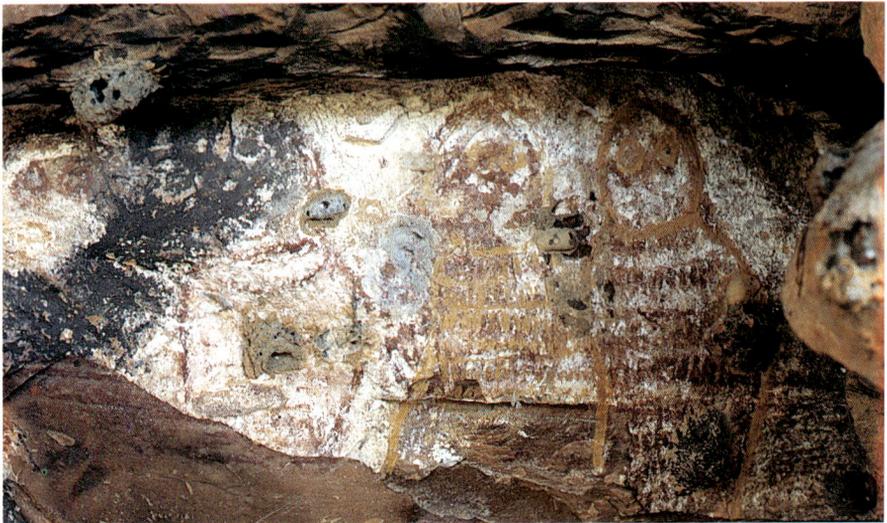

"When they are dull, Wandjinas are unhappy, because people don't come to paint them and we have droughts…" Two fading images from different sites

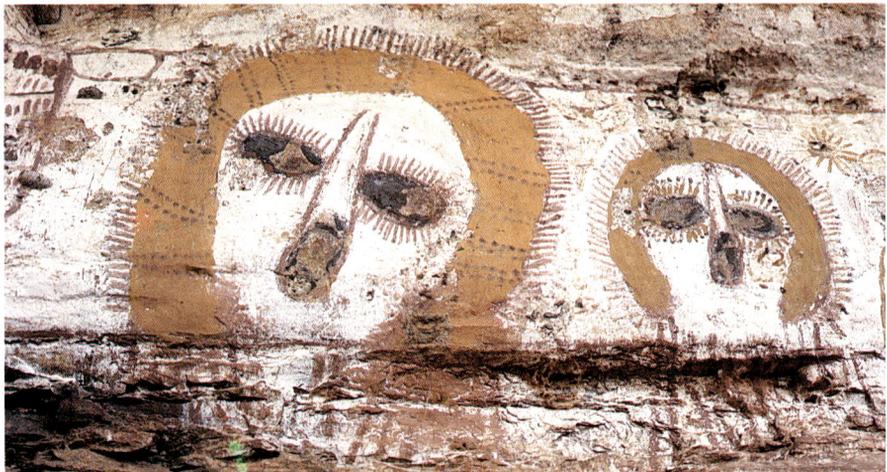

Upper: Bengmorro Wandjinas *Middle:* Three images of Dumby the Owl, Wanalirri
See pp15, 191 *Lower:* Detail from panel on p16, Wanalirri

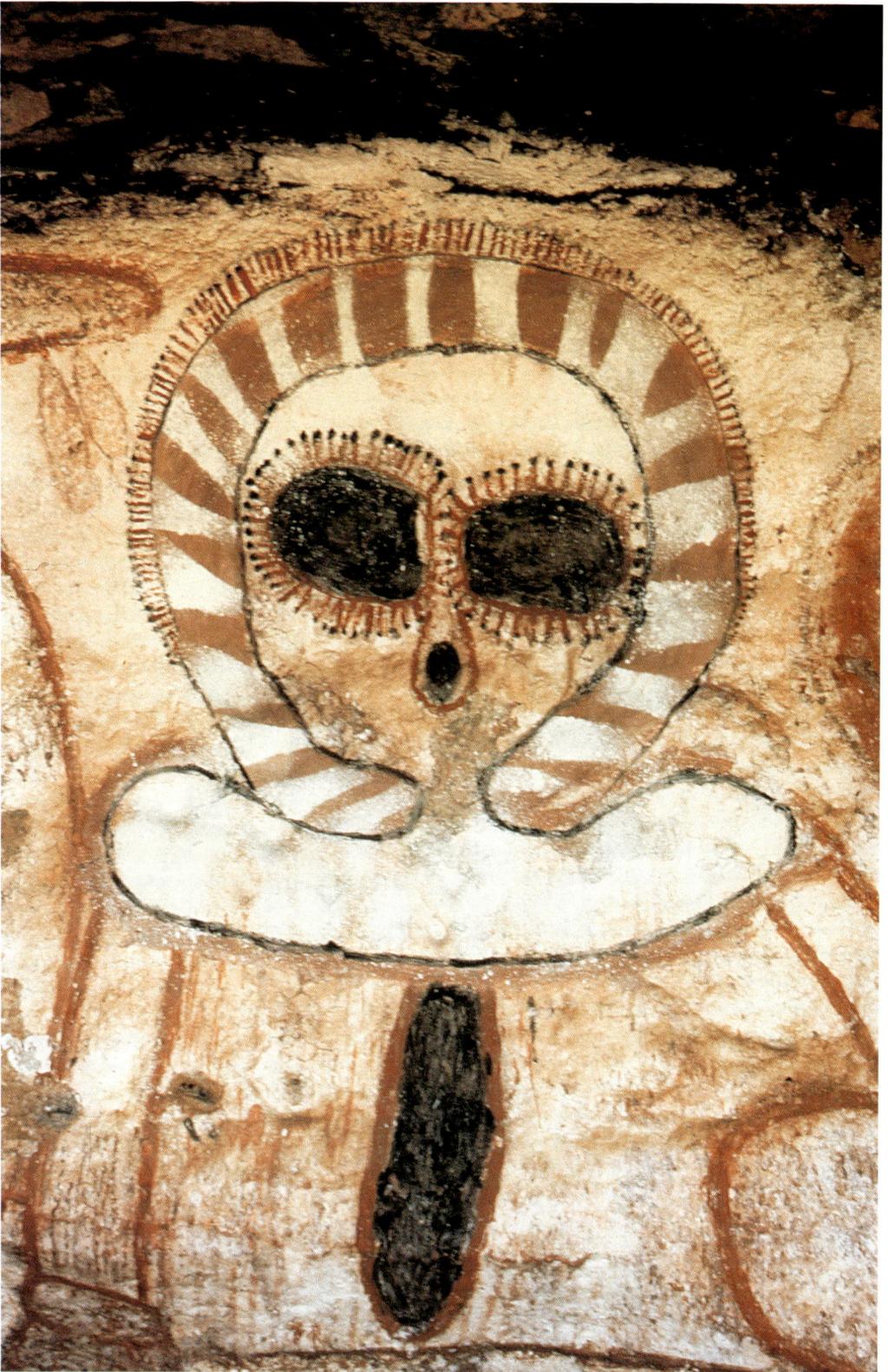

Wandjina *Gunduran* with grinding stone, Donkey Creek. "When he's bright, we have rain. He is happy, we keep renewing him, smiling all the time." *See* pp98-101, 182

narrow, he warned me. I now think that he wanted to tell me, "You will be shown a road. It will be a hard road, but don't be swayed; kalli kalli – don't *snake off* that road."

Then I saw a strange light coming, like a snake in the blue sky. It threw its light onto the mission houses. It was like the trail of a jet-stream from airplanes, that long and luminous. It came from the Western countries to Australia, straight across One Arm Point and Derby. I watched this light.

When it came near, it was strong, like a big searchlight. But the light shone only onto the mission houses, not inside, and where Aboriginal people lived it remained all dark, all dark.

I tried to find the house of my uncle Alan Mangalu, who was a church elder. I had looked after him at the Aurukun Mission conference where he was in a wheelchair, and for the house of my uncle Albert Barunga, another church elder. The light did not come onto them. The houses of all Aboriginal people were in darkness. Then the light disappeared – like when you snap your fingers, just like that.

Another dream followed straight after: Alan Mangalu's father and mother had just died. They were my own grandfather and grandmother, Ernie and Ruby. They went up to where the light had gone, up to space and disappeared. My grandfather Ernie was a great leader, a Church man and a Law man.

After that, I saw all my Ngarinyin people drunk – all Aborigines drinking grog. At the bottom of their beer cans they had black stuff, like charcoal and mud. They were all drunk!

The same night Mowaljarlai had another dream. In this dream he went to hospital.

I was sick and I died. I was put in a coffin. After four, five minutes, the coffin opened. I saw Mary and Joseph.

They wore those big white gowns that have blue stripes and red stripes; and Jesus was standing on a chair, on a throne, in the pure white linen of his loincloth, all naked on top. I wondered why he wore just a loincloth. Joseph and Mary in those beautiful robes, and Jesus as a full-grown man in just a loincloth.

But I tell you, the glory was open and the heavens were open and the angels were going up and down, millions of angels all bobbing up

and down. That glory shone – that glory what people really don't know what means glory – and I have seen it in my dream.

And that light! Missionaries had always said that when you die, you go straight up to Heaven, and they had pointed straight up. That light came from the east, sunrise, from that power place.

Then I was standing in my coffin that had opened. I was preaching to my Aboriginal people in Old Mowanjum and I said, "Look in the east, who's coming now?" And everybody rose. And I said, "I've been talking to you people for a long time, day and night. You never believed me. Can you see it now?"

And then, in front of all those rising and bobbing angels, a mob of light brown tribal people came flying from *Kunmunya* Mission, with webbed wings like the flying foxes, arms and legs stretched out clear. Their wings were fixed to the middle of the spine, at the waist. The power came into me. I felt that power because of that glory. It frightened me because it was so great. In the morning I was speechless, I couldn't talk. I was just lying there, frightened that it had happened to me. Only later in the day could I talk again.

People say "glory" and they sing about glory, but this was the only time, in that dream, that God showed it to me, the whole power. It just stunned me, it went through my flesh. Since that dream I have that strong feeling in me. It stayed with me. How do I deal with it?

What were we to say, or to do, but to listen to yet another dream that followed the same night.

I dreamed I went right across to Palestine country. They had those old huts and synagogues there made of the mudbricks these people used to build with, flat-roofed. That's where I saw Jesus, in the Holy Land, walking between those houses. He turned and looked at me, then kept walking and did not look back again.

He never talked to me. What was he saying to my spirit? That's what I'm asking you – what am I supposed to do, what is going to happen, what is coming?

This light is really live in my body, look, it's swinging me all the time. These dreams have changed my life. It's strange, but the way I see it now is that I must help not only my Aboriginal people, but all people, blacks and whites.

And to come out of that darkness, we've got to try and cope with that true thing, work evenly together to represent the Christ, Jesus, not just Aboriginal-side or just church-side; because this dream told me, "This is the way you must go about it."

And I know now that God comes from sunrise, where power comes from. He comes from the same direction that the Wandjina came from. Power comes from an angle, not from straight above – that is my statement.

At those funeral services you hear them say, "This man was a Christian man, he was a believer, he has gone to Heaven." Everybody is satisfied. The priest holds a good sermon. The funeral service is conducted beautifully.

Then, when we go to sleep, any Aborigine, we dream that uncle or granny or mother, we dream them. We say, "That uncle or granny came to me in my dream." I also dream that our old missionaries come back, night after night.

Now, what gets me is this: I question myself and I question my preacher, and I say, "He's gone to Heaven now, he's gone to be with the Lord and he will never come back." He stops there, the preachers tell us. Few days after, I dream this man comes back. Why do these men come back?

He continued, that for Aborigines there are two kinds of dreams. One is *yarri* – things that come down (they descend) when you are quiet and soundly asleep. The other kind they call *burraal* – when the mind is not in a deep sleep, when you are awakening quickly and certain pressure changes make you feel giddy, you see things with your imagination. The idea of burraal is "lightheaded", flying up and about.

With yarri your spirit is with you, your heart is pumping close and quiet, things come steadily, not rushing.

And everything I dreamt that time was yarri, proper full dream, and it has all come true – terrible! One, two years later, Aborigines started drinking. And they are still dying down and out. They have liver cancer and the kidneys are burnt out. That nightmare is still happening. The people don't respect the incest taboos any more. The kinship system is destroyed, that's the real damage. All this was spoilt by this drink!

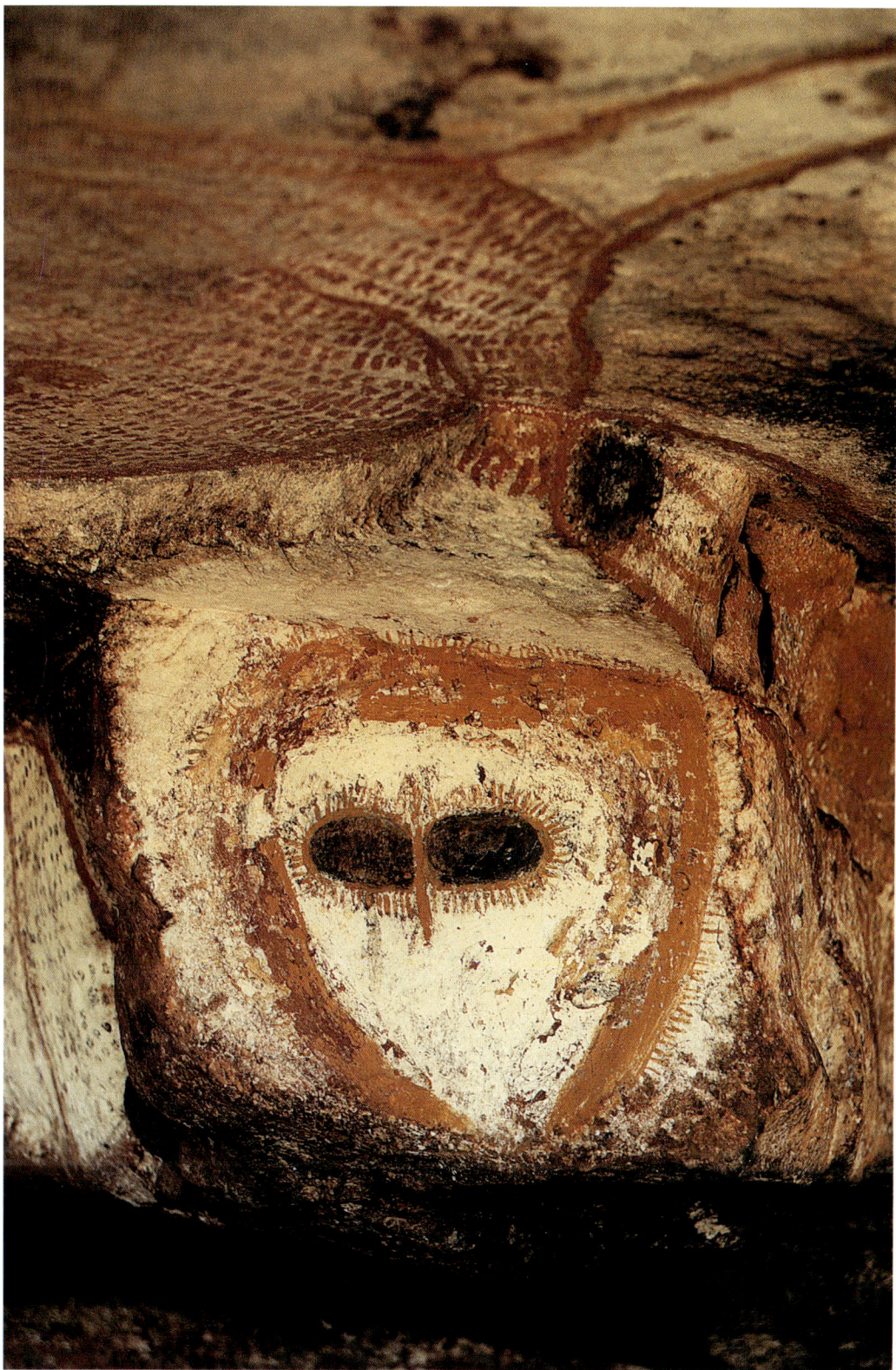

Queen Bee Wandjina on point of ledge, boss of Waanangga site
Sugarbag doorway, *gnari amen,* is dark spot above right. *See* pp71-5, 203

From unrestricted sex they get VD. From the eyebrows to the top of the head their hair is falling off. The doctor started to come out regularly to Mowanjum, giving them treatment now all the time – and it's getting worse. You can see that our tribal life is destroyed.

On a later visit Mowaljarlai brings his new wife Valerie and eighteen-month-old son Claude to Sydney. Claude is a special little boy with an air of natural self-assurance in his dark, stiffly lashed eyes. He has a great resemblance to Mowaljarlai.

"I want to bring up Claude to know about the old culture," says the father. "How do I make them understand, our own Ngarinyin kids and all those white people?"

We talk about collaborating on a book, a latter-day parallel to photographer Axel Poignant's early picture essay and tribute to Aboriginal children. We plan to camp out with a group of young children at the Wandjina places, to follow an adventure-story line in exploring the bush. And we set a date.

Two weeks before departure for the North West, I injure my foot on a jungle path in Papua New Guinea, a bad sprain. This is appropriate, as until now I have never photographed rock paintings without a physical handicap.

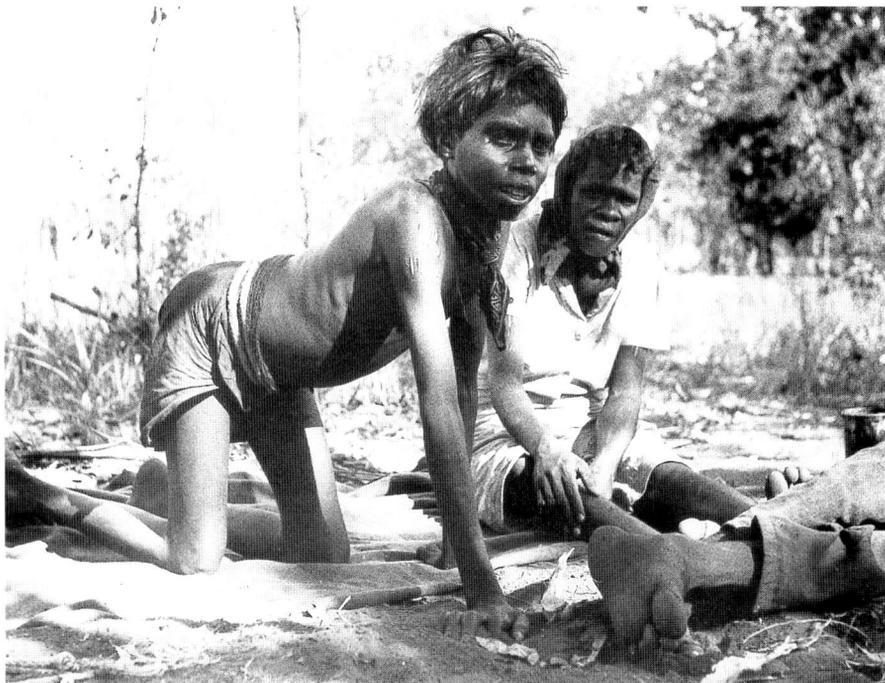

Young Mowal with great-aunt Patsy Angburra, 1938.
Lommel

7

Derby

When I arrive in Derby in 1986, the delivery of a prepaid rental truck heads the list of arrangements that collapse. The company is very sorry about that, but the nearest suitable vehicle is still two thousand kilometres down the track, or inland, or somewhere.

Over dinner with Mowaljarlai at the colonial style King Sound Motel I come to understand that we will be delayed by at least a week, possibly longer. A government-funded education project, repainting of sacred sites, is soon to commence; and Mowaljarlai intends to combine it with our undertaking, which is just not on the cards!

Worst of all, he has abandoned the idea of taking young children to the bush. They can't be taken out of school. Whichever way I turn, there's a bog. We end up brooding in silence over the empty prawn and lobster shells on our plates.

The following day he comes up with a new plan. We will take some young men instead of the children. "Will do them good to see their birthright places. Plenty boys want to come – big mob," he says. But, these young men want to be paid for coming, a daily rate. By whom? I am neither willing nor able to pay them. Who would pay me to go to my church, my art galleries, the shrines of my culture? These arguments go on while Mowaljarlai keeps promising that we will go bush whatever happens.

Then he finds some young men who will come without pay.

"Where are they? What are their names?"

He doesn't know because they've gone fishing. I am ready to blow a fuse with frustration.

At last a twincab Toyota can be cross-leased from the competitors. Still seething with anger I drive out of town to the jetty, Derby's landmark. It flings over tidal mudflats into deep water. Even there, only flat-bottomed ships can berth as they may have to sit out a low tide on sand.

One of the maritime buildings is vandalised. Broken window glass and beer bottles glitter between torn floorboards and smashed wall linings. I decide not to bother waiting for the famous sunset – let whoever-may-care photograph and rhapsodise this desolation.

Derby from the jetty

Instead, I go to see the film *When the Snake Bites the Sun* at the Catholic church school in town. The producer, Michael Edols, had made the film Lalai, which featured Mowaljarlai and Sam Wooloogoodiya, an old tribal bushman from the higher Kimberley coast.

To prepare for a follow-up film, Wooloogoodiya and Mowaljarlai came to Sydney where the old man suddenly collapsed. He died in Michael's arms. His last words were: "You tell my story to my people, Michael." It had taken over ten years for tribal restrictions to be released, to tell this story in a film.

Downtown Derby

Across Hann River Plateau to Mount Bomford (left hill), Mandjilwa, Sickness Dreaming, from Warmaj Mulli Mulli site.

The film begins with the producer's wish to fulfill his promise. He searches for members of Wooloogoodiya's tribe to accompany him to the Dreaming, and he pleads with urbanised Aborigines to grasp this opportunity to experience the site of their heritage.

After seeing the film, I decide that my story must run along similar lines – whatever happened. Mowaljarlai also had a legacy to hand down. I would wait and go bush with him, not back out.

An old Aborigine warns us about going to Gutsache [the traditional language name is *Mandjilwa*], a Sickness Dreaming place near Mount Bomford. The last people to go there became quite ill. Diarrhoea-with-blood is the specific illness manifested at this Dreaming. The Dreaming of Mandjilwa is so strong that it transfers on to everything in the vicinity. "So strong," says Mowaljarlai, "that if you bring a small branch with leaves, or some paperbark, from there and put it into the town water supply, everybody in Derby will get tummy-with-blood. Just from going to this one special place, you may die. Leaves and paperbark from other places are all right."

"Do we need to go there, Mowal?"

"Not there – but it's in Lejmorro country."

"Then you are thinking of heading for Lejmorro again?"

"Yeah – it is very important to find Lejmorro."

8 The Wunnan

Finally, one morning we are ready to start from Mowanjum. Poor Mowal. The two young men who finally agreed to come without payment – "They're not coming now, been out drinking last night. Can't wake'em up; they just turned over moanin' and groanin'." But two old couples, George and Violet Jormary, and Campbell and Dhargie Ellenbrae, are putting their bundles onto the truck.

We will now go to Kalumburu and try to pick up Hector Dargnall, a banman who has been to Lejmorro.

Dharghie is very big. She can only hobble with tiny steps and is obviously in pain. For the last seven years she has suffered a bone marrow disease. Very slowly, she retracts her leather leg-casing into the back cabin.

Mowaljarlai mentions that Jagamurro, the old-man-who-ran-away, could have cured Dhargie's complaint. But he's gone, went bush in '83 and has not been seen since (although it is rumoured that, six years after he disappeared, a wild-looking bushman of his description was seen at an outback station).

Now there are no more medicine men around to teach the ways of Aboriginal healing. Yet, only yesterday, a woman at *Wanang Ngari* Aboriginal Resource Centre had told an interesting story. An Aboriginal woman was sent to Perth Hospital with cancer, a large lump on the tongue, to see out the final days of her life. She put some bark or something onto herself. The lump just fell off. The hospital staff were very surprised, the lady had said.

Now ready for departure, Mowaljarlai's wife Valerie, holding eight-or-ten-week-old baby Gideon, and young Claude are waving us farewell.

At sundown we make camp on the Hann River Plateau. I wander down to the pools where a gentle evening breeze stirs little whispers from between the rocks and rustles in the pandanus.

My hands skim the soft sun-warmed water and fold back the tension of the past days. A flight of jabiru beats slowly upriver. The hassles of Derby lie far behind.

Nallija (tea) with honey brews in the billy. We talk by the fire, on swags, and listen to the soundtrack of *When the Snake Bites the Sun* on Dhargie's battered cassette recorder.

"What is the message in that Sun Story, Mowal? I couldn't quite follow that in the film."

"The message is 'hope for the young people'. I'll tell you the story."

In the beginning the sun was in the earth. The sun did not go into space, the big mother sun. While she was in the earth, she burnt the country.

Then her daughter, the daughter sun, said, "Look Mother, you're too powerful, you burn everything. You better stay here and I'll go up." So the daughter went up.

Way-back, where sunrise is, there's an island we call the gate, *Marranggni Biddibiddi,* the Sunrise Gate. The Gate is a big hollow log. Mother sun wanted to go through, but she got stuck. But the daughter, she slipped through and went out.

Then the daughter turned back and said, "Look Mother, you're too big. And you do burn up everything, right? You shouldn't go through this doorway here and up into space."

So the mother said, "All right Daughter, you go up. I'll be the power here watching you. Every day you will go up and go down and you will come back to me."

A male snake was jealous of this little sun. He argued: "Snakes are more shiny and beautiful than you suns." The daughter sun said, "No, I am more shiny than you." So the snake bit the little sun, right at midday he bit her.

Then the sun got sick. By about one o'clock, two o'clock she was rolling in agony. Going down to four o'clock, she was cooling herself down from her pain, she got cold.

She hung in the fork of a tree. She had only four or five minutes before slipping down behind the world. She fell off this branch she was so sick.

The argument was between *Auwanbanggnari,* a male landsnake, a wunggud animal belonging to the earth, and a beautiful young female destined to become a celestial installation.

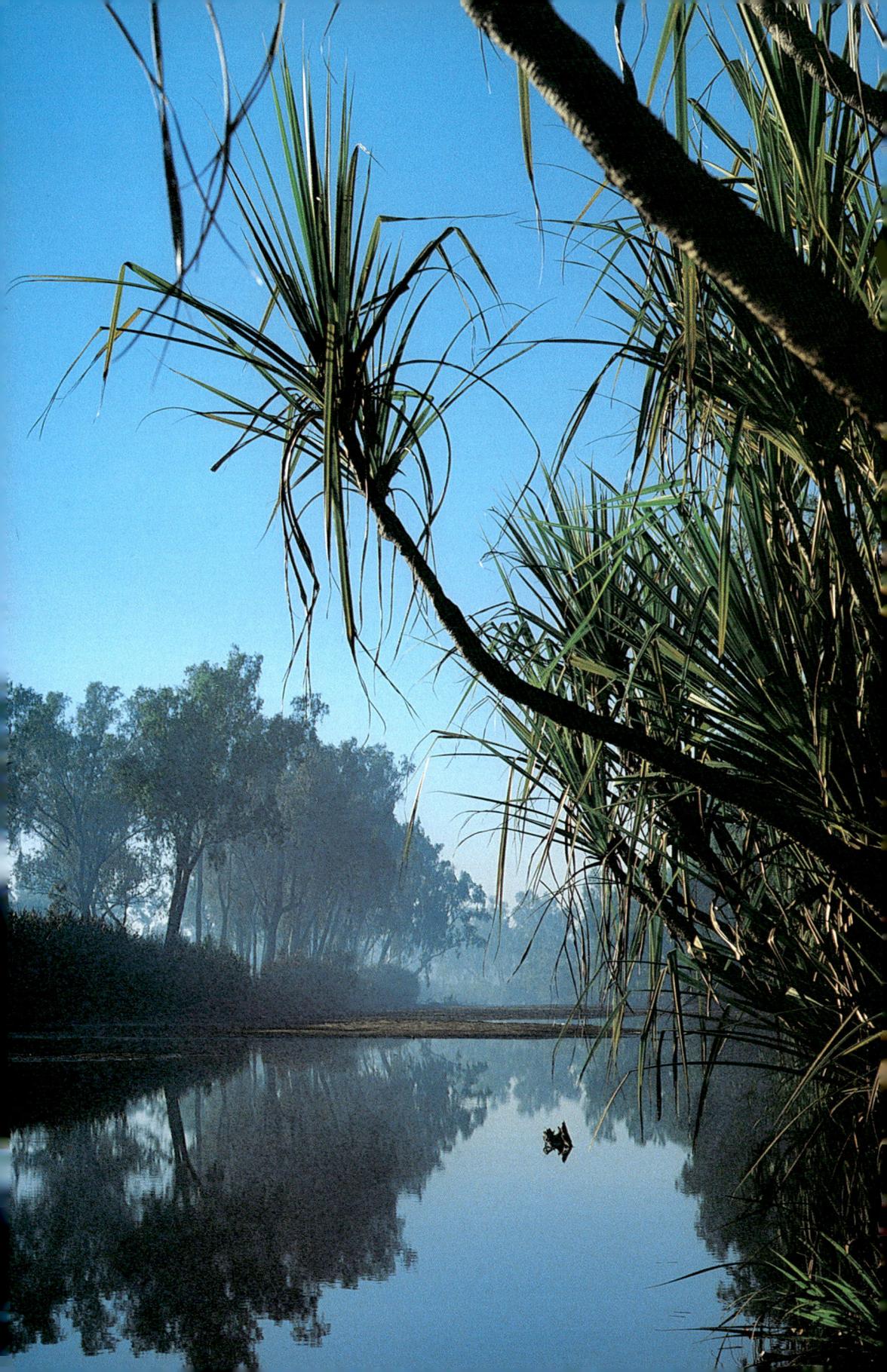

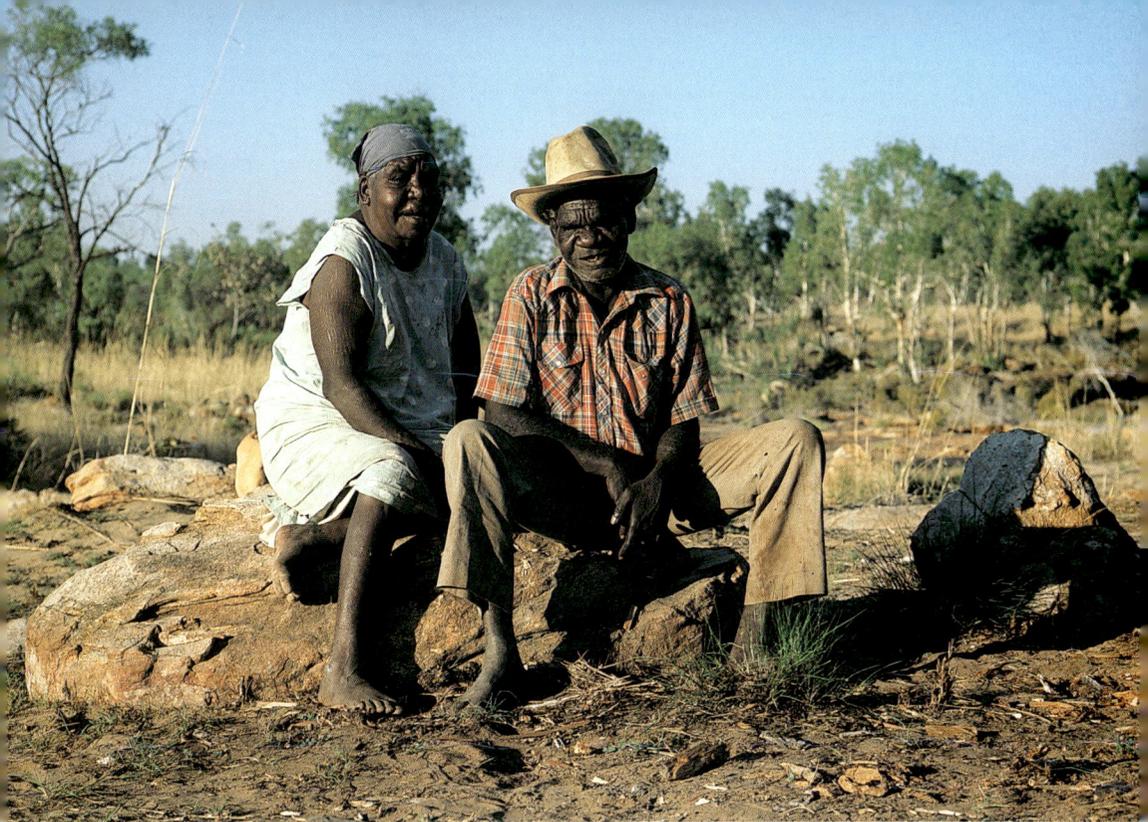

Violet and George Jormary, Hann River country, the inseparable ones

Opposite: Dalnnga, Drysdale River

Bush turkey

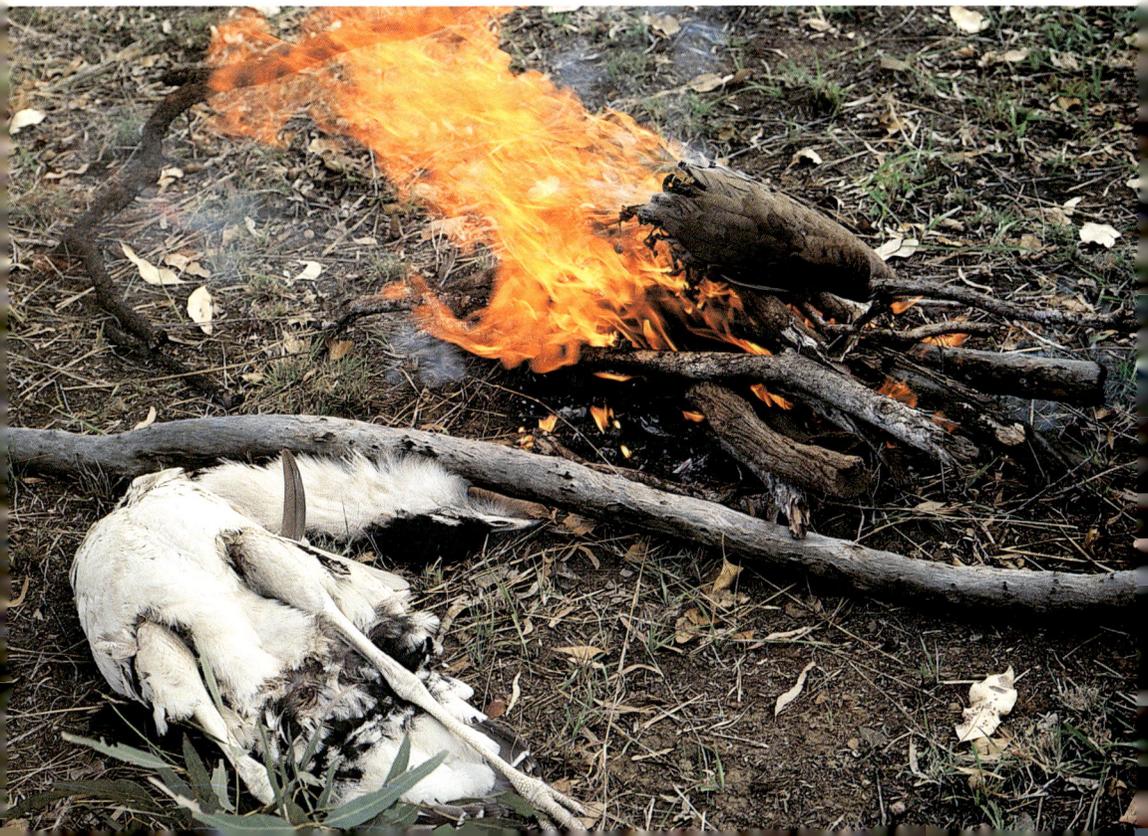

The little sun arrived at her mother: "Mother, I got bitten by that snake because he was jealous that I was brighter than he is." Then the mother hugged the daughter and said, "Daughter, you are all right now. Tomorrow you will go again. I am giving you some of my power. I'll watch you every day as you go." She gave the daughter of her power. And every day the mother sends her off with her powers from right inside the earth, and she watches her go across the sky.

That is the Sun Story. It's a story for the future generation, because the life today is very difficult. But with the restoring powers from inside, the young people can still carry on, generation after generation. In spite of the poisoning of the world, they still have a chance. That's the story. The mother is represented by a big rock.

Auwanbanggnari is a venomous front-fanged snake, a species of the animal kingdom, not the Rainbow Serpent.*

All along Mowaljarlai's story was accompanied by clapstick music on Dhargie's cassette recorder. Now the batteries are flat.

Dharrgie discards them over her shoulder, like bones, then takes the leather leg-casing off, empties her suitcase onto the ground and nestles into the contents with a blanket. The shiny brown leather leg lies guard alongside that poor old body.

In the night I wake and feel giddy among all the stars. Is there an escape from this vertigo of night-space? Both hands dig into the sand beside my swag. Now I'm double-anchored. And I see Mowaljarlai, on his feet, stretching himself, hear him laughing:

"Hey, this is a place of no swearing, no dogs barking, no drunks, no people fighting like dogs and beasts, no motorcar noise, no aeroplane noise, no pollution on the river. It's good to be in the bush, hey?"

During the day the temperature hangs constant in the high thirties. Only silly little observations catch in the hazy web of my mind: that some unspectacular spots along the way have poignant names due to, say, small occurrences.

There is Sump Creek, a stone-strewn crossing inclined to collide with the sumps of motorcars; another location is known as *nitjamrung gnari,* "man made bongle here" – someone urinated the place.

* Auwanbanggnari: Denisonia suta. 0.88 metres.
S.K. Wilson & D.G. Knowles, *Australia's Reptiles,* Collins 1988

At Mount Barnett, where we drop off the Ellenbraes, the Jormarys decide to come along further with us. At Drysdale River Station we find no gloom this time. There is a new manager, the cattlemen at the yard respond with a friendly "G'day, mate, how ya goin'," and the homestead store serves drinks and things with generous swigs of laughter.

Between Doongan and Theda stations we shoot a bush turkey. At the Carson River, the bird is put on a fire.

Twenty minutes is considered ample time for the cooking. Half-raw turkey has more flavour and plenty of vitamins left in the meat.

Violet, once again displaying her indomitable warm sense of humour, asks me to take her photograph as she gnaws at an uncooked wing.

We are still laughing and joking when, shortly after passing a bright ochre-red stretch of soil on the road, we stop and walk a short distance through high grass.

"Maybe this site is the most important for the life of Aborigines," says Mowaljarlai.

Two stone piles, almost side by side, refer to the story of the two Nightjar Men, *Wodoi,* also called *Wodoiya,* and *Djingun.* Human beings were animals at first as well as human beings, Wodoiya a spotted owl, Djingun a little owl of brown-grey colour.

At this place the great *Wunnan,* the Sharing System, and the Marriage Law, came into being. Mowaljarlai, now very composed and dignified, explains that everything is under the one word, Wunnan:

> Wodoi and Djingun, these two Nightjar Men, they made the law for men and women. Djingun said, "When I get children, your sons, Wodoi, can marry my daughters; and my Djingun sons can marry your Wodoi daughters; but Wodoi sons cannot marry Wodoi skin, and Djingun sons cannot marry Djingun daughters – that's wrong." That is the law they made and it remained the same till today.

> That Kinship Law is still very strong. It started from here. If I go to Yirrkala (Eastern Arnhemland and on the Gulf of Carpentaria) all the elders will come out and ask me, "What your skin?"

> "Wodoi," I'd say.

> "Ah well, you go over there, in that group are all the Wodoi mob," they tell me straight away. This goes all the way to Mornington Island, Arnhemland, Weipa – anywhere.

Right here where those two stones are, these two Nightjar Men made a burnt offering. They cooked kangaroo and emu for sacrifice. In the offering is the celebration of the New Life. That is the law. You must dedicate yourself to the law for a lifetime.

Jormary interrupts: "White skin, that's nothing." Mowaljarlai translates this to: "When white people started marrying Aboriginal people, Marriage Law began to deteriorate."

The stone arrangements are almost hidden by long grass. If one chanced upon them, they would not immediately appear to be made by humans. Yet they are the foundation stones of the most important contract in the social organisation of these northern Kimberley Aborigines.

Djingun and Wodoi stone settings, George Jormary explaining, "The two made a law to have right way marriage."

Wodoi and Djingun made an agreement to prepare for a sacrifice. They went out in different directions to bring in their offerings. Wodoi went out for emu, but Djingun made a mistake, he got sugarbag [wild honey].

Wodoi

Djingun brought in his offering first. He cooked his sugarbag. Then Wodoi came along: "Hey, what are you doing?" he said. Djingun said, "I'm cooking this sugarbag."

"You cannot cook sugarbag. It should be something raw, a flesh-offering, with blood."

For this mistake Wodoi hit him on the head and knocked him down. Then Wodoi ran away. Djingun recovered, got up, followed and tracked him. He caught up with Wodoi in these ranges here. And he hit him hard. Wodoi's blood spilled everywhere. That is why we have this red ochre, his blood, on the ground [the red stretch of earth on the Gibb River road]. This red ochre reminds us of his blood and of the laws.

White pipeclay represents peace, red ochre represents death, the blood, in our judging. That's why we paint up our body when judging, either red or white – for justice or peace, so they judge anything without trouble.

The elders will say, "Let's dance first. After the dance you can fight." We first straighten ourselves out before anything happens. Wodoi and Djingun put that law.

Back on the road, the endless flow of stony plains and jump-ups finally runs into a coastal greening. The tortuous road ends at houses, people, dogs, bicycles and a few motor vehicles. We have reached Kalumburu.

The old mission buildings are still prominent – the church, nuns' and priests' quarters, and stables. There is also a presence of nuns and priests, but the settlement is run by Aborigines. Mission rule and regimentation went south with Father Sanz.

We drive to a stately line of old mango trees and are greeted by the brothers Hector Dargnall and Dickie Woodmorro. From nearby rows of simple, very small corrugated iron huts come excited shouts. Hector answers them with a prolonged "Shut—up!" The turkey is immediately divided and quickly disappears out of sight. Reunions with friends and relatives continue throughout the remaining hours of the afternoon.

When looking for a camping spot, the delicate subject of sleeping near dog's poo must be tackled.

"Too many flies here, Mowal."

"That's what we are just talking about, Jutta. We'll camp by the river."

In a cathedral of ancient paperbarks banking the King Edward, sleep comes quickly to weary travellers.

9 Kalumburu

At the greying of dawn I wake to see a figure in hat and boots squatting by the fire. Beyond, the King Edward River lies swaddled in motionless mists. Mowaljarlai is wide awake, stacking the embers in the fire with twigs. "Making nallija, cuppa tea," he says, "because I want to tell you about morning."

Only half awake, I am still curled up in my leaf-padded sand mould. Clarion birdcalls ring through the treetops, punctuated by harsh "craaa—aaahs" of swooping cockatoos.

> You know, Jutta, when daylight starts, it wakes me up. I can't sleep any more. It wakes the whole body. So I turn round and have a look. There is brightness. Piccaninny daylight makes you feel like a different person. Morning gives you the flow of a new day – aah!

Mowaljarlai's arms stretch out wide. Against the rising light I see his chest filling with a long breath.

> With this beautiful colour inside, the sun is coming up, with that glow that comes straight away in the morning. The colour comes towards me and the day is waiting.

Now he is on his feet, pensively pacing out a few circles. Settled again, he tugs at the front material of his shirt:

> You have a feeling in your heart that you're going to feed your body this day, get more knowledge. You go out now, see animals moving, see trees, a river. You are looking at nature and giving it your full attention, seeing all its beauty. Your vision has opened and you start learning now.

> When you touch them, all things talk to you, give you their story. It makes you really surprised.

> You feel you want to get deeper, so you start moving around and stamp your feet – to come closer and to recognise what you are seeing. You understand that your mind has been opened to all those things because you are seeing them; because your presence and their

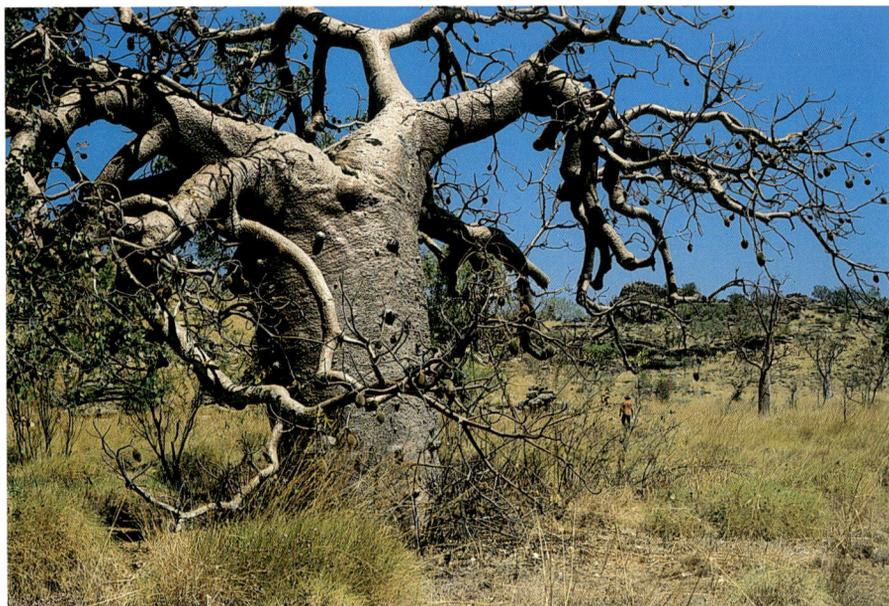

Boab

presence meet together and you recognise each other. These things recognise you. They give their wisdom and their understanding to you when you come close to them.

In the distance, you feel: "Aaahh – I am going to go there and have a closer look!" You know it is pulling you. When you recognise it, it gives strength – a new flow. You have life now.

Dickie Woodmorro, "last history man" at Kalumburu. Photo Patricia Knight

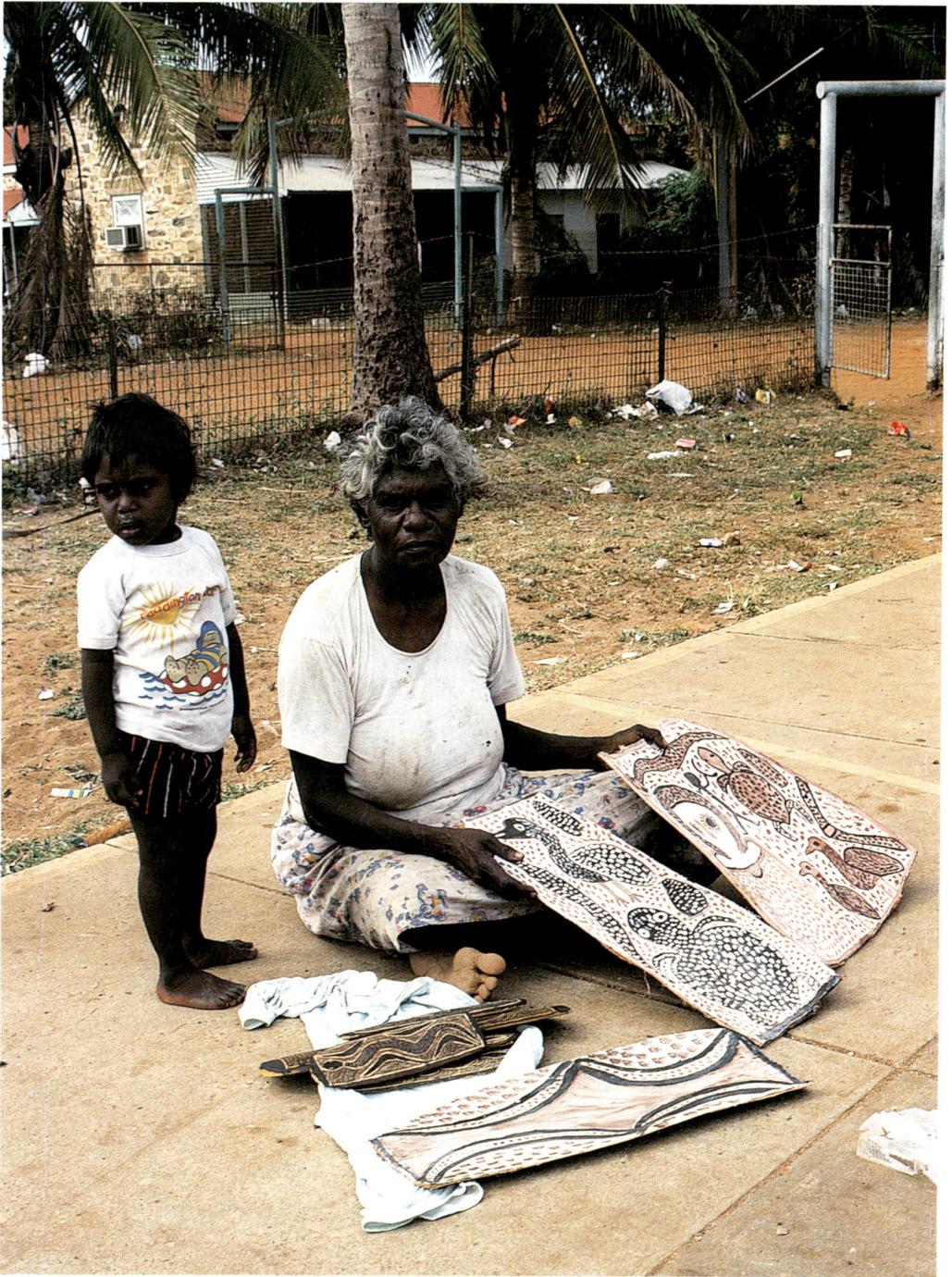

Lilly Karadada and grandchild Edward at Kalumburu with her bark paintings

Then you put it in your storeroom, in the little room in your brains here. You taped him, you got'im in there! You are going off now, to see what the day will hold. You feel a different person. One more day is added to your life, you will be one day richer.

You got country as far as the eye can see, and it's yours. But because of this consciousness, you are going through it reverently, quietly – through the middle of all this nature.

What will happen? Well, every contact you make with the eye – perhaps you don't bother to look at it – but everything is present for you to see. What you go for are the things you want to understand on this day.

The mist has risen. The river is now glittering in light pastel hues. "Time to make a start, Mowal."

No hurry, Jutta, plenty of time still. First I'll tell you what the day will bring. The day brings two things: there is your presence and the presence of the day, right? It brings you fear. Because that day ahead of you is untouchable, laid out completely in time, because of that it brings you fear. You can have an accident, have a snakebite or fall over a cliff.

So this coming day adds two things to your life: it gives you fear and it makes you alert. It faces you like a murderer. That fear tells you, "No, I got to do this and not that."

It is in your mind that you don't want to do *that* because of fear. But fear gives you more strength, more courage. You say no to that thing you wanted to do because it is the wrong thing. Nature tells you that. You have to go straight, not do silly things.

"Do you accept that fear gladly?"

Yeah. When you got fear in your body, then you carry a good thing. Without fear you're just going blind, you've got nothing in here [he taps his forehead]. If you don't have fear, you don't have courage to defeat fear. The more fear the more courage.

Everytime the sun rises you got them both together: fear and study. What more could you want? Without fear you've got nothing in you to become a person, you never learn anything, you have no aware-ness. That's it – you ready to go now?

"Quite ready. I am rearing to see what this day has in store."

56

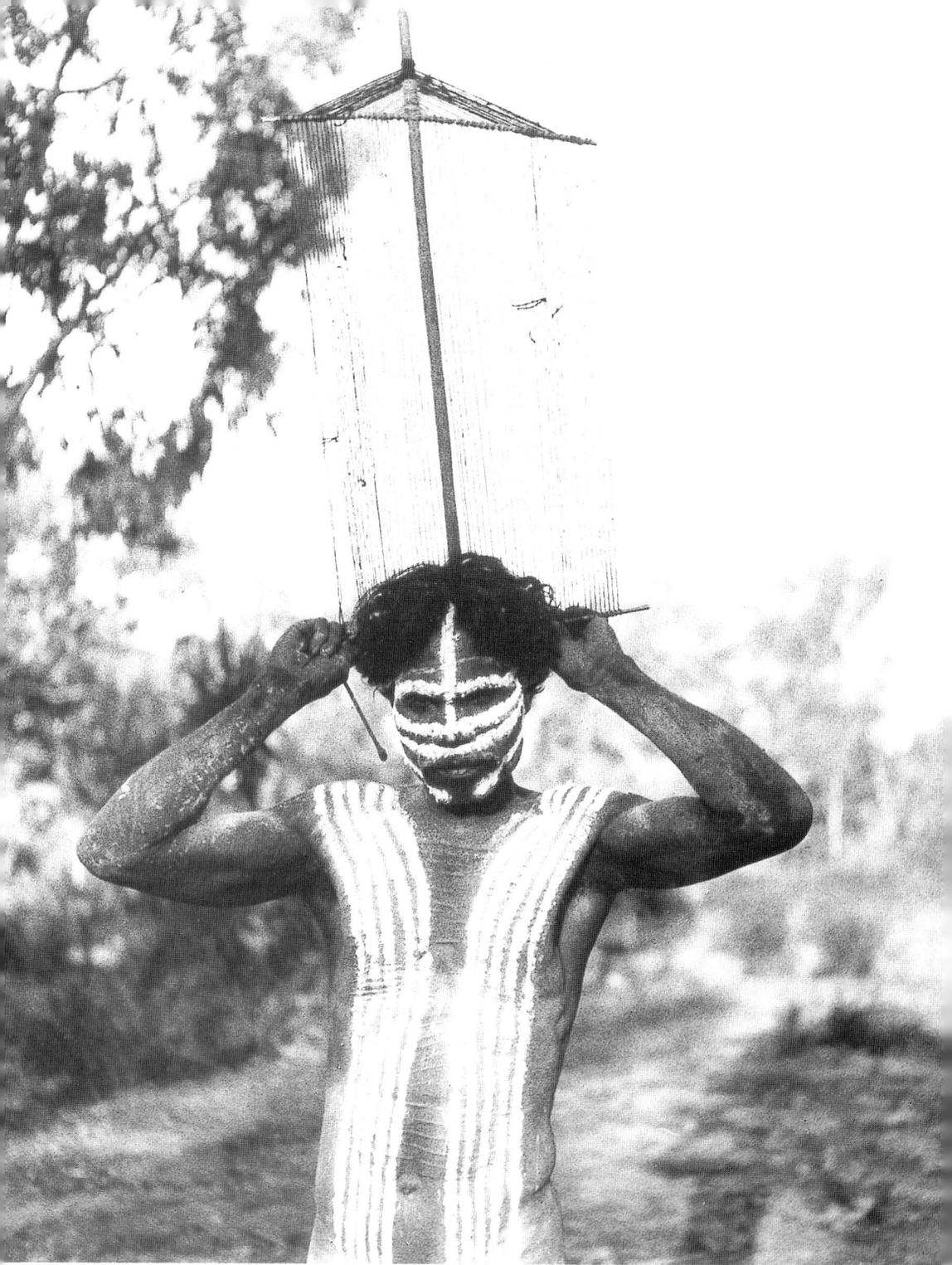

Mowaljarlai's great-uncle Jimmy Kunmunya with dance totem, 1938. Lommel

Caroline Ranges (above)
Johnny Umbagarumba at Waa

Hector Dargnall (below), ochre on mouth from demonstration: "It is an exchange of purity."

10 The Shield around the Light

Alas, by mid-morning we are still held up in Kalumburu. Mowaljarlai must attend to some business matters. The administration building is crowded with people. I escape into a dusty little repository filled with artifacts. Wooden carvings are stacked to knee-height on the floor and plywood shelves bend under the weight of paintings. Portions of snakes, lizards, birds, turtles, Wandjinas and black-white-and-ochre-hued patterns peep out here and there from between the masonite boards. It is quite a fascinating place for browsing, and for waiting for Mowaljarlai.

When I catch a glimpse of him, he is in a group of people who are obviously divided in their opinions. I dart out and grab his arm.

"How long will you be?" He raises his voice above the melee, "... what we talked about ... this morning ... what day brings. ..." As the group moves further away, he shouts back, "Wait!... this is ... tension ... time!" So I wait, away from the passions that continue to clash over methods of marketing the artifacts. But eventually we do manage to get away from Kalumburu, leave this land's end corner of Australia behind and are back on the road.

It is our good luck that Hector Dargnall finally agreed to come with us. About forty-five years ago, the young Dargnall had last been to the Lejmorro site. An old-time bushman, he spent many years of his life walking over this part of the Kimberley country. He has an encyclopaedic knowledge of all its Dreamings.

"Of all those Wandjina places," Hector says, "Lejmorro is the boss, the most important site." Among the old men who have actually been to Lejmorro, he is the only one still able enough to walk the distances in the bush. The other real bushmen we had met in 1980 were Johnny Umbagarumba, the blind-old-man-with-the-bandage-around-his-head; Ngalewan Nally, the cheeky Fred Murphy; Jagamurro, the-old-man-who-ran-away, and Watty Nyerdu who had staked out the coastal Wandjinas with Mowaljarlai. "All these old-time Men of High Degree, they are dead-gone now," he says.

Lejmorro has not been visited for near on fifty years. Hector and his brother Dickie still remember where it should be; other old people had left directions how to get there before they died.

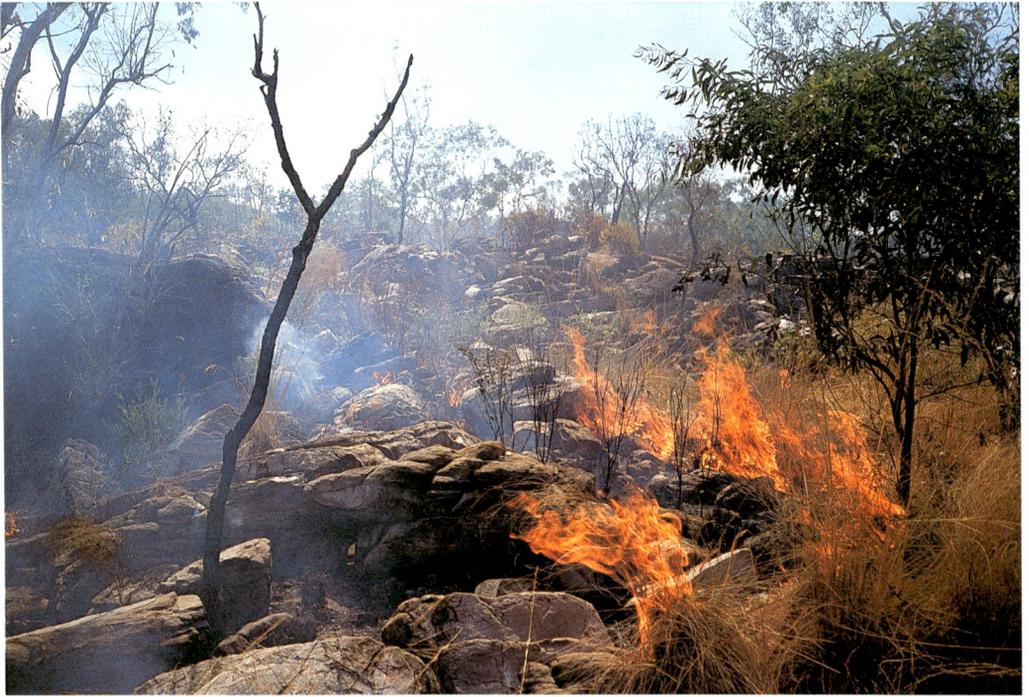

In 1980, when the fires were closing in on us, we were possibly within a kilometre of Lejmorro; when we noticed that we were running around in crazy circles, unable to penetrate an invisible wall.

"Spirit of Lejmorro protecting itself all right these days." The men are laughing about that, but it is not a happy laughter. If they cannot get there and show photographs in argument for Lejmorro's protection – how will they stop mining concerns from drilling or sampling? For all they know, the miners could be there already.

At one time, a muster helicopter flew an Aboriginal woman from Mount Elizabeth to Lejmorro. They had positioned the site area on a finely detailed map. As they approached, there was so much glare that they could not see. Every time they came close to the site, the cockpit windows suddenly steamed up mysteriously.

Hector says, "They come there, she been saying: 'I can't look, light blinding'." And Mowaljarlai: "She said, 'Through that helicopter glass I couldn't recognise the place. On the chart I had recognised the place. On flight back, steam-fog gone'."

I can't help wondering about our chances of getting there this time.

Pointer rock: east, north, west; "The Director"

11 Angguban – the Cloud Dreaming

We are walking towards the shelter of *Angguban,* the Cloud Dreaming, when Hector stops to uncover a tiny waterhole. It is hidden under leaves and branches, like a foxtrap. He is overjoyed at finding this little wunggud hole, where the Long-necked Sweetwater Turtle came out in mythical time – or was it in known Kimberley history for this area?

"Same thing," says Mowaljarlai. "The name of the hole is *Dere.*"

A few steps further, Hector lifts a rounded stone from its sandy mould, then another. He fondles and resettles them gently. One stone is the Turtle, the other her baby.

After passing two sentinel rocks, we are at the main gallery. Two boulders block a full view of the paintings. The stone feels soapy smooth. It is broadly pitted and very dense in texture; so dense in fact, it appears to be wet. The passage between rocks and paintings is too narrow to walk through.

All smooth rocks here are clouds, Hector says. Cloud rocks protect the Wandjina family inside from getting wet. Angguban is the rain-laden cumulus cloud. The sentinels outside are also clouds. They block the entire site; whereas the inside clouds protect the paintings.

Neggamorro Minjel Monggnano is the important Wandjina at this Dreaming. He is a Spirit Wandjina. In one of the paintings he is surrounded by his sons and has a turtle by his side. This turtle, a long-necked sweetwater turtle, is his Chosen Animal.

Neggamorro means "I wonder where she's gone – where is she?" He had lost this turtle. Mowaljarlai explains:

> He was stumped. He could not understand how she had slipped from his presence. He cried in despair, "Minjel Monggnano – I love you so much. I even love the bubbles you make when you are travelling under water – what beauty, what style!"

> Neggamorro came from the water, from the King Edward River near Kalumburu. He had followed the turtle but lost sight of her when she travelled underground. She emerged from the wunggud hole Dere, then crawled a short distance to make a little nest of stones near the

painting gallery. When Neggamorro found her, he carried her to the shelter and put her next to himself in the painting.

Outside, a huge boulder has been split by lightning. Some broken-off rock still sticks in splinters from the sandy soil at the base. Hector points to discolourations in the stone where the lightning hit:

> Neggamorro struck the cloud boulder with lightning. As he struck the rock split. The lightning spear made a deep hole in the sheared surface. From there *Yamben*, a water goanna spirit-man, jumped out.

Yamben is painted beside Neggamorro on the back wall of the shelter. The goanna is a wunggud animal.

> Without the stone sitting there, clouds could not form. You can fly through a cloud, you can dismiss an idea, but you cannot ignore an image that is solidly manifested in the earth. Clouds represent sweet water – the Wandjina. Wandjina put that cloud down into the earth. It is the stone. He painted himself beside it – they are one.

> The cloud goes up in steam from the earth, forms from the earth. When we see the cloud rising – and perhaps it is not far – then we know it is the Minjel Monggnano cloud rising, it is that *Emmamurrai* Wandjina rising, the Wandjina belonging to the *Bremmangurrai* tribe.

The King Edward River, from where the great Spirit Wandjina Neggamorro arose, is known to be the symbol of the River People. They in turn represent this river, which they call *manggnurra* – the river. When referring to the River People, the word "manggnurra" changes into "Bremmangurrai".

> Like the people who wandered away from Israel where they came from, the Israelites, these people come from the King Edward River. They are "Riverites" – Bremmangurrai.

> These Bremmangurrai tribes are distributed over the eastern area of the Kimberley which borders on the Ord River. When people ask, "What country is he from?" we say, "Bremmangurrai." They straight away know the tribe and country he belongs to.

> Every Wandjina is part of the tribe that belongs to a particular gridblock. The sum of all Wandjina over the whole grid is the Creator himself. He shows himself to us as Wandjina. We call him *Wallanganda*. He is God. He manifests in everything in the universe.

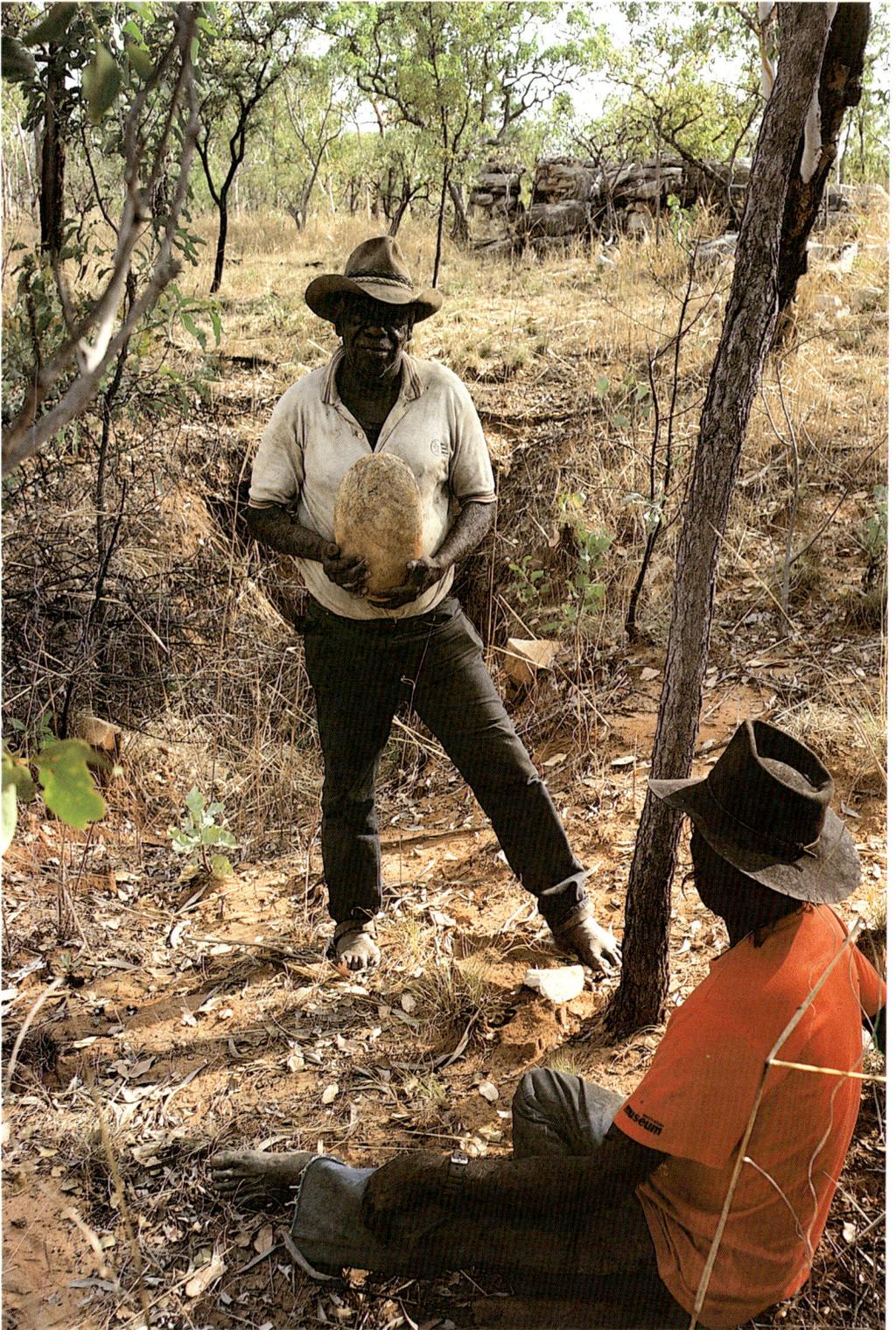

Dargnall holds Turtle stone, with Baby stone at his foot

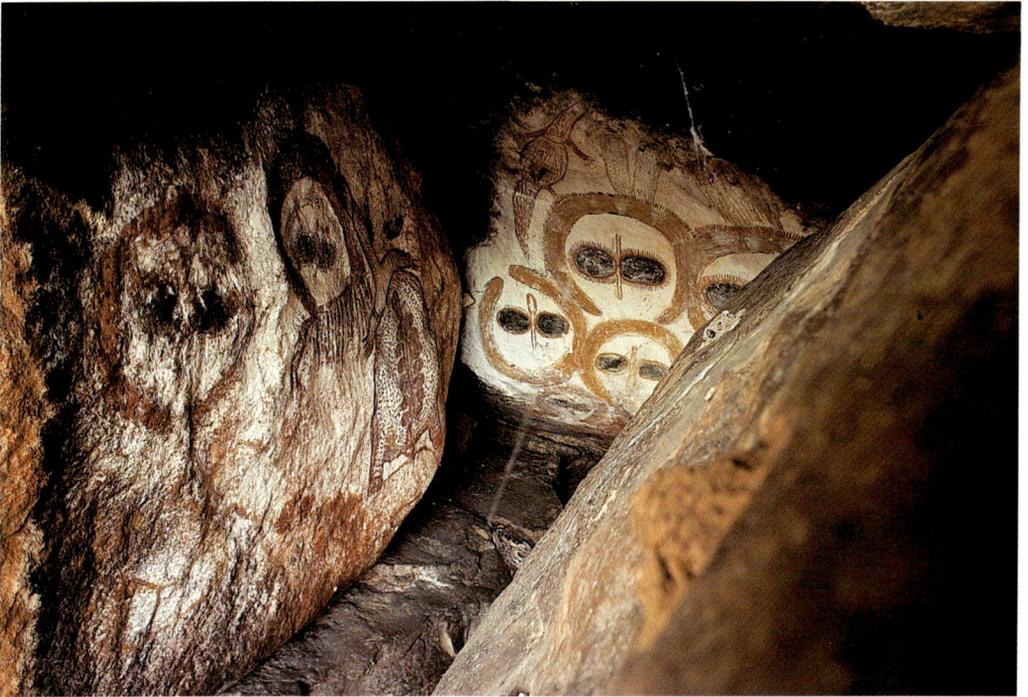

Two soapy-smooth rocks shield Wandjina Neggamorro Mingel Monggnano, and turtle on left side of passage; at end, Wandjina with big "ears" painted with goanna Yamben, a wunggud animal; other Wandjinas are his sons

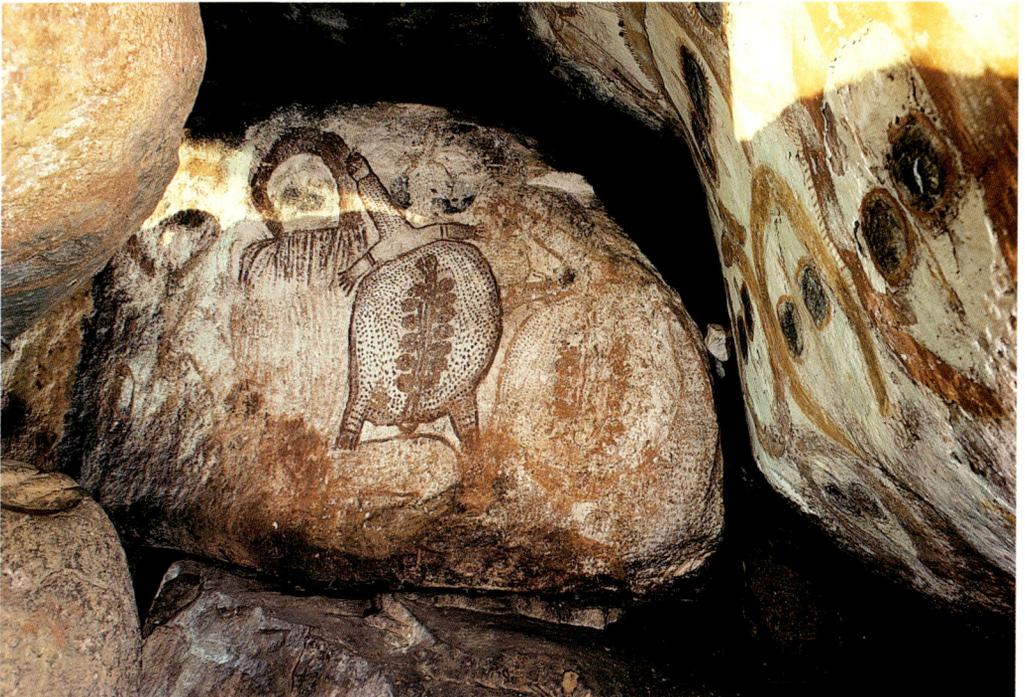

Long-necked Sweetwater Turtle beside Neggamorro Mingel Monggnano. Centuries of over-painting has given the stone a thick coating of pigment; rock on left is a cloud blocking rain

But in each grid we must be looking after one special thing for him, a mountain, the grass, or a tree. The life and increase of these things depend on the water from the Wandjina, from Wallanganda.

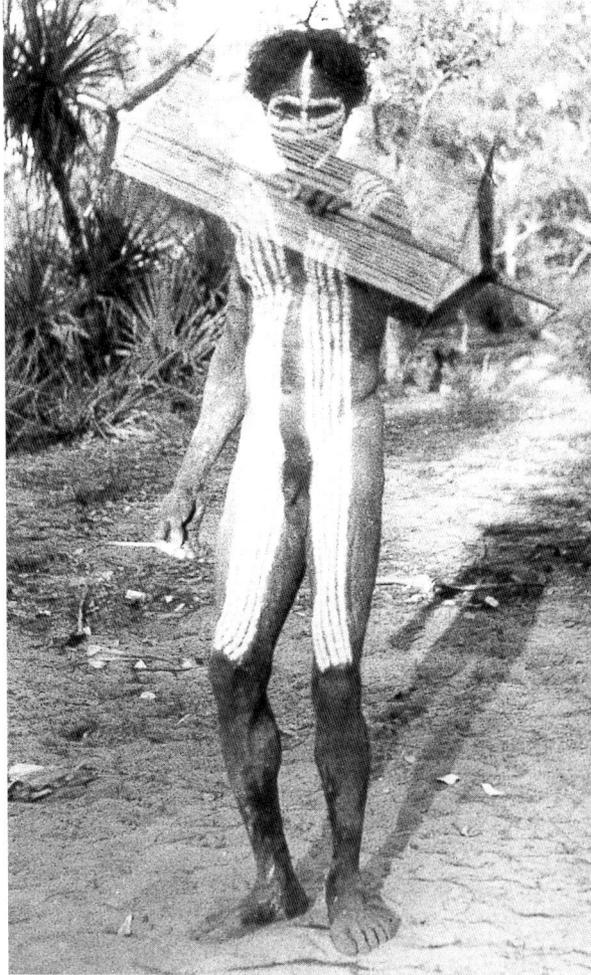

Jimmy with dance totem, 1938. Lommel

The first rain is *djallala bibibibibibibi.* When we hear the first call of thunder it goes, *"Gugugugugugu – goock-oooo."* Everybody gets happy because we hear Him calling us: "That's the Wet coming to you mob now, to give you rain!" We answer that gugugu – goock sound back. We say, "Djallala bibibibibibibi, everything will rise up and grow!" We are happy then. We know that we are not left alone without rain, without water. We express this bibibibi in the shaky leg dance – our joy and praise for being given life.

12 Mowaela – the Duelling Place

From Angguban we move on to *Mowaela,* the battle plain where Aborigines settled their personal arguments. The place has seen fierce combat, at times to the point of death, to straighten a wrong or revenge a grievance. After they fought at Mowaela, there was no more comeback on a matter. No sooner are we out of the truck than everyone disperses along the river bank. Violet and Jormary, the inseparable ones, fish at an astonishing rate: cast line, count to three – pull out fish; line back in, count to three – fourteen blackbream and two turtles are landed in next to no time. A few pandanus bushes further along, Hector and Mowaljarlai stack up a similar catch.

"Crocodile!" Jormary aims the gun through pandanus – *Booooom!*

"Got'im!" Jormary is in the river, diving. "He's here, somewhere, feel'im with my feet!"

Hector strips naked, wades in and swims across. Their heads splash in and out through the water. Shouted advice from the riverbank, more splashes. Then Hector's hand shoots up, clamping a reptile's snout. It's a Johnston River crocodile, close to a metre long.

"Got'im!"

"Wheeee!"

Back at the bank, a tomahawk blow severs the head, Hector climbs back into his pants. A campsite is carefully considered, swags are rolled out – and one is at home.

And the shadows grow while we cook, snooze, stalk through the reeds and the water, tell and record stories. We are talking about the something that is pushing us back from Lejmorro.

It's the *Gi* [pronounced "ghee"]. If you are strange, it pushes you away because there is nothing to attract you; the Gi only wants to see the guy that belongs to him.

If you don't have enough energy to concentrate, it pushes you back, can make you confused, even change the painting or the area so it can't be recognised. Every wunggud does that. When your mind is tuned in and directed towards your Gi symbol, you are in an ancient state of mind; time stands still, because your mind is in a state where

time does not count. It's not like dreaming, seeing things in your sleep. Ancient time is no time.

To go back in time, you walk. It gives you respect for what happened when everything was created. It gives you a quietness of mind – and direction.

George, Hector – "Got 'im."

Here at Mowaela there is peace and time to sort out the criss-crossed patterns of the wonderful Wunnan.

We draw on the ground, box up gridblocks with sticks, fill them with seed pods representing people of varying tribes and an array of totems – leaves, sticks and pebbles.

While the heat and the shrill noise of the cicadas blanket me close to sleep, fish splash and the hawks circle over the cooking smells, my lesson lies graphically arranged on the sand – and thankfully in that little recorder.

I am only half listening, wishing I was just a single-purpose photographer again. "How am I going to get all this into a book?"

"You will do it for us because these stories *must* be written down," he says.

By twilight we have consumed remarkable quantities of black tea. At a little beach by the river, I indulge in a thorough scrub-down, risk a quick dip and then embalm myself from a battery of cosmetics: Nivea Lotion, Hydrating Cleanser, Revitalising Tonic, Visible Difference, Advanced Energising Extract, Nightly Recovery Cream, Cuticle Cream, Camomile Shampoo and Conditioner. When I look at these labels, I suddenly feel a longing for clean pink things.

Refreshed, I return to the ambience of the fire. Comfortable and content, the Jormarys are leaning against one another.

"We can't eat the fish," declares Jormary. "Blackbream without fat makes you sick. Emu, turkey, kangaroo, all animals without fat make you sick; same as white people say fruit out of season makes you sick, no good tucker."

Violet Jormary fishing at Mowaela

The crocodile is already cooked. It lies belly-up and belly-open in the ashes. Mowaljarlai carves down-tail from the crotch. He hands me a morsel which tastes like a mix of eel and chicken.

"So far, so good," I concede, "but I'm still waiting for flaps and flutters when it gets further down."

To my surprise, this causes an outburst of laughter which becomes infectious. When the giggles stop, someone points at the charred crocodile remains, and we start all over again.

"You flutter with kangaroo and crocodile, Jutta," Mowaljarlai chuckles, "and we would think 'Aah, Gi bodysign'!" He fans out his palms towards us for silence.

I'll tell you. A mother: her son has travelled a long way and he is coming back without sending any messages; but she knows through her dream.

I'll give you an example. My mother belonged to the bailer shell. She was asleep and she was dreaming all those baby bailer shells. "He might be coming!" Her birthright is telling her that her son is coming.

Birthright is what my mother symbolised and represented, same as totem. She Gi'd the bailer shell. The Gi is telling her instead of telephoning. The dream lets her know the son or daughter is coming. *Yarri wada* we call it, that means "many dreaming". If the son gets sick, or the daughter, her stomach is fluttering, jump-jump-jump; or here in her breast this milk, it jump-jump-jumps.

Mother gets worried now. "Oh, my son is sick! He might have had an accident!" She knows. When it is moving, she says, "Mowaljarlai?" It stops, she knows. If it is not me, it keeps going. She says, *"Niggu walla?"* and it stops – my sister is sick. Those are the body signs.

The moon comes up. It is bright enough to watch the ants travelling along their paths in the sand. Each ant communicates with other ants that pass in the opposite direction.

In the morning, swags and belongings are soaked in dew. Swarms of flies sit on everyone and everything, cluster thickly under Mowaljarlai's red, swollen eyes. I am covered with hives under armpits, on thighs and legs, itching everywhere I can't scratch.

Jormary complains he was much bitten at the Cloud Dreaming, by the sandflies and wallaby ticks that breed in the campfire ashes at all painting shelters. But after inspecting Jormary's swellings, Hector shakes his head.

"No sandflies," he says. *"Gurriwa, Lalai."* Mowaljarlai clarifies that gurriwa are yellow-brown caterpillars, topjoint-size of his index finger. They hang in thickly webbed bags in trees, like boxers' punchbags. When the bag bursts, they drop in their highly allergic thousands.

According to Hector's diagnosis this bush malaise must be as old as the hills around here, one of the first irksome things off the production line, for Lalai is Creation Time. What next will beset us?

13 Waanangga – the Sugarbag Site

By mid-morning we are searching a long, low escarpment for another painting site. Everything is clamped in a vice of heat. But Waanangga, the Sugarbag site, can't be far. Hector had pointed to a wide open space, the path-the-bee-came from Forrest River.

The bee had followed the river across Hector's country and past Drysdale country. This travelling bee was the Wandjina-of-the-Wild-Honey, followed by those many other Bee Wandjinas who came to paint with the boss at his Dreaming.

After Waanangga they all flew westward to leave Sugarbag paintings at the blocksites of the other tribes – in Lalai, Creation. Hector sets out on foot. Then we hear him calling. He has found the home-shelter of the Big Bee.

Inside, my eyes soon adjust to the subdued light. I am looking at lines of densely painted dots – yellow, ochre, black and white pigments shaping into a central image – the Sugarbag. The Sugarbag stretches along a ledge panel and lies directly above a much older, weathered Sugarbag painting.

The ceiling is curved against the glare outside, a protecting brow that holds an awe-inspiring pageant of painted Wandjinas. A large floater slab on the ground represents a cut stringybark bowl.

On this we settle, now cool and relaxed, and listen to the silent seeing-eye choir of Wandjinas on the ceiling.

Then Hector is on his feet, explaining the painted figurations and their meaning, unfolding the story of the site.

In Lalai, when the Big Spirit Bee Wandjina Waanangga came to this cave with his followers, he put the honey into a *Warari* tree, the oldest tree in history, a softwood with dark flesh that does not dirty the honey.

Later in history a Wandjina Bee Man, *Yadnanya,* came with his Wandjina Followers. He cut the Sugarbag Tree with a tommyhawk. The honeyed log was laid onto the rock ledge. There is a cut-mark next to where the Queen Bee Wandjina lives in the yellow parts of the lower painting.

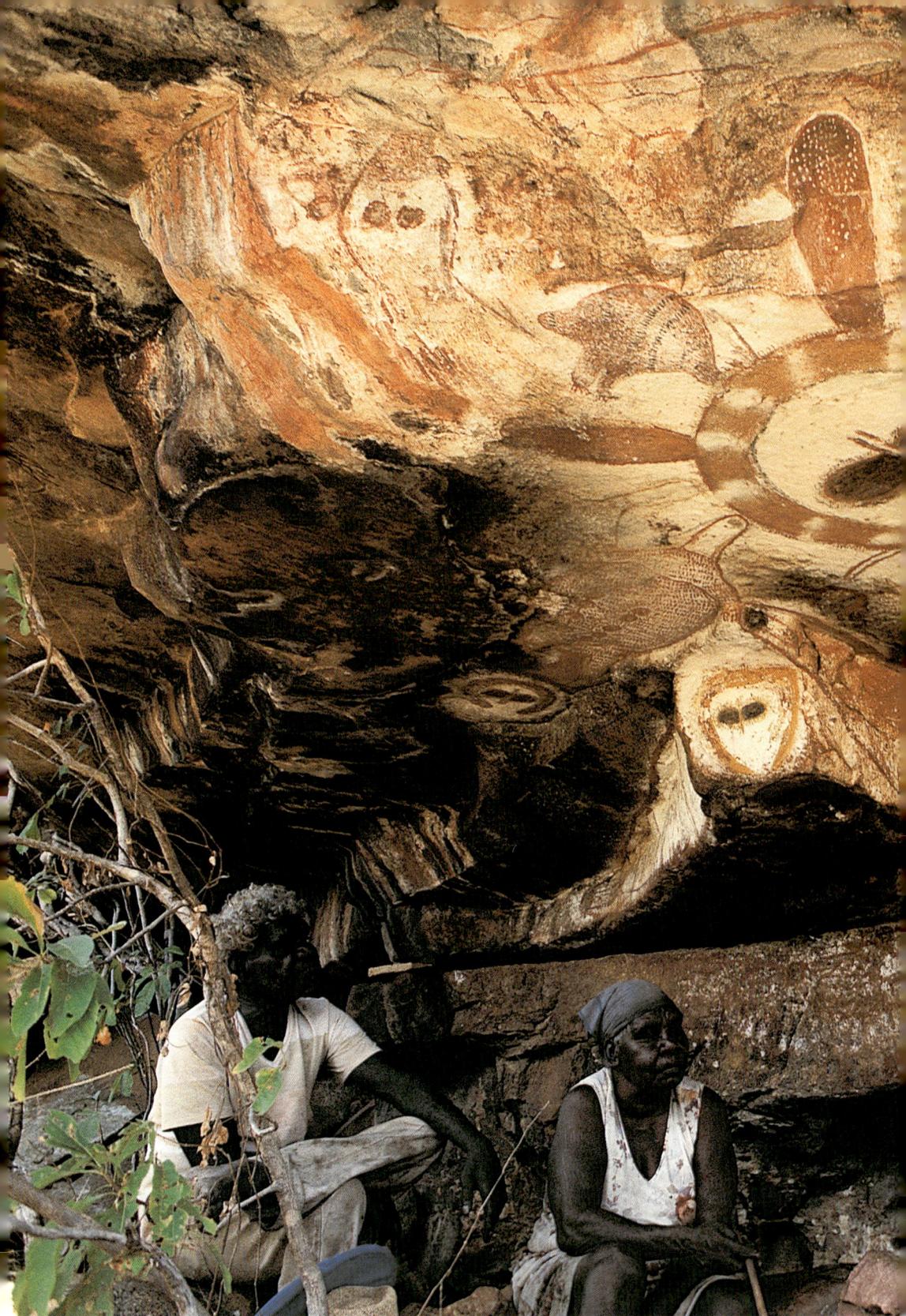

Waanangga; Queen Bee Wandjina at point of ledge that carries Sugarbag painting.

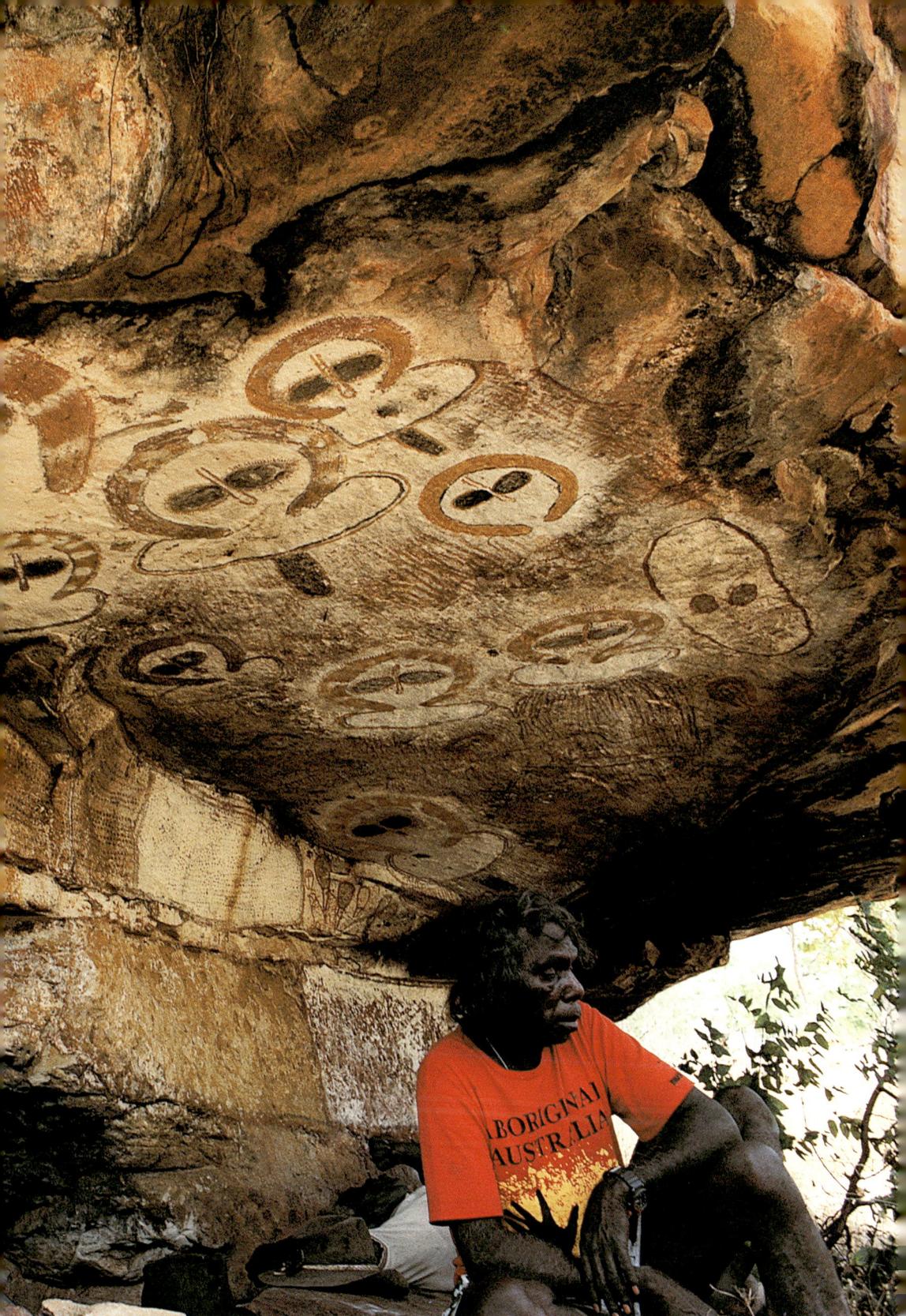

Bee Wandjinas swarm on ceiling. Below them are two layered images of Sugarbag trees, old and new, "laid down as a log" [*c.f.* drawing p203, Appendix 2]

When the Sugarbag Tree was cut, the honey burst out and flowed like water. "Quick, quick," they cried, and put the *anggna*, the stringybark bowl, underneath to catch the honey. The vessel turned into rock – the floater stone on the ground.

And to the place where he cut the Tree they gave his name – *Algnun Dorr Amorangnari Yadnanya:* where Yadnanya cut the Tree.

Ballalong, a table rock in front of the cave represents all components in the Sugarbag painting. Waanangga lies here.

There is a painting of the great *Gullinggni*, the one they call the Rainmaker, and of his shield which he held by two holes, way-back in Ancient Time and right from the Beginning.

Why would a Raingod need a shield? "When a group is incorporated and you represent that group," Mowaljarlai points out, "you have a seal. That shield was his seal. It showed his territory, how far to the border – the area where he did things."

All yellow parts of the Sugarbag are pure honey. The honey is in a bag and separated from the honeycomb, which has a door. The head-part, where the yellow honey stops, represents the traffic movement of the bees.

"That's *angnulu*, his penis-side," Hector says. "That part is separated from the *ngarra*, the pure honey below."

A mood of contentment has descended upon our little troupe, a vibrating alertness yet calm self-assurance. Again that feeling of being at home.

There is occasional humming, a few lines of song, the tapping of pebbles and twigs. Jormary and Violet crawl into the deeper areas, to lightless crannies that hold ochred, dry human bones, freed of their funerary paperbark wrapping, the wallet.

There are bees painted near the door to the honey compartment, some knobbly waterlily roots, and a small human figure. Hector explains every detail of the paintings:

This is a little baby, a spirit child from Olden Times. He came from up north and came crying, cry, cry, cry. He called into this cave and is painted alongside the Sugarbag. He is *Alamat* tribe, the son of *Mangga Utji.* He made it all the way to this cave.

Another little spirit child did not come through. He stopped half-way to here because he had become confused.

All those other Wandjina came with the Big Wandjina, everyone from everywhere came to paint with him here.

He came walking from *Barrayu*, from *Bullinggni*. Along the way the Wandjina got muddled-up; at the same place where that little spirit child was mixed-up because he was lost-kind-of-thing, the Big Wandjina also got muddled-up. That's why that place is called Bullinggni – muddled-up area.

When the Bee left that Bullinggni place, he was buzzing along, buzzing. That Bee Man put a hill there, *Djalgumi*, a little island on the plain. Then he buzzed-buzzed along the topside of a creek until he came to this creek.

We remain in the shelter for several hours and arrive back at the truck still in a quiet and pensive mood.

The narrow flow of the Drysdale, where we make our camp, soon slurps away into scungy mud. Before it reaches the riverbanks, the mud is completely dry and cracked up into hard tesselation.

"Maybe we go wash," suggests Violet. We stroll off and find a secluded rockpool. The water is clear, brushed by low-reaching paperbark branches. For a time we are relieved of this infernal itch, the sweat-raised welts on our bodies – two silent women feeling good, watching a soap container drift between patches of folded waterlilies. We wash each other's backs. Violet's skin feels nice and smooth, silky like a baby's, yet the muscles underneath are much softer. Now, what was that?

"How come you have scars, Violet? I touched them, did I hurt you?"

"No, they my cuts, initiation."

Stretched out and rinsing my hair, I see the old woman's silhouette – an angled dugong, a hippopotamus sitting erect in a swamp – big, charmingly curved, feminine. And see myself as a fat crocodile floating white belly up.

The night at this camp is terrible. Speargrass and gravel are poking through the swag. Itches and ants keep everyone restless. In the morning bliss is definitely absent. Mowaljarlai demands, "Make some johnny-cakes, Jutta. Plenty flour still left in the drum." My dark thoughts are kneaded deep into that damper dough in the enamel wash basin. Then town politics flare up again. The men now want to go back to Derby. I cannot agree to this.

"No way, Mowaljarlai, let's go and find this Lejmorro first."

Malara, the kangaroo stomach that fell out and turned into a hill, Gibb River Road

Decision maker at crossroads, in Wunnan
exchange, trading system, called *duat*

Mowaljarlai uses greenstick skewer, 1986

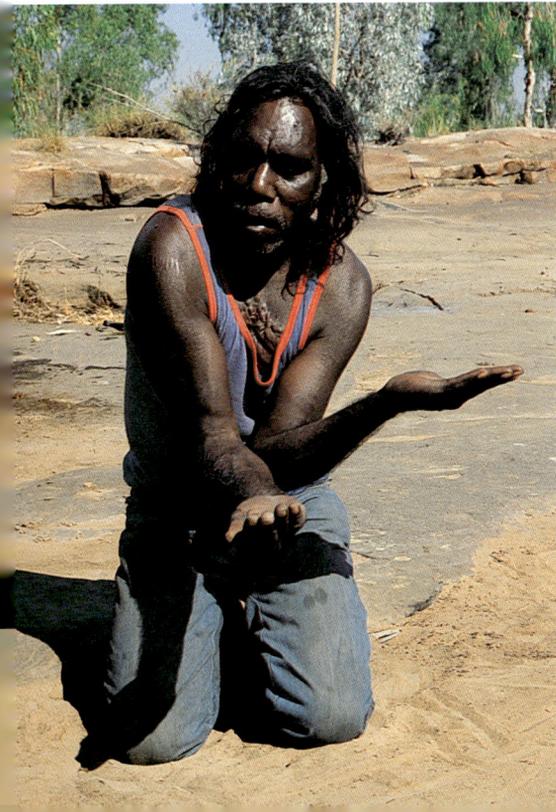

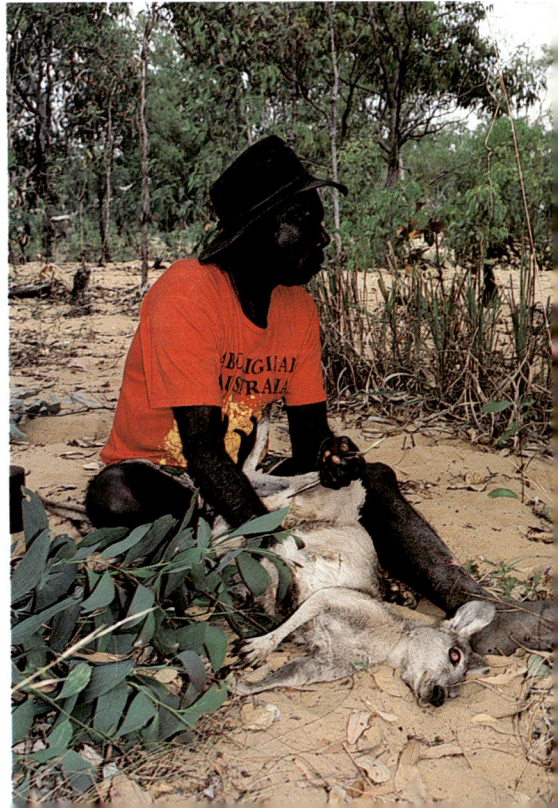

14 The Hunting Diversion

We must search more intensively for Lejmorro, we must find it, "soon or never," say my little voices. I am tense about all the delays and distractions, but I have no influence on the strategies of getting there.

Mowaljarlai's driving is uncomfortable in the bush. He hunts while driving. His eyes sweep, scanning from far right to far left, leap across the track ahead.

The language talk in the cabin never ceases nor abates, di-di-di-di-di-di-di, di-di-di-di-di-di-di, which I know to mean "... and he walked and we walked and they walked...." It *is* really irritating.

Mowaljarlai agrees. When it came to this di-di-di, others before had also lost interest and patience.

"Where are we going to now, Mowal?"

"I think that today we go hunting." The mood is for hunting and total distraction.

"Hey, see all those wild donkeys looking at us! And there's a big emu!"

About twenty dark faces, ears pointed – and one emu – are staring in our direction. At the sound of the gunshot the emu jerks, then flees with the donkeys.

"Got'im, some place!"

Jormary follows. Half an hour later he returns empty-handed: "First time I see this. Donkeys made circle around emu, pushed him safe, on and on, into the bush."

Wild donkey herds abound in the Kimberley because the Aborigines were told by missionaries, "Bad luck to kill donkey. Donkey has cross on his shoulders because he carried Mary and Jesus."

"But how come whiteman choppers can shoot them for petsmeat?" asks Jormary.

We drive through stretches of gum country, bush with eucalypt stands, and through large patches of bloodwood, then come into boxwood country, where we encounter three graceful wallabies.

One goes down with a bullet. Its baby, a pink, hairless little joey, is pulled from the dead mother's pouch, banged against a stone, and thrown away.

"Good bait for fishing, Jutta. Better pick'im up."

"No thank you, the dingoes need breakfast."

We pass a bluff hill not far from the road – Malara. Malara is a kangaroo stomach that fell out and turned to stone, this hill.

Shortly after, Mowaljarlai points ahead, "Look, we're near those Blackheaded Rock Pythons now. Big mob here."

"Pythons!!?"

"The ones we found last time, remember?"

"Aah, those paintings!"

15 Alwayu — Dreaming of Daylight and Darkness

At last the scrub opens to the shining waters of *Alwayu*. Upriver, the Drysdale stops short of a terraced waterfall; downstream, it glistens in a chain of quiet ponds. Pandanus and eucalypt double in mirror reflections. This is the Wunggud pool that belongs to the Dreaming of Darkness.

Although darkness was always on Earth, there is a painting for it high on a bluff in Alwayu. We can't climb up there because of my troublesome foot. I am told the painting of Darkness is also the painting of Daylight:

> When the Blackheaded Rock Python became a widow, she cut her head bald and painted herself with charcoal so people would know she was a widow. On Mount Agnes at Alwayu she struggled all night in the darkness and was singing out for daylight to come, on the sundown side. But daylight came from the other side, from the east. "Oh, I was calling out wrong place, daylight coming up in the east!"

Here in the Lejmorro area, where the light came and pushed out the darkness, Daylight and Darkness painted together.

> Darkness Dreaming is not the same as a Devil Dreaming. Devils don't paint together with Wandjina; they are separate. Hector is of a Devil Dreaming. He totemises the Devil. Wandjina put those people to represent these things, to tell the story of his Idea.

> And his *Idea* became the painting. The land was given and divided out to the people as caretakers to keep his Idea going. People who live today still carry on, because we are still of the same image as that ancestor mob dead-gone before us. Even today we still represent Creation. Yorro Yorro is ongoing, everything standing up alive.

Yesterday, when resting in the Sugarbag shelter, I noticed some bees buzzing about a shrub outside. Bees! They were the keystone to my puzzle. Untold thousands of years ago, the Wandjina had installed the System of the Beehive. There at the Sugarbag Dreaming, the bees were still buzzing about – the same swarms, the same communities, though not the original

bees of course. As individuals died, new ones were hatched. Queen bees reigned and were succeeded. At times the bee communities had swarmed and built other hives in the vicinity. It followed, therefore, that at any time and to this day, all bees around here were descendants of the first bee communities of this original Bee System.

I suddenly understood how Kimberley communities saw themselves in unbroken lineage to the first people in the Beginning.

Miniature "skeletons" from gullet and neck bones of a freshwater turtle.
"These images remind us of how we were created from water."

I am heading upstream with my camera, Mowaljarlai comes up running to deliver a warning:

"Never ever go into wunggud water – very bad," he burbles out of breath. "Downriver is okay," he says, "you can swim there."

"Why is wunggud so bad?"

Because Wunggud is the Snake, and the waterhole is where she decided to stop. That's Wunggud – Her. Where the water is running it becomes "living water".

It is running because, when the Snake became *Midjelna,* which means "she stretched out, unwinding her coils", the waters stretched out too, and are now flowing forever.

But, in the middle of that water, that's Her – Wunggud the Earth Snake, a power. She is here at Alwayu. We dream kids from this

wunggud [water containing concentrated Earth energies]. And in that wunggud water we swim whenever we are sick. The power cleanses us from that sickness. We don't swim in the middle – you can't disturb the power that is inside – only at the end part you can swim, where it flows. The Wunggud inside the power smells your odour, your sweat. They know when you are sick. They get up and then we call this *mulla* – they lick the sore, the sick man's sore.

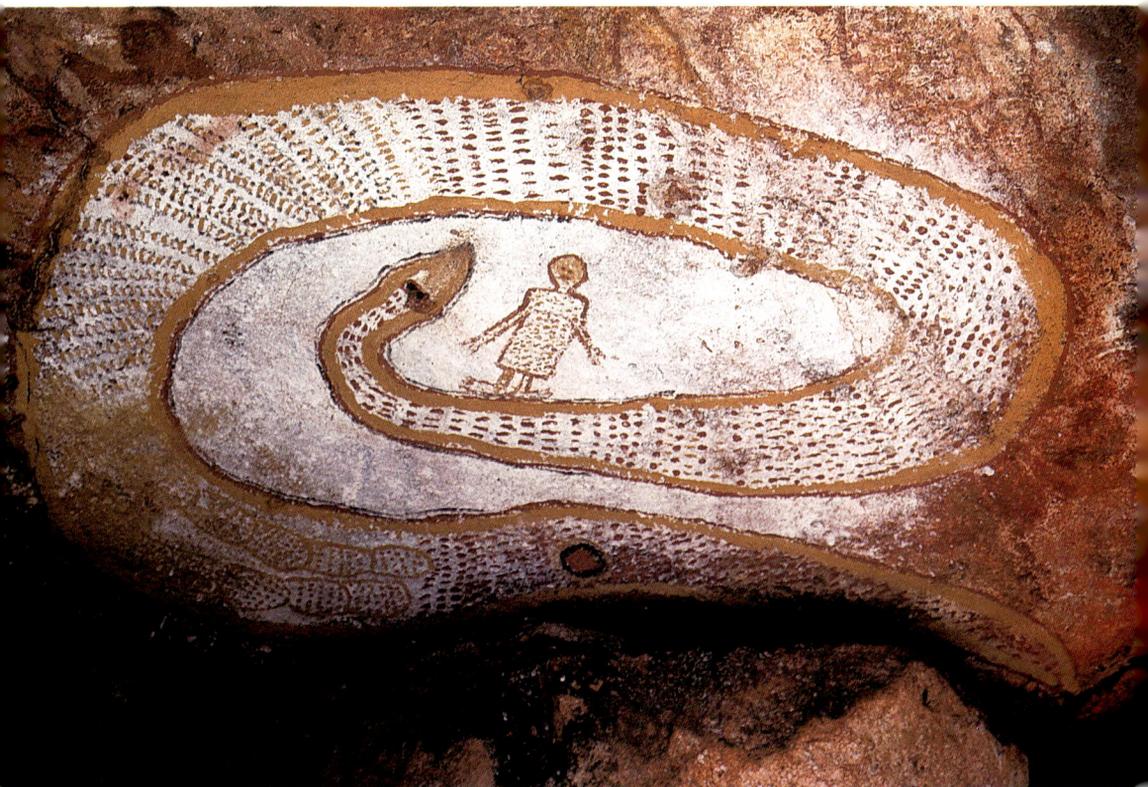

Wunggadinda with spirit child, cameo from Njallagunda Snake Dreaming

"Mowal, are you saying that the Earth energies come up and balance the energies in the sick person's body – that Nature is capable of healing itself, and it's own?"

It's that mulla, lick, you know what it means now. We have no Dreamings for healing, only plenty of Sickness Dreamings. When we are the owner of such a place and we go there, we don't get sick, because we *are* that sickness, that painting, and immune to our-selves. We just represent that sickness.

Later in the day we sit at the edge of the lively waters by a lively campfire. Turkey and wallaby are cooking, the blackbream are ready to eat. We have johnny-cakes, jam, nallija, a damper in the charcoal, two long-necked turtles, big as ducks, and three short-necked ones – all this for a midday dinner for five.

At a distance from the group, I have just settled with my notebook in shade and comfort when Mowaljarlai strolls up, with a strange object in each hand. He brings these things so close that they almost fill the space between our faces.

"Look at these," he chuckles, "that's how Wandjina put his image into his chosen animal – long-necked turtle."

Am I dreaming? I am looking at two miniature skeletons of human form, no more than twelve centimetres high. The heads have an empty space in the middle, appendages dangle from hands and feet.

"You'll never see these again, Jutta. Better have a good look."

"What are they?"

"Wandjina. Violet took them from the turtles."

Violet had freed these figures from the gullet and neck bones of the turtles she caught.

"We will give you one. You can always remember the Wandjina then, and Lalai." Then he tells how every sweetwater turtle holds the image of man.

> That's why the turtle's name is *wullumarra* – "see the *wullu*". Wullu is any wunggud place in nature where a spirit child enters either one of the parents, before or during pregnancy.

To those who still hold the knowledge, this little Wandjina figure in every wullumarra is a reminder of the creation of mankind in this country.

> These stories are not written down, but they are written on the land, into nature; otherwise we wouldn't take you or anybody and show them. They are there for everyone to see – not just to read about.

Early in our association I had thought that Mowaljarlai's references to the Bible were out of context with Aboriginal culture. No longer. Now they were highlighting the historic and geographic differences between two kinds of fundamental edict to me – one a divine imprint in nature, the other written creeds of sacred teaching.

We showed you that sharp hill over there, that Malara. It's a kangaroo stomach. It fell out of the kangaroo and now it's a mountain. People say it's a joke, how can it come into a big mountain? People laugh, how can it be a kangaroo stomach, eh?

I told one missionary, "Do you believe that God made those Ten Commandments? You take it seriously?"

"Yes."

"What is the mountain called where God gave those Ten Commandments to Moses?" He said the name of it.

"And is it important?"

"No, it is not important."

"How come it is not important, wherever it was in Christian land?" And then he tells me, "God gave the *Law Tablets* to Moses, that is important. The mountain is not important."

How come? He has never been there, but he read about it in the Bible and he takes that more seriously. I don't think that Christian missionaries take the Old Testament very seriously. "Too much Law, and too little salvation," I told him.

Once we were arguing about a sacred site where mining people were working in a big cave. I said to those mining people, "In England, Saint Paul's or any of those big cathedrals in Europe, now those places are important for white people, they are the top, supreme, high. Same with the place of a Wandjina painting. If it is blown away, I am useless. No good asking me for story – who is going to listen to me then?"

Our story is painted in the shelters, it's on the rock, on the mountain and in the earth. Miners know, I know, all Aborigines know that we would become nobodies and powerless. Millions of stories we have recorded, white people have been recording – still they don't want to believe! Maybe some believe, I don't know, but money is more important than sacred testimony.

The afternoon at Alwayu is spent in logical sequence to a hunting rampage – feasting, resting and with a quiet stroll to the sunbaking ledges of the waterfall. At sundown, conversation livens up again.

As I gaze over the tranquil waters, my mind fills with a host of joyous spirit children waiting there to be born.

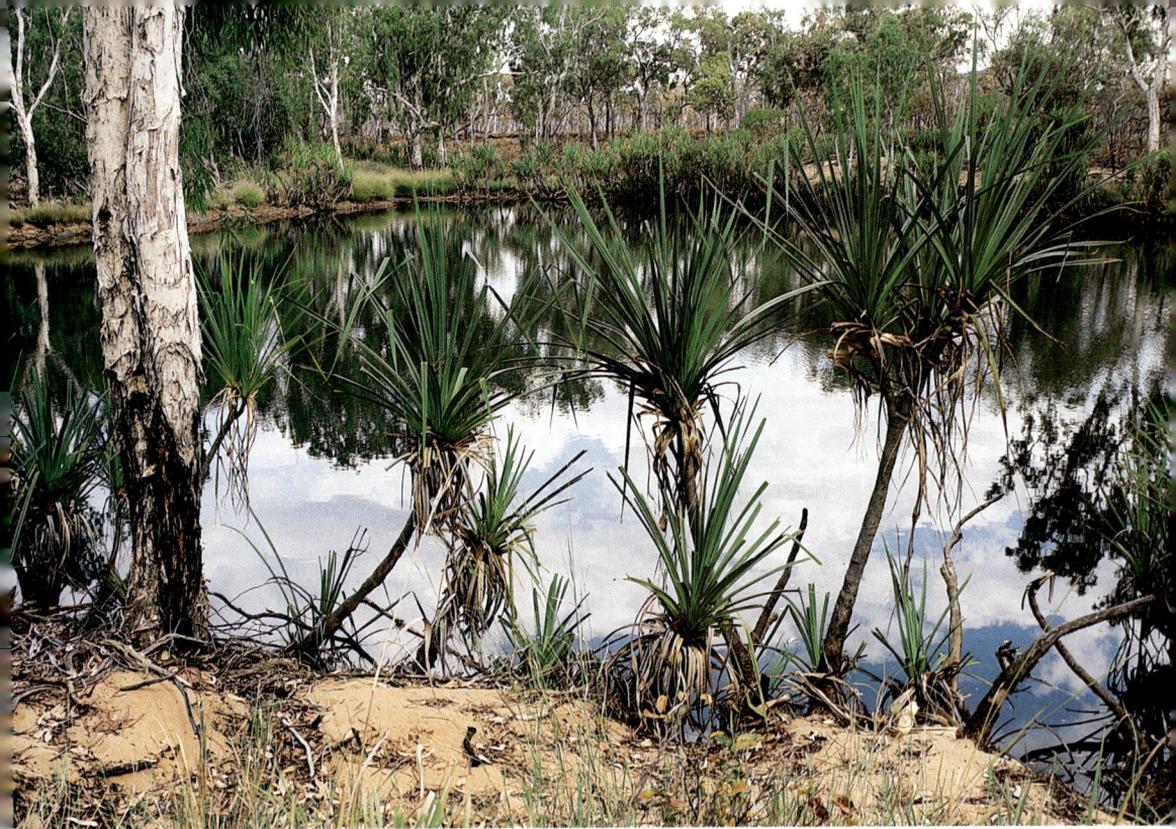

Alwayu, living water

"Talk about those water babies," I urge, "I'm still a bit vague about them."

He meditatively arranges his legs to cross and looks up. "Well, it's like this."

Wonditj, when we talk about Creation Time, means "to build". He built animals, he built rocks, that's all wonditj: when he builds. We also say *annu menggna:* he built us like himself.

The thing is, once he put his own reflection there into the water, that means that he had made human beings. He painted himself, he put a blueprint-picture there, the pattern, right? So that rests in the wunggud water – in all the wunggud waters.

Then he went back to the Milky Way. He did not stop here, he only left his reflection. Now those spirit children are coming out of that wunggud place exactly like his body.

After that, individual *rai* come there to the wunggud place, from *Dulugun,* the spirit region where people go when they die. The rai are the spirit children, the individuals.

84

"The rai and the blueprint image together make a full personality, then?"

Yo. The rai are the little spirits that enter the womb, and they must have wunggud names. The names come from nature, from the wullu. As long as it is wunggud, it is part of Creation.

I'll give you an illustration. I don't say that this is the way my Aborigines taught me – I'm trying to keep that separate from the Bible – but as an illustration I can give you this one:

You look at Joseph and Mary. Joseph was promised to that girl Mary, but in white-man law they don't have sex before they get married. God is talking through a cloud. That power from God is saying to Mary that he, God, is giving her a special Son who will never touch grog. It's there in the Bible.

On the Aboriginal side it's different. The man is married already. He goes directly to the wunggud waters where he gets children that are already there, from the Creator's reflection – two different things, you see what I mean?

"Not quite, Mowal."

Galaru snakes from gallery at Wanalirri. Galaru do not locate together with Wandjina

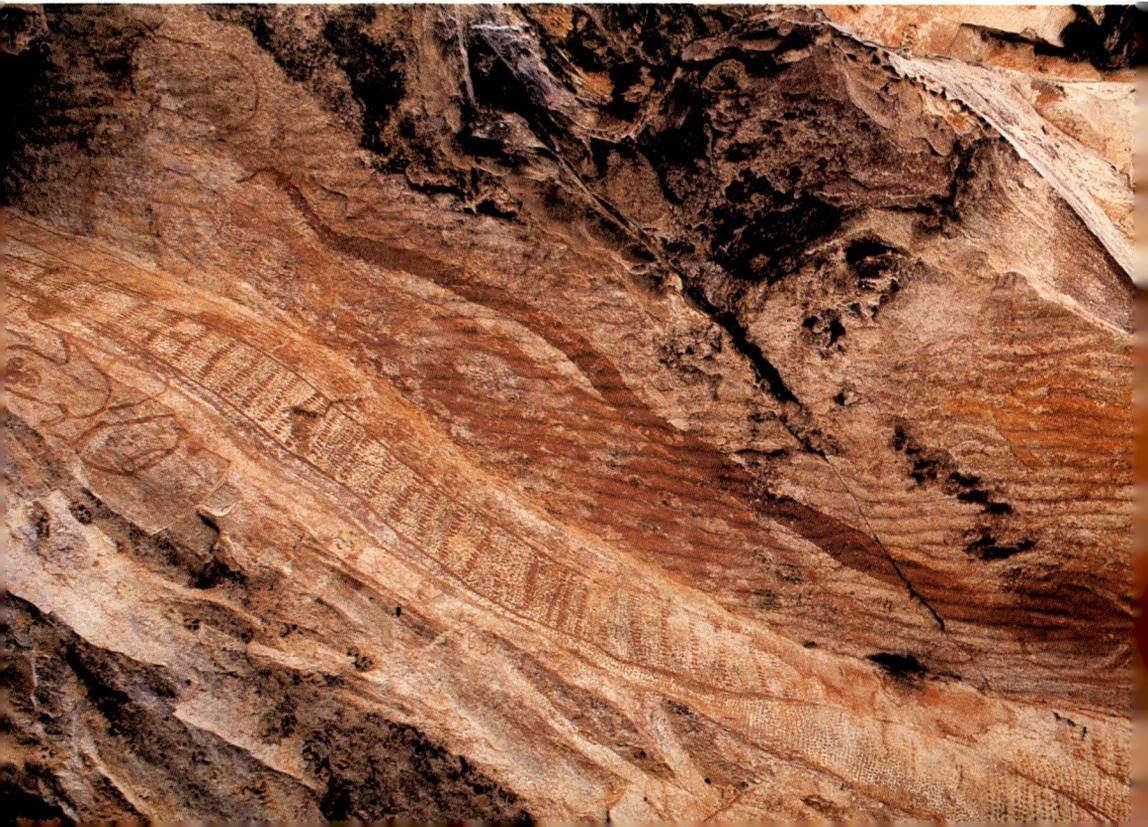

White men think they only have to have sex with women, that's all they have to do to have a baby. For Aboriginal people, God puts the baby into the womb, like he did for Mary.

An Aboriginal man, who has had sex with his wife, goes along to the place where he himself was created, where the reflection and image of God is. The Aboriginal man gets his children from the spiritside, not just from himself.

"Are you saying then that a baby, conceived with love and acknowledgement of the Creation *pattern,* is an immaculate conception every time? Is that why you don't make a special issue of sexual intercourse in respect of procreation?"

Yo. Testament says, "He shall be born. He will not touch any strong drinks" and all that. That's John the Baptist. He was the one who baptised Jesus in the River Jordan. He was an older relation of Jesus, his mother and Jesus' mother were cousins. But John the Baptist said, "I'm not worthy to stoop down and untie his bootlaces. He is more greater than me." He says in the Bible, "He is the Mighty One who is coming after me."

There was no stopping this rapidfire sermon, and I didn't want to either.

After Jesus got baptised, he went into the desert for forty days and forty nights to be tempted by the Devil; to make the Devil tell him, "If you the Son of God, you turn these stones into bread because I see you are hungry." And Jesus said, "Every man doesn't live by bread alone but by the word of God."

And then he takes him on the highest pinnacle of the temple and says, "Now, if you are the Son of God, and you say so, cast yourself from the pinnacle of this temple. You jump down! Lest you dash your feet against the rocks, you won't do that, because the angels will land you nicely, without hitting your foot on the rocks."

And the third and last one: he takes him to the highest mountain. And he looks at all the kingdom, it's so beautiful. He says, "Look at all this panorama, this kingdom. If you bow down and worship me, I will give all this kingdom to you," he says to Jesus.

"Get thee behind me, Satan," Jesus said. "You shall worship the Lord, the Almighty alone." So the Devil left him for a season, he gone for good.

"Thank you, Mowal. It's years since I last heard of the Three Temptations."

Night clouds spread the light of a rounding moon. I am utterly comfortable. Then I drift into a lovely dream, feel warm eyelashes brushing against my cheek. Thoughts alight and dim away, a notion of lighthearted laughter passes by – and I follow, wander lightly with unseen presences. Then I hear a deep, soothing voice say, "The earth is sleeping – touch her, make a wish."

And gently into my hand muzzles a dog, my childhood dog. I feel his head, his body lies close. Oh Ali Baba-dog, everything is good and simple again. I sigh – the dog is gone.

In darkness I scrawl some words into my notebook. In the morning they hang there like a magician's rope, coming from nowhere, not touching ground, a reminder that I had understood *something* during the night – but what? The words read: "You can only see with your eyes closed. Be patient."

At breakfast we once again eat like camels drink, storing the last of the hunting feast inside. Where else to keep food in this thirty-eight and rising temperature? Then the swags are rolled, bags and boxes stowed. I am sad to leave you, beautiful Alwayu.

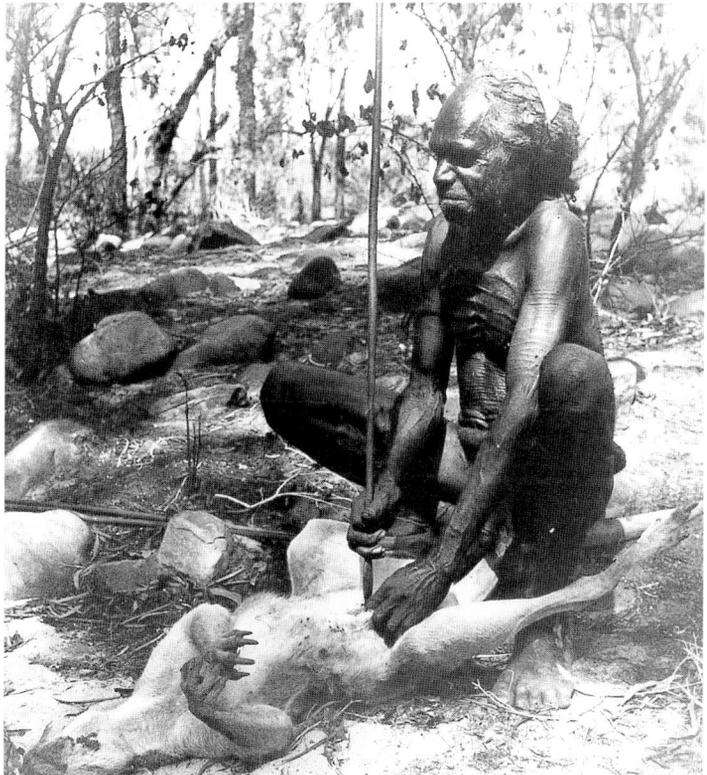

Lawandi, Mowaljarlai's early teacher, opens a kangaroo with double-edged shovel-spear. "It had an iron blade made from a mission horse shoe." 1938. Lommel

Mowal, Dargnall and Jormary at Donkey Creek

16 The Old Pelican

After two more tyre-changes, Mowaljarlai's singlet lies flat to the skin
with sweat. At Drysdale all station-hands are busy. Sorry, but they can't
help till afternoon, the vet's plane has just landed. They are going to test
for TB and still have several holding pens full of cattle to tag. "See what
you can find in the shed," they recommend.

Nicole, a radiant young lady at the station, helps to search the cavernous
toolshed for patches and glue, while keeping a vigilant eye on the where-
abouts of two blond, lively youngsters. Her smile is infectious.

When a man leaves a nearby coolroom with a carton of beer, he elbows
the heavy door so slowly that I catch sight of beef carcasses hanging inside.

"Nicole, would you sell me some beef?"

"I'm sorry, but I can't. We are not allowed to sell meat."

"It's just that I don't like kangaroo."

"You don't?" That impish smile again.

Climbing back into the truck, I find a big parcel sitting on the
driver's seat. "Don't tell anyone, it's a gift," she calls out as I am
starting the motor.

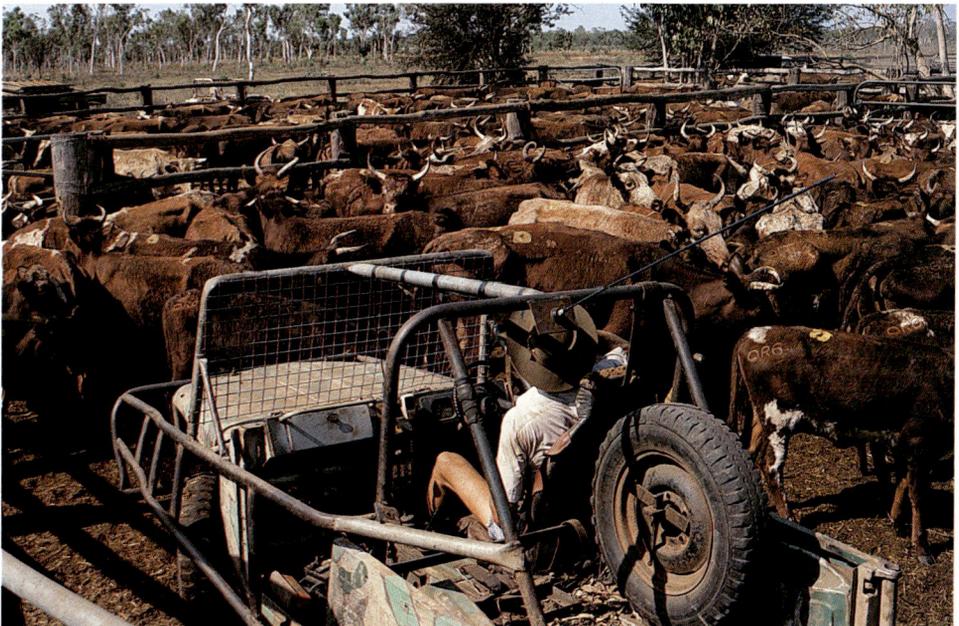

We cross back over Woodhouse Creek. A single old pelican flaps and flops on the water, where the creek narrows and drops over pebbles. He can scarcely lift his weight.

"Old-man pelican. Him die soon," observes Jormary as another tyre goes flat.

The men go off hunting. I fall deeply asleep and wake abruptly to gunshots. What's on? Where's Violet? I have come to love that woman. She is nearby, crawling around on her knees pulling out grass. It could catch fire. She is covered with dust. We go down to the creek, plough through a cloud of insects, then push the scum from a puddle before we can have a wash. Back by the fire, the daily crocodile steams and blisters with a sharp smell.

"Please don't try to tempt me. I am definitely having rump steak tonight."

He laughs: "You don't know what you're missing – that's what white men say when they take our boys to the pub. 'Go on, try this beer, then you'll know what you've been missing'."

So we celebrate this night of a full moon. Full moon brings cool air, good hunting and being merry together. Jormary and Violet, even old Hector, have not camped out for many years.

We are talking about Papua New Guinea, how some snakes there seem to understand the human language; and talk about the Men of the Sea who are said to communicate with fish and to receive valuable services from them. I ask Mowal, had they ever experienced this in their part of the Kimberley?

Yo, in the sundown area. The tribes that live with fish, they totemise fish. Those sea people talk to these fish and they know their names, dolphin or shark, they all have individual names. When they fish, they call them like calling a dog that has a name. And the fish listen to them, they can hear through the water. These sea people used to have help from those fish.

At one time they were fishing from a little island. There was no water on that island, so they could not camp there. When they swam back to the main shore, they called out for help, 'This is me, I am swimming!'

And they called a name, *Kanamudj!* That's a name for a shark. The sharks came and gave them a backride to the shore because they were

their relations. One was a black tiger-shark. Just before he died, the old man Wooloogoodiya showed me that place. They didn't have totemised whales, only those smaller fish and sea animals that live close to shoreside.

My cousin Mick Bungguni showed me a place in Prince Frederick Harbour where he and my mother's father Toby swam across this *wunggud* place, real Snake Country. It's a wide river going up into the mainland, saltwater. Mick said, "We swam from there." I said, "Goodness, it's wide as an ocean!"

These two men had decided to swim across without as much as a branch or log to hold them up. They swam, firestick tucked in the hair-wallet [net] on the head. It sticks out like a horn. It was getting a bit late, then these dolphins came. They were singing out, "This is me! We are swimming! Listen to us!" They were talking to these animals called *alowanawa*, dolphins.

The dolphins came "Ch-chooo-o ... ch-chooo-o...." My grandfather caught hold of one fin, this cousin got hold of another dolphin's fin. They went for a ride on those fish. "Goock-oo-o ... goock-oo-o ... goock-oo-o...." All those fish were talking and laughing. They put them on the shore on the other side. Those dolphins are helpful animals. Today, they don't know us any more.

While we were telling fish stories, the other three had curled up in their blankets. Every night we consume oceanic volumes of black tea, yet sleep comes quickly to all.

We wake to blood-curdling yelps and howls.

"You hear that? Dingoes, big mob coming!" Violet beckons me to move closer. "Bring your swag. We stay close tonight."

"What will they do?"

"They just come for meat. All dingoes here very nice."

"Well, if they come for you and me, Violet, tracking will be easy – plenty of bent grass."

I drag my swag across, cuddle close to her back and feel the resonance of a mute giggle. The dingo growls drift into the distance.

In the middle of night I wake to write down a weird dream. A lady is taking me to her apartment. In the lift she asks for an exorbitant rent. "Dohn't vory, dahling," she says. "Have eet for now. Vee veel argain advertice emeediatly, yes?"

Then I am bending over a chequered table, a chess board. The squares are amber and white glass, dimly illuminated from underneath. I am not playing chess but a solitaire light game.

Each square has a socket, like a press-stud. I can choose from a line-up of glass objects, fragile and exquisitely coloured with undulations and swirls. There are miniature tulip lightshades, mushrooms, complicated orchids – rows of each kind. I am worried about breaking them. In the correct socket, a little bulb lights up. Finally, the squares on the board are all illuminated to the pattern of a night-lit city.

Then I am on a vertiginous balcony. Far below, traffic pulses on a quayside boulevard. Pearl-string lights run across distant bridges. There has been a disaster and I must stay up here, alone and afraid.

Strange, I am fully awake as I am writing yet remember every detail of the dream. I also know, somehow, that our search for the Milky Way is coming to an end.

Typically, the first task at daylight is the mending of tyres. We have no more spares. The inevitable happens, another tyre goes flat. We limp the van on the metal rim back to Woodhouse Creek.

It is still early but the air temperature already high. Hector and Mowaljarlai will walk to the cattle yard for help, about thirty kilometres.

Being marooned, I am curious how we will occupy ourselves during the day. Jormary intends to go fishing. He shoots a sulphur-crested cockatoo for bait. The bird plummets and lies croaking in pain. Its mate wails from a branch directly above. It takes such a long time to finally kill the bird.

Violet and I walk down to the creek. I wash my hair, her back, her dress, my T-shirts and underwear, towels – anything, just to stay cool. Then we go looking for the single old-man pelican, can't see him anywhere. He may have died. It is getting dark.

"Motorcar coming!" Headlights across the creek. A brand-new Landcruiser with three Drysdale men and a woman, Martha. They are bringing Hector, Mowaljarlai and a tyre. How refreshing to have an easy, rapid conversation, hear about day-to-day trivia, outback chit-chat and gossip. Martha is really reluctant but must leave, she is the station cook. Departing, the men caution, "Don't come before ten in the morning, we've got two road trains of bullock to load."

A little later, motor noise, more headlights? An old jalopy rattles up from the crossing.

"It's Jim! Jim Kelly!" The station people had spoken of him. A tall, blond man in clean white singlet and shorts alights.

"They told me at Drysdale to come and say hello to you."

"Well, hello Jim Kelly."

We sit and talk by the fire, the other four have gone back to sleep.

A few seasons ago Jim came to the bush. Why?

"I had made a promise to myself that I had to keep."

He brought a dog with him, a German Shepherd-Blue Heeler mix, and two horses; settled on an abandoned lease way out in Drysdale country. Martha had said, "Every time he comes through the station he brings fresh lettuces, beans, capsicums, cucumbers, watermelons, all kinds of greens. He's an amazing young man."

I can't work him out. He is so reserved and well mannered; it's the *way* he breaks the damper and dunks each piece in his coffee that puzzles me. And why is he so provokingly clean? Oh yes, he would have washed and changed his clothes at the station. The dog darts off to the slightest noise, then returns to crouch by Jim's side for acknowledgement, a firm run of fingers through his thick, shiny coat.

"What's the name of your dog, Jim?"

"Snap."

"He's in fabulous condition. Will he have some damper?"

"No. He's had plenty to eat. He catches his own food."

"Catches what?"

"Yeah. Bullock, grabs them by the fetlocks, that brings them down. Then I come in." He smiles sheepishly: "I hate that bushcattle. They don't belong here to this country. I'm getting rid of as many as I can. That's one of the reasons why I'm up here."

"Jim, what kind of roof do you have over your head?"

"I've repaired the shed of the old people who used to live there, but I want to build a house. Saving up for some metal."

"Why *metal?*"

"Yes, corrugated sheets. Want to cut as little timber as possible. Don't like cutting trees, they are natural, same as grass. Don't like them burning grass all over the place. I'm just burning a very small paddock for the old horse to feed on. What about you? You had a lot of trouble with your radial tyres they said at the station."

"Yes, eight flats so far. We can't go back to the bush. How are you getting on with your car?"

"The old Landy? Bought her cheaply, so she's slow but we get there. I'm used to patching tyres. Always keep a big box of patches."

"How do you get the money for the things you need, Jim, for tea, diesel or the patches – do you collect Social Security?"

He hesitates for a moment, then faces me straight on: "That's why I go to Derby from time to time, also to get some provisions. Used to be in the Regular Army, for six years, but got out of it. Not a bad way to see all over Australia, with the Army – New South Wales, up'n'down Queensland, the Territory – and to get fit.

Then I worked in the West laying sleepers on pipelines. After that I went overseas with the oil company – Arabia, the Middle East." His voice trails off.

"And then?"

"Then I lived in Adelaide and came up here."

For a while we brood companionably. He sits there like a young magi, hands levitating over the flames, the body half withdrawn into darkness. Why does he live here alone in this wilderness? He is such an attractive young man.

Caroline Ranges, road to Munja

Barker River, cyclone and willy willy rock

Blackheaded Rockpython, Dreaming of Daylight and Darkness

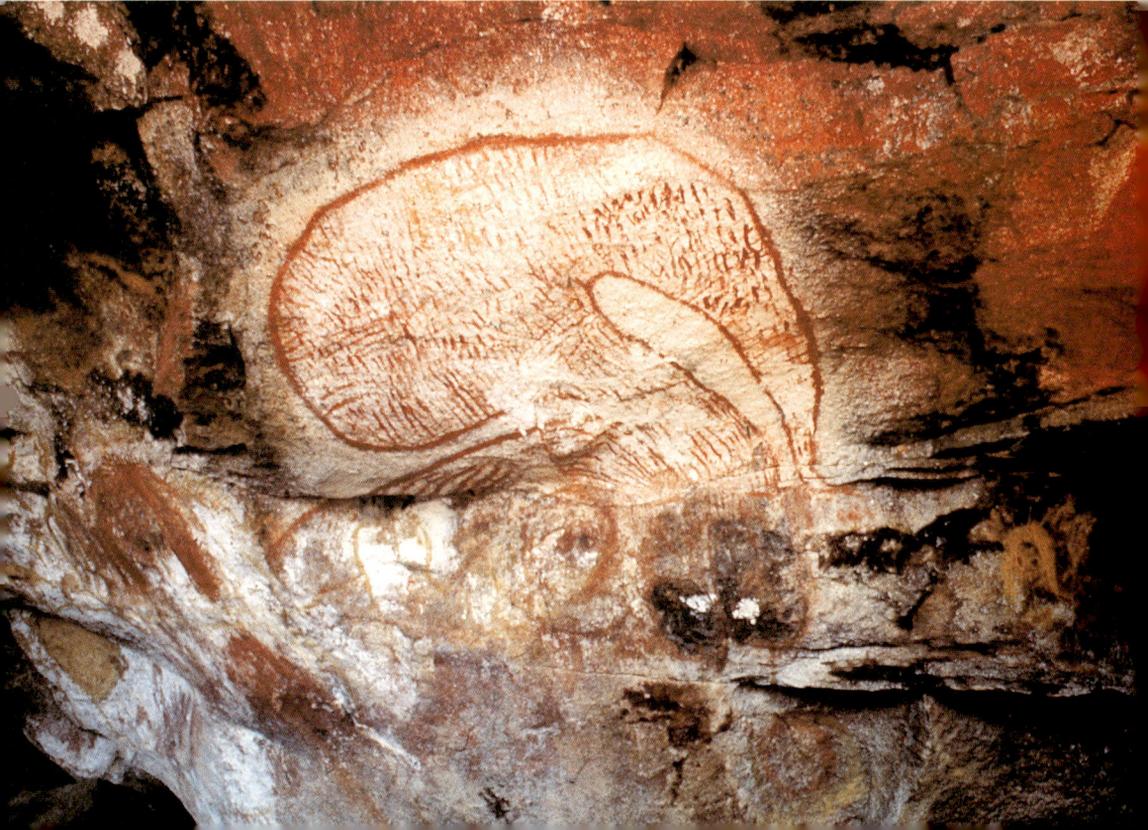

"Jim, do you stay out here during the Wet?"

"I used to come in, leave the horses at one of the stations, do a bit of labouring around Derby. Then I lost my mare. I don't know what they did to her, but when I came back she just wasn't there any more. That hurt – I loved that mare! I found the other one, the horse. He was in a terrible state. The coat was nearly worn off the back and he looked like a skeleton. I just sat down and cried.

"So last year I decided to stay during the Wet. It was lovely. We swam in the flooded river, the old horse and I. Everything is lovely and green with the rain. The trees all have a perfume of their own – like a woman's perfumes. Made me fit, swimming in that river, couldn't be more fit, but got a bit wary of crocs. If you get an infection, you can't get through to the stations for help. That's why I started growing all those herbs – thyme, mint, marjoram, comfrey, sage, parsley and garlic, for cures."

"Jim, you are a young man – how long are you going to live out here, alone?"

Jim squirms. "I know that I'm going to die out there."

"What?! Who told you that, a fortune-teller?"

"Nnnn-o, that Windjana Man. The old horse brings me there. He's sixteen now and still the best rider in the Kimberley. We go riding, chasing bullocks. I'm riding him well past that painting, and when I'm giving him the lead, he turns around and takes me straight back to that Windjana, stands still in front of him and doesn't want to move. He's done that about twenty times."

Jim calls the Wandjina "Windjana", as the sign reads on the Gibb River road – "To Windjana [Storm] Gorge". He pokes a twig through the ashes, flattens some embers, then continues wistfully, "I know it's a very special place, that painting, that Windjana. He means to tell me something. Funny thing the old horse taking me there, every time. That Windjana Man told me all that's going to happen to me."

Then he is quickly on his feet: "I'd better be going now. Always worried about that horse when I'm not there. Next week, he and I are going up to the Glenelg River. If you can get back into the bush, I'd be glad to give you a cuppa tea." Half-way to the car he turns and calls back, "Oh yes – thanks for the damper."

The headlights of the Landy disappear into the night.

In the morning I say to Mowaljarlai what a pity he missed our visitor last night. I should have known better – while he seemed to be sound asleep he had taken in every word.

> Yeah, he knows what is mahmah. All of nature, deep into the earth and all that grows on top – the whole of Creation is mahmah, it's taboo and untouchable. People don't know any more what mahmah is. We have to start thinking about that again if we want to live.

Then he loads up the truck. We're heading back to Derby. Along the way we clear up some matters: Why is a part of Mount Elizabeth called Waa?

> The Scorpion was walking and rattling around going "Wa-a-a-a-a-a-a-", a water sound, because the Scorpion is a wunggud. Animals that were put into the water are wunggud. The Scorpion dug the pocket for the water and is totemised there.

> Where Peter Lacey's father is buried, that's Waa. The old homestead is called Njanggudunda.

Njanggudunda means "Kidney Place". It seems such a long time ago since Mowaljarlai first mentioned that place. I am now anxious to know the full story.

> When the Blackheaded Rock Python, a woman, was widowed, she was speared in kidney section. We say "Love comes from the kidneys." White man says, "Love comes from the heart." With us it's towards that kidney area – Njanggudunda. That was the name of the old station. They renamed it Mount Elizabeth.

Can't help thinking how this country has opened out in my mind, how much understanding I have gained since we started this perambulation through the bush.

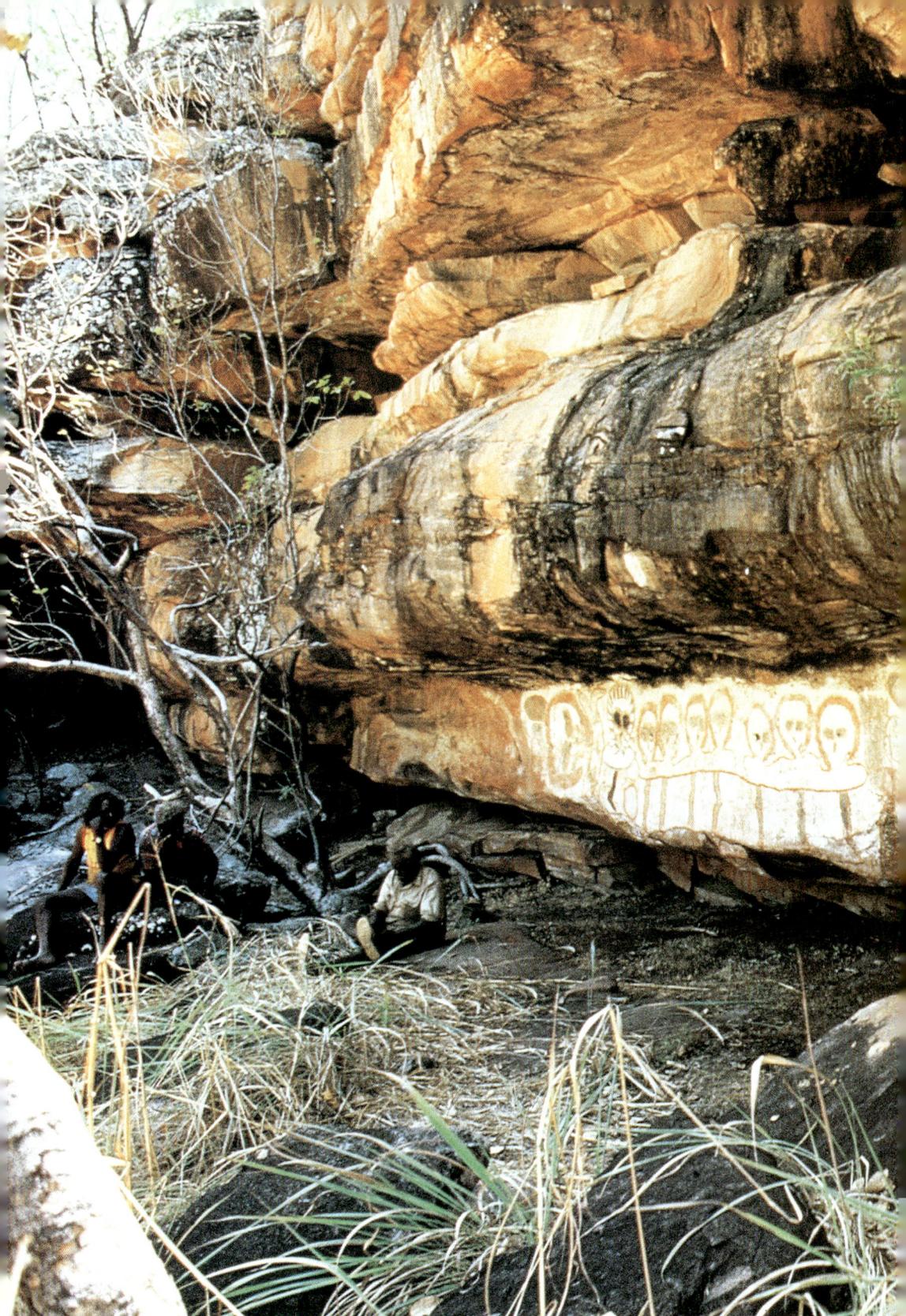

The Cuckoo people, *Marnyangarri*, Track Wandjinas, Donkey Creek

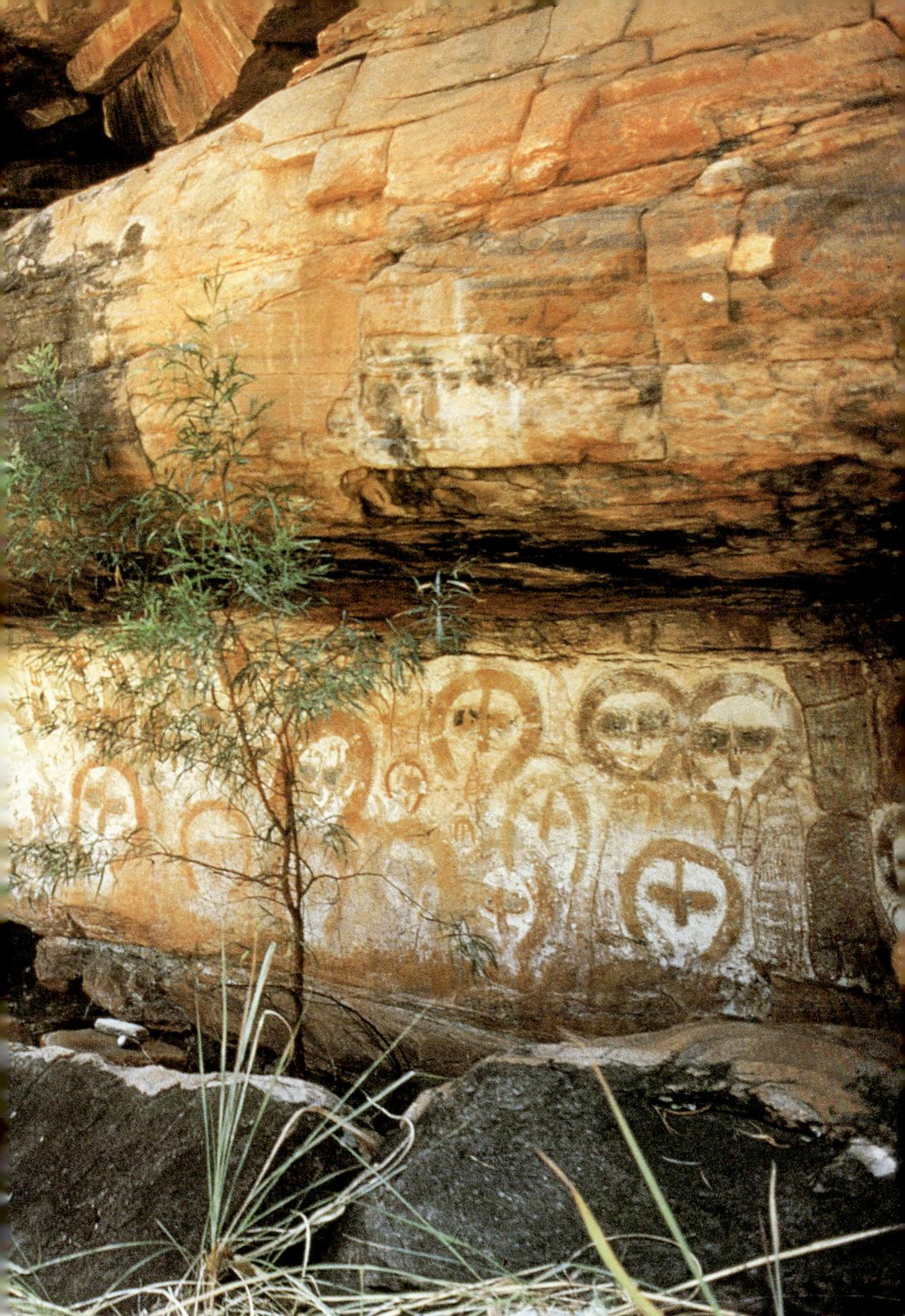

Mowal, Jormary and Dargnall on left

17 The Track Wandjinas

In the vicinity of Donkey Creek, Jormary leads us on a last foray into the bush. Suddenly there is a presence.

"Look at that! Look at them all!" A long row of white faces peer with black eyes through a curtain of grass and foliage. This is no sleepy hollow, but a gallery spiked with lively Wandjinas, rows of glowing new, older and ancient paintings of the Cuckoo people, Marnyangarri. The whole shelter-length of them stares in concert: "This is us, Casa Nostra."

There's an eerie and powerful message coming from the wall.

Mowaljarlai captures that message with a sweeping gesture: "Yeah, they all talk history, genealogy." He remembers speaking of the Track Wandjinas when we were at Wanalirri; how he told us of the Marnyangarri, and the Watjinggnogno of Russ Creek, the eternal Track

Trail of Marnyangarri and Watjinggnognos, Trackites, naming the places of various groups from Wullari to Donkey Creek, forming Law after the Flood

patterns the great Wandjinas left on the country when they came to judge Dumby's tormentors; that the *Aulinggnari,* the Bremmangurrai and the Pandanus people, the *Gundjagnogno,* had laid their tracks to *Wullari* coming from the north, the *Galorugnari* from the northwest.

And he recalls how all those Wandjinas rallied to the summons of the Big *Burrawanda* Wandjina, to whom the tortured Dumby had flown high into the heavens to complain.

"You growl them," Dumby had told the illustrious gathering.

Then the Wandjinas growled at Wanalirri, and it rained and rained, there was a great flood, and the mindless Wanalirri people tried to escape but they couldn't, and they drowned.

At the shelter we settle on the ground, and Mowaljarlai continues:

When those Wandjinas came, their foot laid a path, they made tracks, watjinggno. At Wullari they gave the title to those tracks to their hosts, the *Munmurra* mob, the people who later came to paint here at Donkey Creek. That title is like a seal, stamped on them forever. They became the Marnyangarri, like the Watjinggnogno, "Trackites", people who totemised the tracks of those Wandjina.

They represent the history, the Beginning, the journey and the reason of the track. We must pick up everything from a track – animal track, history, painting, images. We must follow it back to learn from the track, to know how to live with it, to pass it on. All this was brought together here at Donkey Creek.

The string of old and freshly painted Wandjinas is an ongoing record of the Munmurra Wandjina tribe to the present day, perhaps the most comprehensive genealogical casebook to exist.

It started at Wullari, and had been kept sequentially from generation to generation, until now. It explained why some Aboriginal people, living now, still carried the name of their Raingod ancestor. "True," says Mowaljarlai, "they are the original Munmurra community, like the bee communities you saw at the Sugarbag Place."

When I walk along the gallery, the Wandjina's eyes follow as I pass. They oscillate events and judgement of a time long past, a past that is still present in the people with their name.

Strange the thought that, in our days, the names of these Raingods should have to appear on Social Security forms; and that they belong to families who push trolleys through Woolworth's Supermarket in Derby.

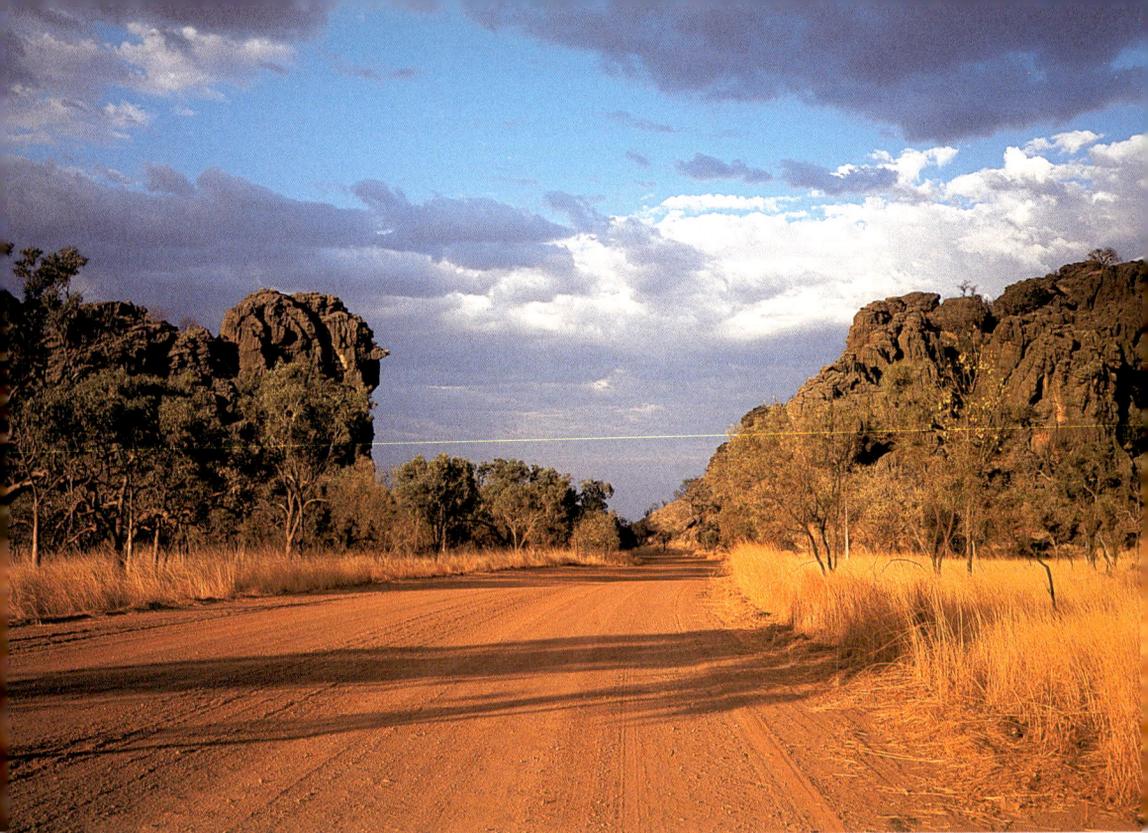

Yamara, Victoria Gap, Napier Range: "Emu dancing, dancing, busted the gap through."
Photo Michael Dillon

Our journey ends without ever finding that Lejmorro, the Dreaming of the Milky Way.

Or had this been a pilgrimage?

There is a saying that in a pilgrimage there is enlightenment in walking around the Innermost. I like that.

I now hand over to the voice of Mowaljarlai for the story of his life.

Part 2
Mowaljarlai

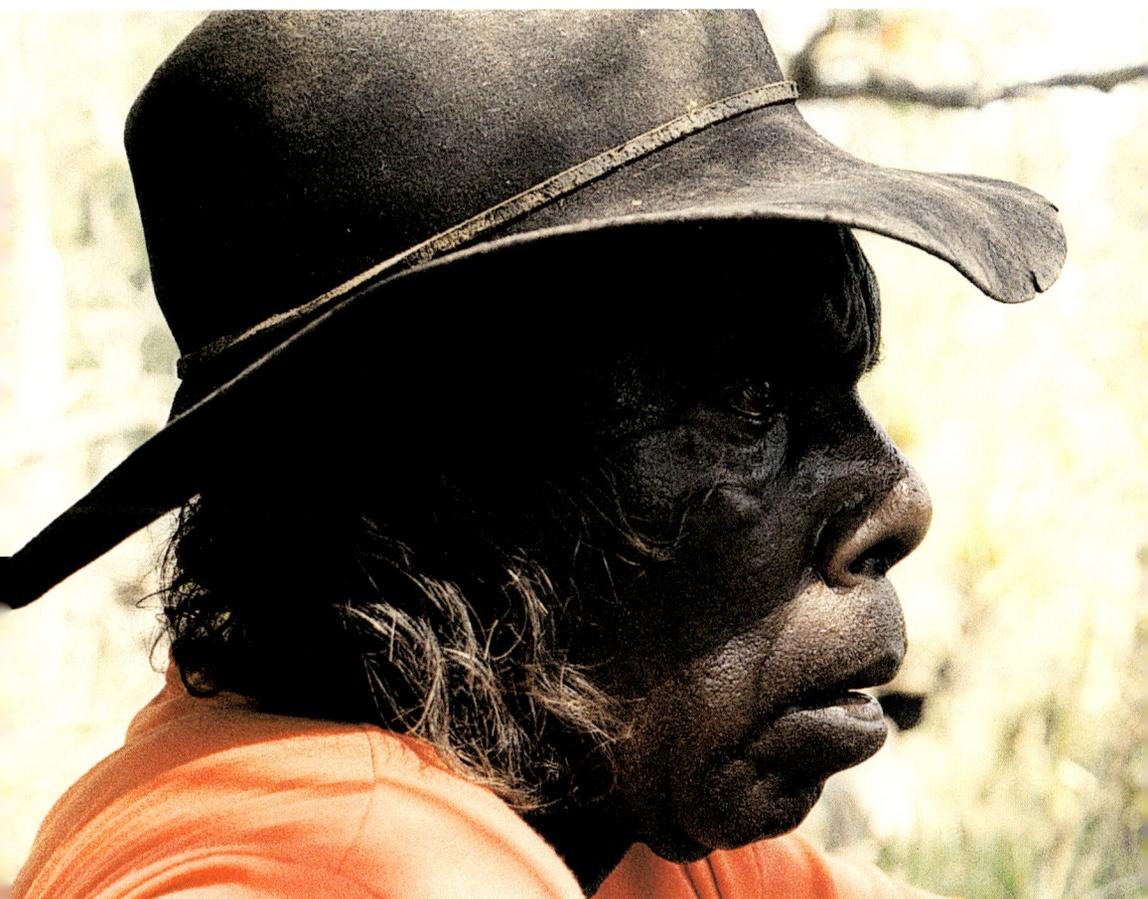

18 Young Days

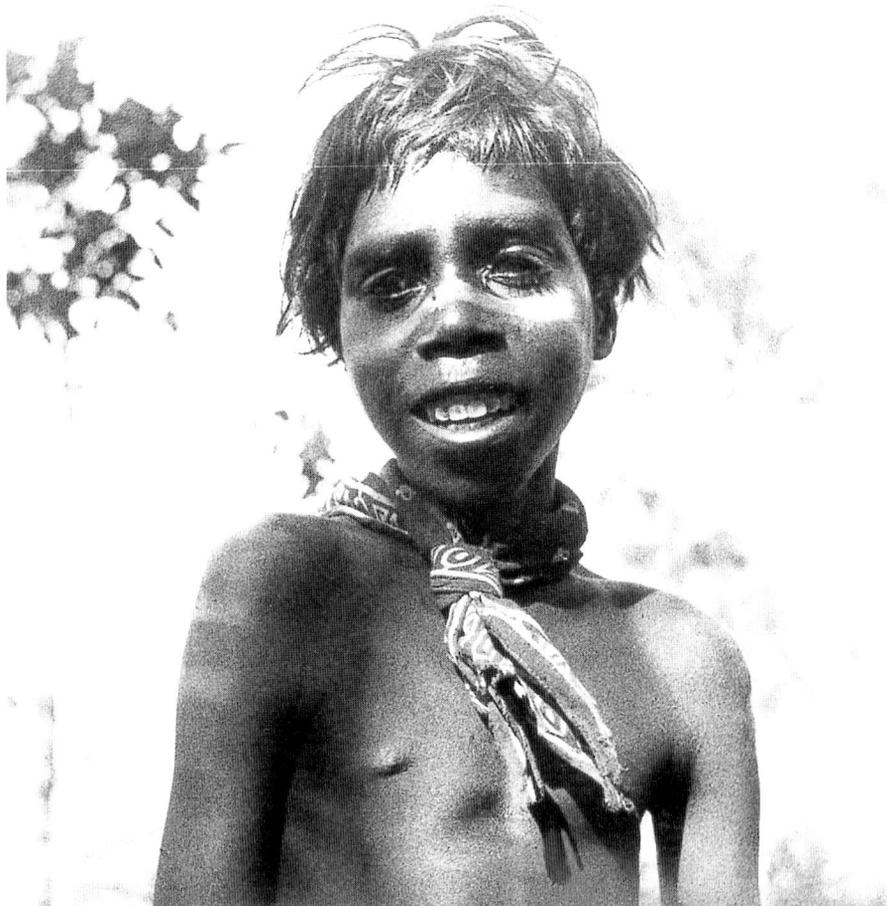

Mowaljarlai, 1938. Lommel

My mother used to tell me stories and made me go to sleep early. All the mothers used to do that. They would go dancing then on corroborree nights and ceremonies like that. While they were dancing, someone would stay back and look after us.

Next day, when the sun came up, the older people had a fire going already. The older men would say, "That's *wudu*," at the fire in the morning. Wudu is the Law saying, "You must not do this: forbidden thing." The older men and women knew what was wudu, the men and women of the Inner Council, and our father and mother.

Then our grandmother, our father's mother, came along. She was responsible for her son's kids. She warmed her hands over the fire and she said, "Wudu-uuu, wudu-uuu," and placed her warm hands on our hands. That means: "Don't rob anybody. Don't steal food or whatever it is that belongs to someone else."

She would hold her hands over the fire again, place them on our eyes – we had shut our eyes – and she'd say, "Don't look at other people's possessions, a thing might look beautiful to you and you might want it."

Then she would hold her hands over the fire again, place them on our nose. And she would say, "Don't smell around. Don't sniff around. Don't smell out things that belong to other people." In other words, "Don't beg. Don't loaf around waiting for other people's things. You train in hunting and catch your own food." That's the story about the nose.

After warming her hands over the fire again, she would place them on our pubic area and she warmed us there. "You must not be sexy, not until you become married and allowed your own wife. Don't be a sexy man go chasing other people's wives. You get killed. It is the Law that you are promised a woman. You must stick to one woman."

In the afternoon, when the sun was setting, our grandfather would be with us again. You know that beautiful colour when the sun is setting? "You look up at that colour," he would say. With a little wooden stick he would go tap-tap-tap on your forehead and he'd say *"Luluai-luluai-luluai-luluai-luluai ..."* tap-tap-tap-tap, "Don't be greedy, don't be selfish, just give the things that you must share with other people. You must be as beautiful as the sunset." Those were the warnings. Every sunrise and sunset they did this, to all the kids, whether girl or boy.

That was the Law that was taught to us every early morning and every sunset, until we grew up. Until we were sixteen, seventeen, eighteen, we were still warned by our grandmothers. We had pubic hair already, we still were warned. They never let go.

Even after we were initiated, my mother's younger sister, our "young mother" as we called her, she would go and get water and put it on our jaw, our face. Only then were we allowed to drink. We could not drink the water that a young woman had caught, because it was *under law,* a taboo-kind-of-thing. It was sacred because she was a young teenager, she went through the same ceremonies as we did with our family. The water given by our young mother gave us protection. When there was a fight, we couldn't get speared in the face or a clubstick pierce our face. It was the protection.

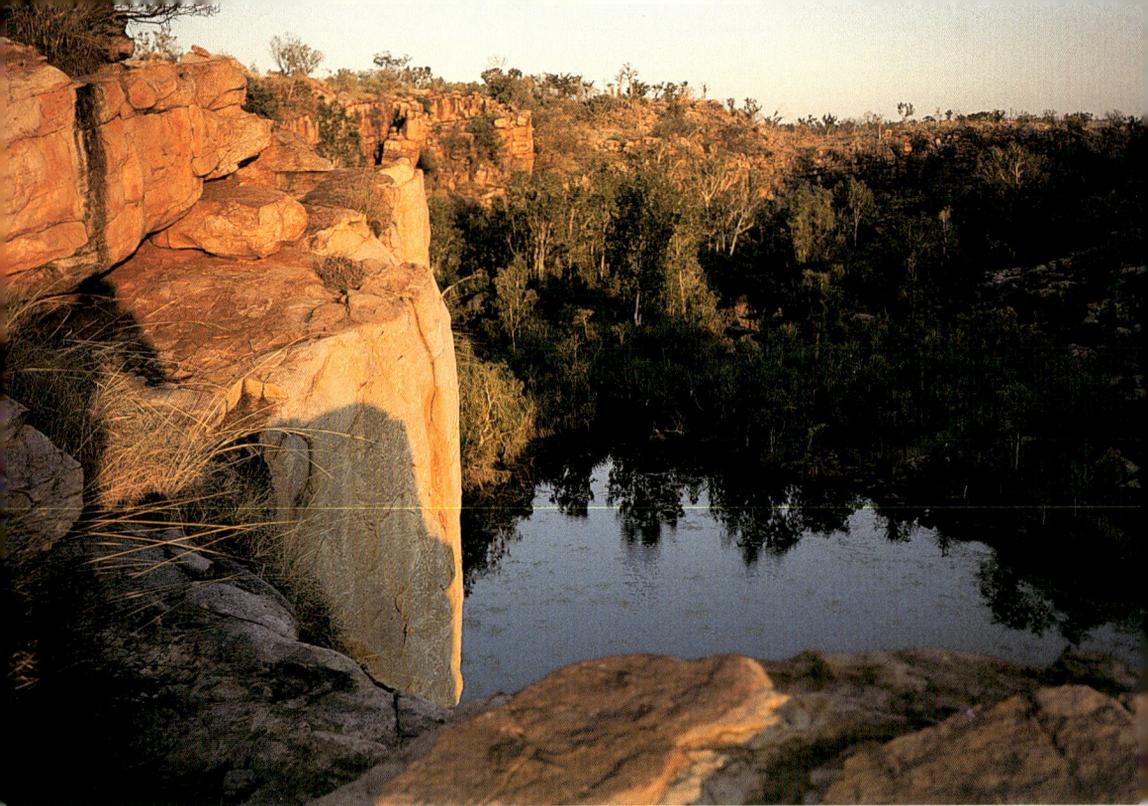

Gumallalla, Prince Regent River. Photo Michael Dillon

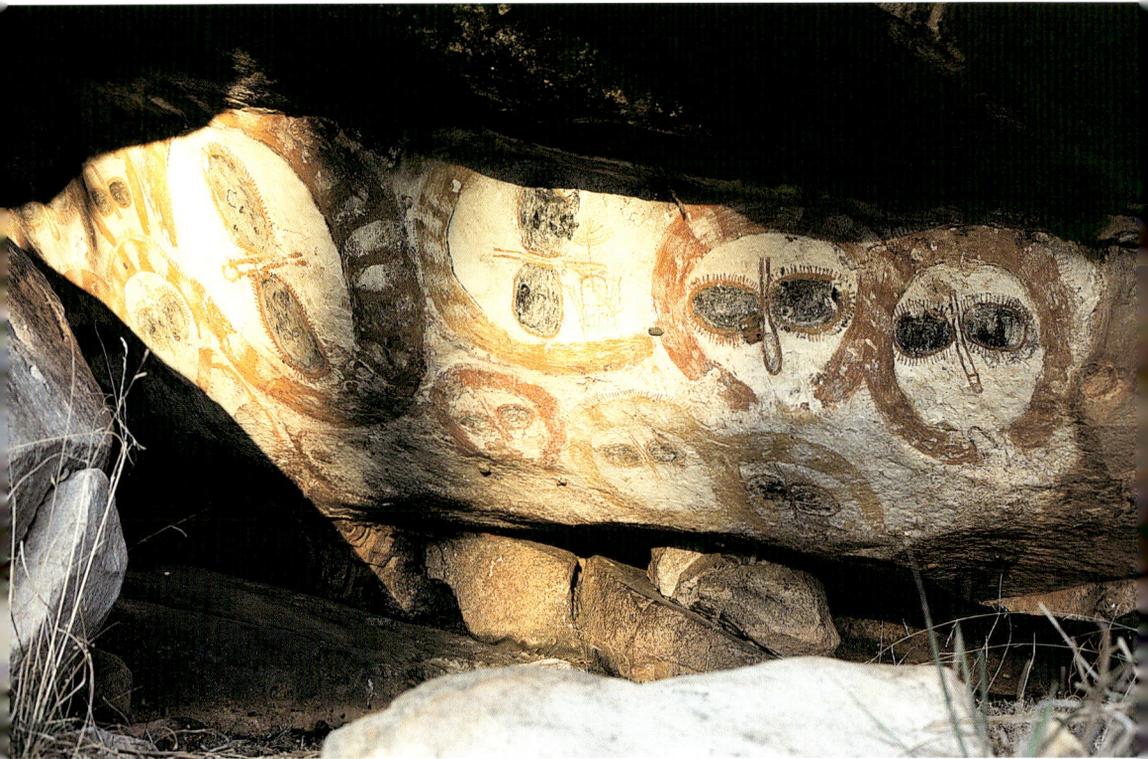

Angubban site. All Wandjinas face east so they can see the light where they were born. An old olumballu shell lay here, a healer's tool

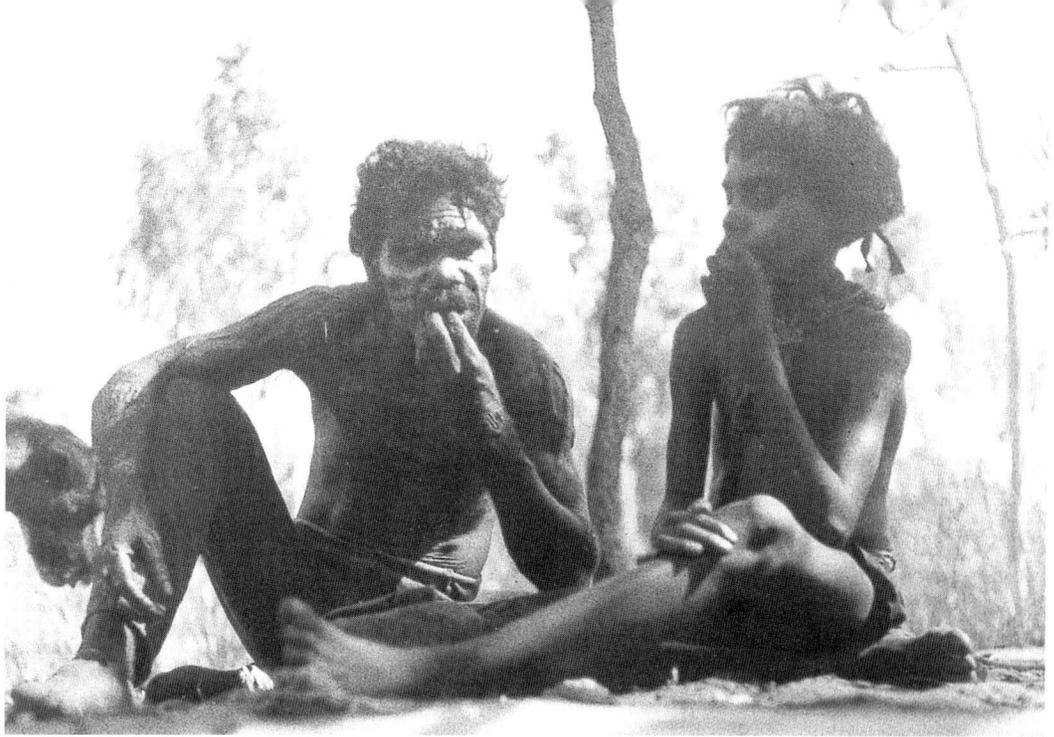

Mowaljarlai with maternal grand-uncle Toby Kingala, 1938. Lommel

I was born at Kunmunya on the coast. It was a Presbyterian mission in the
north of the Kimberley. I don't know the year because the records went
with the mission people, but when Lommel came I was about eight or
ten [1938].

My father and my grandparents were among the early mission converts,
but they also stayed in their old culture. My father, Micky Dirrgal, was a
big boss man, a spokesman at ceremonies and a counsellor at offerings, at
sacrifices and marriage ceremonies.

He was a peacemaker who would talk all night. He counselled reason
with stories and parables. Before a dispute was taken up, they always
danced first, they had a corroborree to remember the stories of the Law –
and to let off steam. After that the old man would challenge good and evil
to bring the parties to reason – and finally be the judge.

He'd talk and preach all night until sunrise. And he walked. Every night
he walked about ten to twenty kilometres and had a good sleep during
the day. He was talking about Life. He told stories and of events in a
parable-kind-of-way. That made people quiet. People listened, and when
they could see the scene, then they grasped the message.

He never told them anything straight, it was always a speech with a
story. Then he'd say: "This is what would happen if ... " or "... this is how
it all came about" and "... better not do this thing yourself, hey?"

He was also a church elder, concerned to bring the tribal and the Christian teachings together, to bring our kids to Christianity, to give them both, our culture and our church. That did not seem impossible to him. "We got to get these two things working side by side," that was his story.

I always went with my father. In the bush he taught me about the old culture. He also taught me a lot of other things. He taught me how to hunt, and he'd take me to the Wandjina sites. The main thing for him was his "lookout position", the position of looking after Wandjinas, checking that everyone looked after their paintings. Before he died in Derby, my father left this message: "You three, Dickie [Woodmorro], Hector [Dargnall] and Mowal – you stick with the old ways."

At Kunmunya, our missionary was Mister Love. He brought me up like a second father. I want to tell you now, and I will tell it again and again – that man and the other old-time missionaries, they were the real pioneers. Mister Love is dead now. He was a long time at Kunmunya. He was Scottish and he was my teacher.

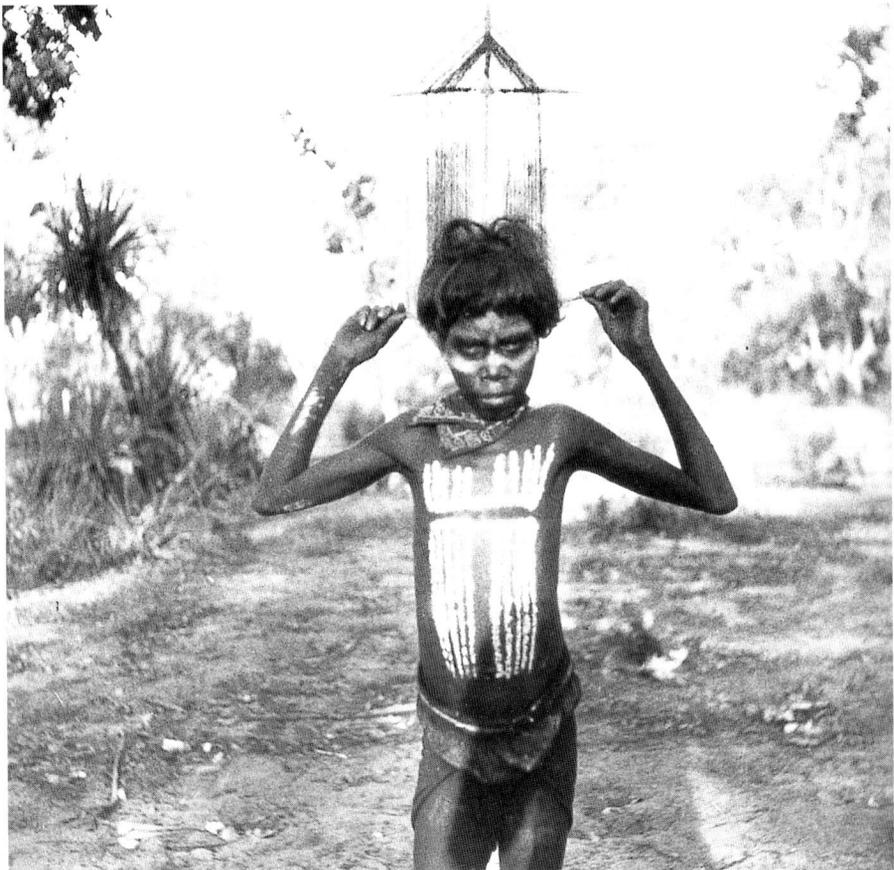

Mowaljarlai with onat, dance totem, representing theme in dance, 1938. Lommel

He would say, "I am not God, I am only a preacher. I can't tell anyone 'You must stop worshipping your Dreamtime places.' That is your Law. All things are sacred. Everything is sacred. These things and your history – the time will come in latter days when they seek their own way out." We were lucky to have such a man at our mission. Also, the other missionaries, they never said, "This is sin! Kneel down at once and promise Jesus that you will never think of your gods again!" or "You finish with your heathenness right now!" No, they never-ever said that at Kunmunya.

My mother's bush name was Algal, a yam from a vine. They called her Lily Dirrgal. She went to the stable where they keep the horses' saddles and that's where I was born. And the young missionary's wife helped her all along. She was pregnant herself. When she had her baby, my mother and the other women helped her with the birth, at Kunmunya.

In my youngfella days, when the tide was low, we used to collect shellfish and mussels. Once the tide started moving back, we went back to the shore very quickly, to the highwater line where the tide stops. We always went with our families, with our grandmothers and our mothers. We could have been swept away.

When a king tide comes in, the sea runs up high between the foreshore islands trying to get through. The water is all over in big strong currents. It builds up high like a tidal wave, but it never reached us at the mission. The mission was five kilometres inland.

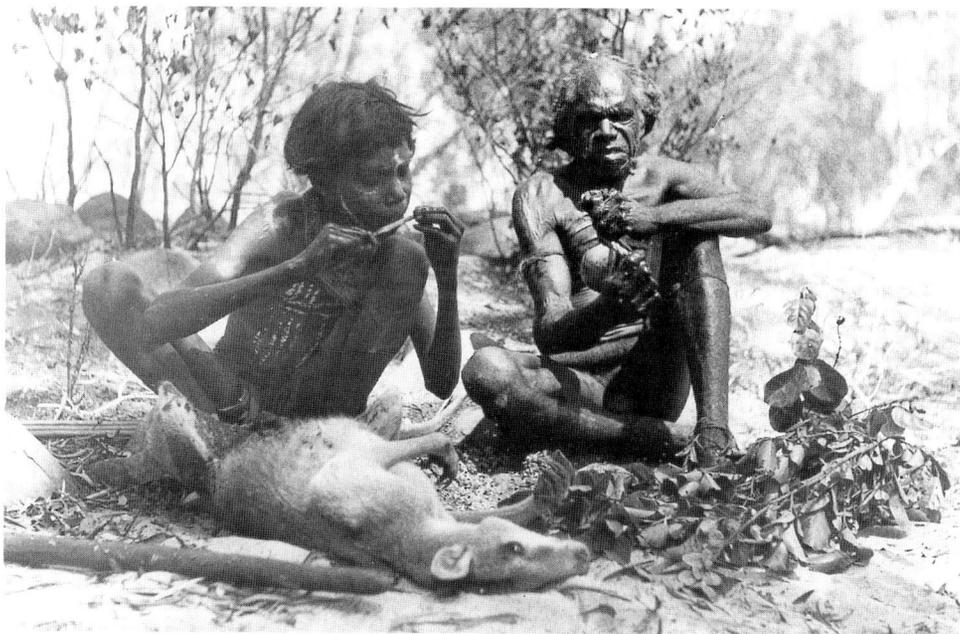

Mowaljarlai's maternal grandfather Lawandi skewers intestines back into djagu, stomach, of kangaroo, 1938. Lommel

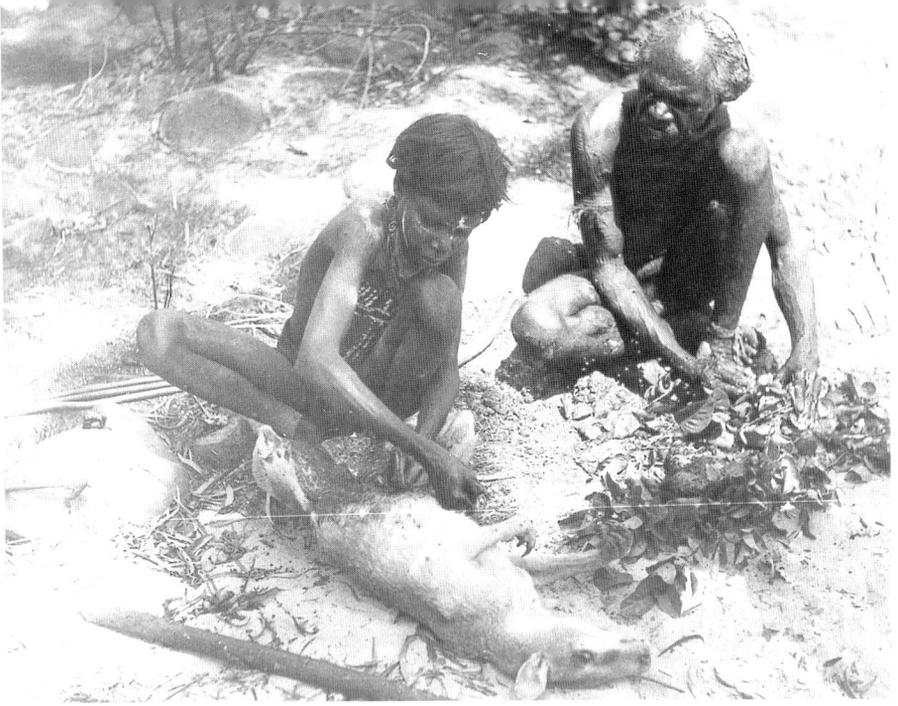

Mowaljarlai learning to gut kangaroo, 1938. Lommel

From November to March we had plenty of cyclones, but our humpies were strong, built of paperbark and the bark from stringybark trees. We were in a wind pocket, the mountain range broke up the wind. There was plenty of rain, but the humpies were really strong and safe.

Later, when we were sixteen or seventeen, we were separated from the family into single men's quarters. We did not live any more with the married people so that we would not make any humbug with other men's wives.

There was a time when we had to go through a training. There was a boss looking after us who was responsible for this training, a man who had married a sister or an auntie or was the husband or promised man of a relative.

He took us into the bush to show us how to hunt. He speared a kangaroo. Those kangaroos scratch and heap up grass like dogs when they make urine. A kangaroo scratches around a young bush with his claws until it becomes almost like a rubbish heap. This man took this grass and rubbed it all over our shoulders. And we asked him, "Why are you doing that?"

"If you want to be a good hunter, you must know kangaroo – smell him, feel him, know him." Then he killed a kangaroo. He opened the stomach and showed us the innards, the intestines. He named everything: stomach, milk guts, kidneys, all this. Then he took a stick and skewered them up, tied them round, and we carried them home.

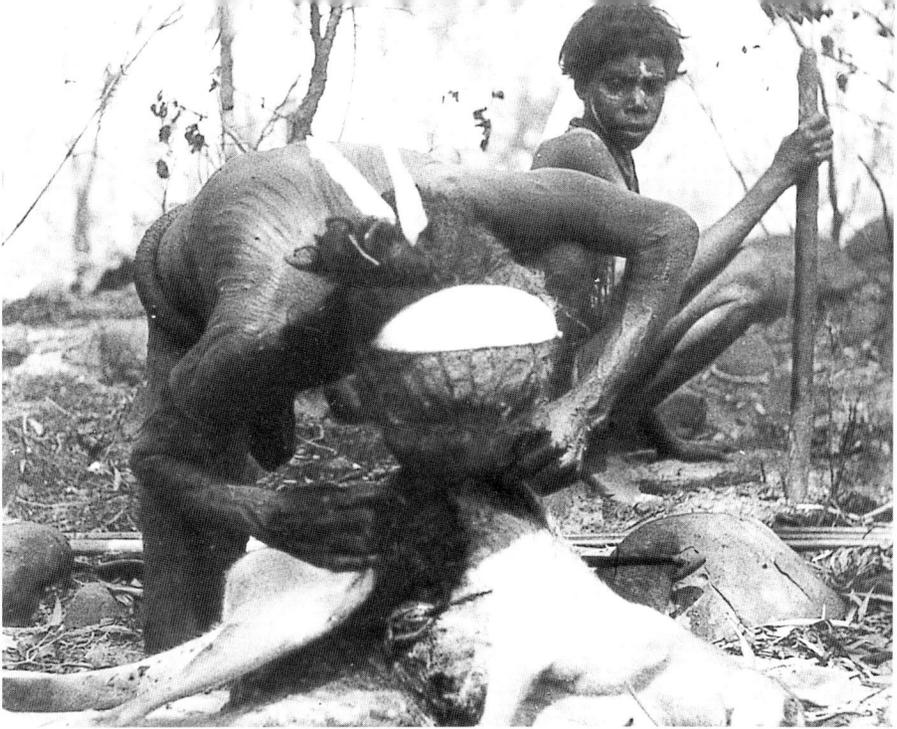

Mowaljarlai and Lawandi. Note hairnet, Lawandi's wallet, which holds firestick
and knife during the hunt and when swimming, 1938. Lommel

He sprinkled the gall from the liver on our head so that it would drip down
into our nose and we could smell it.

"If you want to be a good hunter, you got to smell of this kangaroo. In
the time when you train for hunting, you must learn to smell the life of a
kangaroo, then you become a good hunter."

We didn't eat the liver. We couldn't eat it because it is heavy. It sits on
your legs and makes them so heavy that you can't run, you're pumped out
all the time. But it only makes you heavy when you're young.

When we were matured, he killed a red kangaroo. He singed the
kangaroo and pulled the liver out. He placed the raw liver on our upper leg
– here. We did not feel heavy then because we were now initiated by the
liver. We were allowed to eat it then.

When we learned how to sneak kangaroo, he told us, "Don't tread on
bushes that go 'bang!' Kangaroo has got ears, he will take off." So he
showed us where to put our feet, tiptoe-kind-of-thing, quiet, quiet, without
disturbing things. We learned how to get really close to spear a kangaroo.

At first he made spears for us. Then he speared a kangaroo. He broke
his leg and said, "Put this womera on the spear and then you spear this
kangaroo." The kangaroo was lying down and we got very close, very
close. Then we speared him. "Ah – you got him now!"

One time he left us in camp. He went to spear a kangaroo, broke his leg and left him just crawling. Then he came home and said, "You got your spears ready? Come on, let's go!"

As we went along, he'd say, "Shsshsshssh ... kangaroo there! He's yours. You aim carefully and spear him now the way I showed you how to hunt. If he looks this way – you stop. Sneak him now!"

Now, this was a test. We had to put our feet gently all along. When the kangaroo looked back – we had to stop.

"If you move, he will take off, because he has eyes to see." Then, when he looked the other way, we crept quick-quick-quick.

When we came close-up, we speared him. But that kangaroo was speared before we came. He had broken his leg bone so he couldn't hop. And when the kangaroo was down: "Oh – now you see, you broke his bone! You really are good hunters!"

He praised us. We were standing up high, really high and proud, couldn't say a word, just think: "My word, I really did break his leg!" That was his training.

We'll never forget this man for the rest of our lives. He taught us all those things. Later, he married my sister. He's dead-gone now.

It was his right by the Law to train us young people, because he was going to be married to my young sister. These relationships tied up the whole community.

During the early part of the war I was getting my tribal marks on, being initiated. In those days we were learning to muster, how to handle the horses, brand the cattle and all those things. At the mission we did not sell any cattle. They were only for our own use, no money. We lived on the rations they gave us, and had a big kitchen. An Aboriginal man and his wife cooked for everybody.

In the morning we would first go to church, then come back and have breakfast. I used to milk nanny-goats with all the other young boys in the morning. In the month of May, when it was cold, we had to quieten some milking cows. We had lots of milk, cow's milk and nanny-goats' milk. When it became hot, we did not milk the cows, we let them go.

Saturdays we did not go to church, only Sundays. But during the week we went every early morning about seven o'clock. Then we started work.

A shepherd and his wife looked after the nanny-goats. They took them out all day, brought them back in the afternoon and locked them up. That was their job. So we had goats' milk the year round.

At times we would all go out to stock-camp. Then two young boys had the early night watch, from six to seven in the evening. At stock-camp there was no yard to hold them together, so we would watch the cattle on the open flat. From seven in the evening to sunrise the older men watched the cattle through the night.

After dinnertime, in the afternoon, we'd go out to the garden to plant tomatoes, cabbage, all kinds of vegetables, pick up watermelons or pumpkins and take them to the store. Later on we watered the new plants in the garden.

We could ride from when we were young. At the mission we made hobble straps from bullock hides to hobble the animals. When we got a killer, we'd take the hide off, dry it and put salt on. When the hide was really dry, we'd cut it into nice round rings, then into fine strips. We needed a lot of bullock hides for saddles, for making straps, head-ropes, lassos and leg-ropes.

After we'd lassoed a bullock, we'd tie up his legs and brand him. The missionaries had taught us how to lasso and bring them down. We always worked together. With the older stockmen we put on the ear brand, a half moon and a PM3 [Presbyterian Mission 3].

Then the bullocks were clipped and bag-tailed. The tails went into bags for packing under the saddle. They're like cotton wool. They called that "candelining saddles", to pack them up evenly. Then it was softer on the back for the animal. I still remember how we made the saddles. We had a model and cut our own timber for that. Those parts of the saddle that lie on the horse's backbone are made of very light wood. We flattened this in a special way so it would sit nicely and not fall off. When one of those wooden parts broke, we'd copy that part, make it ourselves.

The missionaries gave us good knives, oil stones and pocket knives. We plaited leg-ropes. We also had cow hides and proper leather from the shops, everything in the way of tools.

The donkeys had special harnesses. We took about twenty donkeys when we went out to cut cypress pine logs. I still like donkeys. Those donkeys pulled the logs home, sometimes twenty kilometres. It was often close to dark before we got back. We had difficulties along the way, like logs getting stuck in the rocks. We'd unjam the logs and then the donkeys could pull them along again. The logs were for the buildings the mission-aries put up. We had humpy houses, but the families with many children also lived in real houses.

It was a big camp. In the early days there were about twelve or thirteen tribes at Kunmunya. That was a big mob, all real bushmen. They used to go to church with no trousers, only with the paints and their body decoration, white clay and ochre, and with a kangaroo hairbelt or a human hairbelt – no trouser, no shirt.

A few men who worked at the mission had trousers, the rest came in naked. The missionaries did not bother about that, man or woman. Women came naked anyway – it was life, it was education.

We had no funny ideas.

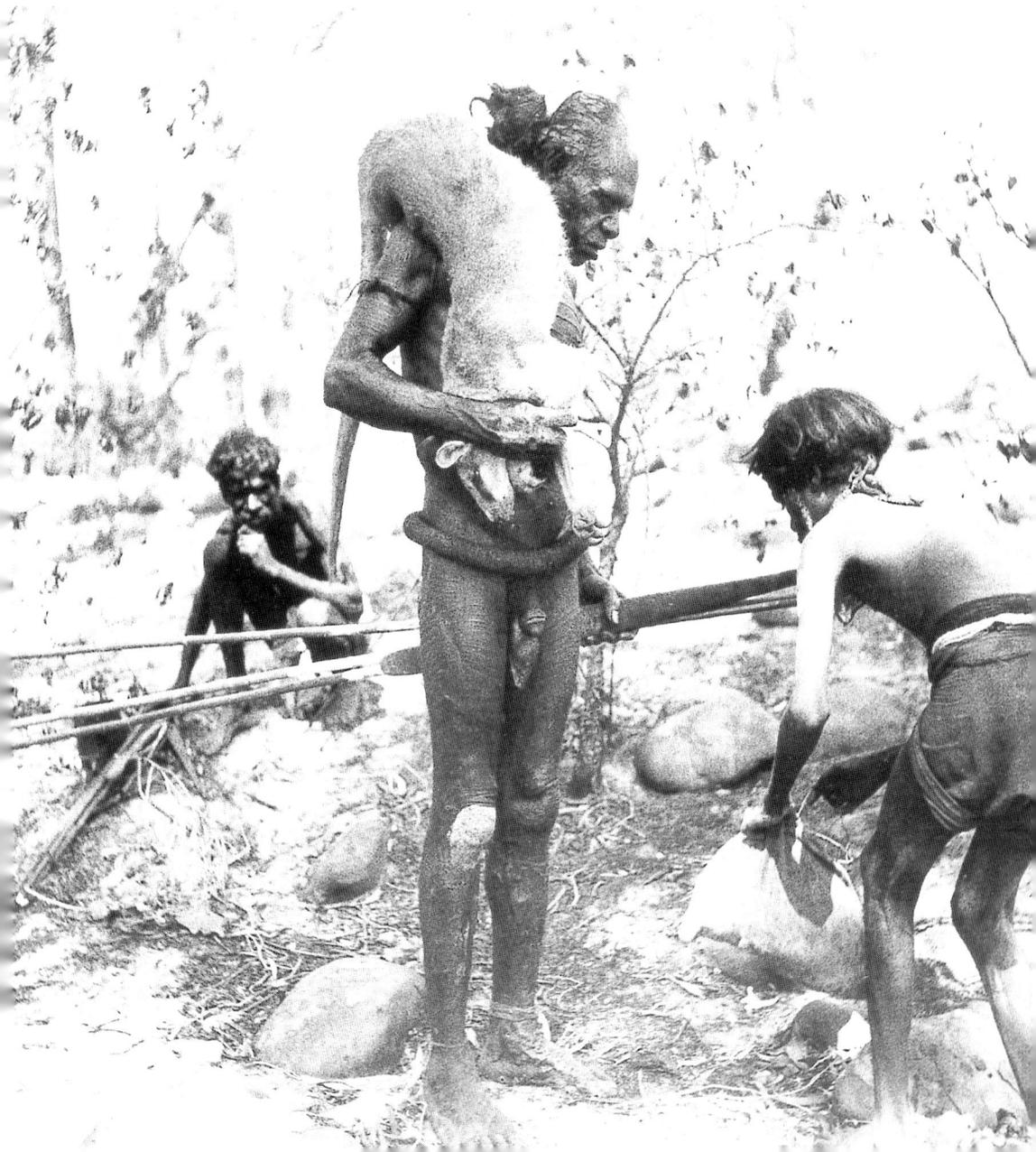

19 Mission Training

During my training, on a holiday or the weekend, I started managing the mission station while the staff were gone.

In those early days only the older people used to smoke pipes. One day, the minister said to us boys, "You're old enough to smoke now." We were about five or six boys who had finished school. At Christmas time we got a present – a pipe, a tin of tobacco and matches. The missionaries filled up the pipes with tobacco and placed them in our mouths. They lit all the pipes for us and we started puffing. It made us giddy and made us silly.

Then the missionaries said, "Right. You are man enough to smoke, you can do a man's job now." So we were put onto different jobs.

Watty Nyerdu was a teenager then and Raymond Gunnat was still a little boy, also some of the others who are elders now. By the 1980s Watty was training young Aborigines to be stockmen and Raymond was Chairman of Mowanjum Community. Watty died in January 1987. All the men who are still active and responsible now, they were all mission-trained. All became church elders. I became a church elder too.

Now, you asked how did Aborigines come to the missions in the first place? I'll tell you. Before the white man, we lived in the bush. The people looked after their country, their Wandjina, their own wunggud places.

From there, they went out in their bushlife, shifted camp-to-camp. They burnt areas only for hunting. When the fire mustered the kangaroo, then the hunters speared them down. They only hunted for food.

Trees were cut only for sugarbag. From other trees, they took bark for humpy houses when they were in flat country, but only when it was raining. When the big raintime came and the plains became boggy, they went back to their caves in the higher places.

At the Wandjina cave a man was at his own home. He had visitors there, maybe his nephews. They cut trees for making spears, womera trees for womera. No trees were cut otherwise. They looked after everything. They wouldn't even burn the neighbour's grass until the neighbour asked him to come and join in a hunt.

Later, the missions came and started to gather some people, mostly half-caste people at first. They told them to go out and talk to Aborigines

in the bush and bring them into the mission. At the mission they became agricultural. They did gardening, training for cattle, all that kind of thing. Only at holiday time they went back to their country to do hunting.

Hector Dargnall, he's one of the old bushmen who stayed out longer than the others; and the old-man-who-ran-away, Jagamurro. All the other real bushmen are dead-gone now.

When the Overlanders came, they started the shooting of the old bushmen. And policemen came round shooting them. Only the refugees were left, the ones that came to the missions. In my grandfather's time the missions saved the lives of Aborigines.

Those station people, they were touchy for their cattle, about Aborigines spearing them down. And the managers were rough. They shot everybody, anybody.

A law was passed through to bring all Aborigines to the missions or to a government settlement. They were chased from the bush like animals in the jungle. It was like that: you sort out the animals you want in a cage. If they run away, you just put a bullet through them. If they stand up, they're saved. That's what happened.

Some Aborigines came to understand the mission idea and became church elders in church groups. They'd go out and talk to their people, explain what these missionaries were on about. The other people followed then because their own Aboriginal men were bringing them in. That's how they all settled into the missions.

Right up north, three mission stations worked with Aboriginal people: Forrest River Mission, Kunmunya and Kalumburu Mission. If the missions hadn't been there, all Aborigines would have been shot clean-out there.

The best times were those holidays when we all went out to the bush. One time, at Kunmunya Mission, our families decided to go on a holiday for a few weeks, to live in the bush with the children.

We killed some dingoes. We used to sell the skulls then, because the dingoes killed sheep and the stations paid for their skulls. The station people also put out poison for the dingoes. The dogs then died at the waterholes and poisoned the water for us.

My father killed a dingo. The family said, "You should take the skull and sell it to get some flour, tea and sugar." So my father and I, we took off very early, about six o'clock in the morning. We had taken a cooked arm of a kangaroo for lunch and for dinner. We walked all day.

About four o'clock, near the station, I happened to spear a little wallaby. My father said, "We won't cook it here, we cook it at the station." So he carried it all the way to Murray Springs Station. It's a sheep station. We got there about sun going down. The old man cooked this kangaroo, covered it up and we went to sleep.

In the middle of the night the police came in. Police used to come during the night, to pick up the people who were sick with leprosy, very quiet. There was this law that sick people had to be chained up, laid on a horse and brought down to Derby Hospital.

These boys woke up my father, they were his relations: "We have come to pick up our sick people to take them to the leprosarium. Will you and your little boy be a guide to take us to those people who are sick?"

Mowaljarlai's mother, Lily Dirrgal (Algal), a young face at rear left of centre; great-uncle Toby on right. Banman/composer has a leprous arm and may have been Alan mentioned in foreword. Head covering observes Rambud relationships. 1938. Lommel

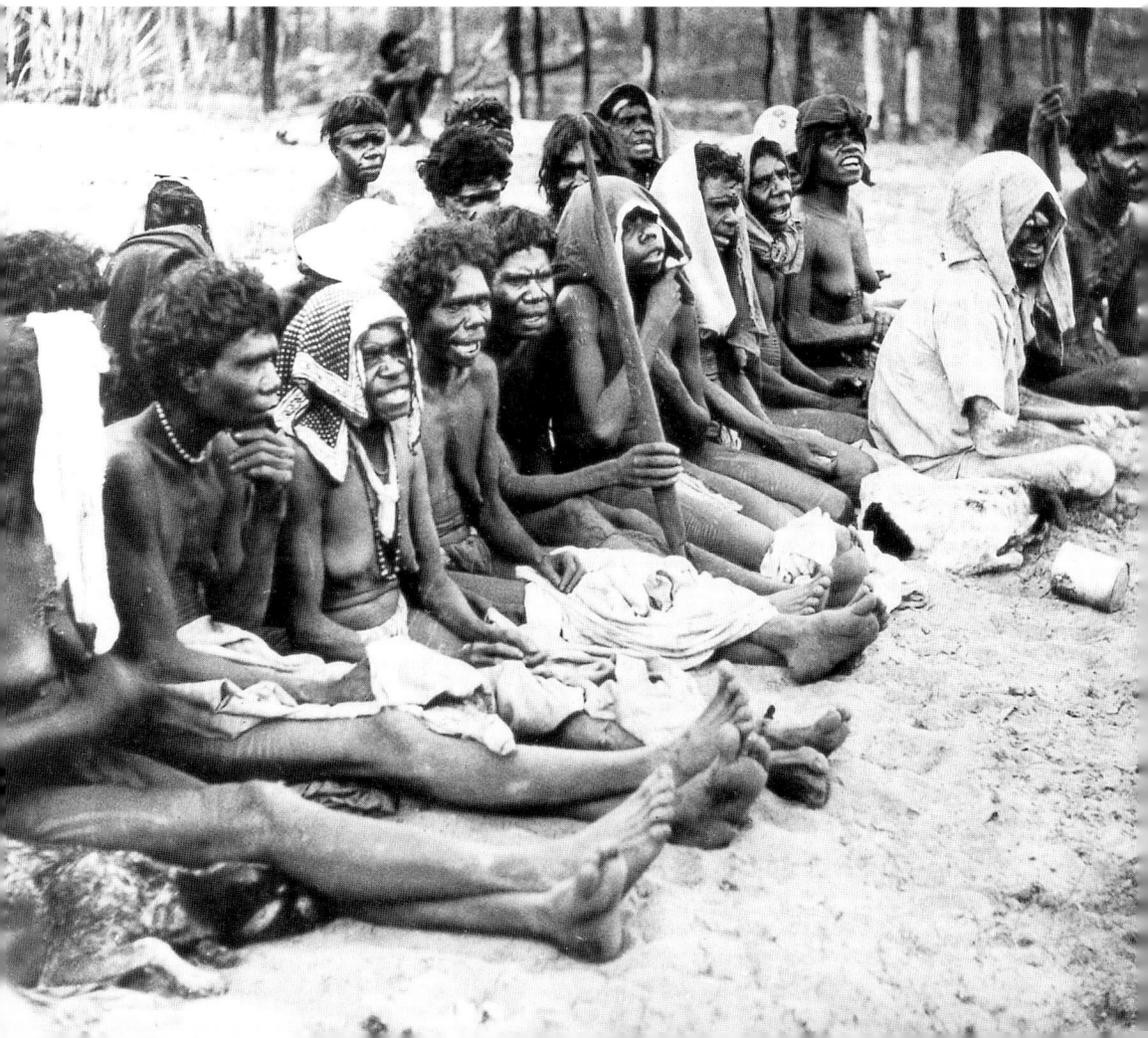

"Yes, no worries." So my father joined them as a guide. We found the people where they camped and brought them together. The ones who were not sick, we let them go. We had arranged to meet the police boys at the junction of Glenelg and Mary's Creek Roads, near Murray Springs Station. They arrived there with more horses and mules. They put the sick people on the mules, then we all went to Pantijan Station, a long way. There the police gave my father flour and tea and sugar.

Then my father and I walked back to where we had left the families, near Kunmunya. They had been waiting for ten days. They were worried that something had happened to us.

Those sick people did not really want to go to the leprosarium. The police boys just had to put a chain onto those that could walk, otherwise they would have escaped. My father and I never touched them. That was the job of the police boys. We had gone to their camps in the bush just quietly. In the afternoon, my father had talked to them. He had a big voice. He had said, "This is me, do not fear. We have come to help you. There is no trouble. Don't frighten and run away."

People knew him everywhere because he was the headman of the tribe. He made them understand the police boys had come to help, to take our sick people to the hospital. They weren't going to shoot anybody. Then they settled down and did not make any humbug. The Aboriginal police boys looked at everybody, no-one escaped. They had guns. They shot bullocks for them and fed them with kangaroos. The people were well looked after and did not worry because my father was alongside them. He told them, "It's for our own good that the sick ones go to hospital."

Some were very bad, they died at the leprosarium. Some were cured and went back to the bush. Later on, the police-and-chain-job finished. The government and the Flying Doctor Service took over from the missions and picked them up in a plane.

In 1972-73 all who had trained to be lay preachers went to Aurukun Mission to study the Bible for three weeks. We would become lay preachers and in the end be ordained. Aurukun is in North Queensland. Mornington Island, Thursday Island and several other Aboriginal settlements, they all belong to Aurukun Mission.

While we were at Aurukun, some legal churchmen arrived there, what they call Judges of the Diocese. They came up and said, "Why are we going to train those Aborigines? They were Christians before us." They had come to think like that because they had looked at our paintings, the stories and our culture.

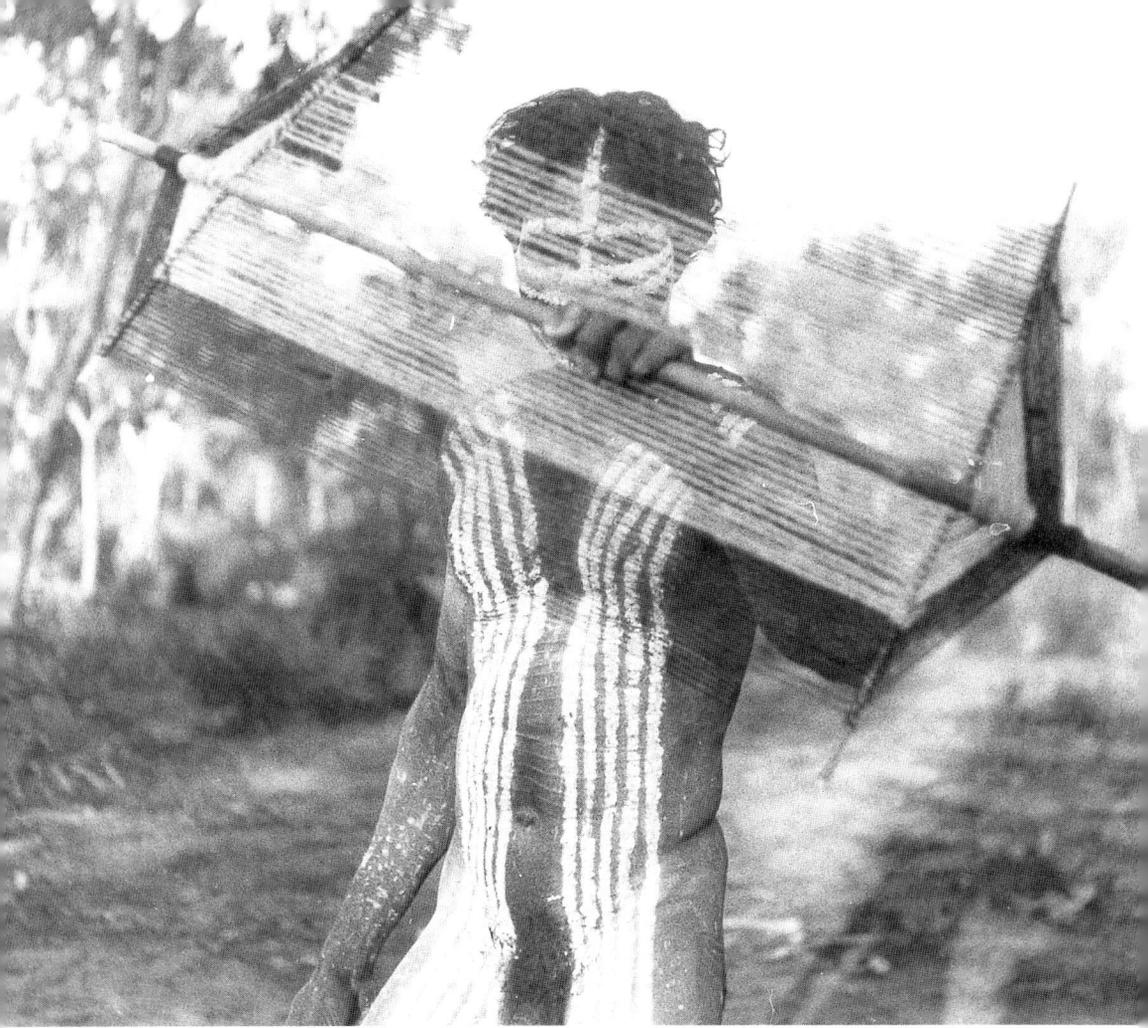

Jimmy Kunmunya, 1938. Photo by A. Lommel

"Why do we make them Christians when they had a complete religion before we got here?" Our story was a bit different, kind of straight, but they realised that underneath it was the same. These were wise people that came.

Then they said, "We can't ordain them as ministers, we can't make them Reverends." We could not get that ordination because we were Aborigines. They said, "They have to have a licence to conduct Holy Communion, to hold wedding services, to hand out passports – and they can't get them." That sort of thing was legally done by the missions and we could not do that, "... as it is a Western culture," they said.

So they sent us home. That was when I decided not to continue with a church career. I did not go back to church for a while. They made me upset, because I thought everyone was the same before God and everything within the church was good. I am still part of the church now and I go to church of course, but it upset me.

20 War

When the war started, I was on the mission lugger. We were going from Kunmunya down to Broome. The skipper was an Aborigine from Thursday Island, a half-caste bloke. The missionaries had brought him across to run the mission lugger.

He taught us how to sail a boat. We used to sit on his lap and hold the tiller. As the wave came, you had to ride this big swell. If you went across, it would tip you right over. We had to learn about all those dangers of sailing.

One time we were on our way to Broome where everybody had been notified that the war with Japan had started. They had bombed Darwin. So the government said, "Put all the Japanese in prison."

All the pearling luggers were out, pearling.

We just happened to come into Broome Harbour when the Army arrived and said, "Get that mission boat! Go out and get all the Japanese from the pearling fleet."

We had two army policemen on our boat, in uniform. They had a Japanese sitting in front so that he could yell out in their language. He was a prisoner already – they had got hold of him first. Two policemen, one each side of him, they had guns with the long bayonet, military rifle ·303. The Japanese was sitting in the middle. I think he was handcuffed, tied up.

Then we'd sail alongside a boat, slow down, and he'd sing out, *"Japanee iru ka?"* What he was saying: "Any Japanese there?"

They would say, "Yes."

"Go straight to the harbour!"

We sailed around every boat out there and this man was yelling out all day, until we were finished. All those boats behind us, they were like a mob of cattle. Then right to the harbour. It was a one-day job.

We rounded up about seven or eight luggers. The ones that had no Japanese, we let them run. When we came into the harbour, the sun was still high. Then we chained them with long chains, click-click, click-click.

They all stood in a line – some men long, some short, some really short. Some necks were pulling up like on a dog leash.

It was a plain chain with padlocks on it. You just wind it around his neck and put the padlock on. The chain was a special one, for prisoners, light. Then we marched them down to the State Government ship, the *Koolinda*. We put them on and they took them down to Fremantle. Big jail house there. Some died during the war, some went back to Broome, their home town. I didn't go on the next trip, but as the mission ship came back into Broome, the Japanese raid was on.

With the aeroplane they came. They bombed Broome, shot all those flyingboats that were in a line out there on the water. Big fires got up.

A lot of Japanese planes were shot down too. They said that one of them had a woman pilot.* They shot one down and they got surprised it was a woman inside. They knocked her down like the men.

Some Japanese planes had bombs, some had machine-guns – *bombombombombombombombombom!* This Japanese woman was well trained. She had a knife. If an enemy came to grab hold of her, she'd stick'im with the knife. She was well equipped, well trained. She knew how to fight a man – the enemy!

* Not recorded in official histories. There is a persistent oral tradition of female pilots found in Zeros downed in Kalumburu battles

Left to right: Paddy Lalbanda, Bobby Wundulmunja, unknown, Jack Karadada, Sidney Lowarla,1938. Lommel

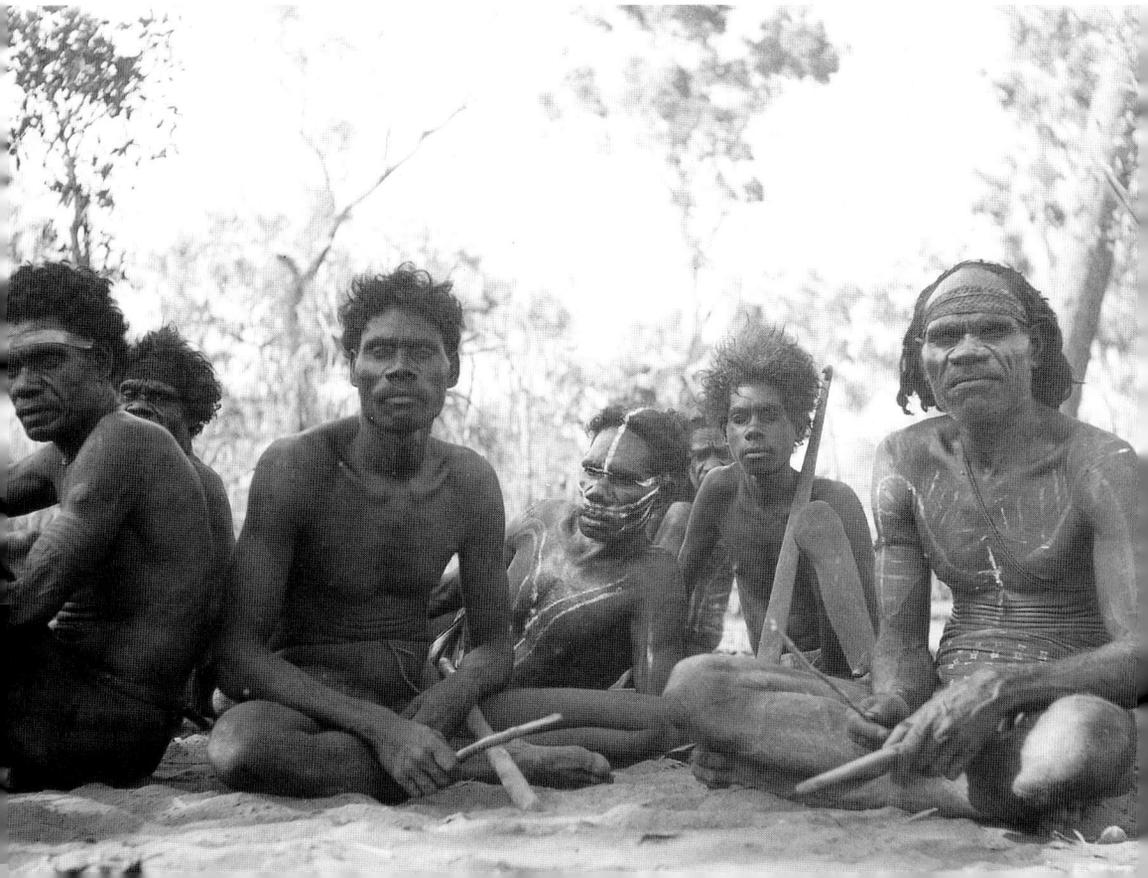

21 US Marine

When the Japanese attacked Broome, the Aboriginal crew and the skipper of the lugger all ran away. The skipper went to Perth. Our people were left behind. Those Aborigines walked back to Kunmunya – a long walk!

The Army picked up the *Wat Leggat*. That boat was named after a missionary, Mr Leggat. He had bought the boat. In business maybe it was the government who bought it.

The Army got hold of that boat and put soldiers on, machine guns and all that. From then on the Army ran our goods-shop, our supplies.

Some surveyors flew in to Kunmunya and I went with them to Champagny Island. I worked with them there, then the Navy put up the buildings for the naval base.

They wanted some Aborigines to be working in the Navy. We had to put our fingerstamps on some paper. I could write of course, I had been to mission school, but they didn't know that.

Then they said, "We'll have this young fella in the landing barge as a pilot." So they gave me that job of running around the coast with the barge, because I knew the shoals and the waters. I liked that job in the Navy.

There was a law: Nobody shooting birds in the Navy. Those guns were not for shooting birds, but for enemy. We still had a good time.

We were in US uniform then, because all the naval bases there were under the US Navy, more or less. Another US navy base called Truscott was up in Kalumburu Mission. That's why the Japanese bombed the mission. After that the Navy shifted to the second Truscott, further away from the mission and closer to the sea.

That's when the war stopped.

I was on Champagny Island. They said, "All right, war finished now. We celebrate all this Saturday." Well, they celebrated. We young people, we were not allowed to get cigars from the canteen. Only for older men to smoke cigars. Cigarettes or tin tobacco we were allowed to smoke, but not cigars.

We did not drink then. We did not drink because of the mission training, but they also did not allow us to drink because there was that law that Aborigines could not drink.

Then they told me, "Well, we like you Mowaljarlai. You helped us here and we had a great time. The war is finished. How about coming with us to the USA? There are a lot of negro women you can marry there."

I said, "What? I don't think I will go there." I did not tell them, but I thought to myself: 'Not for me, negro woman! I'd rather have my own Australian woman.' I looked at my land and my birthright and my children. We did not belong to the USA. If I started marrying a woman there, had my children with a negro woman, then I would be lost in my culture. I would be *wandjat*. That was in my mind.

All my Wandjinas, I would leave them behind, going into the never-never where there are no Wandjinas, none of my land, no totems! That's why I got so scared that on that day I ran away from them.

I had said straight away, "No, I won't go. Negro woman not my type. I would rather have my own Australian Aboriginal woman to marry."

They said, "Okay then." I was dismissed from the US Navy and went back to Kunmunya.

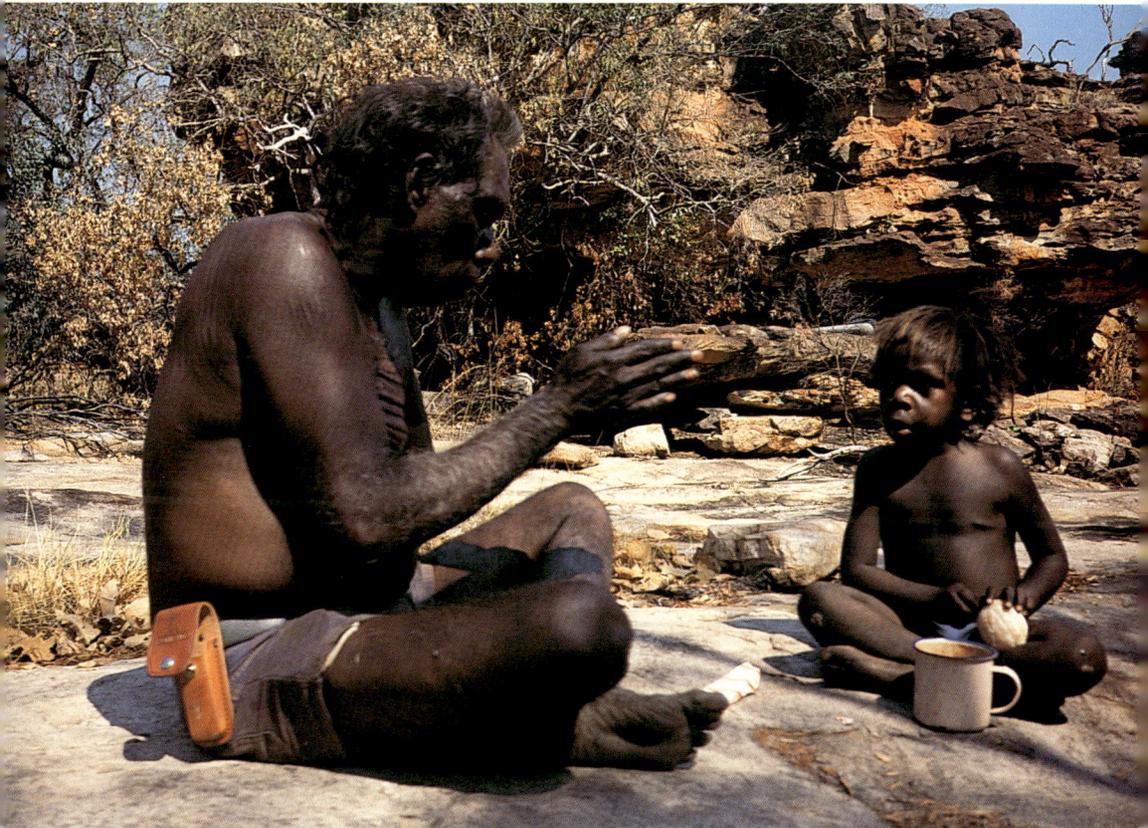

Mowaljarlai teaching Gideon, 1991

When I was back on the mission lugger and sailing up and down to Broome, I had an accident.

At Cape Leveque there is a big lighthouse for ships coming in. We used to deliver mail there before going to Broome, or pick up mail from the lighthouse. There were not many motor cars for mail delivery in those days.

I rowed this dinghy from the deep water into Cape Leveque to pick up some Aboriginal crew. The surf picked me up and tipped the dinghy over and on top of me. I had been sitting in the middle, rowing. When it tipped, I hit the forward seat board with my back and broke the seat in half. It hit me in the kidney.

In the front, I first hit the gunnel and then I hit the ground. You see, the stern part where I was rowing had been lifted by the swell. I was almost standing up. The dinghy fell right on top of me and covered me over. I was pinned underneath. I managed to push this dinghy, lift it up and turn it over. The crew on the shore had seen it and ran along to help me.

After the accident, I did not go to the doctor. It took me another eight or nine months, that's when the pain got really bad and I went to the doctor.

He put me into hospital where they gave me this treatment. It's a kind of bitter medicine you drink from a little glass all the time. The kidney healed up eventually, though I couldn't work for a long time – for about six or seven months.

When I came out of hospital, I went to Broome. Mister Male had a big store and I did the rationing for his pearling luggers and fishboats; also looked after the freezers. That was my job.

I was also a kind of mechanic, fixing engines.

Then Mister Male and the owners had a problem: the boys looking after the alcohol were robbing them. They said, "Blow you, boys, you get out! We will put in Mowaljarlai to look after this alcohol store." When boxes came in, I'd stack them up, look after them and nothing was robbed. They trusted me.

After a year, I said, "I want to go back to Kunmunya." And what did they do? They put me on a charter flight, flew me right back to the mission by plane. Mister Male did that. I had worked with them really well and everything was running as they liked it. When I told them that I was going back to my people, they said okay.

They paid me and paid for my airfare right back to Kunmunya. That's what Mister Male did for me.

22 Great Changes

I've been married twice. The first wife, Djogai, well – we were boyfriend-girlfriend-kind-of-thing – we used to camp about. People reported that to the church elders. They said, "Now, it's all right."

They wrote letters to Sunday Island Mission where she came from, and those mission people replied, "We think mission-to-mission people can marry." But that was not according to our Aboriginal law that way.

Our own people did not really agree because they knew I had my own promised wives. Quite a few in fact, about three, or four, or five. But Valerie, the second wife, she was not among them, she was promised later. Those early promised wives, they are all now married to somebody else.

With Djogai, we had about seven children. I think two died, a boy and a girl. I was on the lugger at the time. It was the big Singapore Influenza that killed a lot of old people and kids too.

We lost them at Derby. That wasn't our country any more. I did not spend much time with the family in those days.

There was always that bother with the community that I was married to the wrong woman, in tribal terms. Djogai belonged saltwater and there were language difficulties. She went back to One Arm Point, and then to Mowanjum, where she lives now.

Valerie was promised to me when she was small, well, she was still at school. When she was about fifteen-sixteen, the community gave her to me.

On our honeymoon we camped out on the Hann River Plateau. We had a great time. That's where I gave Claude's [their first baby] spirit to her. I caught Claude's spirit in Lejmorro country, near that *Mulli Mulli,* when we were working on the rock painting book.

I had carried that baby spirit around with me for over two years because I didn't have a wife.

Then we had the law bothering us, the council and policemen. The police do not really interfere with our law, but there was talk in Derby that we had committed bigamy. Djogai, the first wife, summonsed me for bigamy.

The court said: You have to divorce properly. We had to sign a form then and got a proper divorce – after I was married to Valerie. It's all okay now, because marriage is really a matter for the Aboriginal community.

Towards the end of the fifties there came a big change. I'm not sure what started it, but I know that the missionaries had problems getting food supplies up from Broome. Kunmunya was too far out.

The first shift we made was to a place called Camden Head. We stayed there for a year. Then they shifted us again to *Wotjulum*. It is a reserve near Koolan Island. First, people were transferred by boat, then a lugger went up-coast to Wotjulum again to bring all the dogs and whatever was left. There were a lot of dogs.

We had sold the old mission lugger to Broome and got a new thirty-foot launch for mission supplies. I was skipper and engineer.

About 1951-52, the police and the Welfare people came up to Wotjalam to talk to the community and the missionaries about shifting us to Derby.

There was this last big argument. We said, "Why are we going to shift again? We are leaving all our countries behind!"

Valerie, Gideon [their second son] and Mowaljarlai at Mowanjum

And we said to the policeman, "Look, what will happen if we steal somebody's shirt and trousers? Surely you'll put us in jail," for we had never been in jail as we travelled in the bush.

Then we came to another kind of question: "You got plenty of meat there?"

"Yes, we got plenty meat."

"How do we get it?"

"You will have to buy it."

At Wotjalam we had started to get wages for our work, handling dollars. The missionaries were paying us. From that time on we were buying our own foods and all those things. And from there it carried on to Derby, right up to now. We are getting our pay and have to look after ourselves.

We were really homesick for our country. You see, on the farm and in the bush you have everything. But we couldn't argue back because we were under Australian law. They had decided that we should move to Derby.

You know on the farms, those bulls with rope through the nose, with the ring? That is how we were led to Derby. We did not have any power to defend ourselves. We settled near the road to Broome, at the airport. It happened like this:

About 1952-53, the Reverend Jim Hartshorn was Superintendent of the mission. With him and four or five Aboriginal elders we went to Derby to inspect the place before shifting the whole crowd.

It was a sort of cattle station there at the airport. We went to the manager, old Jacky Lloyd, and we talked about shifting there. He said, "Yes, why not? I'll sell you this block." And the mission bought that land.

Then we had a big meeting with the women and men of the *Nyigina* tribe from near Derby, to make an agreement for us to get that place.

We of the Council had to do this, it was tribal business. We talked about, "Look, we are being shifted again. We have been shifted from Kunmunya way-up north, shifted again and again – and now to Derby. This is the last place where we are going to settle, and it is Nyigina country. Could we have that place?" The Nyigina Council agreed, "Why not? Settle here."

We went back, started moving everybody by thirty-foot lugger. The little launch and the barges took everyone to Koolan Island. There we all jumped onto the state government ship and were taken to Derby.

There are two runways at Derby airport, the big one we land on and another one. They settled us right in the middle. Then the Army wanted to extend one runway for bigger planes to land. So they asked us to shift again. We did shift.

The government gave us a freehold title where the Mowanjum Aboriginal Community is now. It had nothing to do with the mission any more. The mission just withdrew.

We had lost the spirits of our old countries and were cut off from the history side of the culture. I started to ask for grants to go and put all those old stories together. The help came from God, with you three ladies from Sydney, with that book about rock painting. I will have to go on and on with this work because of the powers that were given to me.

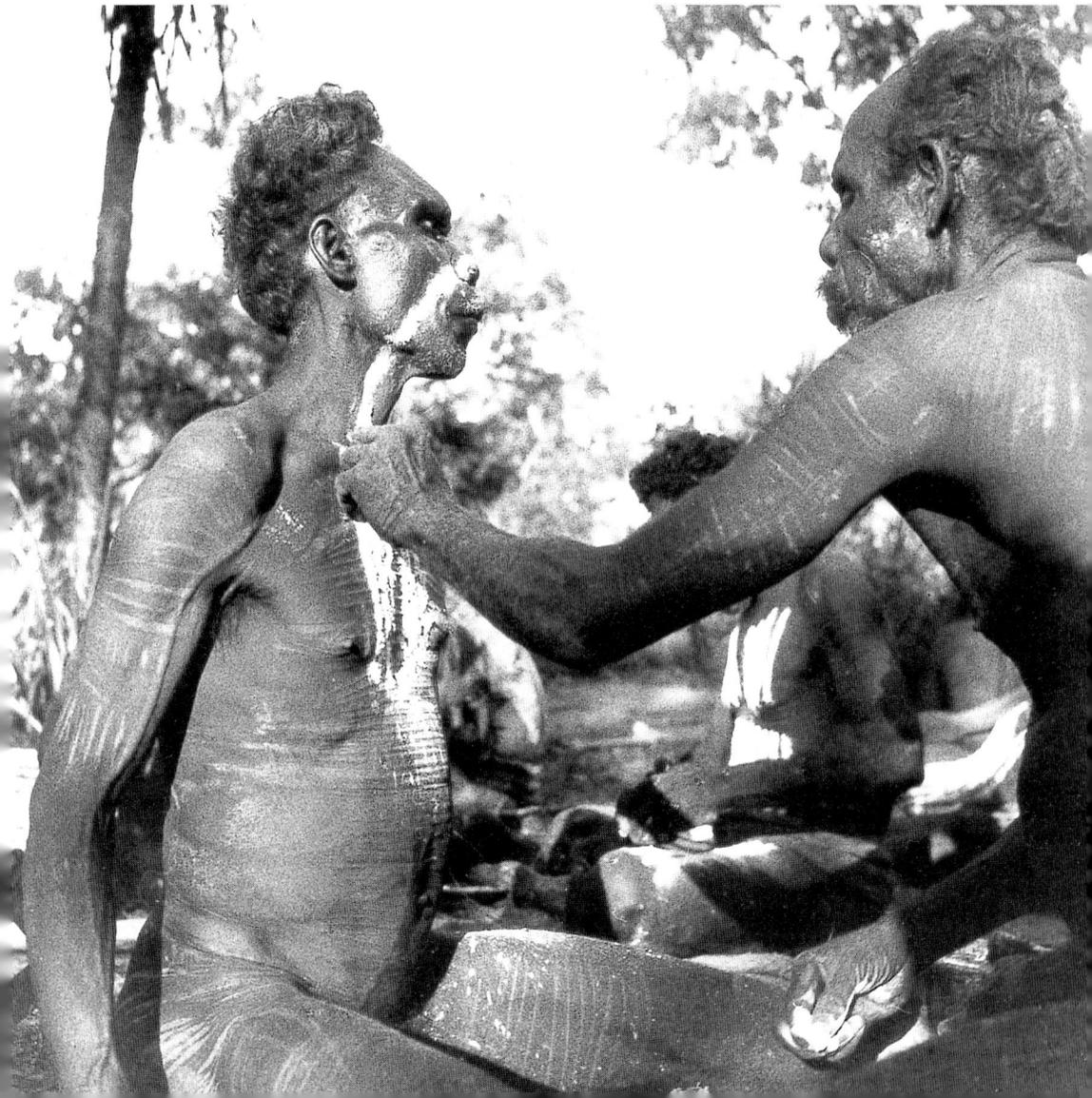

I am Worrorra
I am Ngarinyin
I am Wunambal
Once I walked my country
But lost my place
Then I lost my dignity – spirit.

Once when I walked my country
I was lizard and kangaroo
I was turkey and emu
And the Wandjina walked with me.

Now I have lost my place
I am grog and despair
I am sickness and early death
And the Wandjina can't walk in jails.

How did I leave my country
What brought me out of my land
Can I remember
Did I ever know?

I must remember, I must know
Might be an illusion
That holds me from my country,

For I am Worrorra
I am lizard and kangaroo
I am turkey and emu
And I am spirit – rock
And I am Wandjina.

Mowaljarlai

nami, left, being painted up
r djunbar, corroboree, by
ick Bungguni,1938. Lommel

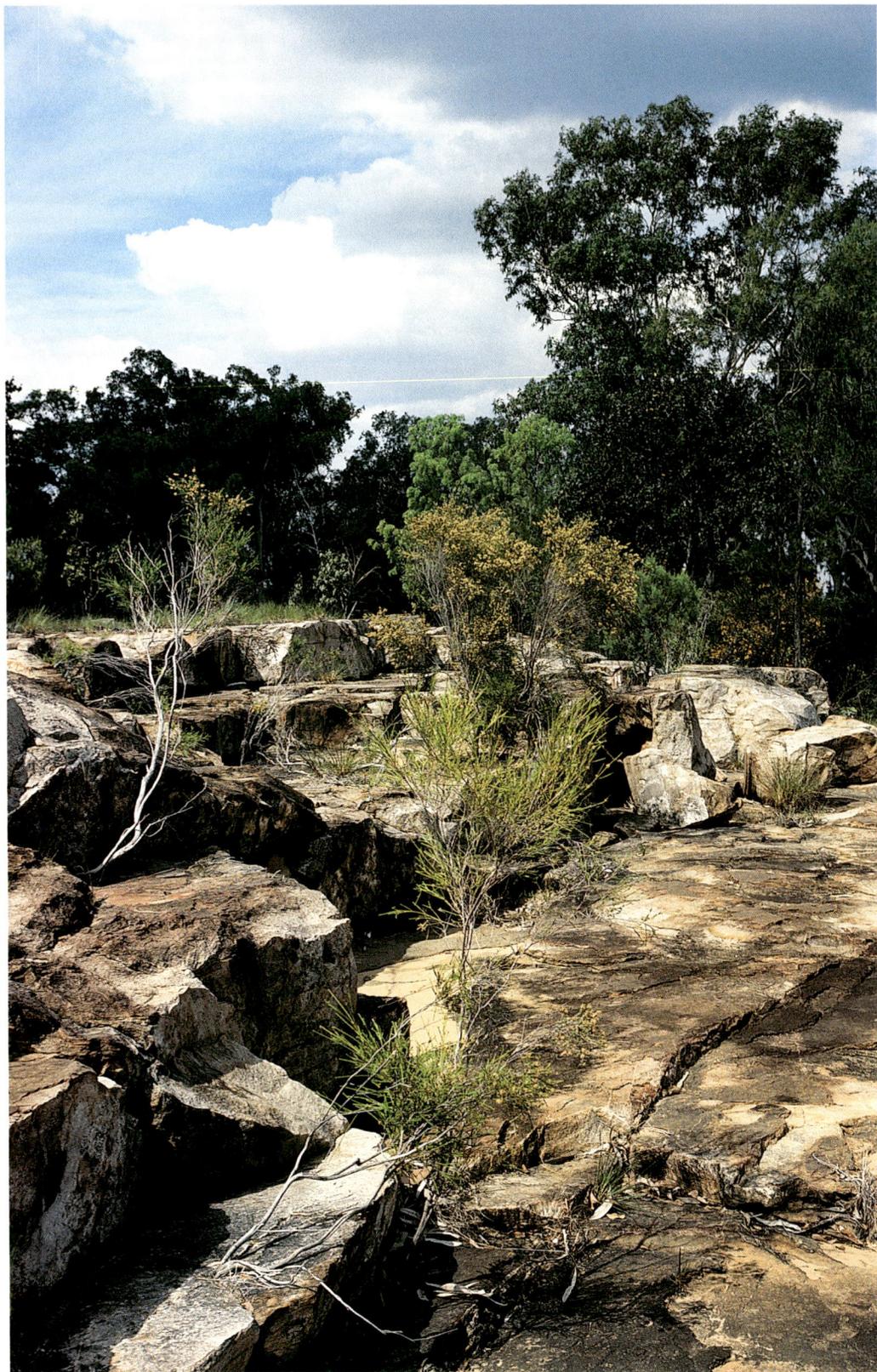

Alwayu

Part 3
Lalai

Angubban, rain clouds, the Travellers. Photo John Wolseley

23 Creation in the Kimberley

In *Narkundjaja,* before the Beginning, Heaven and Earth were two domains – and they still are.

Wallanganda is the sovereign of our galaxy and the force that made everything on earth. He has a form which is perceived but *under law* it can only be shown to men, and only after their initiation. It lies embodied in the Great Star Belt. "That's as far as we go," the old men say, "as far as we can understand," although they assert that Aboriginal people have always known about the existence of other constellations beyond our galaxy.

Inside the earth lives – today and always – Wunggud, a big snake. She *is* the earth and of the primeval substance from which everything in nature is formed. She is female, *njindi,* "her".

Before Creation, she was tightly coiled into a ball of jelly-like substance, *ngallala yawun,* "everything soft like jelly".

Wunggud is the Earth Snake, the name, body, substance and power of the earth. All of nature grows on the body of the Snake.

Lalai is a Worrorra word, *lalandi* in Ngarinyin language. It refers to the active part of Creation Time. Lalai began when Wallanganda, from space, let fresh water fall upon the earth.

Wunggud, the Earth Snake, stirred. She moved and formed pools between her coils to hold these waters. Mowaljarlai: "She deepened her coils into bucketshapes, *garagi.*" In this way she formed the spaces for waterholes, the wunggud waters where she was to reside and remain.

Three expressions describe this action which extends to all wunggud holes: *lulu njuwanignari,* "she slid down the waterhole and stayed there"; *dunggo moni,* "she edged out a place where she wanted to stop"; and *ada njuma,* "where she reigns".

With the sweet waters the Snake made rain. She is still in charge of this process. She controls the rhythm of all cycles: wind and weather; tides and currents; climate and seasons; reproductive, menstrual, growth and life cycles.

Wunggud has her own powers: powers to destroy, to heal [restore her own substance], to clear the way, smash up rocks for gorges and rivers; and powers over the physical conditions preceding the embodiment

of all creatures and growing things. Wallanganda, then as now, is constantly sending batches of energy to Earth. They are stored in the wunggud pools as images. These image projections always precede anything that takes form.

> In Lalai, Wallanganda came down to Earth. He came on order of *Ngadjar,* the Above One, the Master of All Galaxies, the One Beyond Our Understanding – to bring life to this planet.

> He came from above, from Sunrise Country, from the place where the Power comes from. He had sent all that water business. Now he came to put life into it.

The Creator appeared in the form of a Wandjina – mouth and chest shrouded in mist, the head surrounded by circles of lightning and cloud, his gown a curtain of rain – as a Raingod.

> You see no mouth, because that is beyond our understanding, our wisdom, our knowledge. It is hidden behind mist, or fog. That mist separates us from the higher levels that we cannot understand.*

> Wallanganda travelled across the countries. As he walked over the soft ground, the soil formed and hardened into rivers, mountains and rocks. He made trees, shrubs and plants for his landscapes. He made all things of nature.

> His deeds are Yorro Yorro, everything on earth brand new and standing up. Yorro Yorro is continual creation and renewal of nature in all its forms. He installed everything, and he gave it life to continue growing on the back of the Snake.

> Then came the time to make man. "What shall I do now?" this Wandjina said. He was seeing himself alone. He looked down and saw a child moving in a wunggud water. "Oh, that is a kid moving," said the Wandjina. He picked us up and put us on his head and took us along – the image of the little fella, the image.

> Then he saw another picture in a water, a reflection of a Wandjina, of himself. And he took some mud and formed the mud. He made man. He built a first man. Wanditj means "to build the building". It was a mould, a blueprint, a first copyright mould. He did not use his hands – the Creator formed everything with his voice, his power.

> He shaped all parts of the body for the first time. It's like when you build a house, you have to make a formwork. That's what he did

* Daisy Utemorrah teaches: "He has no need of a mouth, he sends his thoughts."

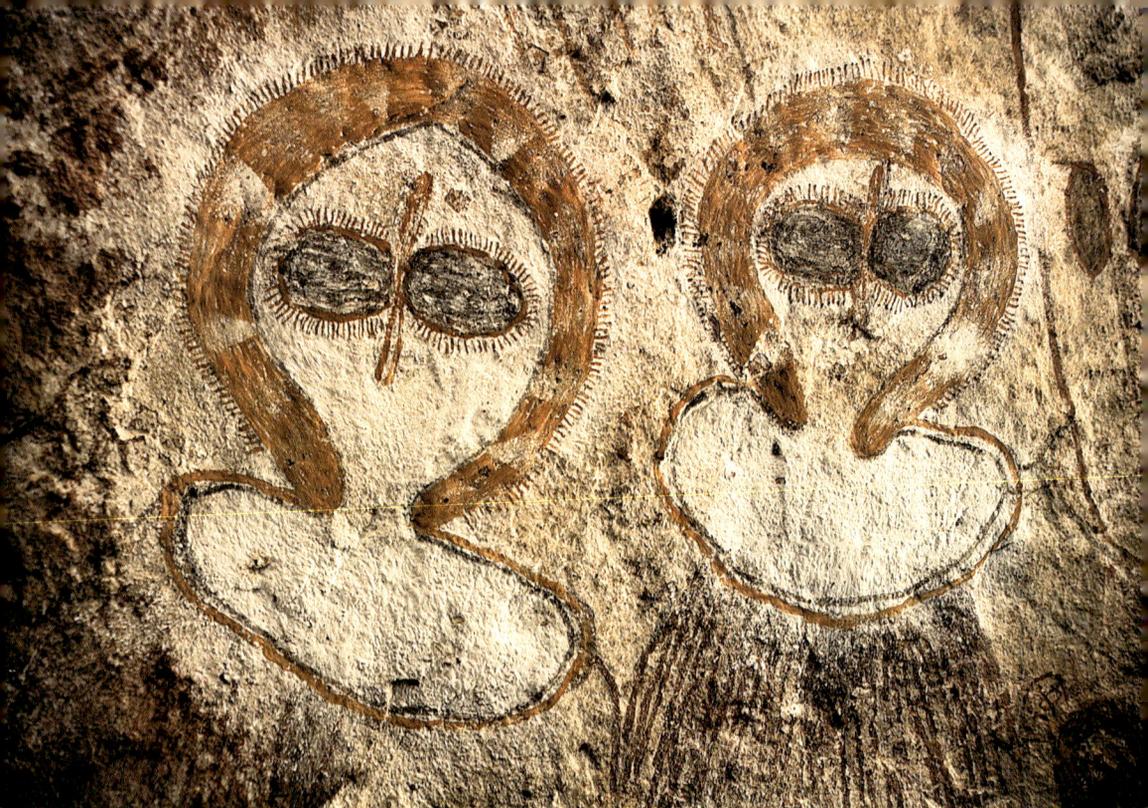

Waanangga followers; Travellers, with rain robes. "Young fella (right) got lost, little wanderer."

Bush turkey

Dhargie Campbell *Opp.:* Carson r. Wunggud wa

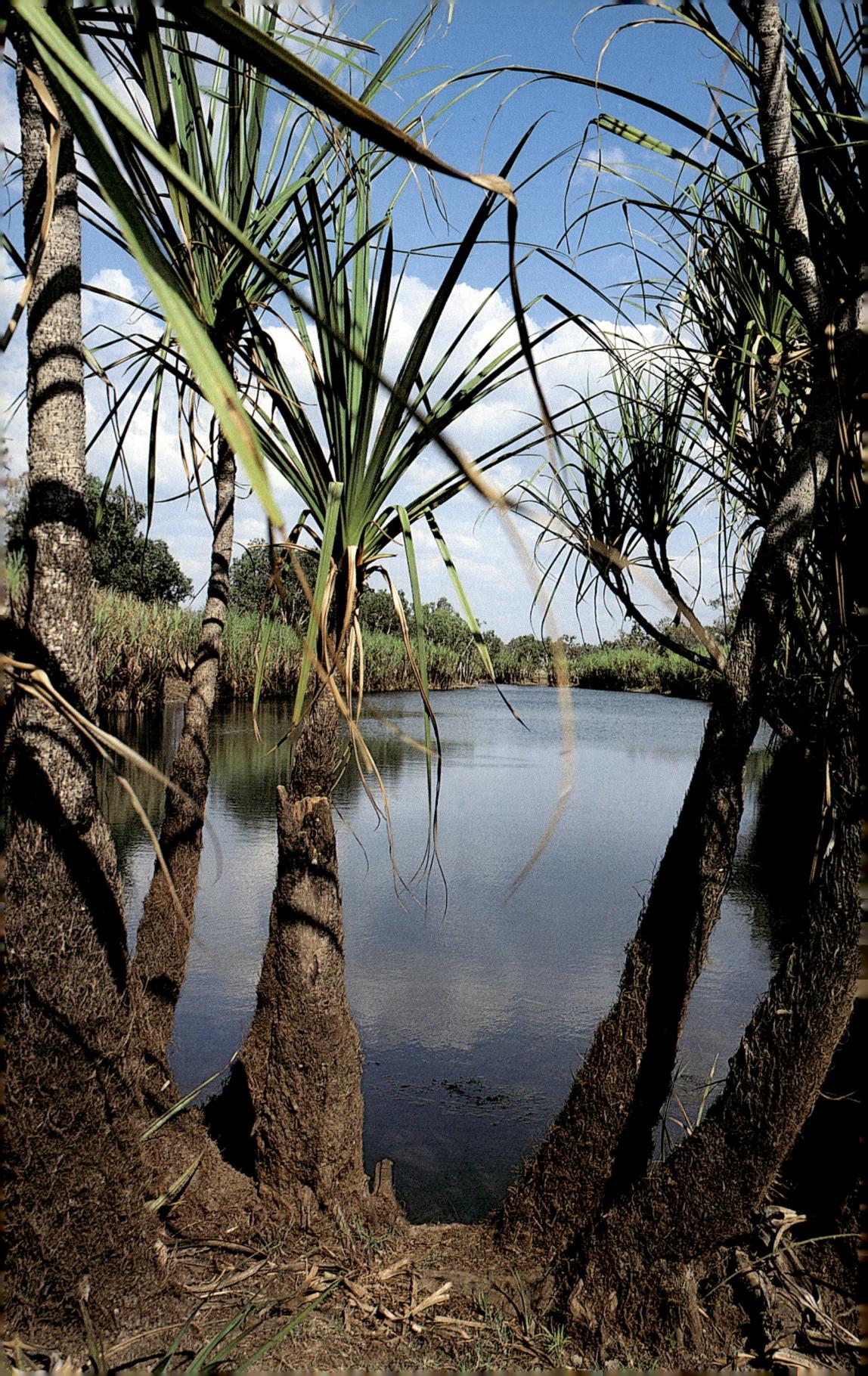

when he made us. When you pull out the boards, you have finished the job. The design is rock solid.

Then the Creator made woman. He made the woman also from mud, like the man. We are all the same. *Najjar* means "same-like, copyright, spit image to himself", as Wandjina. You can see it in rock art. Man and woman are walking about. The design of their bodies had been laid down on Earth.

When he had made the little girl, he put a water mussel between her legs so that man would find it when she grew up, to revere and look after his companion.

Water mussel is mahmah. The name for it is *darrul darrul,* which means "agony and suffering". Young boys are not allowed to eat water mussel because it is the symbol for a woman's body.

Hector splayed two fingers on his arm to form a V. "Wandjina drew that on the earth. That is how he made the private body of a woman." Hector put a finger inside the V – man. "And that is how woman became a woman." Mowaljarlai takes up this theme:

The Creator Wandjina then made animals for food so the people could feed themselves. Some animals – like the *bandau* lizard, the wullumarra turtle, the crocodile and the black parrot – he chose as his preferred animals; he put reminders of his act of Creation into them.

When he made the wullumarra, the long-necked sweetwater turtle, he put a small Wandjina figure, his own image, into the jaw and neck bones of the turtle. Wullumarra: see what I have made out of wullu. Wullu is Creation substance.

In the same way, Wallanganda adorned the back and shoulders of a crocodile, *brungnun ombud,* with a pattern of scalelike tribal marks. As a reminder of his deeds, initiated men wear tribal scars in the same place and pattern. Hector:

He put life into the animals he made, he tasted them: "Ah, very good meat." He became very fond of his first, preferred animal, the wullumarra. When this turtle ran away, he was very distressed until he found her again. He put the wullumarra next to himself in his painting at Angubban, the Cloud Dreaming.

As people increased in number, they were Wandjina to the first pattern again. Humans would always be Wandjina according to the model plan-of-his-vision, his creative projection.

They would enter the world by his patent method, as spirit individuals dreamed into a woman's womb, where a child-body formed and would grow according to the blueprint of the human mould.

When there were many Wandjina people, he divided them into four tribes. To each tribe, the Wunambal, Ngarinyin, Worrorra and west of them along the coast, the Wunggarang, he gave different names by which he wished to be known – he was *Nggawa* to the Wunambal, Gullinggni to the Ngarinyin, and *Yowal* to both. He was *Arrja* to Worrorra. All four words mean "Raingod". In this way the tribes were first distinguished by separate languages. Each tribe was then given a region. In turn, individual Wandjina people were directed to shelters within subdivisions of the region.

In the Beginning, human beings were one with their totem – man was yam, sugarbag, owl, kapok, fish, waterlily, turkey, emu or wallaby – man was present in every kind of food.

A person is inseparable from his totem. Man and totem hold, guard and are bound by each other's life energies. "That is why we say, 'Man was yam or wallaby or sugarbag at first'," Mowaljarlai asserts. "They were first one with their food totem."

This man-totem form is very important; the Creator did not make any kind of seed to continue a line of species. Instead, he packaged the Totemic Principle into man, giving him responsibility for the continuing renewal and well-being of another kind.

When the human-totem Wandjinas travelled to their designated sites, they painted [or merged] their Wandjina-selves and the particulars of their journey: how they formed the land by walking, travelling. Mowaljarlai is emphatic: "It is important to remember that they all *walked.*"

All Wandjina sites are wunggud, places of concentrated Earth power. There is never a cave, a painting site, without a wunggud water [containing Earth energies]. If the painting cave is high on a bluff, the wunggud water may be at the foot of the cliff. It is always nearby. A person will always represent the totem of the wunggud site where he or she was dreamt.

The totems were given by Wallanganda so that Aborigines would not trespass one another, would have no reason to fight for land or food.

Sun stone circle, 'Bone of the Blue'

In my youngfella time, the older people used to teach us: "Whatever law Wandjina gave, we have to look after all these things. Don't muck around with them or that Wunggud will get shock, because you are damaging Wallanganda's creation. You are misusing His gift to us from Creation Time. It is mahmah," they told us.

When man, now *identity man,* left his home shelter for the open country, his totemic identity and source of secured supply remained in safe deposit in the paintings. He would return there to stimulate the idea of the Seed-Gift, ask for increase in the line of his totem, and be himself refreshed.

He knew, and Aborigines still know to this day, that eventually, without this stimulating impulse, species will weaken and wither.

Life-force is boosted by touching, retouching, stimulating and acknowledging the man-totem identity in various ways. The result is an increase in supplies.

Every totem has a spirit, a gi, and it is the spirit of the totem which a person represents. This spirit rejoices in the presence of the brother-person. Should the latter die, his daughter, or a neighbour in the totemic block system, takes over and cares for the orphaned gi spirit.

A visit by totemically unrelated people drains the spirit essence of the gi. In defense, the gi spirit will push away all strangers. It projects an invisible power fence as a shield around its territory. When the unwelcome visitor approaches, he can have an accident or be struck with extreme confusion. Yet, in the company of a person who belongs to the place, even strangers may gain passage. The gi powers long for the totemic alter ego, and they draw him. It is a polarised relationship, oriented along the lines of a force.

With the bases for tribal interaction established and territorial borders drawn, there was food, land and property entitlement and identity for everyone. There were also rules for conduct, protection against adverse forces and immunity from illness – mankind had been organised into peaceful co-existence.

Yuwuddum, "bush name, he had no other, proper bushman", Mowaljarlai's paternal grandfather and Jimmy Kunmunya, cousin-brother, preparing djunbar, 1938. Lommel

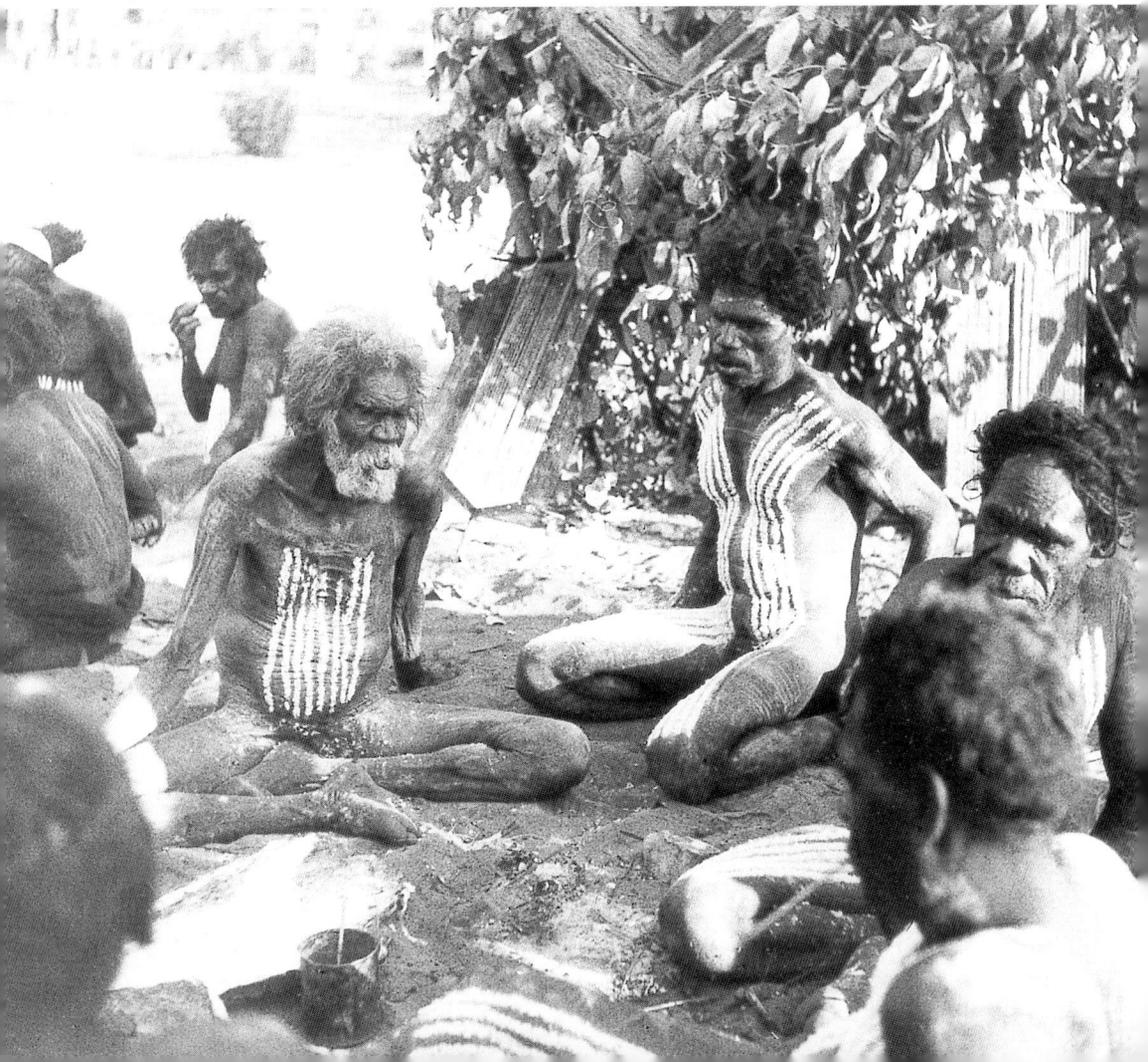

Maggie Guruwarra at Mount Barnett (left), and Kitty Dereluk, composer, doctor woman (right).
"They helped put the history, leaving something valuable for another generation, what is
the history of Australia, for people anywhere in the world to know." *Below:* Photo John Wolseley

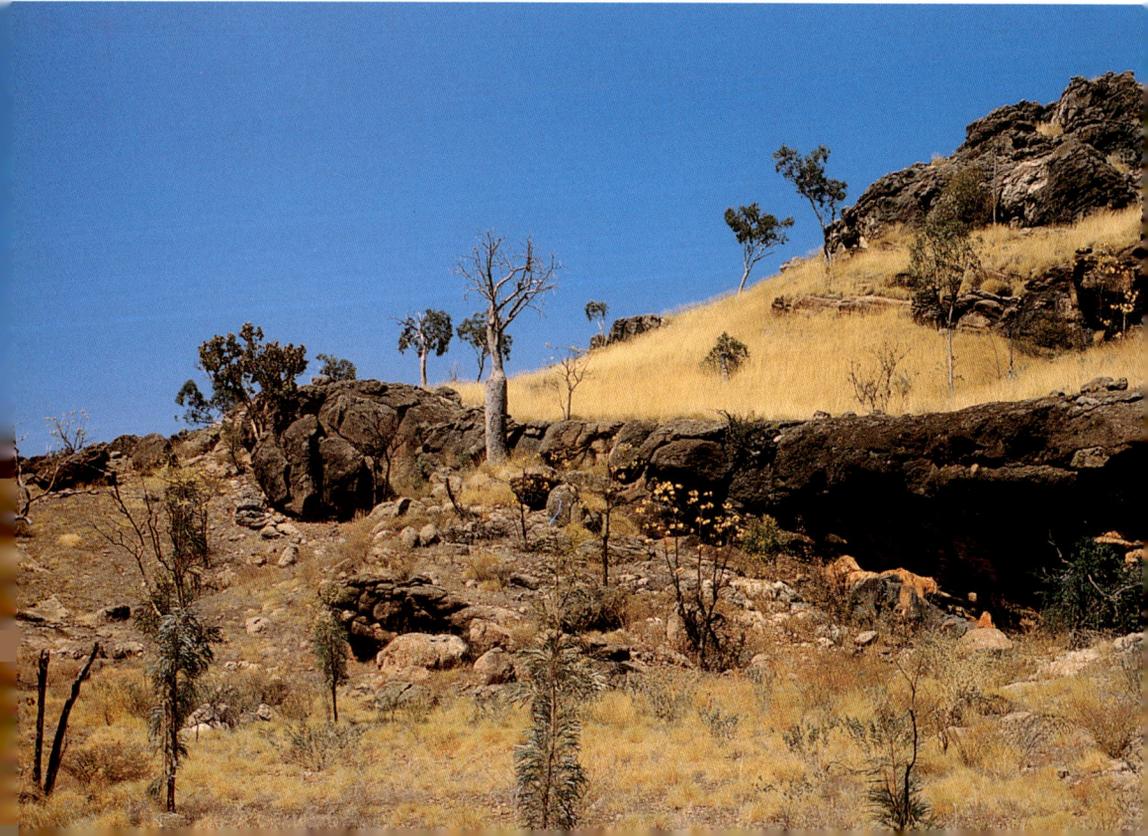

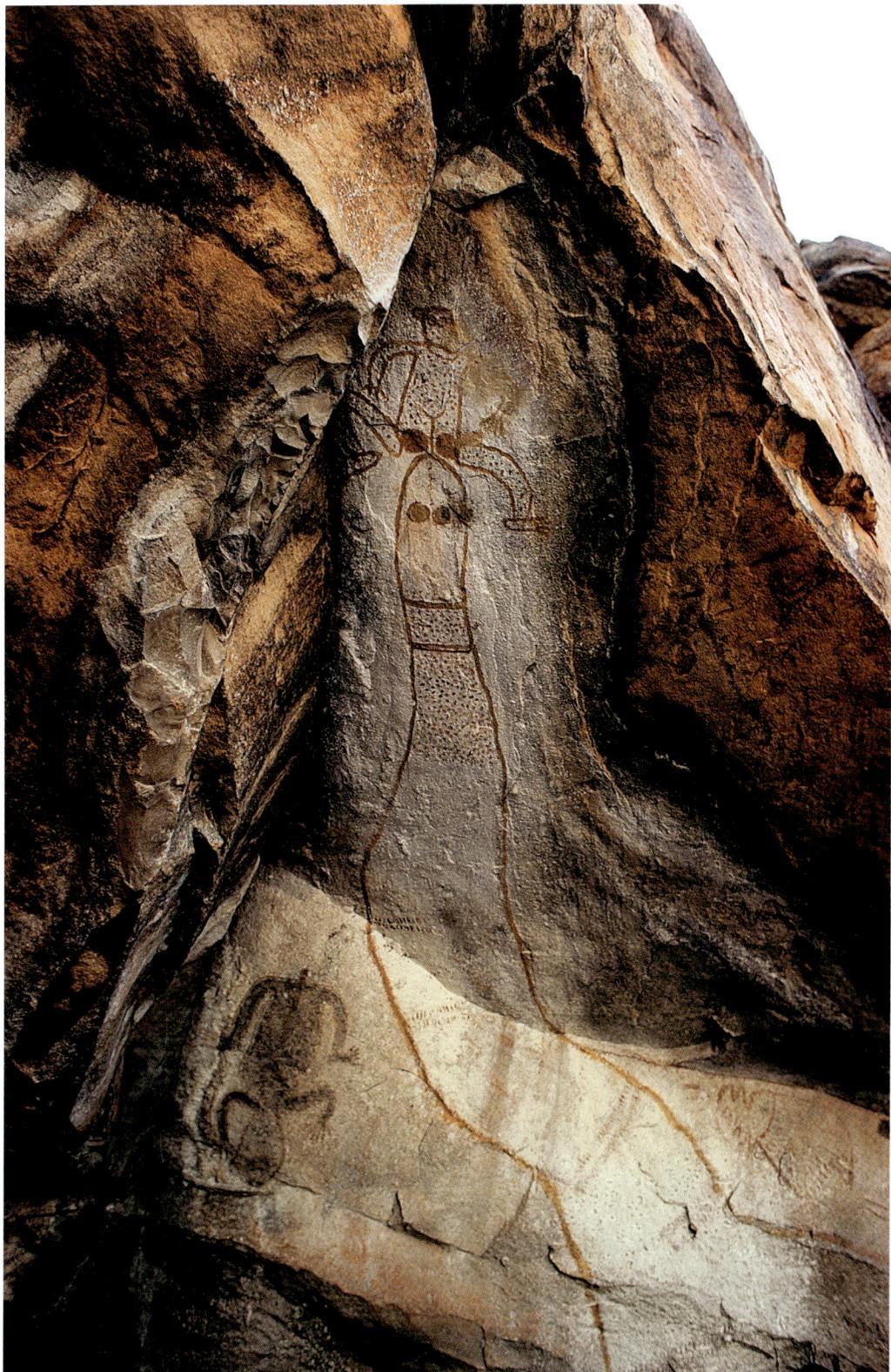

Wunggadinda panel. *Kulawala,* name of this site in Manning Gorge, means "in hot ashes".
Snake Woman, caught in earth fires, pushes a spirit child out of the fire

When Wallanganda had finished his work and provided for all of his making, Ngadjar, the Supreme One, the One Beyond Our Understanding, appeared in the form of the Wandjina *Djaranbolloi*.

He first put his foot into the soft soil near Beverley Springs Station. It became a swamp, *Enggalura* – his Footprint Place.

Djaranbolloi walked over the tribal territories and left his imprint on these countries. When he had crossed a plain, he came to a free-standing rock. He sat down to rest on this bough-shaped little island. The top overhangs the lower parts like a half moon.

Djaranbolloi, Ngadjar, is the Master of All the Heavens. Here at Lejmorro, it was he who finally manifested the One Who Brought Life to Earth, Wallanganda. In Hector's words:

> He came down and sat, and rock now shining. "That's Him now, that Milky Way," he said. "I, Ngadjar, the Above-One, sent him, this Wallanganda." Ngadjar put his own light there, white glasslike stuff. You can see it long way shining; *demba* means "shining".
>
> The Above-One sat for a long time. *He had brought Light.* When night-time came, he went down to make his camp in the shelter. He stretched out and merged with the wall while falling asleep. *He had brought Sleep.* Just like us, when dark comes down and we start make a camp and we lie down. Because Ngadjar did it, we do it too.

With the gifts of Light and Sleep, a return route had opened – man could slip the ropes, the ties of his physical body, and find the home of his spirit. Wandjina caves and wunggud pools are the doorways to the spirit regions.

Then the Snake uncoiled and stretched out. She became Midjelna, "the one that unwinds her rings and stretches out long". Her body was sprouting with a kingdom of living nature. From here she would take over from the Creator. She would persuade man to reproduce by sexual intercourse only, without the spirit portion that put him under the Law of the Universe as Wandjina Man. She offered independence, joint management and knowledge of her own realm and powers – she offered the earth.

> Wallanganda came thundering down on her, *"Wandjat!* You go out of my sight!" And he said, "From now on you do your own thing, and don't come back into my territory! Don't think you can make creatures just with sex, without dreaming spirit-part into them!" And finally: "Crawl on your belly from now! Wandjat – out of my sight!"

Rebuked and foiled, the Snake thrashed about furiously, forming yet more rivers, smashing rocks. Gaping gorges appeared where mountains split.

With this offer of independence, the all-encompassing harmony and order were disrupted. Man could now choose to consider spiritual matters or ignore them. The communities soon became aware of the necessity for social laws.

Wodoi and Djingun, one a colourful and one a grey Nightjar Man, symbolically defined and enacted the basic, and the most important social law, the Law of the Wunnan. The marriage and sharing rules in this law ensured sound breeding, peaceful sharing of resources and cultural knowledge.

Wodoi and Djingun had fought at the Wunnan Place, the red soil jump-up beside the present-day Gibb River Road. There two stone arrangements are still erect reminders of their conflict, which began over the question of whether to cook sugarbag. The resolution of their fight established a new awareness of the total gift of life, an obligation to recognise and honour the Giver – and to return a portion of his gifts in sacrifice. Initiation was stepped up, blood-sacrifice with burnt offerings of flesh started and, in time, circumcision.

Yet another division ensued from this fight. By reason of referring to Wodoi as a meat eater, and to Djingun as a vegetarian, one being of darker, the other of lighter blood, ochre and pipeclay body paint entered into ritual use. They are to highlight a more aggressive or peaceful mood at ceremonies and sessions of judgement.

The introduction of law service and sacrifice segregated the roles of men and women, their areas of service, responsibility and orientation becoming, says Mowaljarlai, respectively Heaven and Earth.

> During her child-bearing years, a woman is tied to the cycles of the earth. Her disposition and specific role are identical with the functions of the earth: life-giving, nurturing, healing, continuing, maintaining and giving service to living things – to the earth. For that she is mahmah – which means respect it, "you can't muck around with it, you cannot trespass into this territory". It is like a taboo.

> When a woman dies, no ceremony is needed. She automatically goes back to the Wunggud, the Snake Cycle of life-death-rebirth. The earth is her own womb as she belongs to the Snake.

The role of man differs. He has to tend the spiritual aspects and maintain the connection with the cosmic regions where the Law of Creation is manifest. He is held to ceremony, sacrifices, judging and guidance within the community. Without these constant services, a man cannot be assured of his passage through death into a new life-cycle. He must earn it. Mowaljarlai:

> So it is now and will always be – Ngadjar is above all, the Incomparable One and before our time. Wallanganda is the master of our galaxy. He *is* the Milky Way. [See Appendix p214]
>
> His body lies stretched across the sky from north to south; his foot is in the north, his head in the south; in the middle is a dark, starless area – where he dipped his foot in the earth. The separation of Darkness and Light is also in the Milky Way and has always been there.
>
> When he, the Milky Way, turns around, we follow his movement like in a magnetic mirror. That is called *wollai* – when we follow by turning in our sleep.
>
> When he is straight above, he puts *bud* – weight, press – on us. When he is moving away, the bud lifts and we get lighter.
>
> Then *barella*, the dawn, comes and rakes up the darkness. You begin to see with your physical eyes, before the birds sing out. Colour comes, and with colour, the day.
>
> That is wudu-time, time for teaching kids. That is the dawn of the first day and every day. With the birds, the fish, the animals, the plants and all of nature we are still Yorro Yorro, standing up in accordance with the blueprint of Creation.

Young Mowa
with toy bird
made from su
bag beeswax.
1938. Lomme

24 The Earth Serpent

In the dry season of 1987 Mowaljarlai went to Kalumburu. We were hoping that Dargnall and Woodmorro would clarify and extend the material we had collected so far.

At Kalumburu, three other old men joined the gathering. They were Ondia Augustin, Geoffrey Mangalgnamarra and Manila Karadada. Their presence completed a ring of the last brotherhood with unbroken knowledge of northern Kimberley history and mythology. They saw this as an opportunity to put their combined wisdom-lore together, and to pass it on to the future generations of their own communities.

Mowaljarlai and I were also hoping for some detailed information on the characteristics of the Earth Snake. We wanted to know to what extent she was responsible for hold-ups and reversals in the life of human beings. Responding, the five old men put the story of Snake Travel together, a register of provisions and impediments attributed to the Snake.

> In Narkundjaja, when the rains came, the Snake had arranged her body for wunggud holes; in Lalai, she had supplied all the materials for the Creation event – except water.

> When the Earth Snake stretched out to declare her independence, Wallanganda could not take away her power, but he cursed her. From then on, the Snake was doomed to go through constant hell fires, and she got burnt again and again.

> We know that, because all the Snake Dreamings [except those of the Rainbow Serpent] show only the ribtop-side. Only the upper halves of snakes are painted. The lower halves got burnt in volcanic fires. She still gets burnt, is wobbly and can't stand up properly.*

> Wallanganda was very angry when he said to that Snake, "Don't think you can make creatures just with sex, without dreaming spirit-part into them. You are fooling my man. You control my man with confusion."

> *Njuwani*: she slid down the waterhole. Then she edged her place, like a bulldozer making a hole, where she could stop coiled up. That edging covers all the waterholes.

* See photograph p16 145

When she started to move again and stretched out, volcanoes erupted and fires broke out. She got fireburnt. Then the Snake stood up once again, the argument continued, and the Snake got burnt again.

There's an image where she got burnt, a painting. Aborigines used that place to burn off for their hunting. We still use it today.

The Snake is deceiving. When she shows herself as a rainbow, only little rain is coming. When we don't see her, then the big rain comes.

Wallanganda had told that snake, *"Wandjat bowa:* get out of my sight! You do your own thing now, go!" The snake fell to the ground, and *manballauria,* she thrashed about furiously. She made rivers like that.

Until then, Wandjina had formed the landscapes – the rivers, mountains, the plains and creatures. Only after she was expelled from the Garden of Creation did the Snake use her wild fury to make more rivers, willy-willies, cyclones – violent things.

Then she crawled to the Snake Dreaming site, the *Mandangnari* Place, to take her picture there. She had to choose her own cave and find her own path. Her powers interfered with all those good things of Creation.

Her spit is like soap when she wants to swallow an animal. She just slides a frog or anything into her stomach. This spit is *gumma,* saliva, like when we munch tucker we don't swallow dry. Snake spit is *munggundu.* Wherever snakes are painted, there are somewhere spiky stones sticking out from a rock surface – munggundu.*

At one place the earth-fires burst a snake and its innards exploded. All the liver and gut flew out. There is an island now, in Prince Frederick Harbour. My cousin and my grandfather Toby Kingala were swimming from that island when the dolphins picked them up.

We Aborigines don't muck around with the Snake because we are frightened of her. She can do damage.

The travel epic of a husband and wife pair of snakes goes back to Lalai. It is an extensive account. The snake pair staked out the areas where the Snake is in charge, and they laid the pattern for a travelling lifestyle interspersed with challenges. They also provided food resources, water and the camping places along the travel route.

* See photograph p153

Angry Wunggud

The Snake Travel documents the *idea* of the reason for creation.

Those snakes were Wunambal snakes. They came from the north and went through their own as well as Worrorra and Ngarinyin countries. They helped putting tucker and clay there, because people have to travel through all three tribal territories and they have to have food there along the road.

The way these snakes crawled, that is the way we go, these roads and camps. Those are the trade routes in our travelling, the Social Road. They made a track.

Snake places are mahmah, untouchable. They give us fear. Anything could happen if we touched those things. That Snake is still alive today and people get banman powers from her, healing powers.

The Rainbow Snake and Wandjina are opposites. The Cheeky Snake, the King Brown Snake, the Rock Pythons and other snakes are different, they belong to the animal kingdom. Wunggud is always a Rock Python. We only eat the Blackheaded Carpet Snake. All others we don't eat. They bite and we die.

The Gibb River Snakes [Galaru Snakes p17] came from the Hann River gorge. They camped at *Mondol* where they had paperbark for their blankets. The paperbark turned into white stone. At Mondol a Snake tied up a boab tree; she squeezed it.

Mondol: she wound her coils around it

The deep mark of the Snake crawling to the top of this tree is still there.
Mondol means "she tied it up, she strangled it". High rocks surround the
tree, guard and support it like props. It is thought to be the oldest boab tree
in history still standing up.

The Gibb River Snakes divided at Mondol. One lot went to the
Mandangnari shelter to put their images there, and one Snake alone
went to Barnett Gorge.

The painting of a Snake in the tranquil Manning Gorge is seen by
many visitors to the Kimberley. It is an unusual image depicting a

girl riding on the tongue of a Snake. Tourists have been known to remark, "It looks like Aboriginal pornography." There is a thought-provoking explanation to the painting. At Manning Gorge the earth-fires caught this Snake. The name of this place is kulawala: in hot ashes. She totemised that spirit child in the painting and saved her when she pushed her out of the fire.

The Snake perished and the spirit child became Snake Woman; she turned into earthly woman and was given a law: to suffer, to have children, pain and troubles; to be the womb of the earth.

Gambi Mirri: Egg Place, showing animal care of young and mate

Had women not made the Law and held the power of the sacred stone before Gorrid, the Great Whirlwind, came to dispossess them at Dilagnari? They had seen the willy-willy of grass, leaves and dust coming. *"Mei mei,"* they cried, "Look out, look out!" And they had crouched to the ground not to be dispersed. Transformed to stone, they were irrevocably severed from their cosmic connection.

At one time, when I stared at the arcane painting in Manning Gorge, my memory took me back to 1980, to the night at Mount Elizabeth.

And once again I thought I felt the tie and pulse between the women in the fireside ring – that great pulse of the earth.

Let us now turn to the domain of men, to the Law that binds men into service to the spirit regions.

25 Law

Some objects are among the most sacred and secret in the life and ritual of Aborigines. Mirrors of a cosmic order, they are marked with the stellar position of law identities in the Milky Way. They represent acceptance of the law of the universe for Earth. The following story tells how these things became a covenant.

> During Wodoi and Djingun time there was a man called *Wibalma* who made sacred things. He kept them in a workshop, at a distance from where he lived. He had a wife who was old and blind.
>
> One day, when he was out hunting, Wodoi and Djingun came to visit him. They came up and asked the old woman, "Where is Wibalma?" And she said, "Out hunting. He'll be back soon."
>
> So the two men went over to the workplace and took a whole lot of things away with them.
>
> Wibalma was a banman – he got a feeling out there in the bush, where he was hunting. He came straight back. [Medicine men have an extended psychic perception.] He said, "What happened here?"
>
> His wife said, "Two men came here, Wodoi and Djingun. I heard them rattling there, but I am too blind to see what was going on. It was silent after that. They never came back to me, they went off."
>
> He got really angry then. He took a boomerang. He got so angry he threw that boomerang and it split an ironwood tree, which we call *djinnang gang.*
>
> He split this tree in half with his boomerang. But then he said, "Ah, never mind, I'll make a new Law from this tree that was split." And he made a new Law.
>
> Wodoi and Djingun came to the community, where they were stopping. They said, "We have a Law. We stole it from this man."
>
> The next day Wibalma followed their track. Where they walked on stone, he could see their track; but where they walked on the plain ground, he could not see their track. He had to go to the rocky places and find their tracks there.

This is how the Law came to be. The sand ground, where he did not see their tracks, represents the space of time since Creation and the introduction of the Law.

Then he came up to where they were and the Council got them all together. They apologised to him, these two, Wodoi and Djingun: "Very sorry, but we got law now. We had to get this thing, a covenant to put agreement on, to make Wunnan a law. That is why we took it away.

"Maggan," Wodoi and Djingun said. Maggan means "no got". They didn't have anything to relate to in life. So Wibalma said, "All right, I won't be angry now. I was angry in the first place, but I split another tree with the boomerang to make a new one."

Wibalma precedes the story of the Jump-Up Place where Wodoi and Djingun started sacrifices, the Marriage and Wunnan laws.

They first exchanged daughters at *Berra Berra Gnari,* by the river near the jump-up, and agreed on bride payment.

Wodoi said, "You make spears, Djingun, and I make spears, so we can exchange spears in sharing our daughters."

The spears were the bride price, the exchange, the tie and seal. Only the *mongun,* the nightjar owl, was not concerned with this law. He was a bachelor and remained single all his life.

Initiation started among those people who were blind, whose eyes were opened by the healing powers of the snake *Krowat,* who had bitten a little boy at a place called *Mari Dudulmeri.*

Only now, at the time of writing, have I realised that the eye-opening refers not to an Ancient Time man and woman who were born with eyes closed like young puppies, but to people's eyes being opened to higher spiritual influences. In this sense the opening goes on now.

After blood-sacrifice started at Mari Dudulmeri, which represented Wunnan, blood had to spill on the earth for someone to be initiated, to be a full Law Man. Initiation then started all over the country. Say the old men:

Wherever initiation took place, *djallala* signal stones formed a big circle; wherever people sat down and asked themselves, "What shall we do?" and decided: "Let us spill blood to be Law people, to belong to our country, to the wunggud places."

In corroborees the Law is perpetually evoked, sung and danced into mind and body memory. A song is introduced by the banman, and after some years, it is traded along the Wunnan route.*

Under the Wunnan, man and woman belong to Wodoi, land and animals to Djingun. Within a subdivision, the turkey is Djingun moiety (one of two halves), brolga is Wodoi moiety.

There is kinship between people and all animals. Such is the Law.

* See pp162-63

Opposite: Mundugu, snake saliva stone
Njallagunda Snake Dreaming, Gibb Riv

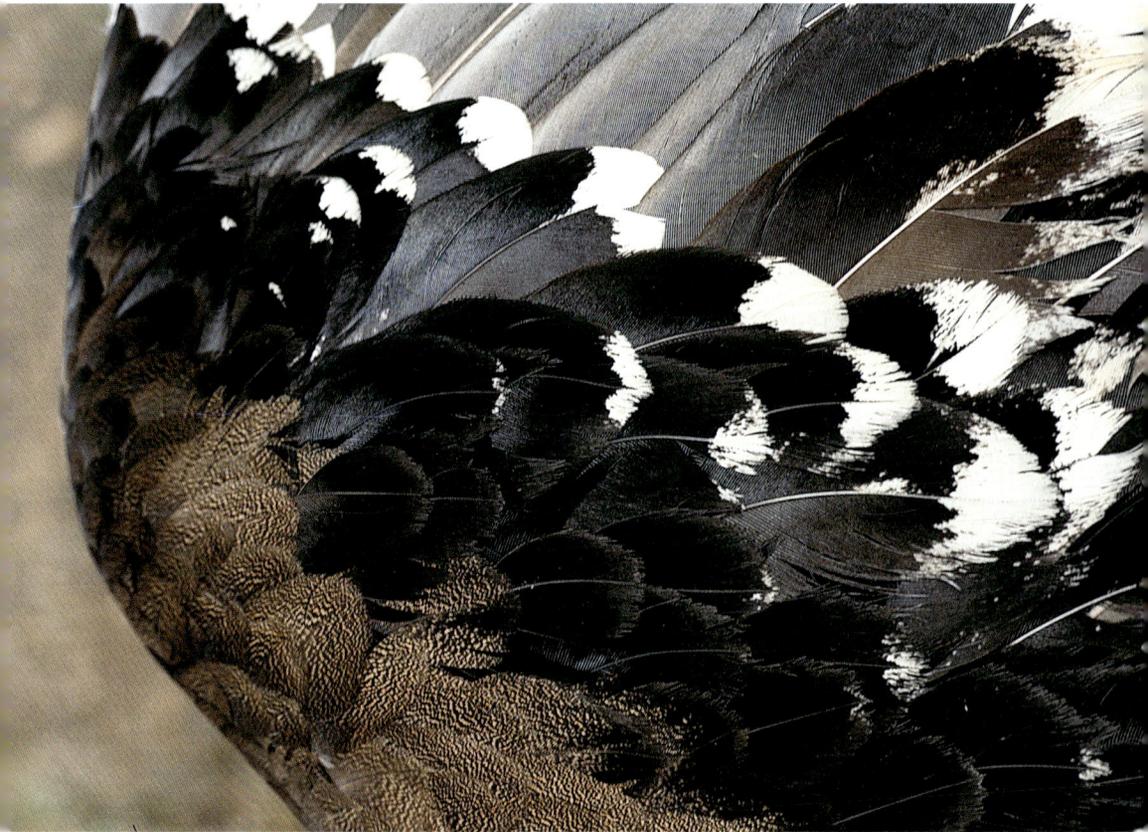

Bush turkey wing

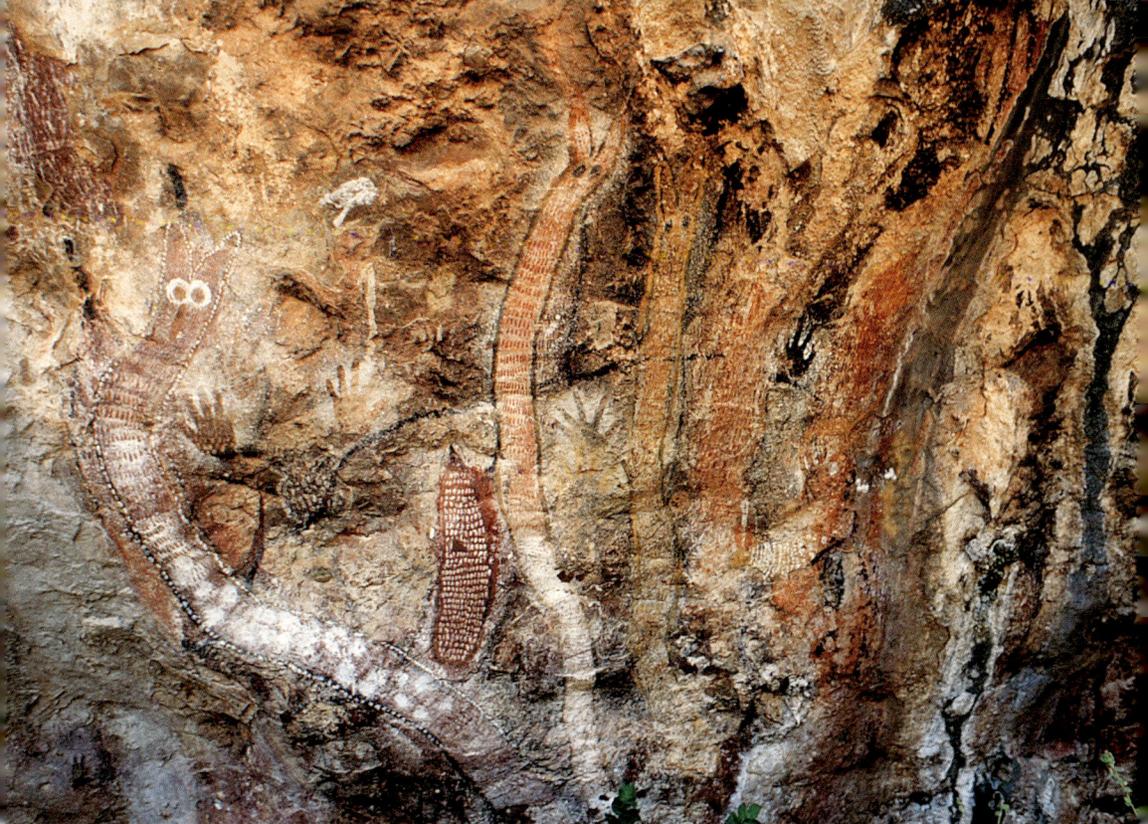

From left: Cobra *Njararaman,* "Cheeky Snake"; Rock Python/cyclone; two images
of *Illangud,* King Brown Snake/willy-willy, at Barker River, Napier Ranges

153

26 Dulugun

The Law is guarded and enforced by the banman, the medicine man in the community. He has spirit powers and special sight (many eyes); he travels astrally and knows how to channel the healing energies of Snake Power. Now the number of banman men has shrunk to a handful, and no-one knows much about their activities. They are said to leave neither trace nor shadow. Dargnall tells the story of how the banman craft was created:

> A little frog was going, "Oingg, oingg, oingg, oingg, oingg…" There was a drought. This frog was singing for water, for rain.

> Now this Wandjina picked up the little frog and put a song on him: *"Di djalla burra djarrum jojojo bindi djarrum kangganda…"* As he sang this song, clouds came up and rain formed. When the rain fell, the frog was happy.

> The little frog and all the other little frogs came out, hopped and swam all over the place. You could hear them going, "Oingg, oingg, oingg…" everywhere. And that's the end of the story.

With the song to bring on rain the frog became the symbol for the banman. From a rain cloud the banman can strike lightning; and lightning is the tool of the law-enforcing banman. This story from Mowaljarlai illustrates the method:

> A man wanted to punish another man for seducing his wife. When she ran away with her lover, he used the lightning song and struck him with lightning.

> When he was singing him, he held two *nulla-nulla* sticks, and then he'd go, "Wrrr-oooffftttt!" When the nulla-nulla sticks cracked together, the lightning hit that man.

The really clever banman are also teachers, but select only the best initiated boys and men.

> They tell them: "You got electricity inside your body from there above. That was transferred to man, electricity inside, a power. It is released from your body. You can feel it when you are standing on

Opposite: Alwa

wet earth. If you want to strike a tree, a red flash goes out from red flesh, lights on the tree and strikes it."

To make lightning strike is a good way to find out what happened. Maybe you want to bring the spirit of a dead man out from his grave, or from a body that lies on a platform.

When it's raining, that's the best time to find out what happened, why this man died or who killed him. The banman can send lightning to the dead man's grave to bring up the spirit for questioning. We can see him up in the air and we can talk to him.

Then the spirit remains with his body until the flesh has rotted away and he and his body are collected.

We gather the bones when they are pure white and we wash them. We take red ochre and kangaroo fat to anoint the bones. We have a big corroboree and dance with waving palm leaves.

The palm represents his lifetime, and the dance shows that he had been a servant of nature. Now he is argula, hidden in the darkness of death, and we follow him there.

After the ceremony, the leader cuts the death cord, the hair cord that was stretched between two poles as a division between the sides of Light and of Darkness. Then the dead spirit is a living spirit again and able to cross the border back into the community. Mowaljarlai:

The death cord is a spirit cord. It has power and protects you. The community and the family decide if he deserves to be brought back. Then, just before the sun slips over the horizon, we deliver this dead man to the community and we celebrate that he is no longer hiding in darkness.

You can't rescue the spirit of a dead man out of the dark. At the moment of sunset you have the power to reach him. It is the moment to make a decision between light and dark. That's what the death cord represents: a division between light and dark.

When we present him to the community, he will be living with them. They cry for him; he is being welcomed, everybody has food. The relatives keep his bones tied up in a paperbark wallet [coffin]. "He is going to camp, to camp," we say, a homecoming to the home camp. Everybody knows he is there and he's alive again.

After about one year, we have to take him back to the Wandjina who created this man. That is why you have seen those bones in the caves.

We open the paperbark with his bones and his spirit can go in and out. We put a bush bucket of water beside his bones, a paperbark vessel with the wunggud water he was created from. He can drink of it and his spirit is now free to come and go as he wishes. We have taken him back to the Creator, the Wandjina.

From there the dead spirit begins the journey to *Dulugun,* the home of dead spirits, and *Dorgei.*

Dorgei is a fountain of talking waters – beautiful. Plenty of trees and green grass. All the people who died before us are there and we join them. It is bright, happy bright, but there is no sun and no night.

You can walk under a waterfall. It is pouring and bubbling. "Gushing", that's what Dorgei means. The water is flowing all year around, always the same amount of water. People drink of it.

People may sleep, do what they want to do. They just live like – spirits. They don't work, don't have to eat, they don't fight like what we have been doing here. There is peace.

Once a year, thinking of their family, the spirits of Dorgei are longing to go back. When the west wind blows, they follow that wind, ride and drift along with the westerly breeze.

They walk on this land. Those with many eyes [the spirit sight] see them at the campfires and everywhere, same body as they were before.

When the spirits come, they don't share food with us. We don't eat their food either, because we are not part of the dead spirit world yet. The tucker is very smelly in that place. We visitors are not allowed to eat it. Their tucker smells because it is a different land, which has a different odour.

In a revisionary session in Sydney, Mowaljarlai and I continue to follow the stages of a dead person's passage to Dulugun. Equipped with map, sketchpad and pencil, we are sitting at my desk.

Libudbud Udman Ngirri Ngari, is the name of a mushroom-shaped *wunnangga* [loose stone setting] on the way to Dulugun. It lies in tidal depths in the Indian Ocean, off the northern coast of

Champagny Island, where the spirits pass through. Saltwater cuts it off. We don't walk about there, it's dangerous.

The word Libudbud refers to what it does —it rings like a bell. Mowaljarlai draws a rounded slab balancing on large pebbles. He demonstrates swaying on the top stone.

The dead man jumps on it and see-saws from one side to the other. The slab hits these rock pebbles that go *"bang, bang-bang."* The spirit is on the signal rock and is tinkling the stones.

Now a feature has appeared on the sketchblock that looks like a coast-watcher's bunker – a tunnel. A figure at the tunnel entrance brandishes a burning torch.

He's going to walk through a dark tunnel here, Bogadju. At the entrance, he first picks up a firestick, a torch. He blows on the firestick and the fire lights up. He can see now. When he comes to the other end of the tunnel, he puts puts down the firestick and flies out to Dorgei.

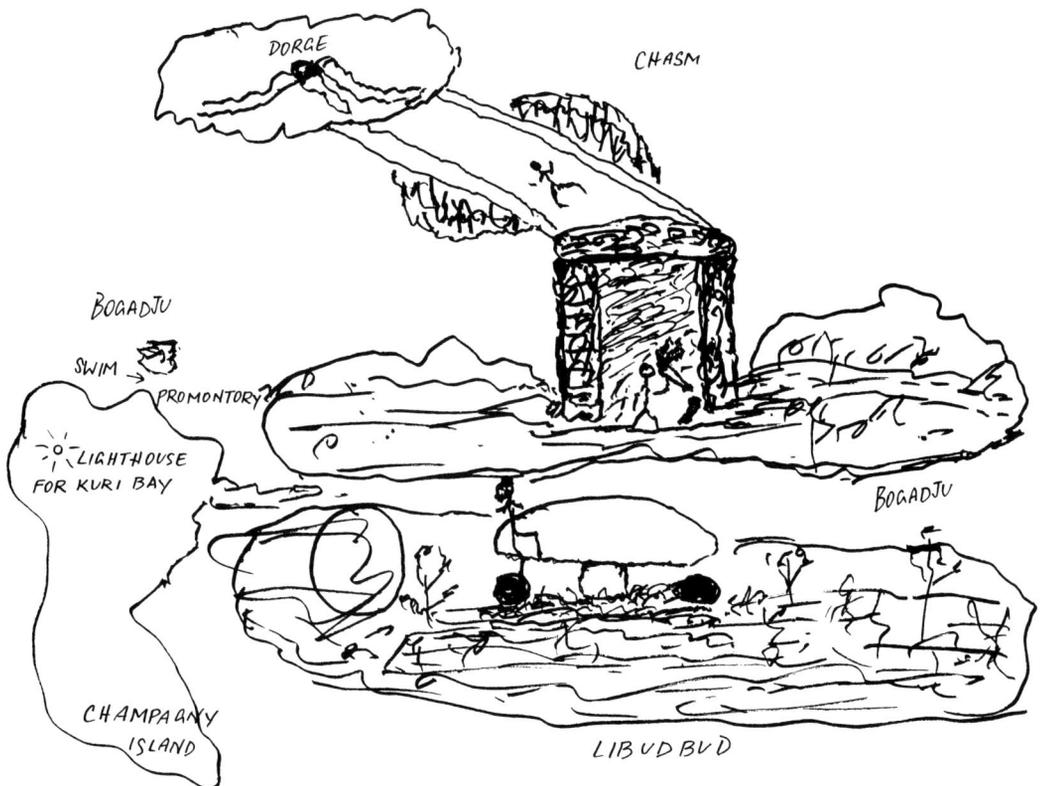

Between Champagny and Bogadju islands,
Libudbud is a step in the Dulugun journey

"You have drawn that spirit as if it was dog-paddling, Mowal, why?"

It's because he's flying between the power lines of a chasm.

Going back to the mainland on the map allows a second launch from terra firma. Humpies are drawn.

> He dies here, with his community. Then he goes to *Libudbud Gadba,* [as the Worrorra call it] he bounces on the mushroom rock. It hits the pebbles below and they ring out ding-dong, ding-dong. That's when he changes appearance. If he was killed by a spear, all his wounds and blood fall down on the stone, all his suffering is washed away when the tide comes up. "He drops his bundle," we say. All sadness, all worldly weights and the afflictions of life disappear. Then he goes on. Before Libudbud, he could have returned to life and his old body, but from here no longer. He is a new creature, a healed man, and has a new skin.

"This rock bell must be delicately balanced."

> It is, and it sounds nice. He gets to the fire torch. He blows it. That's what *bogadju* means. The torch is lying on the ground, just glowing.

> He picks it up, blows, and it glows up gently with a flame. At that moment he's changing from argula into a dead spirit. He can see now and is gaining confidence going towards the light.

> At the end of the tunnel everything is bright, no sun, just pure light. He puts down the torch for the next person. It returns to the entrance and goes out by itself. It's a magic one, the Light of the Fire of the Spirit.

"And what happens in the chasm, is there another transformation?"

> There is no change in there, the chasm light flies him along. He just zooms through, flying in the middle of two light beams.

> The people in Dorgei have listened to the signal and come to welcome him. He meets his old people, they are all there. They cry with him and welcome him home. "You're home," they say.

> One day I am going there, to take a picture of it from the boat.

"Dulugun is a real island then?"

> A real one, on the map, a separate little island from the Champagny naval base* and close to Meteor Island.

* Temporary US naval base during WW2, referred to on p122

We now come to an intriguing story. At first telling, I thought of a freak space incident, but soon came to see the symbolic significance.

A man gets speared inland and dies. The spirit, already very light, starts off to Dulugun. It happens that he is caught in the light-power of a shooting star. Together with this meteor the spirit then flies to Meteor Island, *Langgumania Kalemulu.* This and another, Entrance Island, *Bandjuwarra,* are known to be meteor prone. In this part of the Indian Ocean all islands are part of Dulugun.

> Big mob of meteorites falling there all the time, on the island and under water. A diver could lift them out; or with the boat and the winch. Meteor Island lies near Augustus Island, further out from Port George, near Kunmunya. The spirit now sits on that meteor, a long, chimney-like rock. He is facing back towards his old life thinking about his wife and his family.
>
> The spirits of his mothers, aunties and grannies come across from Dorgei and are digging, digging, digging at the base of the rock. They come to change his thoughts towards the spirit world, to welcome and help him to leave life heaviness behind.
>
> That makes him turn away from his former life. He gets up, he puts his foot on the rock, and when he steps, the *Ammanggna,* his tombstone, tips balance and rolls over, down into salt water. They watch as it goes down, calling "Kaaaa-o, kaaaa-o, kaaaa-o." *Booo-mmmm,* it shakes the earth. He's clear of life heaviness, he flies away, like a rocket.
>
> In our communities, or in the bush, when we see a shooting star, then everybody is silent. We wait for about five or six seconds – that's the time the relatives dig at the base of this stone – and we are silent until we hear that *banggg.*

Freed of his earthly ties, the dead spirit then proceeds through the correct main channel, Libudbud and Bogadju, into *Wallawan,* the big chasm.

> Two beams of light radiate out from the doorway of Bogadju, the Light of the Fire of the Spirit. The two walls of the chasm are the beams. The power of that light floats him along.

The visiting banman comes by a different route and is taken by the Devil. The Devil is Argula, the Deceiver.

He is only argula because he wanted to do wrong things. Argula also
also means "dead person". When a person dies, he becomes argula;
but only when he has just died, while he is in darkness.

When he goes through Bogadju, he changes and stops being argula.
Then he can't drift back.

The Devil chaperones the banman to the edge of the earth's shadow. His
reach is limited. He is forever bound to return to earth. For that reason,
under the Devil's aegis the banman is certain to get back.

Three separate powers influence life on earth: Wandjina; the Snake; and
Argula, the Devil. They always paint (manifest) separately.

The argula-mob protect the banman on the death cord. They sur-
round him with an arc of energy, a kind of walkway of light, so he
can't fall off like in tightrope walking. They bring him back on the
same thing.

This banman remains in darkness [argula]. The dead-mob are on the
light side. The argula-mob reign in the between area. With them you
can come into and out of the chasm, two-way traffic. One-way ticket
goes through Bogadju.

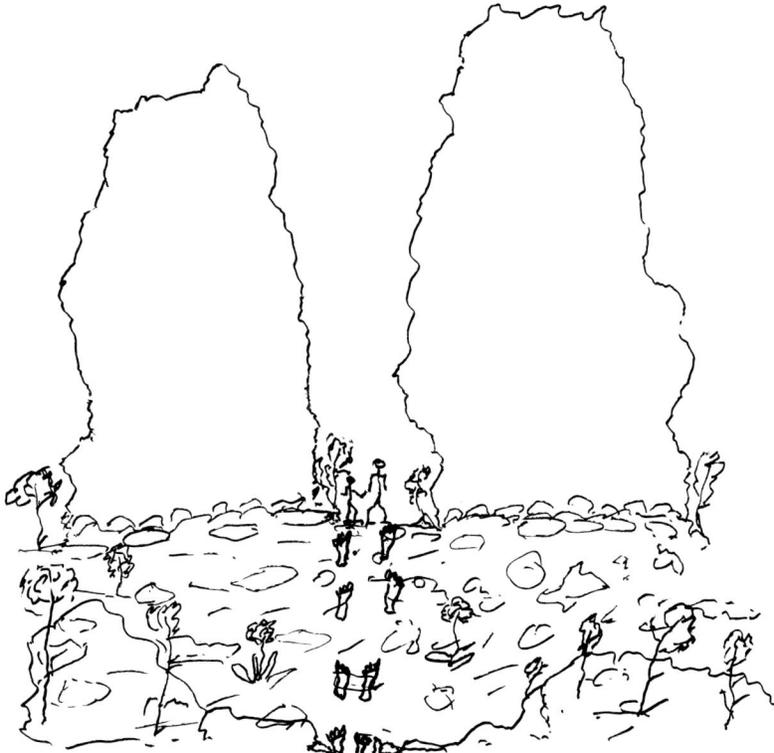

Dulugun gateway

The following songs give further insight. They were composed by Geoffrey Mangalgnamarra and Manila Karadada. Geoffrey says, "I am a composer." Manila: "And I am a composer." Composers bring songs from the spirit world.

With Argula to Dulugun

When we travel around,
then just after tea we feel sleepy,
too early to go to sleep,
but those spirits, they numb us,
in our sleep we see them coming.

They say, "Aye, aye, aye – wake up!"
"What is it, what is it?" we say to those spirits.
Argula, the Devil, he'll say,
"Come and see what is painted up."
"Whereabouts?"

And he'd say, "Way over there, in Dulugun."
He takes us along to near the border,
then he says, "You wait just behind this tree.
I'll open up the doorway and I'll check
if you can come in. I'll tell them
that you have come to see this corroboree."

The Devil leaves the banman men at the door, a side entrance to the chasm. They go inside, they watch the dancing, listen to singing, learn and record it instantly in memory.

Their odour smells strong
like the flying foxes in that place.
We hold the *biyu*, the death cord.
When the singing and dancing is finished,
we get onto this cord.

Then our guide beckons:
"Let's go back home. I'll take you back."

Then you get your community together
and sing them the song, show them the dance.
And you tell them the name of the fella
who was your guide.

The banman goes only once for each song. It is kept for a year or more,
used all the time in corroboree, then traded on. From the same composers:

Another Argula Story

The Devil was sick and died at *An Badda*.
At a place called *Gud Enggnari*
he was covered up in a grave.
After some time had passed, the people got worried.
They had heard him crying
on the range *Waddaburgan*.
They wanted to know where he had gone.

They said, "We'll sing out.
Let's find out from which way he'll answer,
in the south or west or somewhere,
he'll answer us back. Let's call for him now,
it's Dulugun Time."
The sun was *njallara*,
just about setting.

So they went *bang-bang*
with all the nulla-nulla sticks,
and they called, "Cooooo-eee,
answer us where you are!"
"Cooooo-eee!" the Devil answered
from Sundown, from Dulugun.
The Devil formed the sidedoor to the chasm.
He had to carve his own entrance into Dulugun.

Njallara, the colour of sunset, means "arse of the sun", explains Mowal.
At one time it had happened that Manila got locked up in the underworld.

The spirits took me to this island. When I got inside, the boss-spiritman *Kalinda* came. The spirits told him, "We got Manila Karadada here. We want to show him this dance." Kalinda stopped talking and got angry. He said. "He didn't signal me. He didn't let me know he was coming. Shut the door!"

That's what happened to me, it's a song. He thought I had come through Libudbud gate, but that way for a banman is wrong.

Kalinda had mistaken the banman for a person who had died. This is the song of how they locked him up.

Getting Locked Up in the Underworld

The name of this boss-man is Kalinda,
boss-man for all the spirit people.
Grey-haired *Marrul* we call him.
He has grey hair. He came to the door
inside the chasm in Dulugun,
inside where all the spirit people are.

He said, "Who is that?"
"Manila Koordada," they told him.
Then he said, "Why didn't he give me a sign?
Don't go to him," he told these other spirits.

"I give you an order – lock that door!
He's not allowed to get out!
He didn't send a message first.
Don't you blokes go and talk to that lout.
Stop quiet here and keep that door shut."

So they shut the door.
After a while, when he cooled down,
he accepted me.
Grey-haired Marrul we call him.

Marrul have grey or white hair, often a long beard. The term also refers to Wandjinas. Another song by Manila carries an awesome message.

164

You Can't Escape Your Life Record

> In this dream I walked
> and then sat down in an area.
> Suddenly, they ambushed me
> with *jabiri,* spears.
> They came from everywhere
> until I was surrounded
> by all those people with spears.
> I couldn't escape.

It is a song about suddenly being ambushed and trapped, spears looking at Manila from around a big ring – he was well locked in, couldn't run and escape. He would have been killed if he ran, so he had to face them.

> There's a history kept on you.
> All your life's actions can look at you like spears.
> You can't escape your life record.
> The spear-holders are all spirit men,
> they make you face your life record after you die.

One last question remained to be asked on the topic of Dulugun: "In the olden days, did Aborigines commit suicide?"

No, never! Now they commit suicide, like in jails. They want to kill themselves because they are drunk. And there is no fire.

Fire is the spirit of life, love, family life, all those kind of things are tied up with that.

In the womb, we are in a little world. When we are born to the larger world, the first things we see are the sun, the family and the fire, these three important things.

We grow up with that spirit of caring and warmth of the sun, fire and love from our family. Those are the growth elements, the elements of Wandjina. Wandjina can't walk in jails.

When Aborigines are cut off from that, they want to kill themselves. They just die then and go to Dulugun. There is only that one channel. And they are all coming back.

27 Songs

The old bushmen sat under the mango trees. The dense canopy held them in a raft of sombre shade from the midday glare outside. Their chests and arms were scarred with marks of many initiations.

Hector Dargnall was there, Dickie Woodmorro, Manila Karadada, Geoffrey Mangalgnamarra and Ondia Augustin.

They were singing songs that had come from their fathers and fathers' fathers. No youngsters would carry this lore onwards into the future, only Mowaljarlai, who had brought them together – and a tape recorder. They wept as they thought of their Kimberley history in limbo.

The old men evoked How the Land Became Dry, a song of praise for the Snake to stand up from the waters. When she rose and kept rising through the clouds, rain fell on earth. The rain ceased as she climbed higher to tie up the land in a rainbow. Then the land became dry, and the Wandjina painted in the caves.

Another of Hector's songs leapt through ice age and flood, from before our time, when the Big Wandjina walked through the mists, through haze and fog, designing everything. The names of the first composers were still with these songs, no matter how ancient. In essence, poetry will not transfer into translation, and the magic of the rhythm dies. Only stories remain. Some of these emerged from unfathomable depths in time.

[The following songs contains references which are culturally sensitive and should be passed over by Ngarinyin, Worrorra and Wunambal girls and women still of child-bearing age.]

How the Crocodile Brought the Fire

Wunggu was of the Wodoi Tribe.
At night, he camped in the dark without a fire.
He was cold and hungry as he ate his food
without cooking. It was Djingun, the Wandjina
of the Milky Way tribe, the Wallanganda tribe,
who made the first fire.

Mandangnari Crocodile Dreaming, Kennedy River

Ondia Augustin, Kalumburu

George Ainbee (totem bottle-brushtail rat)

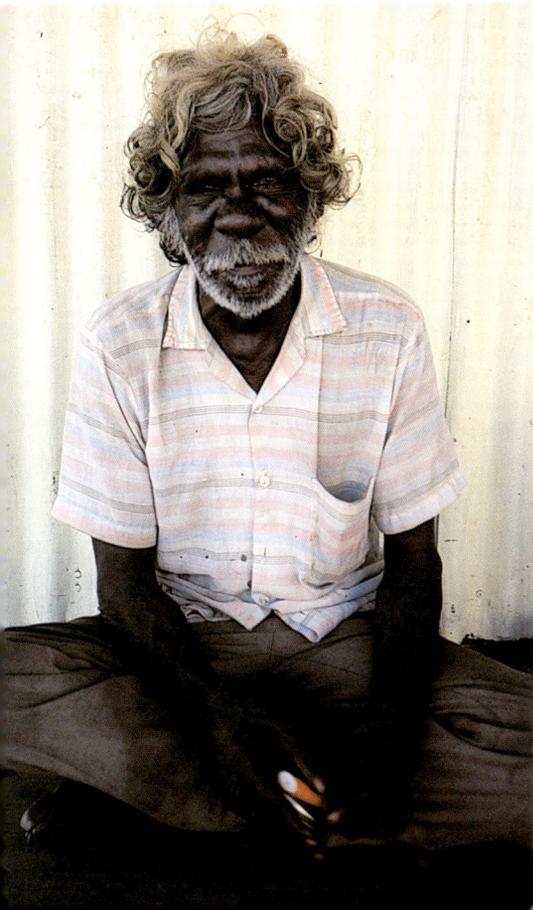

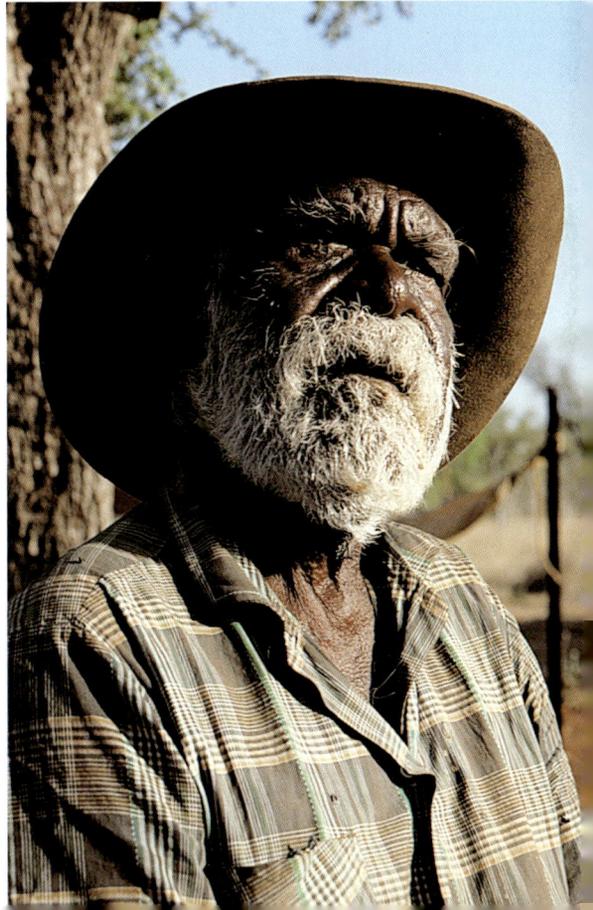

It was burning deep inside a hollow log.
The crocodile had seen Djingun stoking the fire.
He went inside the log and stole a glowing branch.
On his way back to the water
he was hiding the fire in his belly.
It stuck out on each side of his abdomen.

As he slid down the river bank,
the Blue Mountain Parrot –
who belonged to the Wodoi Tribe –
came titititit … took it away
and brought it to Wunggu.

That's why the Wodoi and the Djingun tribes,
all have fire today.
Fire is the spirit of life,
of love and family life.

Man/crocodile marks, the "cartridge-belts"

Hungry Guts, the beautiful, lissom Brungnun Ombud crocodile, is a Wandjina-chosen animal. He still carries fire inside the lower abdomen, *wianu nangga,* two red organs 3-4 cm long. His tribal marks, the *njawalla,* are like a cartridge belt on his compact, streamlined body.

An even colder air of prehistoric climates flows from the following songs:

Wunggu Wodarra Yallimballi Ngagnari

All these words are one name.
Wunggu – the man who camped without fire.
Wodarra, another name – he is my brother.
Yallimballi Ngagnari – Wandjina with rain and wind
knocking the trees down and bending the bushes.
Yallimballi is a Storm Wandjina.
He painted himself at a place called *Mangarari.*

This is the story line:

Wunggu's three names bracket the time from man as a crawling, blind creature to a stage where he begins to cook on fire. He is Dargnall's brother, an ancestor [Hector previously referred to an even earlier time, "before your father and my father was born"]. Wunggu's third name, Yallimballi Ngagnari, indicates that the Earth was still a very rough and stormy place.

Then some kids coming with *ngala,*
hunted animals. They put'em down,
put'em down, put'em down, three.
Karimbu burgnul meri.

Karimbu is the bandicoot.
It belongs to burgnul, a grass.
This bandicoot dug a hole
and wrapped himself in a grass wallet,
in the earth. That was his
little humpy house.

Another Wandjina came along and said to Wunggu,
"Oh no, you should put this animal down
where the fire is, you should cook it."
"But I camped without fire," Wunggu replied,
"I have never cooked meat before."

Another Wandjina said,
"I am *Dargnall Dargnall,* the waterlily."
The Dargnall Dargnall Wandjina
took a waterlily from where it grew.
He dug a hole in a flat rock and put it inside.
Then he made a lid of paperbark and put it on.
It was a camp oven.

The Dargnall Dargnall waterlily was Hector's first forefather. During flood and ice age the bark lid turned into rock. The lidded slab, known as the Camp Oven, is still visited.

Then the Wandjinas Dargnall Dargnall
and Wunggu had a conversation.
"I have a big name and you have a big name too.
We are two equal big men," Dargnall Dargnall said.
"There are two caves here and we will share them.
I'll take the low shelter because this place
Mangarari is my home.

Waterlily pads and roots, bees gathering from the flowers at Waanangga

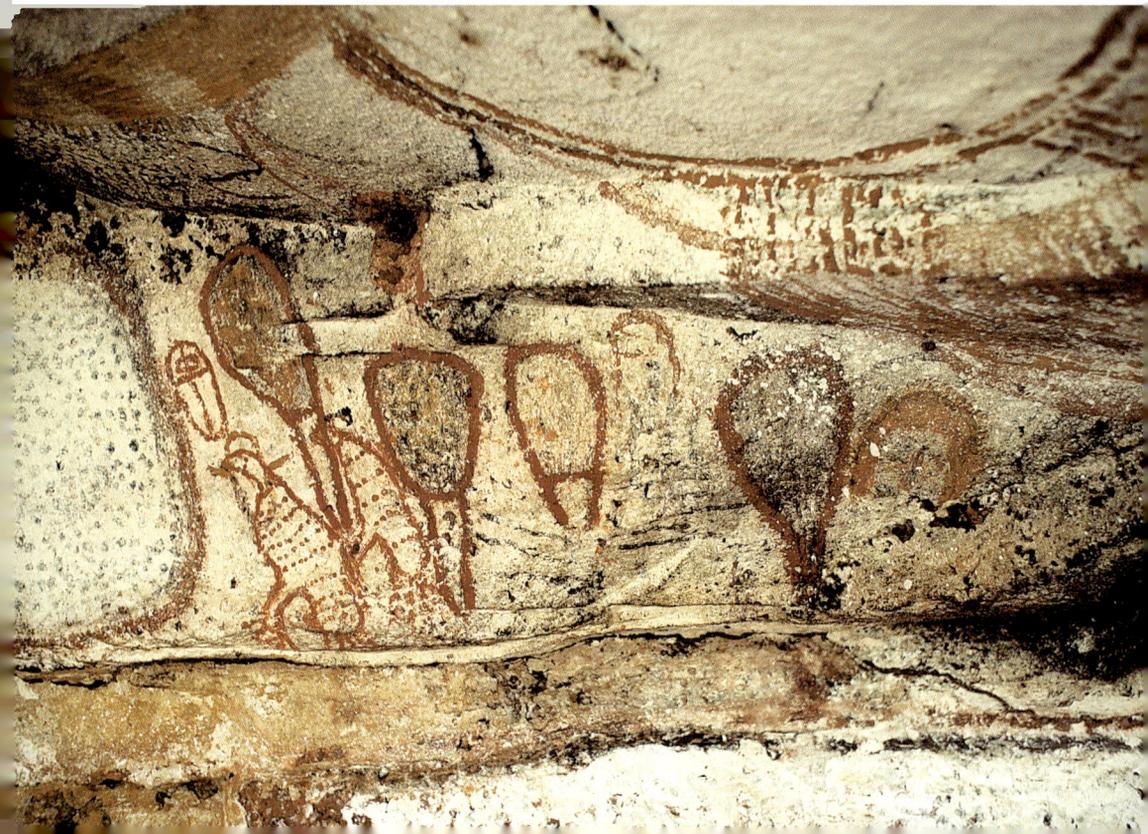

This is me, *Bulludgnu Illagnu,*
the waterlily in the little camp oven
in the lower shelter painting.

"You Wunggu, you travelled from afar,
so you will take the high shelter.
It lies in the direction of the land
where you camped."

And they made a distinctive land-sharing agreement between two
equal Wandjinas.

"You cannot lift this shelter from the earth,"
Dargnall Dargnall said to Wunggu,
"You cannot take it away. It belongs to here."
But Wunggu lifted the shelter and carried it away.

Mowaela; waterlily tucker in wunggud "sweet water from Wandjina"

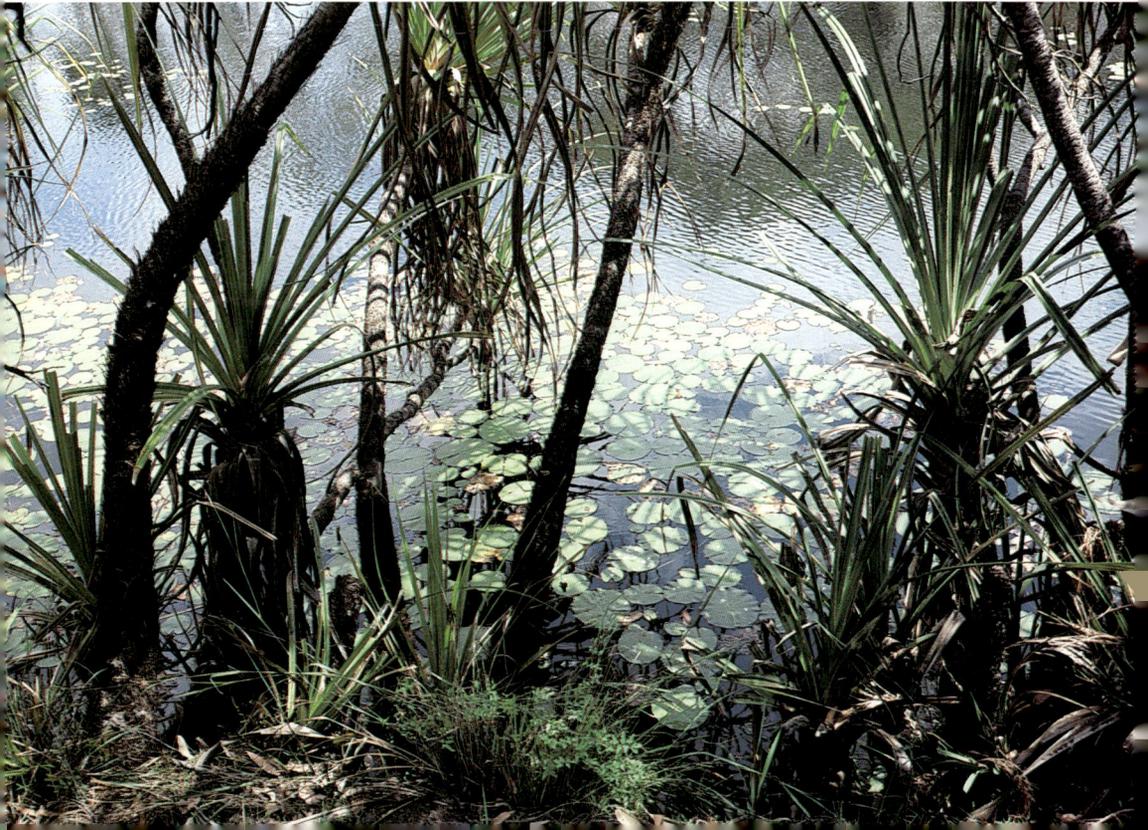

"It's a range we call *Mannunggu,* Mister Ranges," says Mowaljarlai, "because Wunggu carried it."

The Mannunggu Ranges are in the Drysdale-Doongan area. "This is how the Wandjina sorted out the real estate before they handed it to the people."

Singing story to their clapsticks, the old men surfaced concepts long thought lost in the depths of time.

One refers to the Snake's shadow falling onto the earth at sunset, projecting colours of darkness.

Another tells of a mountain range which is suddenly covered with a scaly danger-skin, a warning. Yet another story at once reveals an amusing-looking rock to be the very persona of a devil.

A touching little story tells of a woman's sullenness. When I asked what it was meant to express, Mowaljarlai smiled and reminded me gently, "Just not to forget that these things happen in life, people will sulk."

Then a wobbly island is brought to attention. It has to be straightened – it is toppling because the earth is still jellysoft, the island without a solid foundation.

And, with yet another story, we become aware that the Snake's powers, still very much alive and active, are blocking mankind from higher knowledge.

But in the Dry, Aboriginal people always knew through songs that their main camps had to be where the Snake was holding the water for them.

In times past these songs travelled along the trade routes all over the country and were constantly evoked in corroborees.

First news of a modern event, the forced landing, in 1932, of the Junkers seaplane *Atlantis* on the extremely inhospitable and isolated northwest coast of the Kimberley, also came to Manila by way of the spirit world.

I was walking [in my mind] over *Kayagnu* country and saw an airplane sitting down. I said to myself, "Olo, this is an airplane that fell down here. Who belongs to this fell-down airplane?"

When it's sitting on the wheels it's like hanging. I then asked my spirits, "What country this?"

"This place is called *Yayit.*" At the Berkeley River.

"And this big hill here that's hanging up so high?"

"That big mountain is Kayagnu and you are standing in Kayagnu country now."

Then I asked them, "Who belongs to this plane that fell down?"

"It's a German plane." Instead of saying "German", those spirits were saying, "Djarmani". The spelling is different, but the rhythm is right.

This story, sung to clapsticks, is now part of local history.

The Seaplane that Fell Down

Place in Yayit.
What about this plane now
where it's hanging up on the earth?
Between Yayit and Kayagnu.
That what fell down on Yayit
it belong to Djarmani people.
Yayit and Kayagnu, on land
between the island and the mainland
where this big mountain is,
in between the two and nearer Kayagnu.
It landed there. That's where it fell,
right in the middle, on land.

A book and a television mini-series, *Flight Into Hell,* about the crew's forty-seven-day ordeal of survival later made the event known around the world. The pilot Hans Bertram and his mechanic Adolph Klausmann were found by Duwarr, whose widow Manuella Purrwan still lives at Kalumburu. Duwarr was with a hunting party, which cared for the two aviators, while Miamun guarded the seaplane. It may have been Bundumirri, then wife of Duwarr, who encountered the police search party and led them down to a gully tp the place where Bertram and Klaussman lay.

"Bread, bread!" were almost the first words they uttered to the punctilious Constable Marshall, who refused credit in his report of the rescue, stating that the downed aviators were already found, when he got there – by Aboriginal hunters from the Drysdale area.* In gratitude for the rescue, the 1932 German Government made citations and awarded a number of medals, none of which went to the hunters. No official recognition appears to have been given to Duwarr, Miamun or Bundumirri.

* Western Australian Police Records

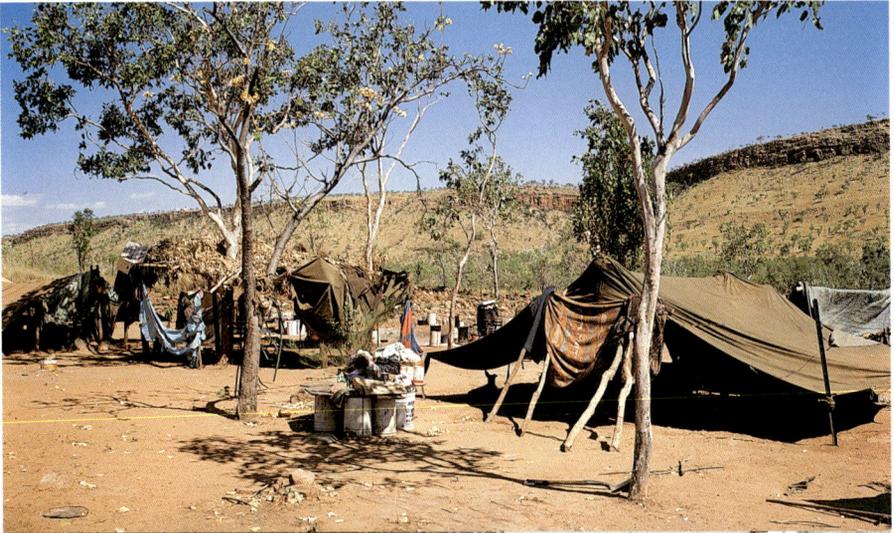

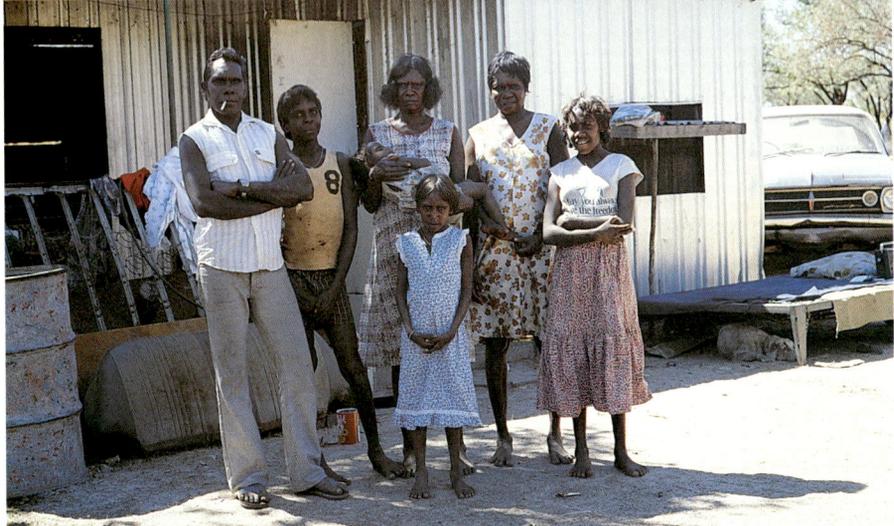

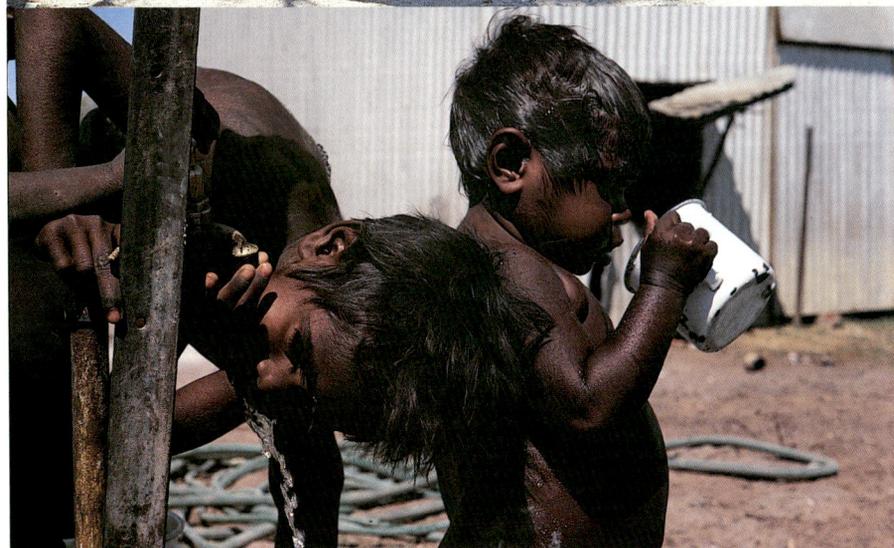

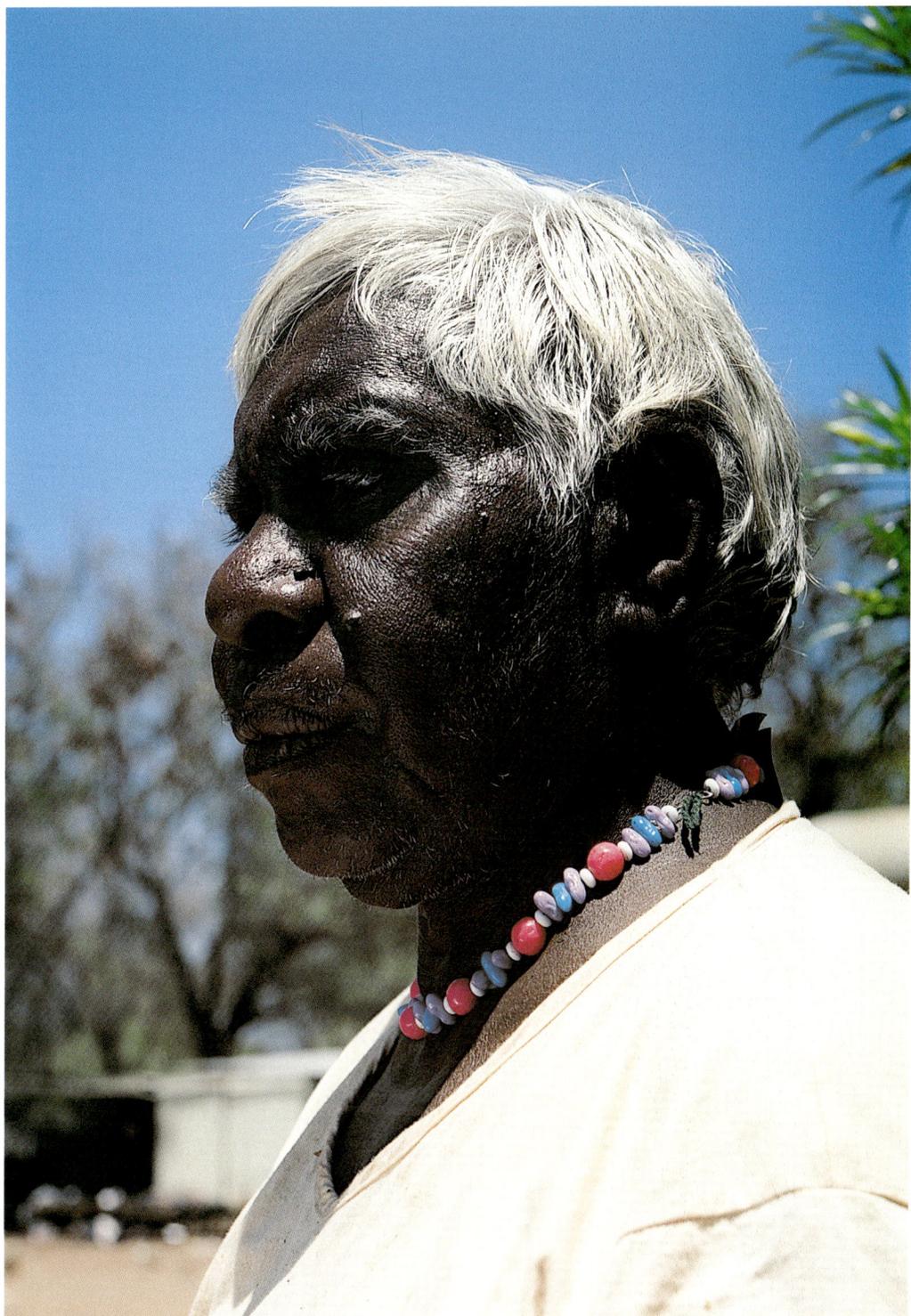

Daisy Carldon, Mount Barnett, born on Carlton Station. *Opposite above:* Iminji outstation, Settler's Creek. "Here the people came after they were kicked out, when helicopters took over cattle muster." *Middle:* John Martin (Scotty), composer, song man, with family at Waa. L to R: Scotty, Mark, Maisie Martin, Maureen (front), Jessie, Tracy. *Below:* Meda Station

28 Healing

This old-time story, told by Geoffrey Mangalgnamarra, reveals how a banman is given healing powers from the Earth Snake.

A young man said to an older banman, "I want to be a doctor. Could you aim for that Snake, direct my wish to her that I want to become a doctor."

The banman said to him, "You like? you feel happy?"
"Yes, I want to be a banman doctor, *gadun murrungaddu.*" Gadun means "professional doctor", murrungaddu means "to handle magical things". You must study these things to become a gadun.

An old experienced banman, a man-who-climbs-up-to-the-clouds, then broke a signal grass, a skinny spearlike reed that had magic. He threw it to the Snake who was sleeping deep in the water. The grass went down and bumped into the snake. It woke her up. The people were watching from the top to see if the Snake would come up.

First thing that came out of the water was a boab tree. The second one, a paperbark tree. Then another one, a Leichhardt pine. Last came a pandanus. Those were wunggud trees.

After the trees had come up, then *she* came up – *Burruburruba Djingit Binji.* Burruburruba came up and launched herself onto land. She surfaced in the shallows and glided onto the land where all the men were standing. There she came to a full stop. With her some *yanggu,* waterlilies, had come up.

The banman men then asked her to make this young man a doctor, to give him a *jagula,* a quartz stone. There is healing magic in this jagula. The Snake has a voice; she can talk. She said, "Yes, I will do so." The old banman men said to the Snake, "Give us this magic. We will put it on him."

Then the young man became a doctor, doing good and helping people till he got old and died.

The name of this magic stone is *Olumballu.* A power/healing stone, a *kandukandela,* it transfers to another banman when the doctor dies.

At one time, a relative was mortally ill. Message went to the doctor: "Your brother very sick, just about dying. Could you come over and fix him up?"

"Yes, I will do so," he said. "Bring him to the water. I want to dip him in the water." Then he yelled out to that Snake and the Snake came. She licked the sick man with her tongue. He was all right. He walked and he lived again.

It's different now from these old banman people that were called gadun. These days we don't have these clever people any more. Today we get cut by knife and sewn up again.

Before, the banman looked at this sick man, saw the place where he had the pain. "Ah, here is where you have the pain." The gadun then sucked the bad blood, spat it out and had taken the suffering away. The good blood was flowing, the man became strong and never suffered again.

At times, these old-time doctors also practised the laying-on-of-hands method of healing. I asked Mowaljarlai if he had actually seen such extraordinary healings.

Sure, first time when I was a cabin boy on a lugger. We used to get trepang,* smoke them, put them in bags and sell them to China. A young fellow had a blocked bongle, a blocked bladder. He couldn't pass water.

They sat him on top of the hatch on the boat. A banman sat behind his back. His own brother sat on the deck beside him. They opened his legs. They put this olumballu in the back, in his kidney area. They pushed it through. It came out in front and the water rushed out. His bongle rushed out and the olumballu fell out with the water.

I have seen that. This banman had said to me, "Just come and watch." It was unbelievable to me. I was just a young cabin boy at the time, cleaning the portholes with Brasso. The man with the blocked bongle lived until now. He died just recently.

There are plenty of banman stories around. One banman walked away with the leprosy.

Mowaljarlai heard this story from Wilfred Goonak and William Bunjak. In the late forties, they lived with the former leper, lately a clean man, on the Mitchell Plateau. They were all bushmen.

* Sea Cucumber, probably Holothura scabra

He was covered with leprosy like oysters that grow on the rock. Everybody was frightened of him. So he said, "I am going to the Snake Wunggud to clean myself up." He told everybody.

In the night he went away to see this Snake. They followed his track, but the track ended at a mountain cave, where the earth had opened for him. "Oh, he down there," they said. That time, he was lying on a rock in the cave. The Snake was licking him, cleaning him.

When the men on top sang out, "Hoi, you down there?" he heard them and got up. On a stone, an olumballu, he was taken into some water there, under a ledge, then the stone took him right to the surface. He jumped off, swam ashore and walked away. The stone went down again.

Mowaljarlai laughed, "That's a banman story, really talk among banman people, gossip. He was away for about an hour, in the night. In the morning he was totally clean. I saw him clean after that. Everybody knew that story."

Dargnall at Alwayu Daisy Utemorrah at Gibb River

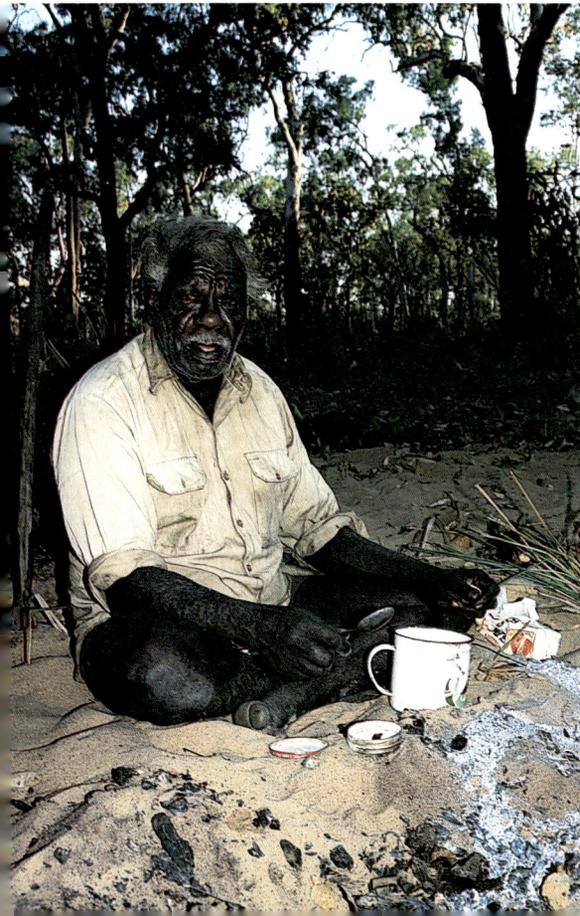
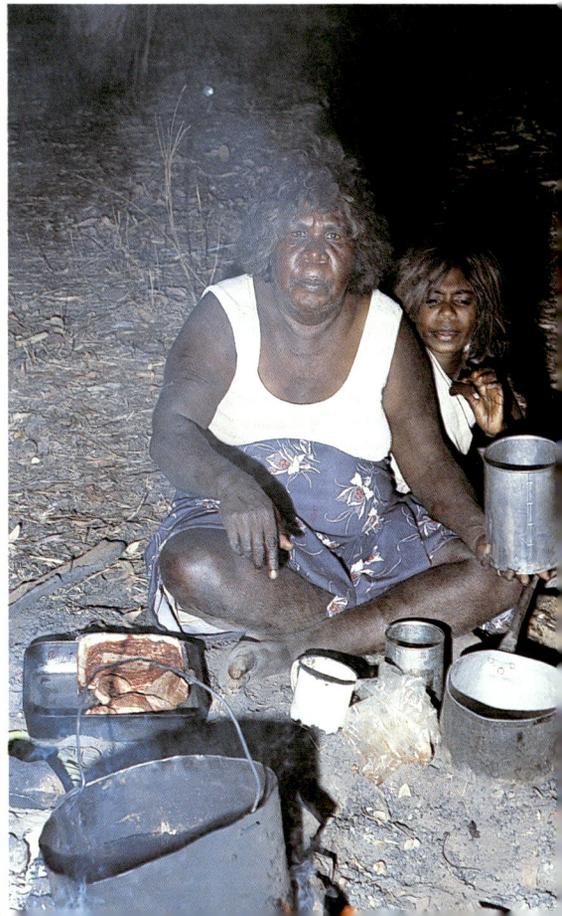

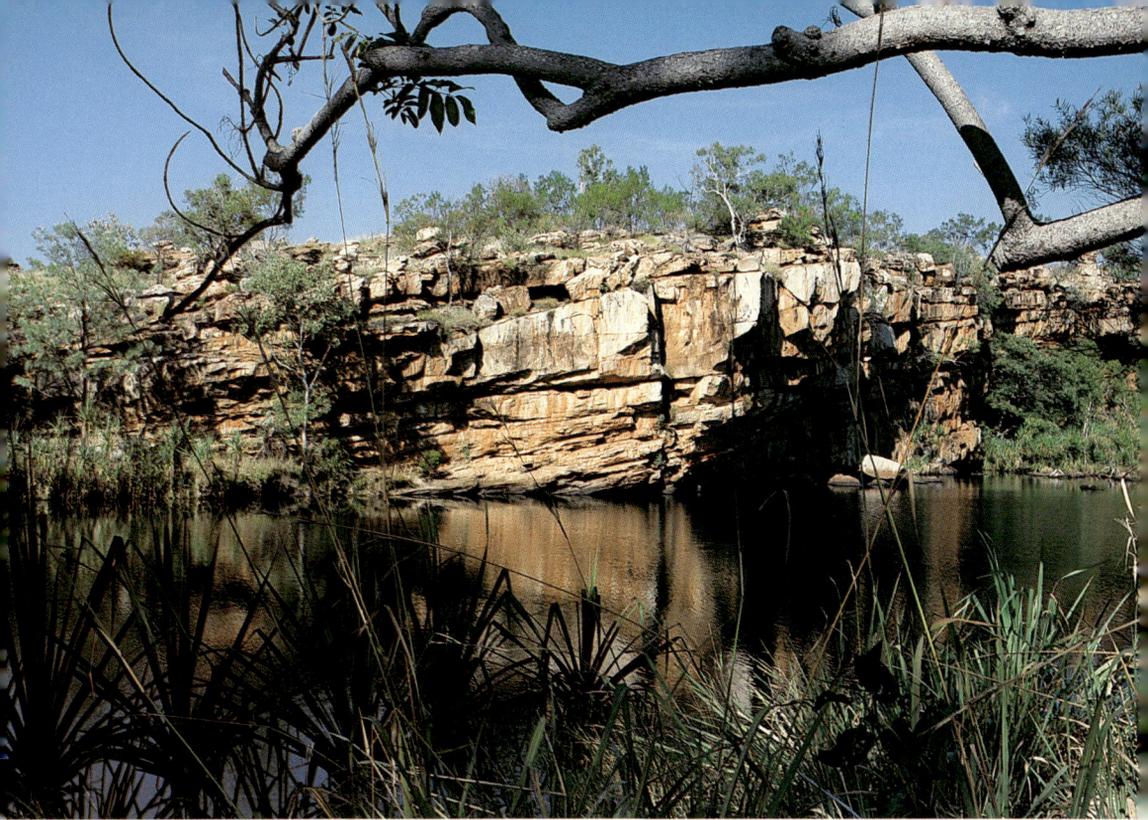
Manning Gorge, where a Wunggud Snake came to rest

Boab. Photo John Wolseley

29 The Flood

Kimberley lore recalls a Flood that is notably different from the one in the northern hemisphere. Here it was a flash-flood that came up and went down within twelve hours.

We discussed this in Sydney. It is held that some Worora people survived on a mountain in Prince Frederick Harbour; while in the lower Ngarinyin and Wunambal countries even fewer lives were saved. This is Mowaljarlai's story of the Flood:

> A long-long time ago, more close-up to Creation, there were people living in this country when a sweeping flood came, very fast. Some people survived.
>
> My father used to tell me they hung on to a tree called *wumberagun,* with black berries on it, because they have the strongest roots. English people call it wongai tree.
>
> That was on Doubtful Bay Mountain, in Walcott Inlet. There is still a waterfrost of white crystal around the top of that hill, four or five feet down from where the survivors sat above the water level.
>
> Others climbed hills at Kalumburu and at Kununurra, where Illarra, the long silver Barramundi jumped when the Flood came. The mark of the water is still there.

The story goes that where Illarra the Barramundi jumped, it turned into Mount Foot, the mountain facing Lissadell Station near the dam at Argyle [shown as Pitt Range on maps].

> This became a sacred place for women. When the floodwater went back, some women came down from the top to trap the Barramundi with a grass fishtrap. They were bending down and rolling the spinifex trap, when the Barramundi jumped between their open legs and pushed a hole, a gap in the mountain.
>
> The women changed into a group of *wurrunda* trees [paperbarks of the tea-tree family]. The gap represented the inner walls of a woman's genitals. It became the women's private place where they bathed when menstruating. Young boys were not allowed to go there.

The Barramundi then swam towards the Ord River and left the higher waters behind. That's where they made the Argyle Dam now.

The floodwater went down fast. The Barramundi turned back east. When the water was down, Mount Foot became the Barramundi, representing it. Where they pushed the net, the women all changed into wurrunda trees, barramundi trees. It's a prayer place where they touch the trees for more barramundi to come.

There the Gap formed. It's a little pocket, a dent, a little window, where all the diamonds are. They have blown it away now, you can hardly recognise it. It's completely wiped out by the Argyle mine. It makes you cry, that place.

In other places, some of the Ngarinyin and Wunambal also survived. But later, when the Ice Age arrived, all living beings turned into rock.

Those earlier people who lived before the Flood, they got destroyed. The second mob, they were the Wandjina men that manifested, painted themselves, at Wanalirri – Tucker-Yam Wandjina for instance.

When the Wandjina walked back to their homes, they waded knee-deep through the roots in floodwater. They put the pattern down again after the wipe-out, they started Life all over again. What they manifested then is what we are looking at today. That's what we go and show people, what we know.

That's why we call ourselves Wandjina people. Everything started all over again after the Ice Age. It was Creation again! What happened after the Ice Age is this mob now – Wandjina again.

But how could they know that people and the social arrangements were there before?

Those animals and people who turned into rocks, they were the Before Ice Age mob, the *Birrimitji*. They painted the Ngolngol Rain Spirit, the Hopping Djua and the Lightning Spirits. We don't know about these, they were here before the Ice Age.

Where the Yam Wandjina walked to the cave, there are human footprints. And he has a painting there. It took place after the Flood because it is a human footprint. They walked about and their numbers increased again.

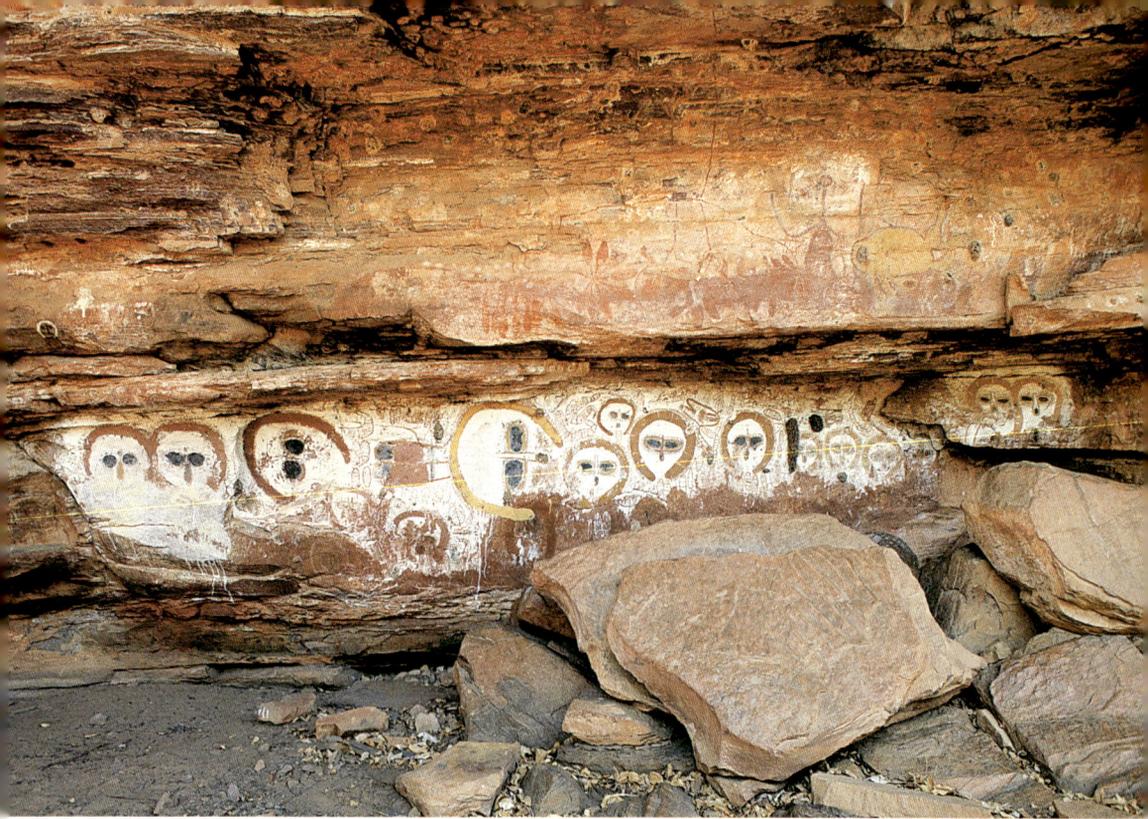

Wanalirri. Ancient Before-the-Flood paintings of Ngolngol Cyclone/Rain Spirit and Djua, the hopping Devil-Devil Bird (upper right). Mowaljarlai's ancestral place

Marnyangarri: Cuckoo Wandjinas, history and genealogies, a continuous series at Donkey Creek ..

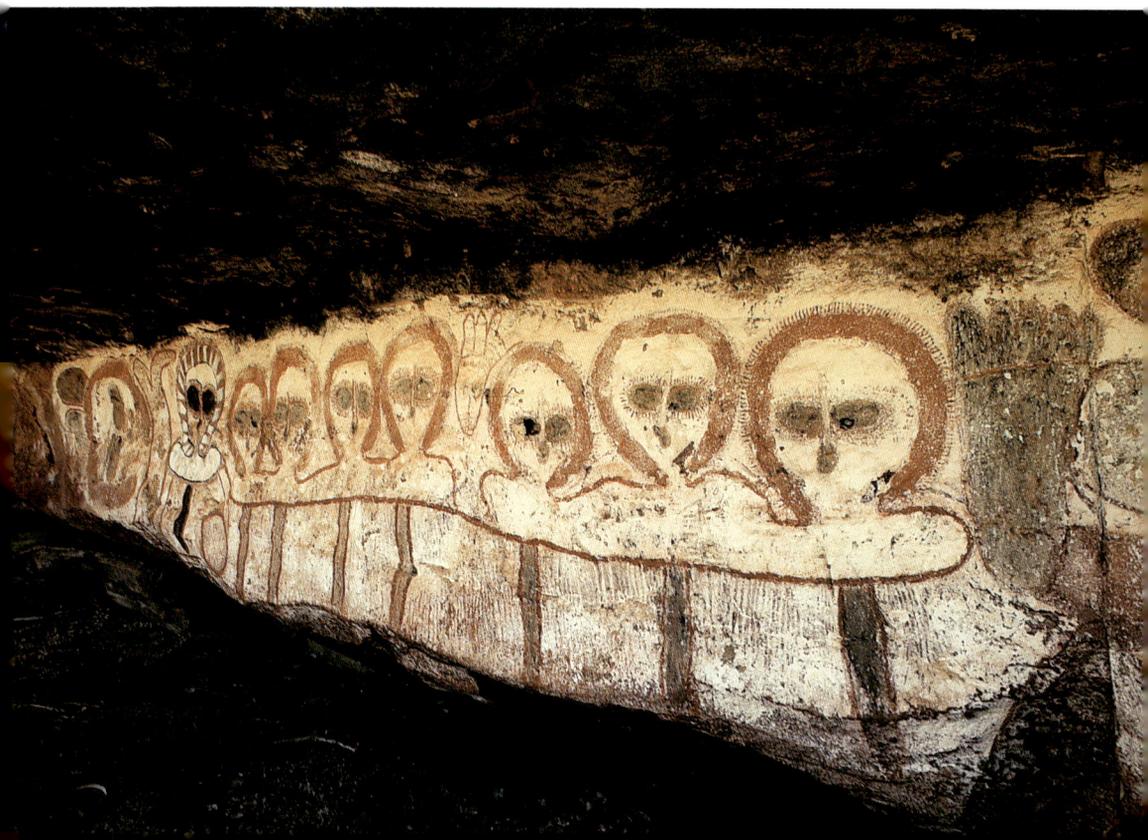

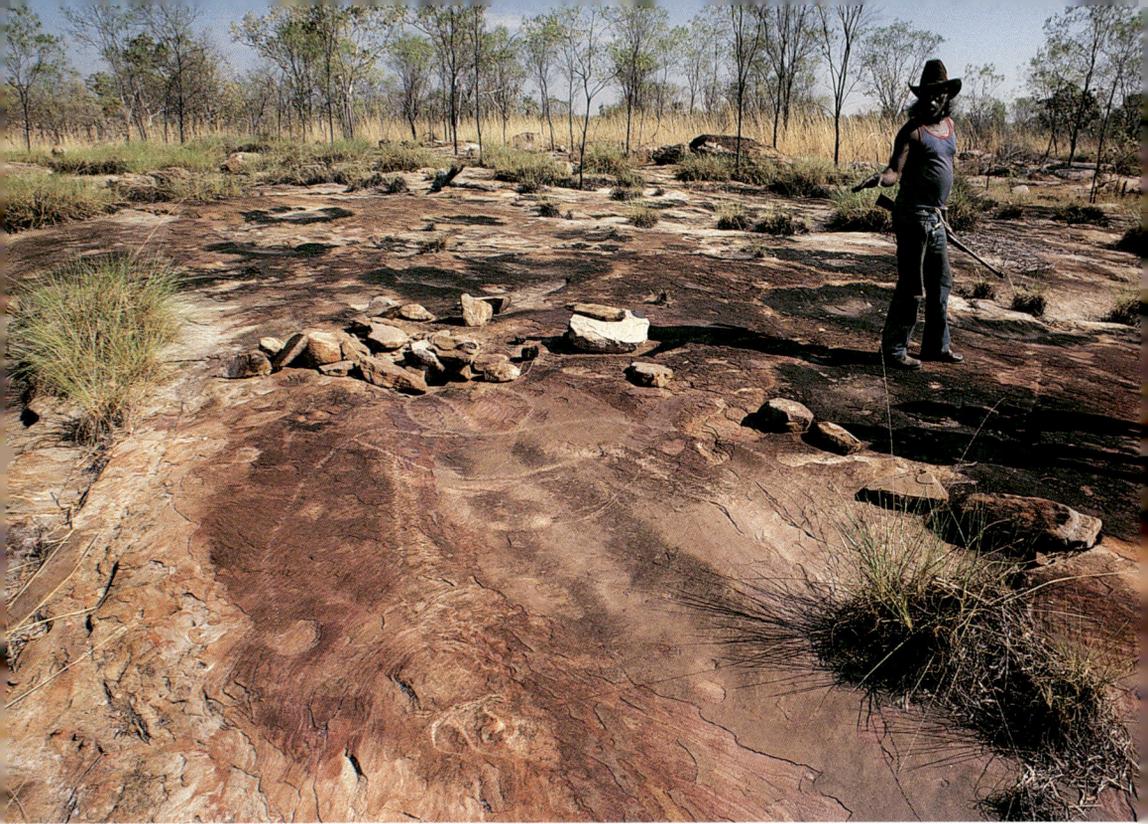

Wandjina Mejuk, incised in the rock, indicates an important site nearby. The stone arrangement surrounding the head has been scattered by cattle and donkeys

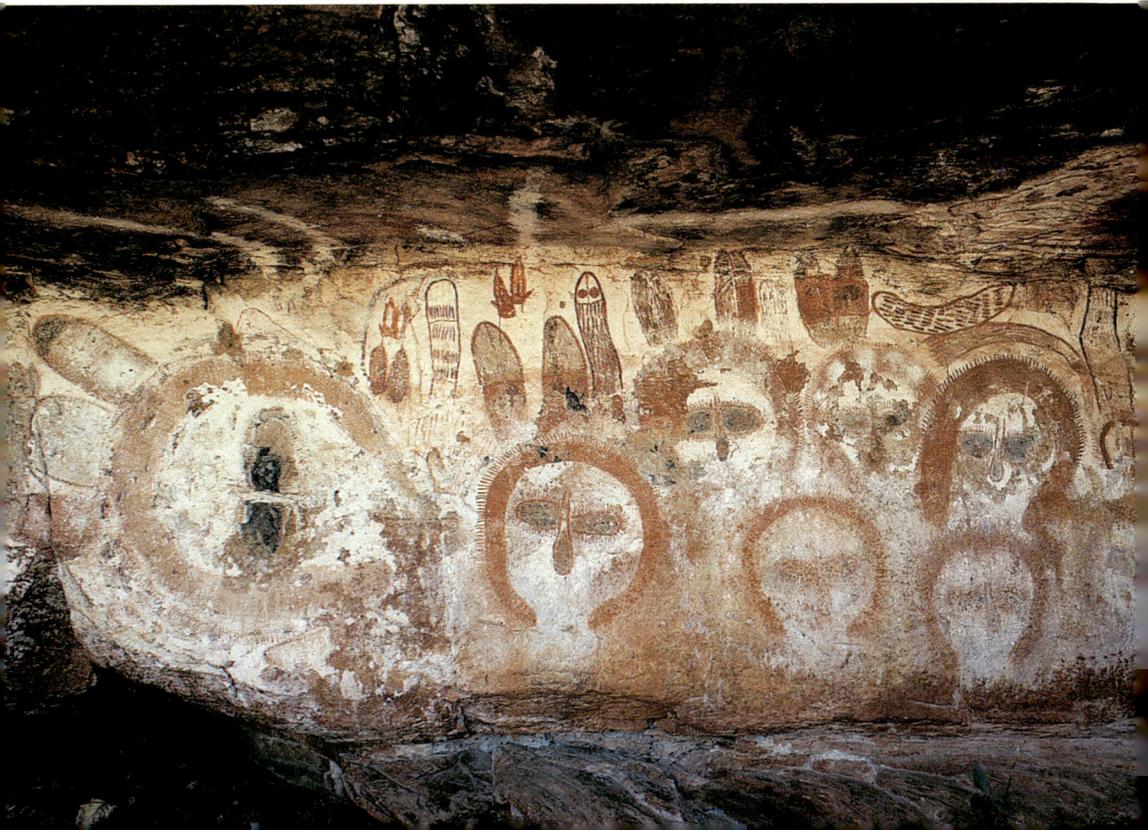

PREPREP FLOOD PAINTING

MITCHELL PLATEAV

RANGE 200 FROM CAVE

FLOW OF RIVER

FLOODSTONES

FLOOD PAINTING

MEN

CLEANSING PLACE

WOMEN

ALTAR

'DILGNI'-MUSHROOM INCENSE CLEANSING

TREE OF KNOWLEDGE AND LAW

STONES: 'UNMALLARI ULARI BANBUGNUNN...
... MEANS- 'BELONGING TO WANDJINA,
... SANK WITH FLOOD

KING EDWARD RIVER

DRYSDALE RIVER

ROWE RIVER

ER FALL

TWATER TO HERE

PRINCE REGENT RIVER

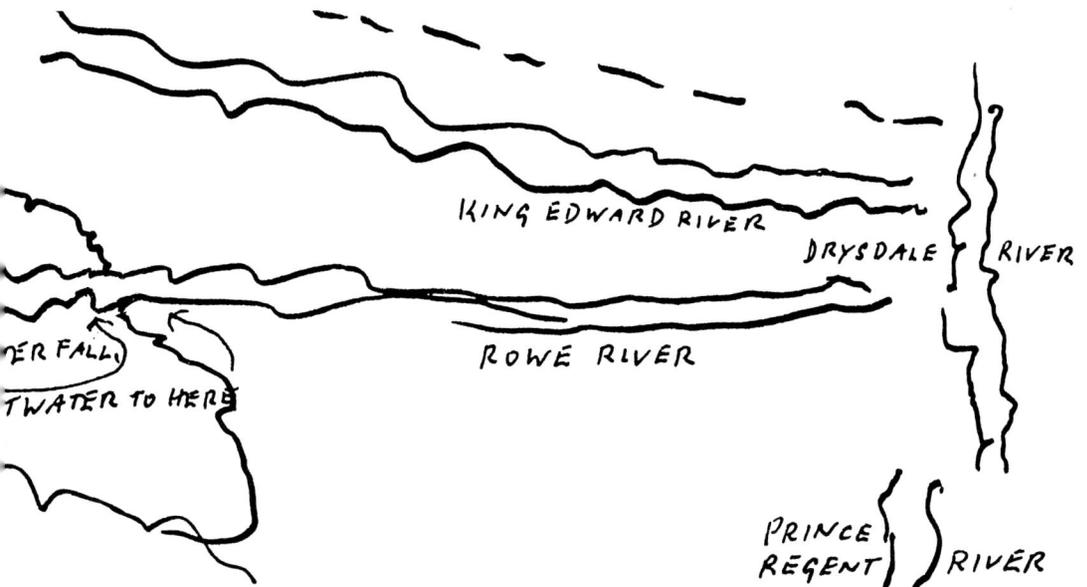

VE:SHELTER: WULLUNG: GNARI
MEANS - 'HOLY WATER REPRESENTING CREATION

DEAD WANDJINA

'LAMBARRA'- HISTUCKER
(WITCHETTY GRUBS)

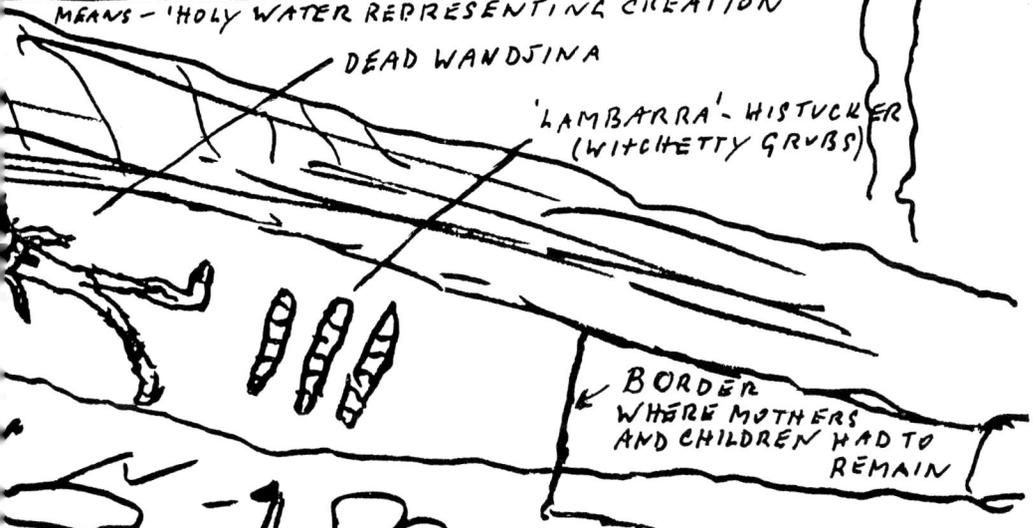

BORDER
WHERE MOTHERS
AND CHILDREN HAD TO
REMAIN

WARRABI - WHOLE AREA
MEANS - 'WHERE HE SWAYED
ALONG

TOMAHAWK

GUT GNUNGGA' -
FLESH MEATBALLS

The Flood story

185

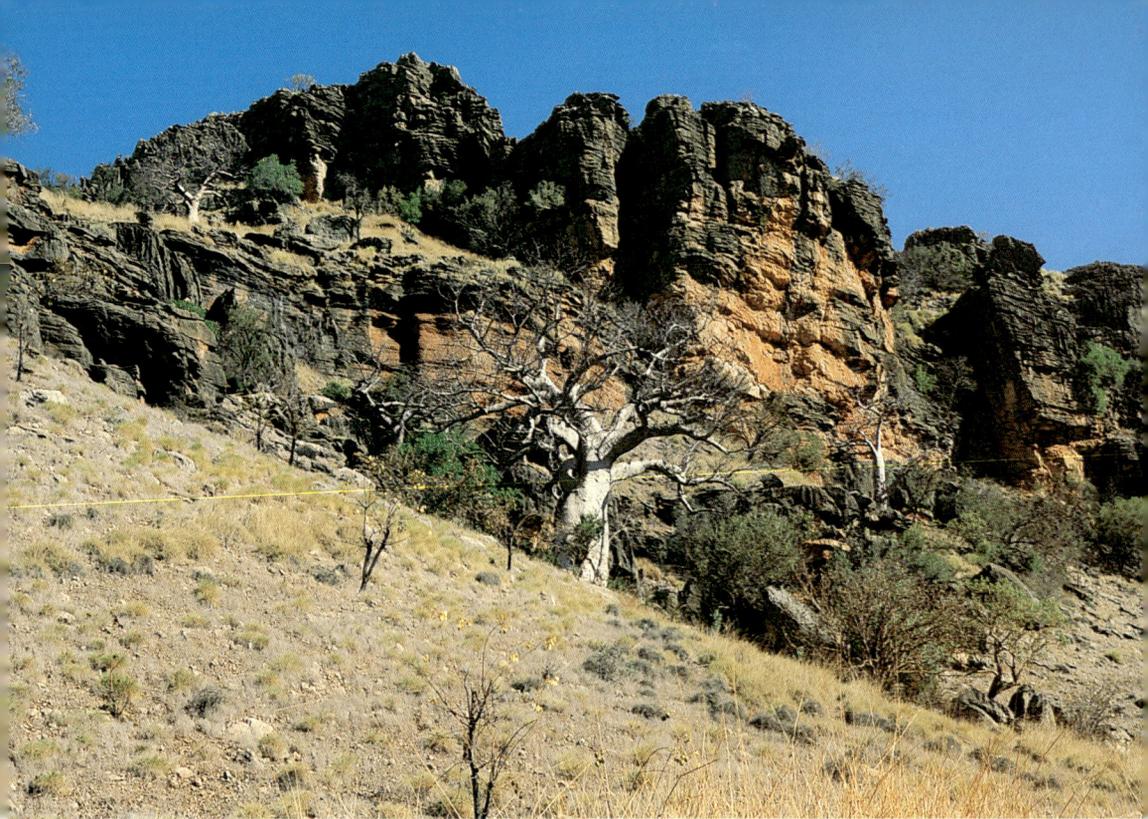

Yamara, Victoria Gap, Napier Range

Left-handed Waderi [Wodoi]. People had used crocodile like a boomerang or spear to run through a man when fighting, thrown eels, turtles, brolgas at each other. Angry Wandjina *Rowalumbin* punished them for maltreating animals by drowning them all in the Barker River

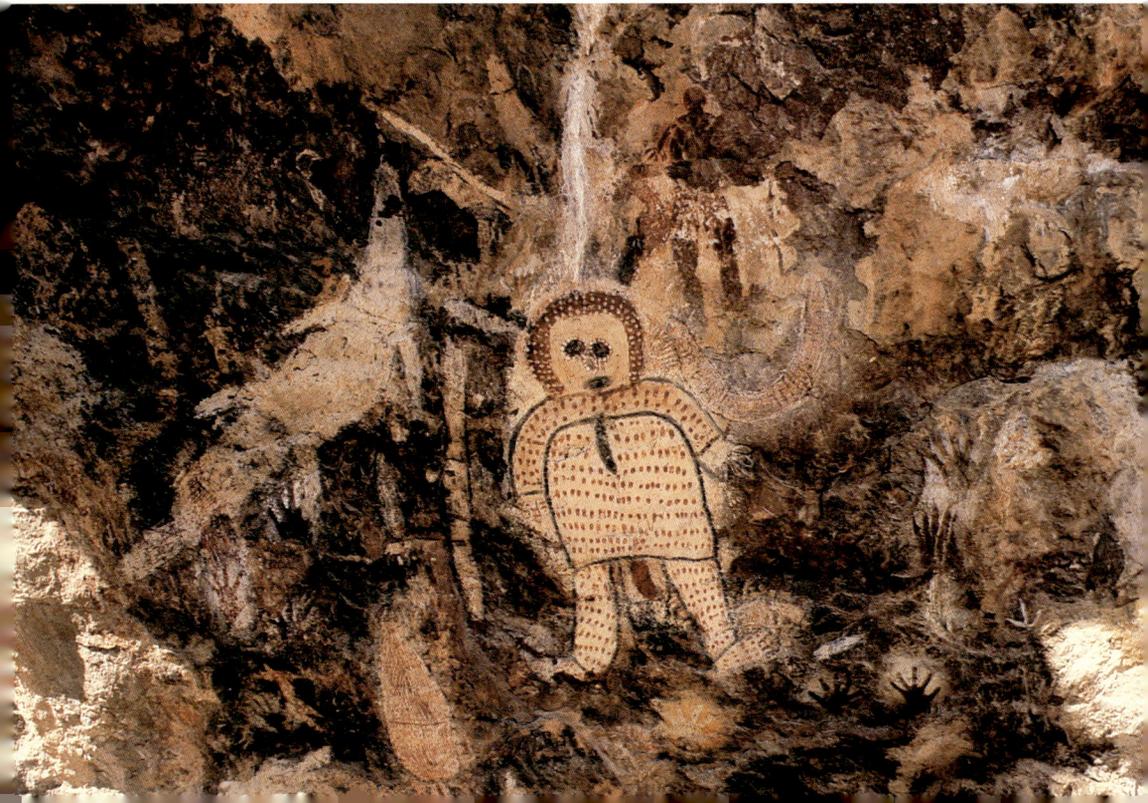

It was a *re*-Creation then? And the Wandjina returned to revive his original, but by then petrified, patterns from the time of the Beginning?

Right, that's what we are really talking about. Every Aborigine knows that after the Ice Age everything started all over again. As a whole, I have come to understand this myself only not so long ago. The people that painted the Ngolngol, the Lightning Spirits and the Djua, they are the oldest kind, before the Flood, people called *Munggugnangga,* from Ancient Time, when this land was all one big continent: *Bandaiyan.* Those Ancient Time people, they had their own grids for land, animals and food totems.

When the saltwater went down after the Flood, some people were cut off from the continent on islands. Because of the laid-down grid system, they had yams, wallabies, lizards and dingos again in those islands. They totemised their island, and they started off with a different language.

The Ice Age left the old rock art. After that, Wandjina started to put his print again on his chosen caves. He renewed everything – same as in Lalai.

The people that were cut off on islands, they made rafts and boats to swim from one island to another and back across to the mainland. They were Worora, Wunambal and Wunggarang people. The Bigge Island (Wiyuru) mob that knew the story, they are all dead now. People died – but we know their story.

Rugunda, site on Roe River; snake taking bandicoot in a cave

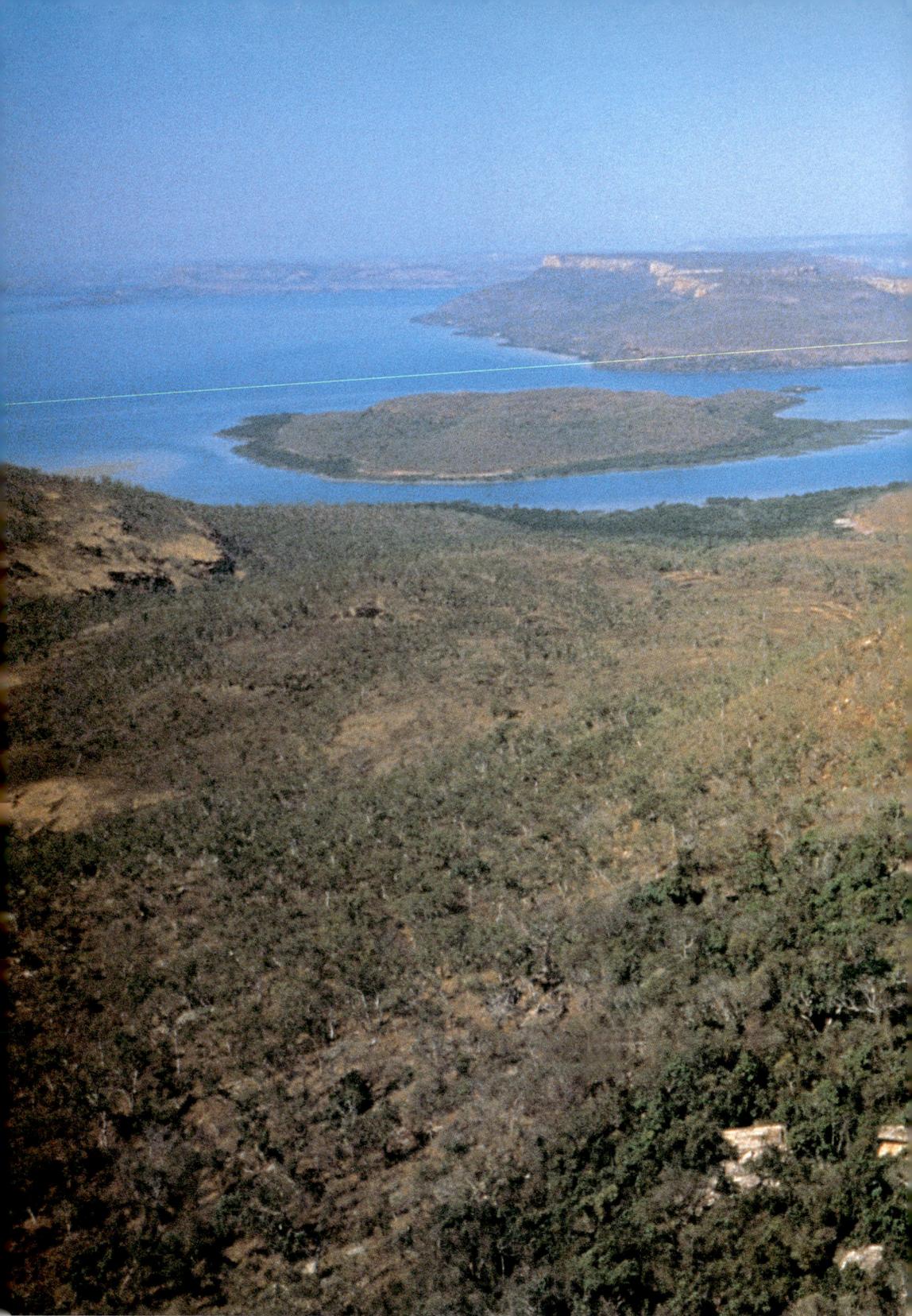

Kimberley coast from Mount Trafalgar *Nyanganyanyi*, showing *Bandjuwarra*, Entrance Island.

188

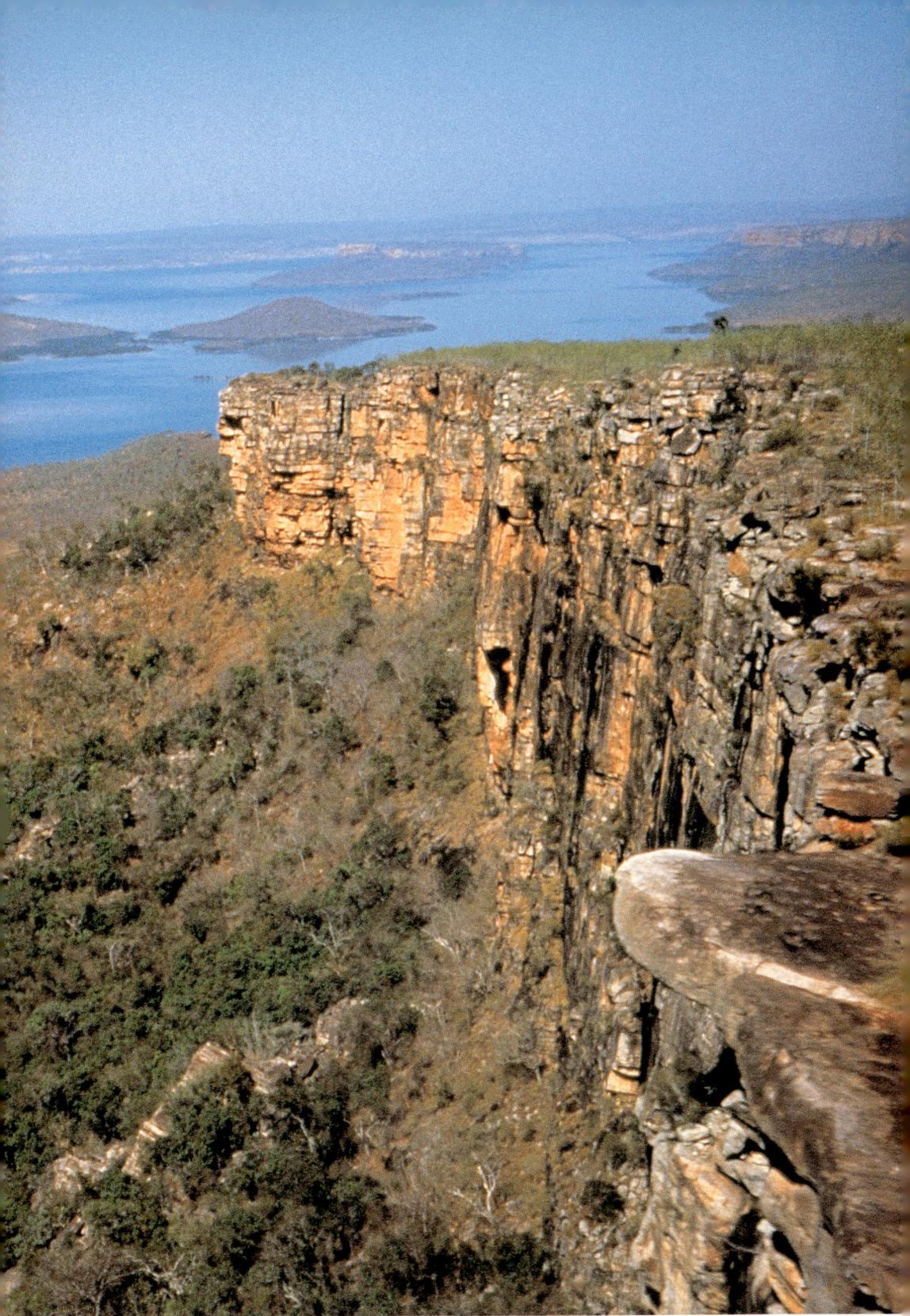

189

30 Bandaiyan – Corpus Australis

Did the Kimberley people know that Napier Range was a Great Barrier Reef in the ancient Gondwana Sea?

> Yo, that's why we call it *ballul* – reef. You can't walkabout with bare feet, it cuts you footbleeding like walking on needles. You can see mud there and shell-goods all along the desert. We know that the land and the ocean changed in the Flood, but the pattern stayed on the ground, wet or dry.

At this stage Mowaljarlai resorted to a drawing pad. He sketched an outline of Australia and filled it with a criss-cross pattern that reminded me of the weave in Fijian lobster traps.

Then he pretended to lift the lattice work, the image of Australia, with the scoop of his hands. He was showing me a three-dimensional continent. His eyes, over the top of scratched spectacles, sought my fullest attention.

> I want to show you something. I want to show you how all Aboriginal people in Australia are connected in the Wunnan system.

> The squares are the areas where the communities are represented, and their symbols and the languages of the different tribes in this country from long-long time ago. The lines are the way the history stories travelled along these trade routes. They are all inter-connected. It's the pattern of the Sharing system.

> In history, the Flood started up north and went all through the country. We call this land *wurri malai* – stooped, because it's sloping down, bent. We think of Bandaiyan in those terms, as a human body. From Central Australia the country starts to dip, it's slanting to the south. The high country is more level because the topside lifted up.

> The globe shook itself to slide the water off. There is a Wunambal song: *"Garra wurri malai minji,"* this land was dry quick because the lower side was draining away quick. The land just shook itself, and the water rushed out as quickly as the Flood had come in, very fast. I am giving you this image of the earth shaking itself. This image was given to us in song. Images overcome Earth power any time.

Then Image power is stronger than physical laws?

> Any time. And, because of that slope it is harder to go north than it is coming down south in this country.

Do all Aboriginal people observe that?

> They know that, we all know that. It's the same for white people, but they don't know it. If you are going Kalumburu-way, climbing up, it's slower; when you come down, it's faster. But people don't take notice of that, that the country is sloped. I'll tell you something, how we see this country. The whole of Australia is Bandaiyan. The front we call *wadi,* the belly-section, because the continent is lying down flat on its back. It is just sticking out from the surface of the ocean. Deep down underneath are the buttocks, *wambalma,* from where the leg joints run into the pelvis and right across to the other side.

Then you see Australia as a full and rounded body?

> Yo. Inside the body is Wunggud, the Snake. She grows all of nature on the outside of her body. The sides are *unggnu djullu,* rib-section. This rib-section goes right across the country, above the navel. Uluru is the navel, the centre, *wangigit.* The part below the navel is *wambut,* the pubic section. There is a woman's section, *njambut;* and a man's section, ambut. The shoulder parts are *manu.*

Mowaljarlai indicates the regions between Port Hedland and Townsville.

> On sundown side and in the east the connection extends out to the islands, because it was a bigger continent before the Flood.

Were the islands a part of this Bandaiyan body of Australia?

> They are *ungadjella,* all the islands. They are connected. So is Tasmania, the footside, *wemballaru.* Right up top is the head-part, *ulangun:* Cape York, Arnhemland, Kimberley, Bathurst and Melville islands, that area. Below the Gulf of Carpentaria are the lungs, *wumangnalla.*

I find this concept of a Corpus Australis extraordinary, and wonder if other continental bodies are also lying on their backs, floating in the oceans that surround them.

> We think along these lines, but we know only Bandaiyan. On this we interact as a corporation. It is intact.

Intact? What about the areas where there are no Aboriginal people still surviving, or at least not living traditionally there any longer?

> You're wrong there thinking like that. The land remained, you can't get away from that. It acts for the people and their imprint is still there. If the land sinks into the ocean, the symbols will still be there. Only if the whole continent is blown to pieces and nothing is left of it, then it will be finished.

When Mowaljarlai translated the Kalumburu tapes of the five old men, he had found that some ancestor stories were going back to when the islands originated, and even further back, to what the Birrimitji, the In the Beginning people had seen before the Ice Age – that moon, sun and some of the stars had been on earth, for instance; and that the Birrimitji knew why they went up to space.

"New generations that need to know" – Marcella Nyandi and Jane Djungai (top),
Gibb River Station

One song told about a flood, long before the last, that was brought on by *Kallowa Anggnal Kude,* a star with trails. The symbols that testify to these events are still in the Kimberley.

> The important one is the "Song After the Flood", the one that praises the Big Wandjina for coming and standing it all up again – a praise for his re-Creation and restoration. This song was not made today.

The old men claim it is from the time the Flood went down. It was the praise for coming and touching life into all of nature for the second time. (Examples are the songs on pp166-71.) Mowaljarlai sighs, and suddenly looks older and really tired behind those shabby spectacle frames.

> We've lost so many stories. Many anthropologists in my time, like my missionary, Mister Love, they went about for months recording Wandjina story. But they never went back as far as Creation to connect it up to the present. They never put it all together as it was, right up till today. I only find out yesterday, only you and I are doing this. I can tell you, it would take a thousand years to put the whole detail, all the pieces together.

> The old-time people, who knew, died many, many years back in their grid-places. I say that we got no hope to show the new generation, the future generations, no way. They can only study – but they wouldn't know where it was, where everything is written into the country.

A Wandjina Dies

Mowaljarlai has often been reminded not to compare his old culture with the Christian religion, but to him the analogies are there; as they were in the wisdom of his father and his grandfather.

Writing this has brought me to acknowledge and accept these comparisons. It has also led me to give a more purposeful attention to my own spiritual nature. It still came as a startling revelation when Mowaljarlai first spoke of the Flood Wandjina, one exceptional Wandjina who *died* – over ten or twelve thousand years ago – so the people would have Life.

The Wandjina died at Wullunggnari, on the Mitchell Plateau, where three stones represent the Flood. A Wandjina died? Wandjina merged with rock, the earth, but they did not die!

> This Wandjina was grey-haired – Marrul. He had come after the Big Flood. He had walked to Wullunggnari, which means "holy water representing Creation". He arduously dragged himself and some *lambarra* [large witchetty grubs] to a deep tunnel-shelter. There he had died, as a sacrifice for us. The name of the area is *Warrabi:* he swayed and heaved his body along with the lambarra, his special food, which we respect to this day.

There is a stone altar by the shelter, and *Walguna,* the Tree of Wisdom, Knowledge and Law. At times of ritual this tree was hung with sacred objects. They vibrated awe from cosmic spaces into a ceremony of rebirth. Here, both men and women initiates would undergo a sacramental baptism to be reborn of water and of spirit. These were the proceedings:

> Hunting weapons, spears and womera were taken away.
>
> The initiates were naked and without tools, to remind them they were born without belongings.
>
> Week-long periods of teaching and preparation followed.
>
> Sacrifices were made.
>
> Sacrament, His holy flesh, was taken on the tongue in the form of small meatballs.
>
> Men and women were baptised in sacred wunggud waters (separately but as equals in adjacent parts of the river).

Opposite: "His head is facing sunrise, see his eye.
We place him in his country."

195

Through an arched gate, symbolised by the arms of two elders, initiates jumped over cleansing mushroom smoke, *dilgni*.

Hunting weapons and coolamons were ceremoniously handed back. They could then continue with day-to-day living, and were allowed to teach.

They had entered a new life, were reborn through the love of the Wandjina who gave his life for them.

At Wullunggnari, where the Flood Wandjina died, initiation of men and women was equal, up to the highest degree, though the women had to be past child-bearing age. They all became priests and law-givers.

No wonder the old bushmen say that the white man's ceremonies in church reminded them of their old culture. What is more, the mystery and testament of Yorro Yorro, the divine movement of eternally ongoing Creation, the renewal of Life, lies embedded in the soil of their countries – symbol and stone, Spirit of the Kimberley.

Opposite: Wunggud stone
Wadningningnari, Manning Gor

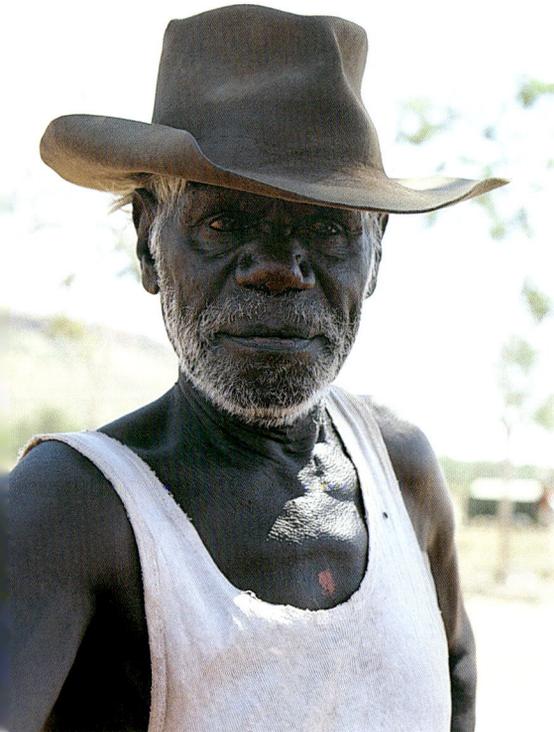

Rastus Ullingi, Iminji Suzie Dabingali, Gibb River Station

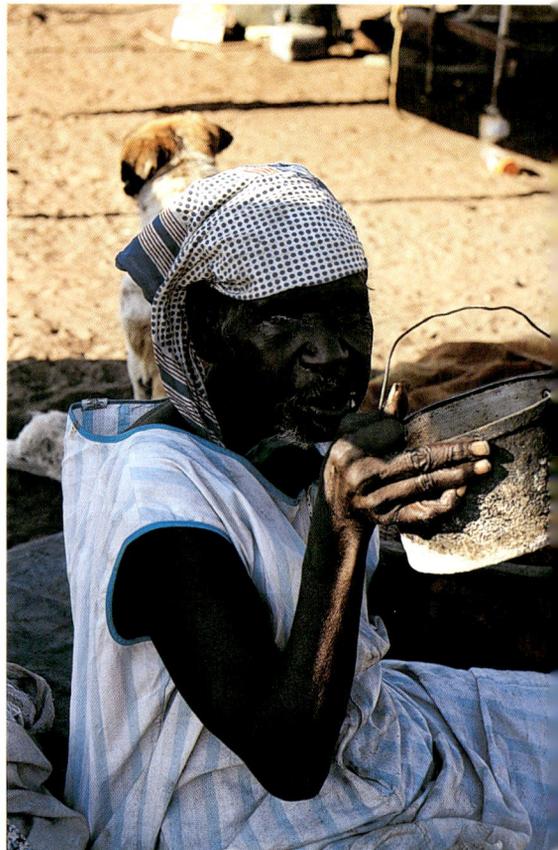

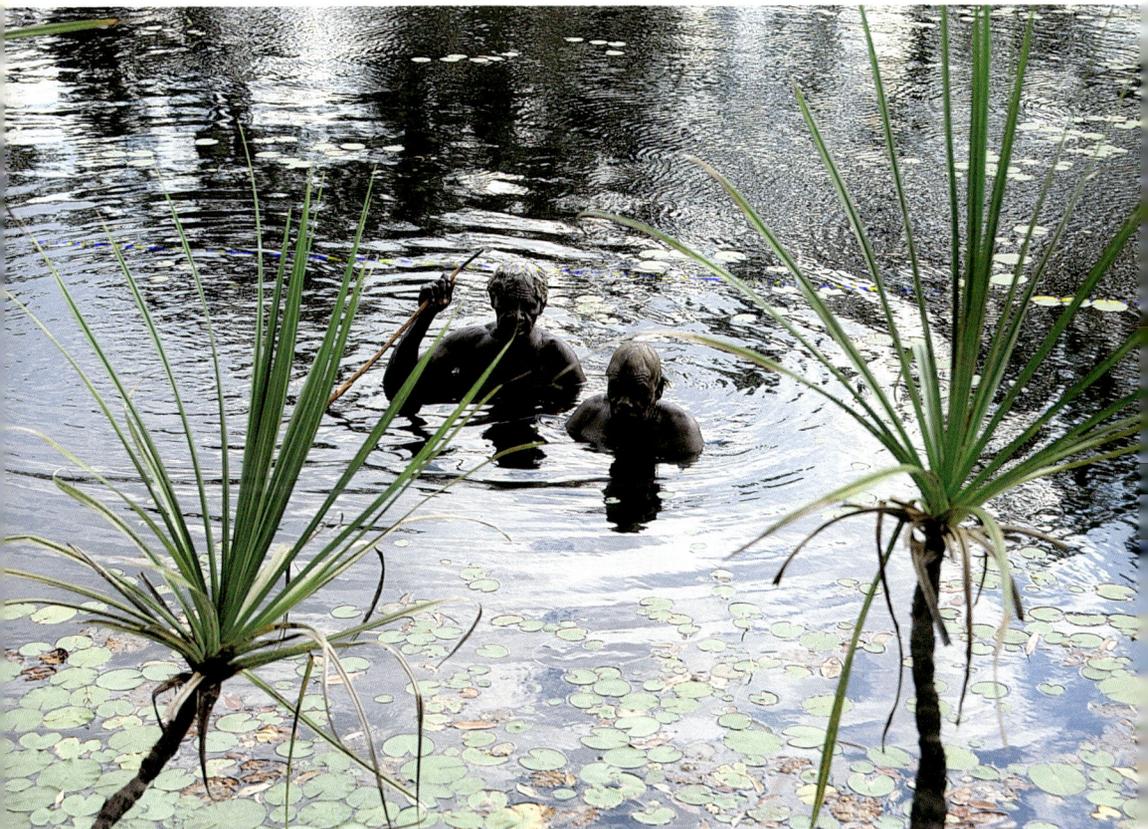

Hector Dargnall and George Jormary at Mowaela

The final word is Mowaljarlai's:

> The world was perfect when created. Nobody knows God's purpose. He just put it the way he saw fit, his own way. And he gave us symbols in earth and stone. It is established forever.
>
> He gave us *Gi* symbols to represent who we are and what area we come from. We feel it in our spirit, we feel it in our body – it is just Creation.
>
> We don't ask him why he did it, just carry his image and his symbols. We take his great power seriously and sacredly. We never change his stories, they are put down. We don't update his stories in new version – we just live by it every moment of our lives.
>
> But when the old men die, all this knowledge will be dead-gone. The stories we told the missionaries and anthropologists are all locked up, maybe thrown out at times. The next generation will never know how to put the culture together again. All this material is too far from the communities. We'll be left to live with nothing, our only treasures locked up.
>
> > Once I was past and future, now I am only the present, today, the moment, and that is hard to bear, with no past, no future.

Mowarjarlai died on 24 September 1997. A funeral ceremony in Derby brought together from all over Australia and New Zealand many who had known and respected this inspirational elder. His body was then flown to the Mitchell Plateau to be placed traditionally on a stone platform. Three years later, the bones were collected, washed, ochred, smoked, and taken to "camp in camp" until his relatives were ready for the *djunbar* to set his spirit free for the journey to Dulugun.

He had said repeatedly during the two final years of his life: "We have to bring Wandjina Spirit across from the Kimberley to the East of the continent to empower Sydney for the Olympics. Then that spirit will go out into the world."

Three years later, the ochred and smoked bones were finally placed in a Kimberley Wandjina cave. In Aboriginal belief his spirit was free. The date was 16 September 2000. The night before, during the Olympic opening ceremony in Homebush Stadium, Sydney, a gigantic Wandjina image was raised over Aboriginal dancers, the Worrorra Wandjina Namarali. Three and a half billion people saw it and in those few short moments Wandjina spirit was all over the world.

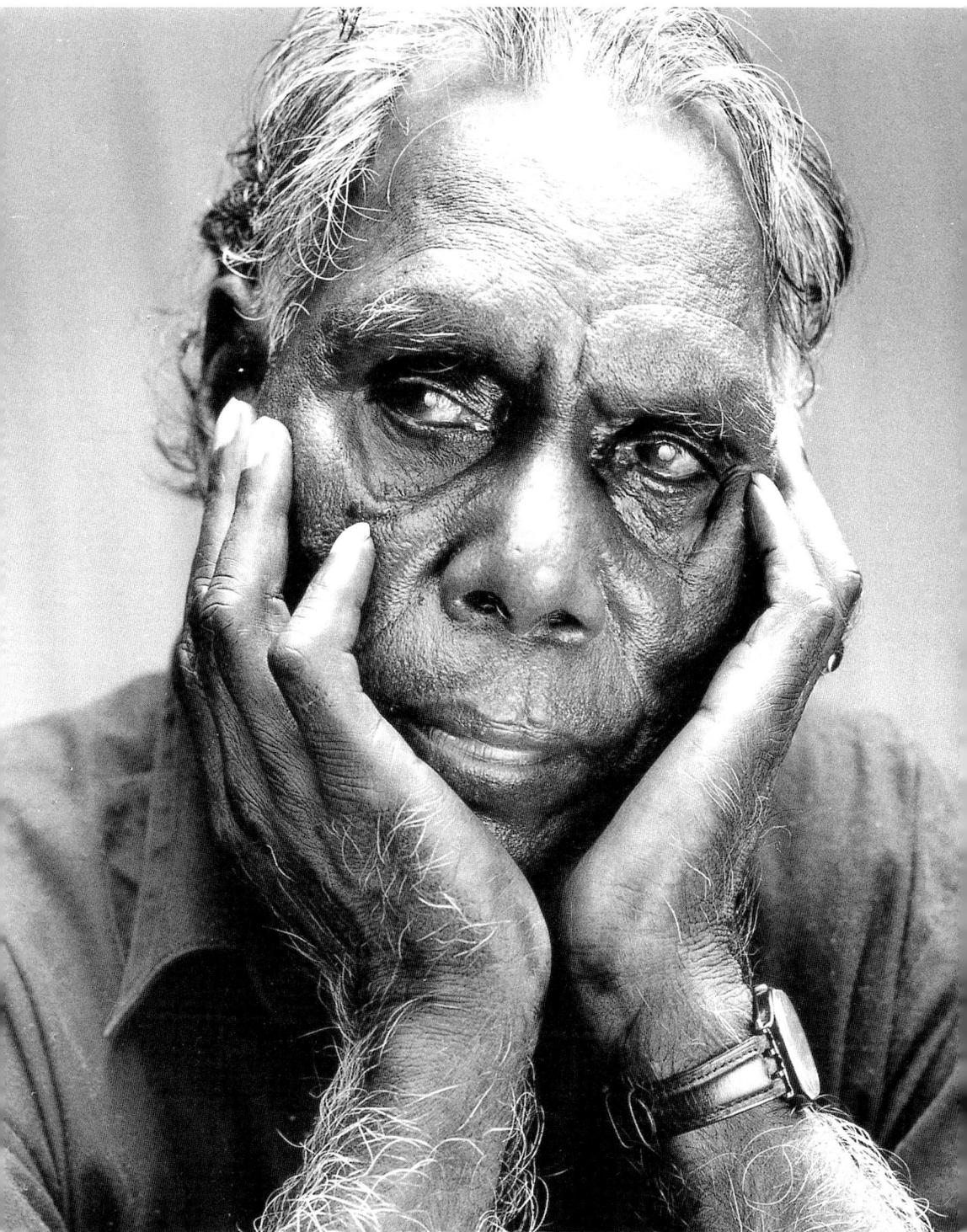

Mowaljarli in 1996

32 Guyan Guyan

Since the first publication of this book some controversy has arisen over the relationship of Wandjina and Wunggud figures, and the disciplines of culture represented by them, to rock paintings known in common parlance as Bradshaw images, from the first European to bring these sites to wider notice. The Ngarinyin call these paintings *Guyan Guyan*. Unlike the image energies deposited by the Creator Wandjina, they are held by the Ngaranyin to have been painted by their ancestors during a key era, the *Djanargi Djanargi* phase of human evolution. In this era, Kimberley people expressed with exuberance and sophistication a new knowing of themselves as humankind, who they were and what they were totemically representing, or "Gi-ing". They danced this in ritual, and they painted it. Mowaljarli commented on the Guyan Guyan paintings that, "they are dancing history forward."

There is also debate over the age and origin of patterns of indentation or cupules in rock sites in the Kimberley and elsewhere.

The following dialogue recorded in 1996 may offer a new perspective. The cupules are described as arising from Wandjina activities.

J: Mowal, how do you know that the people in the "Bradshaw paintings" were the same people as you were?

M: We call them Djanargi Djanargi. Those are the men, the dancing ones. They are Djanargi tribes. Djanar-gi,"I just put you in the direction — gi." You got that gi on the end. That's a gi symbol now. So you come into the symbol.

J: Gi is the symbol for connection, the connecting?

M: Like I am a hibiscus. And Neowarra is a Wandjina. Neowarra gi's that Wandjina. It's his totem. *Their* totem is that stone knife. That's *their* gi-symbol now. They gi-d that flick of a stone.

J: How does the stone flick come into this?

M: They had nothing in their hand. We call them *Munggugnangga* — "Nothing in hands." They didn't have a knife, or a tomahawk. They thought of tools. That's *munggu nangga,* looking around, "Oh, what can we find, what can we use? Let's test everything,

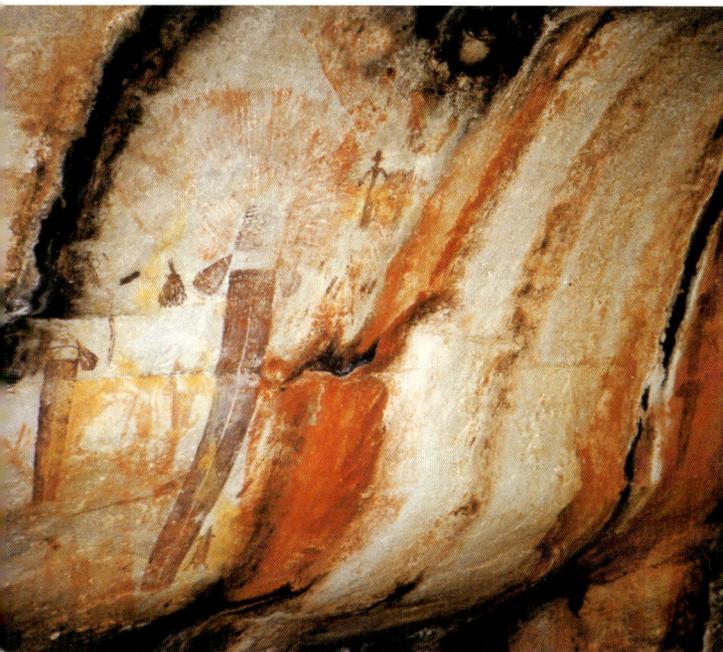

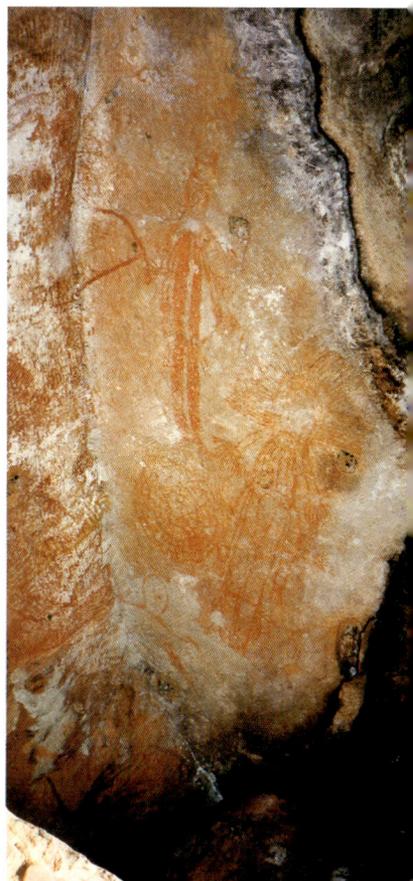

Guyan Guyan era rock paintings,
Donkey Creek site

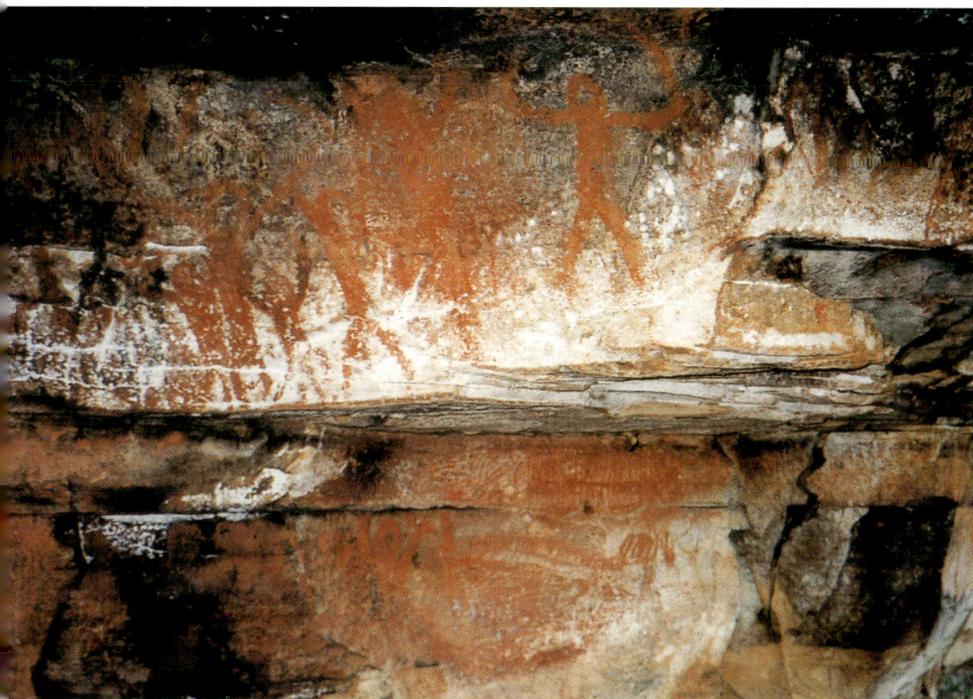

this stone!" They find out now. They become scientific. They were naming those stones *gimbu,* which ones to use. They start doing this, shaving (flaking) it. They found a useful stone for this. That's their gimbu. They said, "This is very good. We are going to use this for the rest of our lives." They started cutting with those knives. Start cut the skin. It's a Law now, a commitment. They started *gangar.* We call that gangar, knife. All knives. The stone knife specially for cutting flesh and cooked meat and skinning kangaroo. Putting tribal marks, that's all gangar.

J: They invented the use of stone?

M: This is a scientific mob now. Before, they had nothing.

J: Djanargi Djanargi are men in the Beginning of (the era you refer to as) Ancient Time?

M: Yo.

J: Paddy Neowarra gave three names for three periods. Can you give me those three periods?

M: I have given you Djanargi now. That's number one, the Beginning of Ancient Time. The second is Mungu Nangga, for when they had a session meeting, they were talking about plan-ning, as a group. Then they said, "Tomorrow we look for... You two go there, you two go here, you two go there." They started planning work.

J: What does munggu mean?

M: Looking, with their eye. Walking around looking like this, "What should we get?" Searching.

J: And nangga?

M: Nangga means explorers. To find out, to explore. We say, "Everyone should find out, explore." They were feeling happy, enterprising.

J: And the third one?

M: Guyan guyan.

J: What does the word guyan mean? Do you use it now?

M: That first word *guya* means "go". And that last part, that -yan: with a purpose. Guyan: "you go and look for." That's an order. It's a timetable belong to them. What day to look for something. "Tomorrow you go looking for things."

J: This is all within Ancient Time? We understand that there were long spaces between the three stages. There was an awakening of spiritual awareness, law making, start of initiation, social organi-sation, first banman people, tools.

M: This lot now. That's what we are talking about. There's the banman mob there now in the paintings. You know, *Djillingna,* that woman one, that woman painting, in the cave, where young people are not allowed to see it. Very important. It only for old people. They know this big mother one, she is sitting down with open legs. She is the Mother Earth. No young people look at that woman. Paddy took Jeff Doring there and made pictures of it. Mr. Coates took a picture of it for Professor Elkin. There are paintings of this Earth Woman everywhere.

J: In the Guyan Guyan paintings the dancers don't have breasts.

M: They're all men, skinny ones. That's their mother, that Djillingna.

J: What about the boomerang as a symbol, the crescent symbol? Not just as a weapon.

M: It's a sacred object. It belongs to woman.

J: In the paintings that I have seen, dancers are not holding the boomerangs in their hands. They are just next to their arm.

M: The dancers are men, the boomerang shapes belong to Women's Business. The boomerang shapes are *mundi,* painted like that.

J: In Lily Koordada's paintings of Wandjina, she always includes turtles and boomerangs. Why is that?

M: Boomerang started off with those Djanargi. Wandjina told them to make these weapons. It became sacred for women's side from that mob now.

J: When it is next to the arm like that?

M: We call the dance *mundigai,* acting with the mundi, the sacred Woman's Business, because this lot started it off, this lot Munggu Nangga.

J: Did the people in these paintings have the same totems, the same rituals, as yours?

M: Brolga, Ibis, Quail, Emu, Duck, Dove, Honeysucker, Bush Turkey, all those decorations refer to that. Then, if we paint, we must put decoration this way, bird painting onto our body. The Owl paint, or if we got Ibis, well, we make ibis with grass tied up with nose sticking out like ibis. Or turkey. Or brolga. Grass one.

J: You make an image out of grass with the beak sticking out in the front.

M: Yeah, on the top, in the cap.

J: They are dancing with these tassels, with decorations.

M: I'll tell you about the decorations. One of these long ones, they call *ururumal.*

J: What does that mean?

M: It slides down here. You know when a thing hangs down? It's a slider decoration. For looking beautiful. The end part of ururumal, the -mal, means it's lone, the end part hangs down on its own, "lonely necklace". It's separated, lonely. Ururumal, "It hangs lonely, on its own."

J: Just hanging down as a loose string with end tassel?

M: Yo. Another is *wanalan.* That was made by this hair here, a hair belt. It was twisted, it was a broad one, like a band, human hair. They had a twisted tassel hanging down here, in front of the pubic, to cover. We call that *walput.* Walput for woman and man, for they all wore it.

J: They already started covering themselves.

M: This is the inventing time, what they started off with. They started all this. Then we got hold of it. We still using it today. All the bush time, when we walked about; when Lommel was with us. They had these things wearing.

J: But we have the picture here of your grandfather without one. (P.109/114)

M: He wore it all the time. Just sometime they turn it around on the waist so it doesn't get in the way for hunting. In that picture of my grandfather the hairbelt is wanalan. He lifted the kangaroo up, you see him put the kangaroo underneath his hair, that is *djagarra.*

J: They did have a belt. Did they make string from bark for those tassels?

M: Hair, long one, called djaggara. Wandjina hair, your hair, my hair — all djaggara too. They spun this hair and twisted it into a long string. They didn't plait it. They were winding, twisting the long hair like that. They made a tool. This front part (on top of the head), they overlapped it. Then they rolled it up. They bind it up. They shut this end with string, a knot down there. That is a bag for the stone knives. Round one. They kept their knives in that pouch.

J: They tied it up at the back of the head, and at the waist?

M: They didn't tie it up at the waist. They carried those stones from their head. It hung like from a post, down this way. The weight of it rested on their back. It couldn't bring their neck back because it sat properly in the net. The shoulders balanced it.

J: They appear to have made tight armbands out of some fine fibre and stuck leaves into them, similar to the Trobriand Islanders, who use herbs in their armbands like the feelers of an insect, antennae, for heightened perception.

M: We do that with bird wings, feathers and leaves. We do that for dancing. Rhythm goes out into the action. That's all decoration.

J: And those Ingaladi, the Lightning Brothers, they represent lightning. But they are not Wandjina, are they?

M: They are Rain Mob, just the lightning. Angubban is the Rain Country, the Cloud Dreaming, *Murrumbabiddi*. This is the Wunggud country. They tell stories at wunggud places.

J: There are always two lightning figures. Why always 'Brothers?'

M: There are two or three different lightnings. Ordinary lightning little skinny one, what smashes a tree; and this Big One, he don't smash, but he big one what start off cyclone. It hits the earth, makes a whorl, it cuts a big trench. That ball sitting down there. That power, like a big football, a basket ball — ball lightning. It will cut the ground, he sink down and he makes a big hole there. Goes into the earth. That's why they call them the Lightning Brothers.

J: What is your idea about those cupules, the patterns indented in rock thought to have been man-made, at Jinmium, Kimberley? I heard that they also exist in other places.

M: Those stones, stone as a cloud, all soft. When earth was soft, you know? When Wandjina walked, the big Creator Wandjina, he come to this cave, he wanted to settle down yet. He sweat, and it's still there for us to look at. We say: He sweat, "Here, *nguning*," we say, "nguning, nguning here." When that sweat come down, we call that sweat of Wandjina, nguning. You know how we get sweat, really pouring? It fell off his face, when he has a spell, when he was resting, at the cave. It sprinkle, sprinkle. It squirts, sprinkle on the rock. It's everywhere now. That's the Wunggud, from this sweat, from His face. We get spirit for children now,

children's names. Woman may be called *nguniella,* when she gi-s that little pothole (totemises it). That's the Wungudd now.

J: This is from the time when the Wandjina walked?

M: He sprinkle sweat, and it hardened up now.

J: These cupules are everywhere, also in Vanuatu.

M: Wandjina walked everywhere, it still is a cloud and the rain. Doesn't matter where his footprint, everywhere. It's a drip-drip, everywhere. Everywhere His sweat dripped. You see it anywhere. It reminds you "Oh, Wandjina, good, here!" It's like that jaw belongs to turtle, how man was created, Long-necked Turtle*, it's a reminder, like that. The print of Wandjina everywhere.

J: Why are some Wandjinas lying on their side in the paintings, while most others are painted upright?

M: That's the main Wandjinas, having a rest. He lie down.

J: I observed at the Neggamorro place, Angguban, the Cloud Dreaming (p.63) that the cloud stone protecting the images in the back of the shelter is a different texture of stone from the rest of the shelter. Is that in other places as well?

M: Whatever colour they got, yellow cloud, blue cloud, white cloud and black, different clouds.

J: Where Wandjina left His image in the caves and sites we visited, those cloud rocks protecting the Wandjina images were always different, much denser, finer than the sandstone, or wall, behind them.

M: When you come to the sandstone, you see black-brown colour on top of the cave. Inside is white one, white colour. That's the cloud now, that white one. This one dried up, on top, it became brown. It's the same cloud. Inside the cave is the white one, where they do painting.

J: The protecting stone is different to the wall stone, the canvas?

M: That whole stone was a cloud. It's a different colour now, the colour of the earth.

J: And the cloud was still soft?

M: Like a snow, like a fog, dew. That cloud. He carried the cloud, we call cloud-carrying *burrul manuba.*

J: Is that why Wandjinas lift up the clouds over their heads in your paintings?

* The Wandjina manlike skeleton in the turtle's neck bone structure

M: Yellow one, red one, the lightning, then dark one at the bottom, more in the forehead. That's when He low. That's all the clouds, he carried them.

J: Each whole escarpment is a cloud then?

M: All clouds. They line up. Not only one. Where all the painting is, it's all cloud.

J: The Wandjina gave you the example for painting your face.

M: That's called nguning now. When His face got watery, water fell down on the earth. When that sweat fell, then it dried up. It made this paste. Now, when we have mud here, mud painting, along the cheek and the jaw, now when you get sweat, all those peel off. It's heavy. He painted Himself, and this upraided, this thing was running off, slowly.

J: What does the word nguning mean?

M: Dirt. The mud, dirt that came off His face. It rolled off His face.

J: So nguning is the (sweat and the) mud, the dirt, from His face paint.

M: It dropped. It couldn't disappear, but it sunk and made little holes. Then it reminds us, because of this little thing,"Oh, nguning," we say. If it didn't make a hole, we couldn't tell story.

J: How do you know the "Bradshaw" people are Ngarinyin? Are most of the guyan guyan paintings in areas of your country, on the Mitchell Plateau?

M: They are there. We are the Ngarinyin mob.

J: What about the Wunambul and the Worrora?

M: The Wunambul and Worrorra were same as us, at that time. We know the people in the paintings are in the beginning, making tools. Archeologists said, "It's eleven-thousand years ago." So what? We've been talking about that a long time. Now they find us, now. The symbol is still sitting there. Then they come with these instruments. We're telling them, "This is the Wunggud belong Creation Time, right?" So they get all these measurements now, measurements, stick-them-down. "Oh, this is fifty thousand years!" So what? We've been telling him it's there. And we did laugh at him — now he's finding out. He never believed us, but he believed his instrument.

J: Some researchers don't believe Kimberley Aborigines have been here ever since Creation time. The instruments don't come up with this suggestion, or this timing. That's why they can think that you got here later.

M: We go in front. All our history is front. Now he's coming along with history behind!

J: Dr. Paul Taçon of the Australian Museum argues that, due to the stress of everybody moving together, the Serpent became a symbol of unity as well as of Creation and Destruction.

M: That is the power really, from Wunggud side. But with all that painting, the three don't paint together. Wandjina on his own, Snake on her own, and Devil on his own. They're separate.

J: Ngarinyin, Worrorra and Wunambul are being described as "subsequent cultures" to the Bradshaw people. They are accused of hacking out some of the paintings, of purposely destroying them.

M: We've got no reason to pluck the paint down, for what? This is what I am talking about. We don't go to white man church and pluck things out. They do this in our churches.

J: What you said at the first Rock Art Symposium in Darwin has lingered in people's minds for a long time.

M: We never had a chance of recording properly the *meaning* of the art. We never get into the rhythm of explaining the story properly, working proper hard, making a big book for the whole of Australia.

J: One message is, "Everything goes in cycles, back to the beginning."

M: When we die, we go back.

J: To be born again. And you also say that of the earth?

M: That's *yulput,* it means every wunggud place now is caving in. Yulbut means 'caving in'. Same places where you have beautiful waters, waterlilies and all that, the earth is caving in now. It's falling inside. We call it *yaworara.* Yaworara is 'sinking in'. This is the history what happening now, it's going back now, going back to the Creator. Because the Creator waiting there. The Wandjina. The Wunggud. Everything returning back.

J: So you see the earth as an entity. And every so many thousand years the earth also goes back into Wunggud.

M; That what we are saying. That what Wunggud is. That what yaworara is. And that yulput, that caving in.

J: Do you think that's due now?

M: It's due in coming.

J: Mowal, are you still teaching about the universal connection with the stars?

M: Yo.

J: A consciousness of the earth being just one little part in the whole of the universe?

M: That's what we're telling the young initiates: "You see it here: now, in the night you can see it there in the Milky Way and all those stars. There they are now," we are telling them. You can see it, that reflection now. "Oh yeah," they see it. They know. This star lot up there was down here. They went up to space, and now they're up there.

J: How do your youngsters cope with that?

M: They listen, they listen really. We're sitting there, in a big ring. We parcel it up. One teacher comes out with one little bit. Another feller come out with more, to the end of this story. A pupil can't tuck all these stories in properly. But he records it. He's got to sort it out.
 When you're with him, one teacher, one pupil, that is different. You just give him one little story at a time. You give a student the parallel, a positive side and a negative side, he follows that straight away. He remembers what this man was saying, starts fitting it in. He patch it all up, in here (head). He gets it all clear without doubt now, because that one-man was telling him. "Oh, I remember what that old man was telling me there." He finds the line through the pattern. That is what the young people need to do. I was taught that way, yo.

J: Are there still people teaching like that, again?

M: Four of us, five, six. Some older woman, Paddy Neowarra, Laurie Gowanulli, Paddy Womma, Hector Dangall, all this Ngarinyin mob.

J: What are you are telling them? "You've got to come also under our Wunggud, the stronger space in the universe, the stronger Wunggud to go with your English Wunggud belonging?"

M: It's like this ashtray here, this is England and this is Australia. They came here. The red flag thing, England, all the law in here.

The law of the British came over here, White man law I'm talk ing about. This is the earth, the land Australia is up in space also. It's reflecting, the Wunggud. It still reflecting there in space, the law. And we're losing it here.

The British also have their Wunggud, and it is reflecting here in Australia. Do you understand what I mean?

J: No, not quite.

M: This European lot came over here. They settled down in Aust-tralia. They put down all their rules, British rules. We are holding them now, in Canberra, everywhere, in Sydney. Sydney is called after Mr. Syd*. There's the imprint now. British Wunggud is here and up in space. And Australian Wunggud is also up in space. "You need the Wunggud belong to this country," we're telling them now. We are telling this feller, "Now you listen to me about my Wunggud belong to this country. You have to understand." We're telling them now, the English (descended) mob: "You were born here, but you don't know the rules, the spirit belong to this country. You have to listen to us." Like we had to listen to him. This bush school and all those things are like that, not just in your head, but in your powers. That's what we Ngarinyin are talking about now. And Worrorra and Wunambal too. That's a gift now, a gift from us, a gift for wider Australia.

J: Do these people at Bush University understand this now?

M: Well, we teach them the beginning, the beginning.

Ngallewan Nally at Njallagunda Snake Dreaming, Gibb River

* Lord Sydney, Thomas Townsend, 1733-1800

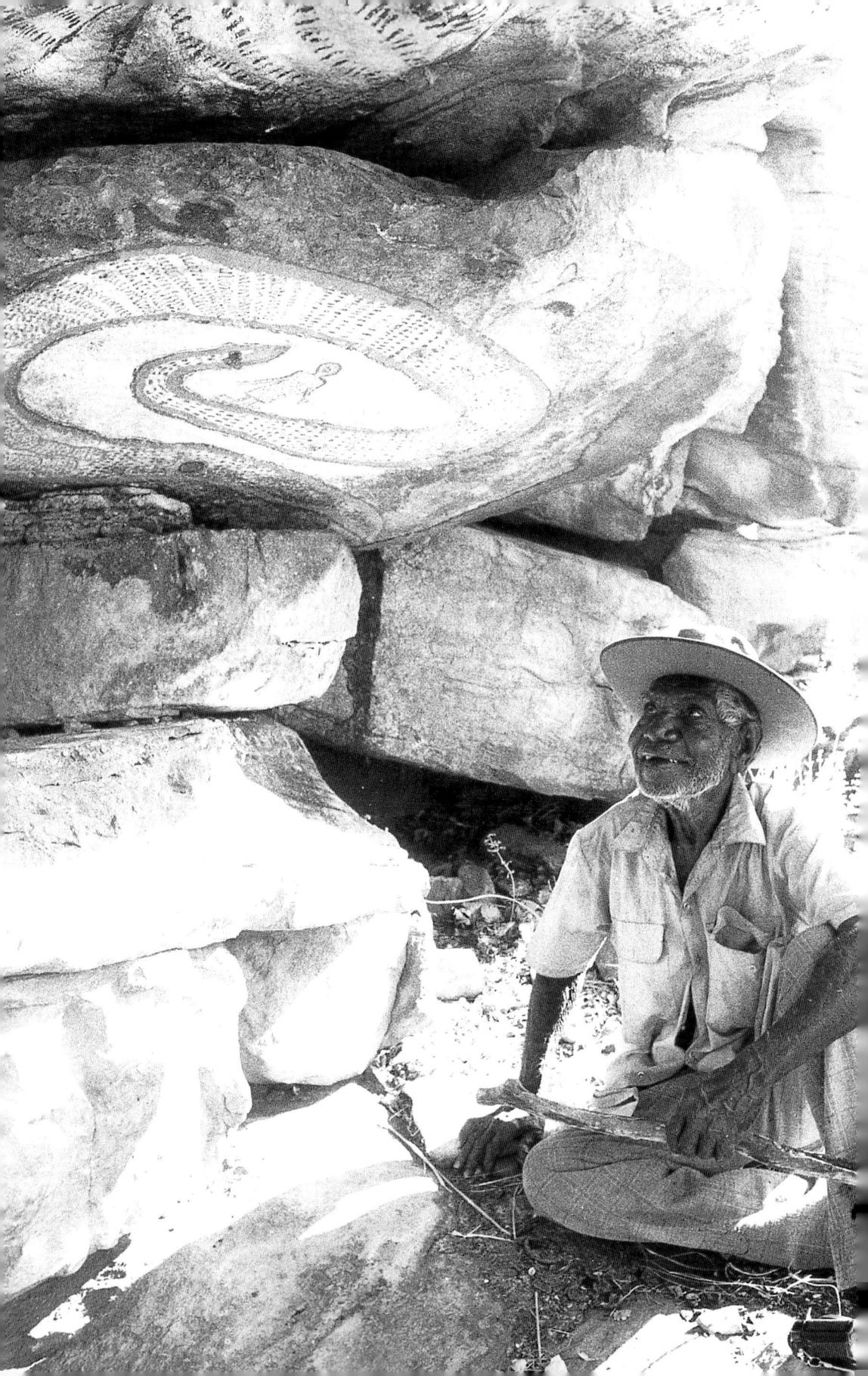

Features of a Wandjina

Djagarra or Jagarra is the Wandjina's hair, in radial lines.

All rings around the head represent clouds and lightning:

Malngirri, the Lightning Ring, is the first or closest to the head.

Djilij: second ring, dark, low, rainladen clouds, "the woolpack".

Angguban: third ring, clouds building up big rain, cumulo-nimbus, the Travellers.

Ngangnol kude: fourth ring, cirro-stratus, high windclouds.

Bimak: fifth and sixth rings, distant cloud bank that flashes lightning, signals first rain after the Dry.

Big Spirit Wandjina have large eyes, never have a mouth nor ears as such [there is an exception at the Barker River site]. The line between the eyes indicates where the power flows down, and is not a nose.

First generation Ancestor Wandjina, Wodoi and Djingun, may show a mouth. Wallanganda, the Creator Wandjina, did not create with his hands, only through his voice, with power.

White areas on face and upper chest represent mists, regions beyond our understanding.

Ranggu is the narrow black plaque in the middle of the chest, his heart.

Omba, wavelines to the side of the heart, are ribs.

Kurimbi, spray-painting, is done with the mouth.

The hairbelt is plaited with human hair.

The pubic sheath is woven of hair from the Chosen Female Kangaroo sacrificed to him. Since this offering she belongs to the Wandjina.

Only earthly people, ancestor people in Creation-time form [e.g. Wodoi and Djingun], and Argula, the Devil, have testicles on paintings; they were meant to have wives and children. Big Wandjina carry only a pubic sheath and the hairbelt.

Knees, ankles, anklebones and feet may be indicated and the legs decorated with body paint.

All body paint is referred to as *djirli* – beautiful colour, but only white is spray-painted with the mouth.

It is an interchange of cleanness and purity, the watery essence of life.

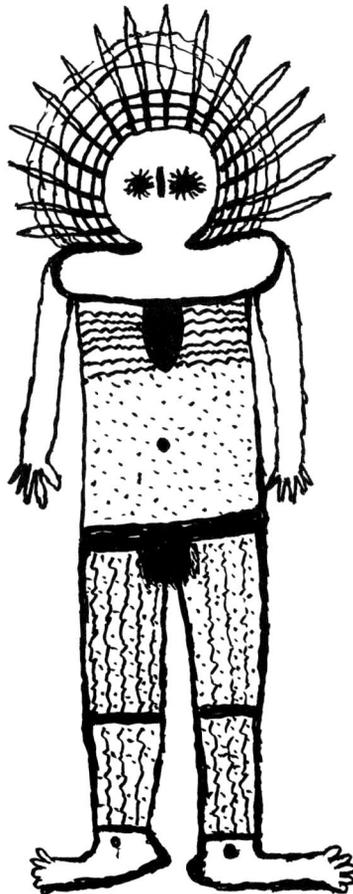

Waanangga, Sugarbag

Bent pipe: amen, the eye

1st hatched area: *onja,* yellow eggs

2nd hatched area: cheeky *mala*
[stings the tongue]

3rd hatched area: quiet mala

clear area: *arin,* reservoir of liquid
honey, connected to the outside
by a cut, with honey pouring
into a coolamon, *garagi*

This drawing can be compared to the photo-
graph and explanation on pp71-75. The garagi
at Waanangga site is extremely important, a
sacred, table-like rock, positioned under the
painting of the honey log, which must be
treated with care and reverence.

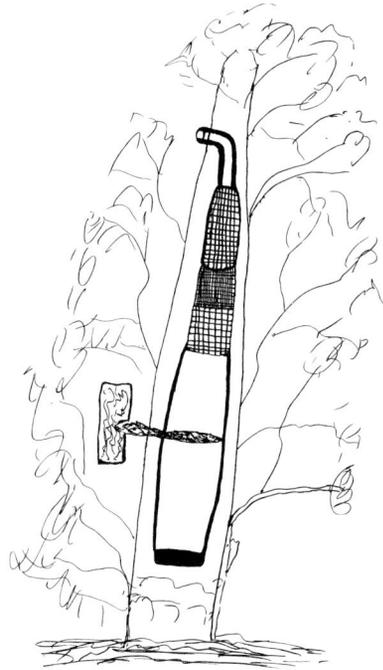

Bandaiyan — the Body of Australia, Corpus Australis

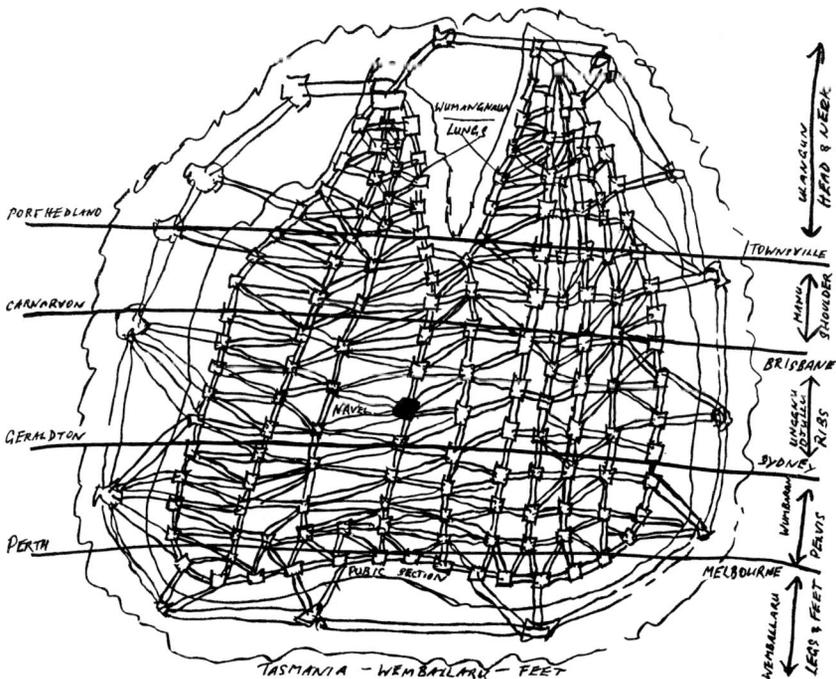

Time periods

Under the mists that hide eons of evolution we can touch on some helpful stepping stones, fairly consistent reference terms for time periods that Ngarinyin, Worrorra and Wunambal groups of Kimberley people use.

1. Before Our Time – Narkundjaja – before Creation

 Heaven and Earth are separate realms, Wallanganda is in the Milky Way, Earth a jellysoft snake floating coiled to a ball in the cosmos. Fresh water falls on earth.

2. Lalai – the active part of Creation

 Wallanganda appears on earth in the form of a Wandjina Raingod to install all of nature and bring life to the planet.

3. In the Beginning

 Wallanganda lays down the blueprint mould, creates man and woman.
 Basic organisation. Wandjina paint in shelters.

4. Way-way Back – Ancient Time

 Awakening of spiritual awareness, law making, start of initiation, social organisation, first banman people.

5. Flood and Ice Age – interruption, Wipe-out

 Divides prehistory and known times. Images turn to rock during Ice Age.

6. Stone Age – Munggugnangga

 When only stone tools were used for killing animals, Aboriginal people hunted with string-rope traps and clubsticks. No spearheads yet, but little flaked stone knives and manufactured grinding stones. Mowaljarlai explained that the Ngarinyin thought of this stage in evolution as sectioned into three sub-stages:

 a) Djanargi Djanargi - Flaked stone knives, they call *gimbu*, are their first tool, also first tool symbol. They started to name things.

 b) Munggu Gnangga - They became conscious they had "nothing in their hands", no tools, started planning, as a group, searching, exploring, experimenting.

 c) Guyan Guyan - "Guya" means:"go!" with "ya" it means: "tomorrow you go look for things", an order. They are now working to a schedule, with a purpose. Acknowledging and dancing their totems..

7. Long Time Ago – Djuman Nangga

 Wandjina came back for re-Creation after Ice Age Wipe-out, painted in shelters once again. Teaching, acceleration of technical advancement and introduction of healing. Wandjina taught the people how to make spears and womera, the spear-thrower. Boomerang, coolamon and digging sticks came into use.

8. In the Olden Days – "when we all still lived in the bush"

 Expanse of time from the introduction of tools to the arrival of the Europeans and shift to missions and government settlements.

9. Yorro Yorro – from the Beginning to the present and onwards

 As long as we are standing up with everything in Creation; as it was in the Beginning and will be for as long as nature regenerates itself. Ongoing creation, perpetual renewal of nature in all its forms.

Glossary of Aboriginal language

Ngarinyin (Nga), Worrorra (Wor), Wunambal (Wun). Common usage: NWW.

Sounds: **b, d, g, m, n, l, w, y** as in English
 a as in English 'father', *not* 'mate' or 'apple'
 e as in English 'set', *not* as in 'me'
 i as in English 'pit', *not* as in 'find'
 j as in English 'joy', but also like y in 'yes'
 ng as in English 'singer', *not* 'finger'; comes at the beginning of words
 ny as in English 'canyon', *not* 'many'

 o as in English 'poke', but also sometimes as in 'lock'
 r w tongue tip curls back, as US English 'car'or 'Mary'
 rd w' tongue tip curls back as in US English 'card'
 rl w' tongue tip curls back as in US English 'girl'
 rn w' tongue tip curls back as in US English 'barn'
 rr rolled, tip of tongue tip taps roof of mouth, as Ital., Span.
 u — oo, as in English 'clue', *not* as in 'but' or 'cute'

ada njuma	'where she reigns [sits, stays] forever' (Nga)
Adjar	Raingod; the Creator; rain (Wor)
Alamalla barria	a place (Wun)
Alamat	place of hot, or cheeky, yams; name of old tribal area (Nga)
Algnun Dorr Amorangnari Yadnanya	place where Yadnanya, Sugarbag Wandjina, cut the tree (Nga)
Alowanowa	dolphin (Wor)
Alwayu	Dreaming of Light and Darkness, wunggud waterfall where widowed Blackheaded Rock Python sat down, Mt Hann (Nga)
Algal, algal	yam creeper; stump of vine 'aims down, where yam is, after bushfire', so directing searcher; name of Mowaljarlai's mother (Nga); Algarljar (Wo)
ambut	male pubic section; *also* lower part of Bandaiyan, continental Australia (Nga)
amen	eye (Nga)
Ammanggna	stone, sound of the splash when it tips into the water (Nga,Wun)
An Badda	a place, where the Devil died, foot of hill near Mt Barnett (Nga)
Anbula Mirri	Snake's Tongue Place (Wun)
anggna	stringybark bowl, bucket, coolamon, cradle (Nga)
Angguban, angguban	Cloud Dreaming, Travellers; rain-laden cumulo-nimbus; third head-ring of Wandjina (Nga,Wun); Anggubanu (Wor)
angnulu	penis area (Nga)
annu menggna	he built us like himself, in his own image (Nga)
arin	liquid honey, sugarbag (Nga)
Argula, argula	the Devil, Deceiver, or quality thereof; dead person (NWW)
arral	spikes, spurs on emu leg (Nga)
Aulinggnari	a tribe (Nga)
Auwanbanggnari	spiritual and common name: front-fanged venomous snake: *Denisonia suta*; *also* long muscle, upper thigh [where snake bit daughter sun] (NWW)
Balgajit	area of a mountain range, including Bold Bluff, Isdell R. (Nga)
Balja Gni	hill which represents the snakes frightened and running (Nga)
Balja Mirri	Speeding Place (Nga,Wun)
Ballalong	table rock in front of Sugarbag paintings (Nga)
ballul	reef (NWW from Nga)
balmadaa	place, home camp, any river junction (Nga)
Balmadurra	where legs join body; junction of Hann R. and Station and Snake Creeks (Nga)
Bamale, bamale	King Brown Snake, spiritual and common name (NWW); Bamalinya (Wor)
Bandaiyan	continent; land mass, nature, people in relationship; Australia (NWW)
bandau	small tree-climbing lizard (Kwini)
Bandjuwarra	Entrance Island, near Kunmunya Mission (Wor)
banman	deeply, profoundly initiated man, doctor man, Man of High Degree (NWW)
barella	dawn (NWW)
barram barra gnari mari	'let's paint ourselves as a couple, make a picture of the two of us there' (Nga)
barrawan	bushnut with hard shell and narrow kernel (Nga)
Barrayu	a place, Drysdale Station area (Wun)

bedja	'ready', 'okay, let's go' (Nga)
Bengmorro	Wandjina site (NWW)
Berra Berra Gnari	swamp where in Dreamtime all flying foxes took off together, near Carson R.; first two words render racket of wings hitting branches (NWW)
bimak	far cloud [bimak njumerri:lightning flash]; 5th & 6th head-rings, Wandjina (NWW)
Birrimitji	In the Beginning people, before Ice Age (Nga)
biyu	death cord (NWW)
boaludje	come (Nga)
Bogadju	island of passage; tunnel place; 'fire torch'; light of the spirit (Wor)
bol bowanja	'you go one way and I the other' (Nga)
bongle	bladder (NWW) 'Wunambal say it light, Barn-'; Worora say it heavy, Bon-'
booroo	strength, power (Nga)
braag mirri	'we unwound ourselves' (Wun)
Bremmangurrai	river tribe/s (Nga,Wun)
Brungnun Ombud	young crocodile, 'anyone walking slowly, hands trailing behind, like croc drags his hands and legs, tail kick him along' (Nga)
bud	press, weigh upon, 'darkness press on us, in sleep' (Wun)
Bullgnawari	where they emerged, end of a gap, 'let we two go through' (Nga)
Bullinggni	place of looking, finding, being muddled-up, Carson R. (Nga)
Bulludgnu Illagnu	'waterlily under lid, covered, as in camp oven'; bullu: crouching (Wun)
bungarra	goanna: widely adopted name (outside language)
Bungguni	name of Mowaljarlai's cousin, also a place name (Wun)
burgnul	a grass (NWW)
burraal	light-headed, waking too quickly, dream type; see also yarri (NWW)
Burrawanda	Big Wandjina to whom Dumby appealed; 'judgement place' (Nga)
Burruburruba Djingit Binji:	Healing Snake; 'she came up, launched herself and landed' (Wun)
burrul manuba	Cloud-carrying (Wandjina behaviour) (NWW)
Burrumba Mirri	satisfied place (NWW)
Dalngga	spiritual and common name of snake from Drysdale area, and place/pool (Nga)
dambun mowa waringara	'I don't recognise the place, I'm bushed' (Nga)
Dargnall Dargnall	waterlily; Waterlily Man; [Hector's name, totem] (Nga)
darrul darrul	agony, suffering; helplessness (NWW)
demba	shining (NWW)
Dere	waterhole, Sweetwater Turtle Dreaming; bubble hole: 'Bubbles opened the way for her in the earth, busted her through.' (Nga)
di djalla burra djarrum jojojo bindi djarrum kangganda:	'little animal with big feet [frog] singing through nose for rain, river dry, everybody suffering, just about die' (Wun)
didgeridoo	wind instrument, wood tube (outside language); djelabun (Nga)
Dilagnari	place of dog, place of bad temper (Nga)
dilgni	cleansing mushroom smoke (NWW from Nga)
Dilminji	a place; shock, reaction to cold, 'oh I'm cold' (Nyigina)
dingghal	signal stone, radius bone of a kangaroo (Nga)
djagarra	Wandjina hair, also human hair; also jagarra (Nga)
djagu	stomach (Wun)
Djalgomirri	name of a hill (Nga)
Djalgumi	hill on the plain, like an island, Drysdale Station area (Nga)
Djalla Dondien	Mt Shadford, Caroline Ranges, honeyeater place; 'someone was talking, talking, then stone covered and squashed him'(Nga)
djallala	a stone arrangement, signal stones (NWW from Nga)
djallala bibibibi…	'everything will rise and grow'; [stones are stood up for ritual] (NWW)
Djanargi Djanargi	Beginning people (lit.: "I put you in the direction."
Djaranbolloi	Wandjina who camped in dark without fire when it rained (Wun)
djarral	glassy quartz; hail (NWW from Nga)

Djellanbini	a place (Wun)
djiggi ngarran	string from sinew; 'put there for us to use, we get it off the tail'; place in Barnett Gorge where the symbol of this is found (Nga)
djilij	rainladen cloud; second head-ring of Wandjina (NWW)
djirli	beautiful colours, as of body paint (Nga, Wun)
djillubumma	give birth (Wun)
Djillingna	Mother Earth, Earth Woman (as in sacred paintings) (Nga)
djimbila	banman quartz (NWW)
Djingun	Nightjar Man, ancestor, small brown-grey owl [co-originator of Wunnan marriage system with Wodoi] (NWW)
djinnang gang	ironwood tree (NWW from Nga)
Djua	devil; Devil-Devil Bird with big penis [*see* juwarri: ghost]; Hopping Djua is depicted as a scrotum (Nga,Wun)
Djuman Nangga	Long Time Ago; period of many improvements; old-time creators (NWW from Nga)
djunbar	dance/song, corroboree(NWW)
Dorgei	fountain where spirits unite; flows forever; gushing, pouring, bubbling, happy singing out; spirit gatherer (NWW)
duat	decider, especially in Wunnan trading, sharing, meeting (Nga)
Dudmonggonna	thumping, preparing [camp activity]; home camp; a place, Prince Regent R. country; where snake faeces became white ochre (Wor)
Dudunmaia	Victoria Gap; emu talking as she danced and broke through (Ungummi-Umeda)
Dugud Mirri	where snake impressed, a home camp (Nga)
Dulugun	Home of Dead; [dulu: gone to place; gun: out of breath] (Nga)
Dumby	Owl in story of punishment for cruelty (NWW from Nga)
Dundu Mirri	'you and I place'; one emu was talking to another (NWW)
dunduba	emu talk (NWW)
dunggo moni	place; [she] edged out a place [where she wanted] to stop (Nga)
dungnana	cabbage palms (Nga)
duwa	ankle (Nga)
Elandanna gnari	a place where their paths separated (Wun)
Emmamurrai	River Tribe Wandjina (Nga)
Enggalura	Footprint Place of Djaranbolloi, swamp, Beverley Springs Station (NWW)
gadba	happens (Wor)
gadun	'real professional' doctor (Wun)
gadun murrungaddu	healer who can handle magical things (Wun)
Galaru	Earth Snake group (Nga)
galgen	yellow-berried tree; daughter-sun climbed it, to ascend sky (NWW)
Galorugnari	northwest tribe and their place (Nga)
gambi	eggs (Nga)
Gambi Mirri	Egg Place; 'let's lay an egg here' [place of snakes] (Nya, Wun)
gandula	goanna (Wun)
gangar	knife, knife use (Nga)
garagi	coolamon/bucket; bucketshapes of coiled snake (NWW)
garawut	pebble country, basalt country (NWW)
garra	stopping, forestalling, defraying; *in Law:* pay the price (NWW)
garra wurri malai minji	land dried fast because the low side drained quickly (Wun)
Ghi	push, hunt him out (NWW)
Gi, gi	personal relationship to increase totem; two-way guardianship; everybody's individual totem; conversation time; spraypaint (NWW)
gimbu	stone flaked knives
gnari	place (NWW)
gnari amen	eye place or penis-side, opening of Sugarbag, honey tree (Nga)
Goroni, goroni	kangaroo boss mother, Yahmaroo's wife [*see also* Nganowat] (NWW)

Gorrid, gorrid	Whirlwind Spirit; wind that cleans up the place, willy-willy (Nga)
Gud Enggnari	Covered-up Place, near Mt Barnett (Nga)
Gugugugugu–goock–ooo	thunderclap imitation (NWW)
gulay	plum tree with green fruit; *also* the fruit itself (Nga)
Gullinggni	Raingod Wandjina, the Rainmaker, a Creator spirit (Nga)
Gumallalla	Prince Regent R. (Wor)
gumma	saliva, spit (Nga,Wun)
Gundjagnogno	Pandanus people (NWW from Nga)
Gunduran	Wandjina, Watjinggno site, Donkey Creek (NWW)
gurrigurri	to run (NWW)
gurriwa	spider, caterpillar (NWW)
Guyan Guyan	Those who go (went, before) with a purpose. Represented in rock paintings, at third, inventive stage of evolution (as in tool making); also Bradshaws (Nga)
guya	go (Nga)
ilela gude	they [her children] all stand up with their mother (Nga)
Illangud	King Brown Snake (Nga)
Illarra, illarra	spiritual and common name of large fresh- and salt-water fish, 'the long silver one' (Nga); Barramundi (outside language)
Inori	'Egg he left', round stone (NWW)
jabiri	spear, iron, shovel-nose spear (NWW)
jabiru	a stork (outside language)
jagarra	Wandjina's hair (NWW)
jagula	quartz stone, often with healing powers (NWW)
jerji	clear white stone or shell; mother-of-pearl (Nga, Wor)
jojojo	yes yes yes [*also* yo] (NWW)
juwarri	ghost [*see* djua] (NWW); juwarru (Nga)
Kaaa o	Johnston River Crocodile (Nga)
Kalinda	boss spiritman and singer (NWW)
kalli	boomerang (Bardi)
kallowa	star (Wun)
Kallowa Anggnal Kude	name of a celestial occurrence, a 'star with trails' (Wun)
Kalumburu	pathway, now a community, previously a mission (Wun)
kalwa	kapok bush (Nga)
Kanamudj	name for a certain shark (Nga,Wun); Kanamadia (Worora)
Kandiwal	Native Cat, Creation-time inventor of womera; *see* witjingarri (Wun)
Kandukandela	magic stone; power, healing stone; *see also* Olumballu (Nga,Wun)
Kandula gnari	Goanna Place (Wun)
kangganda	frog singing, yelling out for rain [*see* di djalla burra…] (Wun)
karimbu	bandicoot (NWW)
Karimbu Burgnul Meri	Bandicoot Grass Place: 'he brought grass and made it all soft there' (NWW)
Kayagnu	an inland hill (Kwini)
Koolan	Worora Island near Wotjulum; means 'asleep' (Wor)
Krowat, krowat	Healing Snake, spiritual and common name; *also* glassy quartz (NWW)
Kulawala	name of site, Manning Gorge, meaning 'in hot ashes' (Nga)
Kunmunya	Full place; mission site [kun: full, munya: too much food] (Wor)
kurimbi	spray-paint, as applied by mouth (NWW)
Lalai	Creation, Creation Time (NWW); Lalaige (Wor); Lalaigalla (Wun); Lalandi (Nga); 'we all say Lalai for short'
lambarra	large witchetty grubs (NWW from Nga)
langgu langgu mirri	'swelled under mouth like a balloon', 'snake puffs up when frightened' (NWW)
Langgumania Kalemulu	Meteor Island, where dead spirits wait for meteorites to fall, first way-station to Dulugun; 'flying possum cut the hill like a two-hump camel' (Wor)

218

lej	little lights [as of stars] (Nga)
Lejmorro	Milky Way; boss site of Wandjina paintings; spirit centre (Nga)
li	look (Nga)
Libudbud	clanking noise of boulders; tidal rock in way of dead: Dulugun gateway (NWW)
Libudbud Gadba	stone signalling dead spirits in Dulugun, telling them another is coming (NWW)
Libudbud Udman Ngirri Ngari	the stone that signals Dulugun spirits; place 'where they [the newly arrived, who have just died] touch that clanking stone' (Nga)
Lu Mirri	Snake Place, quicksand, nobody allowed to walk there (Wun)
lulu	slid (Nga)
lulu njuwanignari	Glenelg R.; 'she slid down a waterhole and stayed there' (Wor)
luluai-luluai	give-give, don't be selfish or greedy (NWW)
maggan	without, to have nothing (NWW)
Mahmah, mahmah	sacred, given by Creation to be cared for; strictly to be protected (NWW)
malai mindi	talking of stomach, offal (NWW)
mala	stomach [cheeky and quiet mala are 'stomach' of honey tree] (Nga)
Malara	kangaroo stomach hill, 'guts place', Upper Drysdale R. (Nga)
Manballauria	place near Pantijan; thrashing around (Nga)
Mandangnari	Snake Dreaming; Saliva Place; home of Manda Tribe [Gum People]; Gibb River region; Crocodile Dreaming (Nga)
Mandjilwa	Sickness Dreaming Place, near Mt Bomford; *also* 'Guts-ache' (Nga)
Mangarari	Fog People place, Doongan Station, Drysdale R. area (Nga)
mangarra	horny-tailed kangaroo (Nga)
Mangga Utji	name of a man; spirit of a parent in Sugarbag story (Bunuba)
Manggarari	fog off the water, place near Doongan Station, home camp (Nga)
manggnurra	river (NWW)
Mannunggu	mountains carried into place by Wunggu; 'Mister Ranges', Drysdale R. (NWW)
manu	shoulder; upper region of Bandaiyan, continental Australia (NWW)
Marara	a creek that joins Isdell R.; snake speared in the tail (Nga)
Marebodo	name of a man; ancestor (Nga)
Marella	Wandjina painting in Hann Gorge (Nga)
mari	penis (Wun)
Mari dudulmeri	place, site of first blood sacrifice; *see* Krowat
Marnyangarri	Cuckoo people who became Trackites with Watjinggnognos (Nga)
Marranggni Biddibiddi	the Gate, Gateway, 'where sun goes through' (NWW)
Marrul	grey-haired boss song-man; *also* Kalinda (NWW)
Mayure	Snake's Neck Place, home camp (Wun)
Mejuk	Wandjina incised on flat rock announcing Warmaj Mulli Mulli site (Nga)
mei mei	look out, look out (NWW)
memangat	sandstone country (Nga)
midjella munggudjo gnari	'little round heap', like an island in the gorge (Wun)
Midjelna	Creation Earth Snake who shaped land; 'unwinding, stretching out coils' (Wun)
Mingunya	St George Basin, Port George (Wor)
minji	did; happened [used to end a sentence, to confirm it] (Wun)
Minjil Monggnano	name of a Wandjina (Wun)
mirridji	white river sand (Nga)
Mondol	place in Hann R. Gorge, marked by boab tree, which snake 'tied up, strangled', making deep coil marks (Nga)
mongun	nightjar owl (NWW)
Mowaela	the battle plain, where the Turtle came out (Nga)
Mowanjum	Ngarinyin, Worora, Wunanbul Community near Derby; *it:* settled at last (Wor)
mulla	to lick; in the banman story, a snake licked his sore (NWW)
Mulli Mulli	*see* Warmaj Mulli Mulli [short form]
mundegba	tracks where he crossed the river (NWW from Nga)

mundej burwani mundewallo 'crossed from one river bank to the other' (Nga)

Mundi	sacred Women's Business (Nga)
mundigai	acting with the Mundi, ie. in dance ritual (Nga)
mundugu	snake saliva represented by stone slivers (Nga)
Mungana	hill, Sickness Dreaming, Mt Bomford (Nga)
Mungurra	King Edward R. (NWW)
Munggugnangga	people of Stone Age; time of stone tools, grinders, flaked stone knives (NWW)
munggundu	snake spit, tree gum (Nga)
Munja	cattle station; community (NWW)
Munmurra	Lightning mob who came to paint at Wullari, Donkey Creek [Trackites] (Nga)
Murraro	Roe R. outlet, Prince Frederick Harbour (Wor)
Murrambabiddi	Cloud Dreaming era and actions, fluid-formative stage of evolution (NWW)
murrungaddu	handler of magic; *see* gadun (NWW)
Namarali	Worrorra Wandjina, hunter and leader (NWW)
Najjar	blueprint, mould; 'spit image'; [repeated for emphasis] (NWW)
nallija	tea (outside language)
Narkundjaja	'Before Our Time' (Wor, Wun, and in Ngarinyin loses last *ja*)
Neggamorro	Old Turtle Man, Angguban Wandjina (Wun)

Neggamorro Minjel Monggnano Angguban Wandjina speaks of turtle, "I wonder where she's gone, I
love her, even the bubbles she makes, what beauty, what style" (Nga)

Ngadjar	the Above One, Master of All Galaxies (NWW from Wor)
Ngagnari	Wandjina Place; 'rain and wind, knocked, bent down trees' (Nga)
ngala	meat (Nga)
Ngallagun	Waterlily spirit paintings (Nga)
ngallalla yawun	time of Creation; 'everything soft like jelly' (NWW)
ngallara	grass country (NWW)
Ngalluwal Mirri	Flying Fox Place (Wun)
Ngamarra	King Brown Snake, spiritual and common name; 'for snake's sake' (Nga)
ngangnol kude	cirro-stratus wind cloud; fourth head-ring of Wandjina (Nga)
Nganowat	Yahmaroo's wife; boss mother, kangaroos; *also* Goroni (NWW)
ngari	area, place (NWW)
Ngarinyin	language group of the central Kimberley (NWW)
ngarra	pure honey (Nga)
ngarun	this is us (Nga)
Nggawa	Raingod Wandjina, the Rainmaker, a Creator Spirit (Wun)
Ngolngol	Cyclone Spirit; Rain Spirit (NWW from Nga)
Ngolngol kude	cirrus clouds (NWW)

ngungguluma kalli kalli pamaneri 'don't have a crooked spirit, stay straight' (Wor)

nguning	sweat of the Wandjina, also a name for patterns of cupules in rock (Nga)
nguniella	in a state affectedby the nguning, as in totemised or 'gi-d' by them (Nga)
Ngurru gonna gnari	Listening Place; 'snake listening to flying foxes chattering' (Wun)
niggu wala	spoiled, over-ripe, slimy state; sickness; *see also* wullu (Nga)
nitjamrung gnari	urinated; 'made bongle here' (Nga)
Njallagunda	Snake Dreaming, Gibb R. (Nga)

Njallangga darr mumanggnari place, 'where her [goanna's] tail went up first'; now a stone standing up,
in Charnley R. area (Nga)

njallara	sunset; literally, 'arse of the sun' (NWW)
njambut	female pubic section; *also* lower part of Bandaiyan, continental Australia (Nga)
Njanggudunda	Carpet Snake, spiritual and common name; Kidney Place, Mt Elizabeth (Nga)
Njararaman	'Cheeky Snake', venomous, aggressive (Nga)
njawalla	initiation marks; 'Everyone has them; crocodile spilled his blood, beginning of education, everyone donating their blood to the earth.' (NWW)
njindi	female, 'her' (Nga)

Njunggunnu balya kallola 'Wunambal Snake talked Wunambal'; place near Montgomery Island (Wor)

njuwani, njuani	'she slid down the waterhole' (Nga)
njuwanignari	'slid down and stayed there' (Nga)
nulla-nulla	hitting stick (outside language, in widespread use)
Numenba	Champagny Island (Wor)
nuwala	a fresh- and salt-water fish 'the short brown one' (Nga); barramundi; *see* Illarra
Nyanganyanyi	Mt Trafalgar (Wor)
Nyigina	language group of Derby area and lower Fitzroy R.
Olumballu	banman's magic stone, from Earth Snake; *see also* Kandukandela (NWW)
omba	ribs; wavelines to side of heart of Wandjina (Nga)
onat	bone, or pattern, of the djunbar, or corroboree (Wun)
onja	yellow eggs of bush honey bee (Nga)
pamaneri	'he doesn't want to be that way' (Wor)
rai	personal spirit, baby spirit that enters foetus (NWW and other Kimb. languages)
rambud	mother-in-law; barrier, windbreak, screen (NWW from Nga)
ranggu	heart; narrow black plaquelike area on Wandjina chest, the 'powerline' (NWW)
rere mirri	'where they rattled' (Wun)
Rowalumbin	Barker R. Wandjina (Ungummi-Umeda)
Rugunda	name of snake, which swallowed bandicoot; Roe R. site (Nga)
rurrwa	crawl to lay eggs; be with a pregnant belly (NWW)
ruwa	to scrape along, as do feet in thick grass (NWW)
Ubbaburra	name of signal stone (Wun)
udman ngirri gnari	'what always sets off the clanking' [in Dulugun: foot stepping on pebble, place where they touch it, trigger stone] (Nga)
ulangun	hill; head; high part; top of Bandaiyan, continental Australia (Nga)
umangat	sandstone; range (NWW from Nga)
Umari	name of a gorge (Kwini)
Umbul Majeri	Two Eyes Place; home camp (Wun)
ungadjella	islands; outer parts of Bandaiyan, continental Australia; *also* ungadjon (NWW)
Unguwan	hill; Sickness Dreaming place near Mt Bomford, 'Guts-ache' (Nga)
unggnu djullu	rib section; mid-upper part of Bandaiyan, continental Australia (Nga)
urumal	unclosed decoration, as in a loosely hanging tassle (Nga)
Waa	Mt Elizabeth; Wunggud's sound, scurrying scorpion/centipede; Stinging Place (Nga)
Waanangga	buzzing of Bee Place, 'waaaaa…'; Sugarbag, wild honey, Wandjina site (NWW)
Waderi	ancestor Wandjina (Ungummi-Umeda); *also* Wodoi (Nga)
Waddaburgan	mountain range; crying hill, near Mt Barnett (Nga)
wadi	belly section; lower central part of Bandaiyan, continental Australia (Nga)
Wadningningnari	Manning Gorge; 'she looked back, like a snake' (Nga)
Walguna	Tree of Wisdom, Knowledge and Law (NWW)
Wallamba	Red Kangaroo Man, track; his wife is Gowarrgnana (Nga)
Wallanganda	Creator Being, senior Wandjina, appointed by Ngadjar (NWW)
Wallawan	name of chasm; Dulugun gap for passage of dead (NWW)
walput	pubic cover (Nga)
wambalma	buttocks, legjoint-to-pelvis; mid-lower Bandaiyan, continental Australia (Nga)
wambut	pubic section; lower part of Bandaiyan, continental Australia (Nga)
wanalan	belt of twisted hair, decorative and practical (Nga)
Wanalirri	Wandjina site, a pound with many boxwood trees; *also* name of a people (Nga)
Wanditj	to build the structure (NWW from Nga)
wandjat	to be parted, as from ties with people and land (Nga)
wandjat bowa	get away, go for good, never come back [emphatic] (Nga)
Wandjina	Raingod, Creator (NWW)
wangigit	centre, navel; central part of Bandaiyan, continental Australia (Nga)

Warari	honey tree, yellow-flowering, grey-barked softwood (NWW from Nga)
Warmaj Mulli Mulli	Wandjina who carried Big Red Yahmaroo naming Kimberley areas (NWW)
Warmun	community, Turkey Creek (Kija)
Warrabi	place where Flood Wandjina swayed with the lambarra [witchetty grubs] (Nga)
warri	fire-burnt (NWW from Nga)
Warringari	Warmun, Turkey Creek, people, 'our anchor mob in the law; sunrise mob, who scorched themselves in the fire' (NWW)
Watjinggno, watjinggno	site of Trackite Wandjinas; tracks (NWW from Nga)
Watjinggnogno	Track Wandjinas, Trackites (NWW from Nga)
Watty Nyerdu	man's name; 'end of crocodile tail' [where father found his spirit] (NWW)
wemballaru	feet, 'footside'; lowest part of Bandaiyan, continental Australia (NWW)
wianu nangga	two red organs in crocodile (Wor)
Wibalma	early banman who made the Law (NWW)
witjingarri	native cat; see kandiwal (Wun)
Wiyuru	Bigge Island, Scott Strait, Bonaparte Archipelago (Wun)
Wodarra, wodarra	one of Wunggu's names; 'he is my brother' (Nga)
Wodoi, Wodoiya	Nightjar Man, ancestor, colourful spotted owl [co-originator of Wunnan marriage system with Djingun] (NWW)
Wojin	powerful, dangerous Wandjina (Wun)
wollai	to turn (NWW)
wollngga	roots of plant like waterlily (Wun)
womera	spearthrower (outside language); yanggal (Nga)
wonditj	to build, start it off (Nga)
Wongai, wongai	Creation Time Women; tree, Wumberagun (NWW from Wor)
Wongga	yam plant (NWW from Wun)
Worrorra	language group, northwest coastal Kimberley (NWW)
Wotjulum	place, used for relocated mission during 1950s (Wor)
wudu	teaching, warning, of things forbidden in law (NWW)
wul amangnari	'place where he slept' (Nga)
wul inninggnarra gnari	'where he laid him down' [killed him] (Nga)
Wullari	Donkey Creek, place of Wandjina judgement on tribe who hurt Dumby (Nga)
wullu	creation substance, dough; a sore that never heals, bad leg that leads to death; 'that wullu take people to death' (NWW)
wullumarra	long-necked sweetwater turtle; literally: 'see the wullu' (NWW)
Wullunggnari	Mitchell Plateau; holy water, Creation; Flood Wandjina died there (NWW)
wumangnalla	chest, lungs; mid-upper part of Bandaiyan, continental Australia (NWW)
wumberagun	a tree with black berries; also wongai (NWW from Nga)
Wunambal	language group, central northeast Kimberley (NWW)
Wundorra gnari	a mountain place (Wun)
wundu mirri	'where we lay on flat rock to warm ourselves' (Wun)
Wunggadinda	Manning Gorge; snake personage (Nyigina)
Wunggarang	a language group (now extinct) of islands adjoining Worora
Wunggu, Wunggud, wunggud:	Earth Snake; Creation spirit, formed many places, typically water sources; Ancestor Wandjina who camped without fire, obtained fire; common term for such spirit, and place of spirit, eg: deep parts of waterholes; also night, darkness; (Wun)
Wunnan, wunnan	marriage, sharing and exchange system and law (NWW)
	cf: Wanang Ngari Resource Centre, Derby (Nyigina)
wunnangga	a loose stone; setting of moveable stones (NWW)
wurrad	danger (Wun)
wurri	sloped, as of country; bent over, as of person, tree (Wun); see garra wurri …
wurri malai	stooped, sloping down, bent, 'nothing to balance you' (Wun)
wurrunda	a species of tea-tree or paperbark; barramundi tree (Nyigina)

Yadnanya	Wandjina who cut the Sugarbag tree for the first honey (Nga)
Yahmaroo	kangaroo which was carried the last stretch of long journey by Warmaj Mulli Mulli, a Wandjina who named Kimberley country (Wun)
Yallanba	name of a mountain (Wun)
Yallimballi Ngagnari	Storm Wandjina: 'I go bending down trees with force'; violent wind and rain spirit (Nga,Wor)
Yamara	Victoria Gap in Napier Range, 'where Emu dancing dancing broke through' (Ungummi-Umeda Language)
Yamben	Water Goanna spirit-man, from blackwater goanna (Wun)
yan	with purpose (Nga)
yanggu	waterlily (NWW)
yarri boaludje	come down, as from tree, hill, rock, car, downstairs (NWW)
yarri	dream, a floating dream state; *see also* buraal (NWW)
yarri yarrying	dreaming, floating up and about (NWW)
yarri wada	many dreamings (Nga)
Yaworara	singing in (or back), also reverting, reforming, going back to beginnings (Nga)
yawun	time (Wun)
Yayit	Berkeley R. mouth, north of Drysdale Station (Kwini)
yo	yes; *also* jo (NWW)
Yolyol	'where Snake came up', a creepy, slimy place (Wun)
Yorro Yorro	ongoing divine Creation, in absolute or holistic terms, 'everything standing up alive, brand new' (NWW)
Yowajabba	Montgomery Is. (Wor)
Yowal	Raingod Wandjina, the Rainmaker, a Creator spirit (Nga, Wun)

Glossary of other terms

Akubra	a brand of felt hat
Brasso	metal polishing fluid [brand name]
camp-oven	heavy, lidded stewing and baking pan/pot, traditionally of cast iron, with a loop handle
cheeky	hot, as of food; aggressive, as of snake, goanna
hairbelt	waistbelt or armband woven mainly of human but also other animal hair
humpy	simple shelter of natural materials
johnny cakes	camp scones
outstation	smaller community with family and cultural connection to the area; developed [as a return to homeland] from a main community or town; originally outlying pastoral live-in facility
sugarbag	wild honey from small stingless bee native to Australia
overlanders	pastoralists who drove original herds from Eastern to Western Australia
trepang	sea cucumber, *also* beche-de-mer, subject of long-standing trade
yam	edible root vegetable, similar to sweet potato

Index of illustrations

Photography by Jutta Malnic, unless otherwise shown. All drawings by Mowaljarlai

General Index

Illustrations shown by italics for photographs, bold type for drawings

Djingun, ancestor, 212; conflict with Wodoi, 143; land/animal totem, 152; maker of fire, 166; obtainer of law, 150-1; representation/function, 49-52, *50, 143*

Djogai, 125

Djua, 18, 181, *182,* 187. *See also* Devil-Devil

Doctor woman, *140*

Dolphin, 90, 91, 146

Donkey, 78, 113

Donkey Creek, *35;* genealogy, 101, **100,** *182-3;* site, *98-99,* 100

Doongan, Station 49, 172

Dorgei, 157-8, 159

Doring, Jeff, 203

Doubtful Bay, 180

Dreaming, of children, 9, 86, 137, 145, 205-06; classification into buraal and yarri, 39; Cloud-, 62, 136; communication by, 70; composer's, 165; Crocodile-, *165;* Daylight/Darkness, 79; lasting effect, 37; Lejmorro *(see* Milky Way), 28; life-change, 37-8; light as precursor, 36; prophetic, 33, 36-7, 91; Sickness-, 43, 81; Snake-, 11, 14; of Wild Honey Wandjina, 71

Dreamtime, missionary attitude to, 109

Dry, -season, 18, 22, 145, 172, 212

Drysdale, River, *6,* 7, 47

Drysdale River Station, 5, 49, 173

Dulugun, gateway **161;** home of dead spirits, 157; -journey stages, 157, **158,** 161; judgement, 165; location of, 160; songs/stories about, 162-5; as source of individual spirit (rai), 84

Dumby the Owl, story, 15, *34,* 101; link with Trackites and land apportionment, 101

Duwarr (who found the *Atlantis* flyers), 173

Dying, stages in, 158-9, 161. *See also* Dulugun

Earth, in Creation Time, 169; domains (rival), 132, 143, 145, 213; energies, 81, 132-3, 137; female oriented to, 143; -fires, 14, 16, 141, 149; landscape formed, 133; -ly manifestation, 5, 8, 29, 63, 181; power, 133, 137, 191; as sacred (mahmah), 97; -shadow, 160-1; -Snake (Wunggud), 14, 80-1, 132-3, 141-3, 145, 173, 176, *199;* and sun birth story, 45; as womb, 143; -Women, 8

Edols, Michael, 42

Education, as cultural task, 194, 209-10; fire as aid to, 105; from the track, 101; in tradition, 104-5, 110-2

Elkin, Prof., 203

Ellenbrae, Campbell, 49; Dhargie, 44, 45, 48, *134*

Emu, 19, 21, 22, 129, 137

Energy, and concentration, 67; Earth-, 81; totem, 137; in images, 133; Life-, 137. *See also* Power

Entrance Island, Bandjuwarra, 20, 160

Family, activity pattern, 104-12, 138, 165; fire as spirit of, 168

Fear, as awareness, 53, 56; of mahmah places, 147

Female, boomerang symbol, 203; burial ceremony, 143-4; Earth Mother, 203; initiation, 195-6; law power, 8, 149; mother as regenerator, 45, 48; roles, areas of service, 137, 143; Snake, 149; sun as, 45; teachers, 10, 104-7, 196

Fire, origin of, 166; as spirit of family life, 168; -stick, 91, 158-9, 160; as learning aid, 105;

Fish, 144; communication with, 90; cooking, 23; as creation identity, 180; rule for eating, 67; totem unity with human, 137

Flood, agent of re-Creation, 170, 180-1, 187; cause, celestial, 194; cause, rain, 101, 166; cause, Wojin, 15, 18, 101; dating, 195; events, **100, 184-5;** and sacred place, 180; and sea level rise, 190-1; traditional knowledge of, 190-1; -Wandjina's death, 196. *See also* Dumby

Flying Doctor Service, 119

Food, individual duty to provide, 105; source and renewal through totem, 132, 136-7

Forrest River, 18, 71, 116

Frog, rain song, 146, 154

Funerary paperbark, 74, 157

Galaru snakes, 14, *17, 85*

Galactic awareness, 132, 144. *See also* Cosmos

Galorugnari tribal group, 101

Gangar, 203

Gate of the sun, 45

Gi, 67, 70, 138, 198, 200, 205-06; -powers, 139

Gibb River, 4, gorge, *16;* road, *xxi, 3,* 32, 52, 96, 143; Snakes, 146-8; sites, *16-7, 153, 180, 211;* Station, 14, 193, 196

Gift, 143; cultural, 210

Gimbu, 202

Glenelg River, xvii

Goanna, 63, *65*

God, 37, 38, 119, 129; and conception, 85; home of, 84; purpose of, 198; Rain-, 74, 101, 133; reflection, projection of, 86, 133, 137; sites, 83; Wallanganda, 63. *See also* Creator; Nadjar

Gondwanaland, 29, 190

Gorrid, 8, 20, 149

Goonak, Wilfred, 177

Gowanulli, Laurie, 209

Great Barrier Reef, 29, 190

Grid (land), 66, **192, 205;** -blocks, 68, 71; -places, 194; system for life, 187

Grog, beer, as nemesis, 36, 39, 85, 90, 129

Gulf of Carpentaria, 191

Gullinggni, Wandjina, 74, 137

Gunnat, Raymond, 115

Guya, 202

Guyan Guyan, 200-08, decoration in painted figures, 204-5

song in, 151, 152; and Wunnan, 44, 50. *See also* Law; Punishment

Song, rain-, 154, as ritual, 28, 152; at sites, 74; stories of, 154, 162-71; trade in, 163; as vehicle of social order, 152, 190-1

Spirit, -boss (Kalinda), 164; -child, 9, 14, 74-5, *81, 82*, 85-6, *141*, 149, 205-06; in country, 33, 128-9; in death (*see* Dulugun); and death-cord passage, 162; as falling star, 160; Gi- (totem), 138, 198; -home, 142; Kimberley as entry point, 33; -kinship, 138; and lightning, 156, 181; -loss as illusion, 129; and males, 144; orphaned, 139, -part (of child), 142; -powers, 154, 164; rai, 84-5; rain has affinity with, 156; self-protecting, 60, 139; source, 84 (*see also* Dulugun); -ual awareness, 196, 198; -ual nature, 195; Wandjina, 62-3, 137,198, 212; -world, 156-7, 162, 172

Stars, 5, 192

Stellar origins, 84, 132, 142, 209. *See also* Creation; Milky Way

Stock camp, 113

Stone, Bamale Snake, 6, 7, *13;* snake saliva, *153;* symbols, 3, 61, *64, 76-8, 167*, 172, 196, 198; tools, invention, 200-02; turtle, *64;* Wodoi/ Djingun, *50-1;* Wongai Women, 8, *12. See also* Index of illustrations, Stone phenomena, 228

Stone knife, use (gangar), practical and ritual, 202

Storm Wandjina, 169

Subsequent cultures, Aboriginal as, theory, 208

Sugarbag (bush honey), beeswax toy from, *144;* conflict over, 50-1, 143; Creation story of, 71, *72-3*, 74-5; Follower Wandjinas, *134;* genealogy, 79, 100; as Marriage Law gift, 50-1, 143; Queen Bee Wandjina, *38;* -tree parts, **215**

Sump Creek, 48

Sun story, 45-6, 48

Suicide, uncharacteristic, 165

Supreme One, 142

Sydney, xvi, 33, 198, Lord-, 210

Taçon, Paul, Dr, 208

Tasmania, 'the footside' (Wemballaru), 191

Theda, 49

Taboo, 106; Snake Spirit, 146; and tresspass, 143; and water, 80, 105. *See also* Mamah

Teaching, banman pre-eminent, 154; of banman, 154, 176; Bush University, 209-10; from nature, 53-6; of hunting, 110-12, 145; method, 104-7, 209; parent's, 104, 107-8, 180-1; by relatives, elders, 110, 138, 196; of stock-work, 113, 115; by track principle, 101; at wudu time, (dawn/ sundown), 104, 144

Tension, in meetings, 59; at sites, 67

Tools, stone, invention, 200-02; carrying net, 204-05

Totem, dance-, 57, 66, 108; increase-, 123, 138; to forestall conflict, 137; identity-, 70, 137-8, 167, 200-02; intimate knowledge of, 90-1; as link to land; 68; -mic alter ego, 139; -mic principle, 137; mother-in-law, 19, 39, 117; unity with food source, 137

Totemisation, of Devil, 79; of fish, 90; of island, 187; of scorpion, 97; by spirit child, 14, 149; of track, by Wandjina, 101

Townsville, 191

Track, as life pattern, 15; as symbol of law, 151; as totem, 101; and Wunnan trade routes, 147

Trade, 152; in songs, 163, 172; history as item of, 190; -route origins, 147

Training, agricultural/pastoral, 116; Christian, 118-9. *See also* Teaching

Turkey Creek, Warmun, 11

Turtle, as human image, 82, 206; hunted, 67; painting of, *65;* stone embodiment of, 62, *64;* as Wandjina's preferred animal, 136

Ulangun (head) 191

Ullingi, Rastus, 196

Uluru, navel, centre (wangigit), 191

Umbagarumba, Johnny, *vi*, 18, *20, 58*, 59

Ungadjella, islands, 191

Unggnu djullu (rib-section), 191

Universe, 63

Universality, 37

Urumal, 204

Utemorrah, Daisy, ix, 4, 133, *179*

Victoria Gap (Yamara), 2, 29, *102, 186*

Visits to sites, xii, 15, 106

Waa, 18, 20, 97; outstation, *174*

Waddaburgan (Range), 163

Waderi, *186. See* Wodoi; Ancestor Wandjina

Wadi (belly-section), 191

Wadningningnari, 49, 196

Wahroonga, 33

Walcott Inlet, 180

Walguna, 195

Walk, creative, 137; a bush condition, 23, 77; habit of Mowaljarlai's father, 107; a Jagamurro characteristic, 28, 53; wartime endurance-, 122; Watty Nyerdu's tracing of country, 59

Walkway of light, 161

Wallaby, 70, 82, 117, 137, 187

Wallanganda, Creator, 63, 132, 144, 212, 214; in dispute with Midjelna, 142, 145; form of, 133, 144; giver of totems, 137; linked to Djingun, 166; reminders of, 136; sum of all Wanjinas, 63; taboo image, 13. *See also* Nadjar; Creator

Walput, 204

Wambut (female pubic section), 191

Wanalan, 204

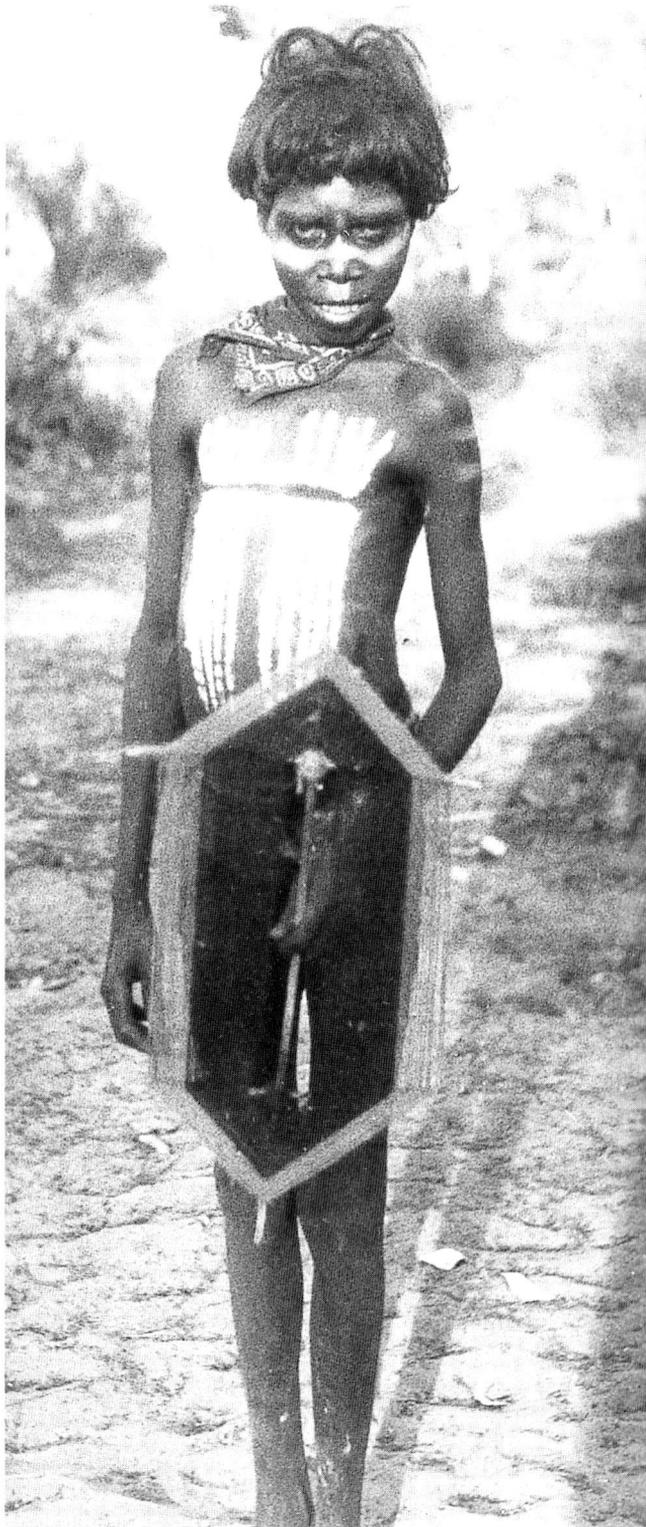

Mowaljarlai with dance totem Onat, near Kunmunya. 1938. Lommel